Marble
and
Mud

Around the World in 80 Years

MARION KAPLAN

MOHO BOOKS

Published in Great Britain by Moho Books, 2020.

ISBN 978-0-9557208-5-7

Moho Books, Wiltshire, Great Britain.
email: contact@moho-books.com
website: www.moho-books.com

Marion Kaplan is at: www.marionkaplan.com

British Library Cataloguing in Publication Data
A CIP catalogue record for this book is available from the British Library

Designed by Mark Tennent: mark@tennent.co.uk 01903 210601.

Printed and bound in the UK by CPI Group (UK) Ltd, Croydon, CR0 4YY.

Contents

Life is made up of marble and mud

Nathaniel Hawthorne

Introduction

WHAT'S here, text and viewpoint, is entirely personal. The photos arose from assigned work, from moments of relaxation and high elation, and from inconsequential travel. They are in no way encyclopaedic but, I hope, informative, pleasing and maybe in aspects even enlightening. The list covers countries in all seven continents – plus a few islands – where digging in boxes and files turned up not just images from recent journeys but photos, nearly all black-and-white, from when I started out. Which was in the 1950s, a long time ago. In places, on some stories, I hold a large range to choose from, in others pathetically few. For these pages, photos came first, the text followed.

Of the world's continents – and I have roamed them all – Africa remains closest to my heart and strongest in my memory. There I discovered grand skies, great spaces, odd contrasts, brave and hospitable people, amazing wildlife, astonishing natural beauty, and the career in photojournalism that made my life endlessly enthralling. Stories of upheaval, conflict, suffering and tyranny, and happier colourful events became my meat and drink, the fire in my blood. Photography, today almost a commonplace thing, its wonder lost, began for me in Africa. It was and is a compulsion that led me, across decades, to almost every corner of the world.

A freelance always, I was assigned by a plethora of publications including the American news magazines *Time* and *Newsweek*, *People* for the many visiting and resident personalities, *National Geographic* for less ephemeral features, and by the British papers *The Observer* and *The Times*.

What's not here are the countries I missed, for whatever reason. No assignment to go there, never considered going there, too pricy, too far from home (wherever that was), too nameless, too familiar, too challenging (which troubled me only rarely).

And why do all this now? Well, I'm no longer young, nor as agile as I was. But I've had such a fascinating time and, for all the years, I'm still addicted to news and in my heart am still a photojournalist. So, it follows, I want my photos to be seen, to spark interest and enjoyment, even when all the world is a photographer, even when the world is struck by modern plagues.

The text is meant to provide context. At times it's not much more than a bald précis, a potted history of each place. Even where I elaborate, include an anecdote, touch or expand on politics, mention passing presidents, offer an opinion, it's from my own perspective. I've always loved words and a good story, have always wanted to know more than I could see through a viewfinder. Photos reflect only when I was there, the words a lifetime of watching and reading. It's likely, of course, that I haven't got everything right. For errors, I offer my excuses.

I'm too old to be politely humble, yet not too old to declare a continuing passion for our fabulous planet, to be respectful of the opinions of all peoples everywhere, excluding the extreme and ultra-weird. And, crucially, I'm still young enough to value and appreciate the love, kindness and generosity of all those who gave my life its joy and meaning. Now, on with the show.

Part 1

Africa

AFRICA. A vast territory, Africa encompasses more than fifty independent countries, each with its own history, identity, geography, economy and culture – or many cultures. All countries, with the single exception of Ethiopia, have been significantly affected by colonisation. Africa's natural wealth has been stolen, its peoples abused. Africa has experienced famine, drought, flood, coups and revolution. Slavery violently eroded societies and regions. Africa's nations have suffered swarming locusts and appalling diseases from malaria in the tropics to wide-ranging smallpox and the modern plagues of Ebola and Aids.

Endless hardship, accompanied by corrosive politics and bureaucracy and, in places, the scourge of corruption, have held back prosperity and stability. All the same, extraordinarily resilient, many Africans surmount their past through courage, determination and technology, including solar power and the modern miracle of smartphones.

Predictably, Africa has changed a great deal since the years when I lived there. Populations have expanded. People are better educated and, since phones became commonplace, better

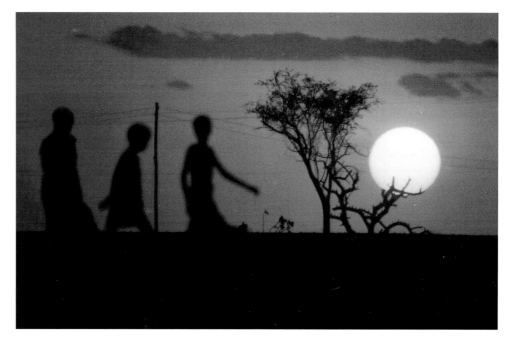

informed – though, it follows, more easily deceived. Lies and rumour are as prevalent in a better connected Africa as anywhere else, making it hard to get good news – as about, say, vaccines – properly understood.

Africa's resources are as tempting now as in the abhorrent slave trade era. China's Belt and Road initiative, a modern version of the old Silk Road linking trade and development, has heavily impacted the infrastructure of many countries. Most conspicuous

Above: *Africa's sunsets are often spectacular; this one was in the Ogaden in Ethiopia.*

are four new railway systems: the Mombasa – Nairobi railway (485 km, 301 miles), Addis Ababa – Djibouti (759 km, 472 miles), Abuja – Kaduna (187 km, 116 miles) and Angola's Benguela railway (1,866 km, 1,159 miles).

Empire builders created storied railway lines. The Mombasa-Nairobi line, completed in 1899, was nicknamed the 'Lunatic Line' for its high cost, £5.5 million, and for all its challenges. China's role in present-day Africa is as remarkable and repeats the enormous potential of the first railways. There are thousands of other projects and the debt, as in amount of money, that Africa owes to China is incalculable. A lot has been written about this hugely ambitious Chinese policy. One headline that caught my eye: 'Beijing denies that it is trapping developing countries in unsustainable debt.'

If demographics are a challenge for African leaders, there are still basic social, environmental and geographical facts that are a reminder of Africa's singularity.

African rivers – the Nile the world's longest – are a dominant feature (and a thrill) and, as water becomes more precious than oil, an infinitely valuable resource. African wildlife, threatened and diminishing, is still a glorious asset, a boon and a blessing. African minerals that are mined largely to the profit of non-Africans are, all the same, economically and socially a benefit.

That space, that sky, the deserts, mountains and forests, the long heritage of ancient wisdom, the arts and crafts that colonialism tried, and failed, to erode, the skills of today's writers, musicians, scholars, economists, engineers, doctors, conservationists and other capable and creative men and women, are evidence of both the eternal and the admirably progressive Africa. I have moved on and away but the allure is still strong.

Botswana

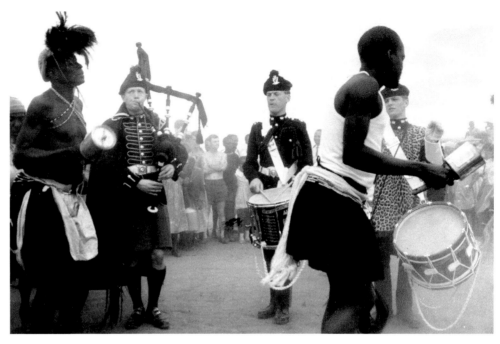

■ BOTSWANA – has been stable, steady and prosperous through all the years since it won independence in 1966. It is a land valued economically for its wealth in diamonds and enjoyed by tourists for its spectacular wildlife and the prodigious Okavango delta. Yet for a period before independence, when Britain ruled over what was the protectorate of Bechuanaland, head-lines focussed on a single topic: the marriage of the predominant African chief, Seretse Khama, to Ruth Williams, a young English woman working as clerk to a Lloyd's under-writer yet frequently belittled as 'typist'.

If the marriage was an issue in England (and described as 'nauseating' by South African premier Daniel Malan, then embarking on government by *apartheid*), a 'white queen' did not appeal to the nation's Batswana people either. Yet this was a loving marriage that endured. Seretse and Ruth won

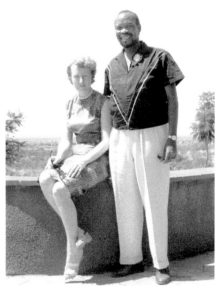

Top: Royal Irish Fusiliers performed alongside local drummers to celebrate Botswana's independence in 1966.

Above: Sir Seretse Khama, first President of independent Botswana, with his British-born wife Ruth. Their marriage in 1948 was controversial.

the respect and support of his tribe and confounded British diehards with their dignity and increasing popularity. Seretse was elected president of an independent democratic Botswana – I was there – and ruled, with Ruth at his side, until his death in 1980. In 2008 their oldest son, Ian Khama, was elected president, serving for ten years.

An unexpected problem arose in the presidency of his successor, Mokgweetsi Masisi. Too many elephants. In a decision questioned by conservationists, but pleasing rural communities bitter over damaged crops, the Botswana government lifted a ban on elephant hunting. Causing alarm too was the government's wish to re-open the ivory trade. The environmentalist view was that this would have a catastrophic effect on the elephant population, already losing some 30,000 savannah elephants to ivory poaching every year.

Botswana had been largely spared the ferocious poaching that had struck African countries in the new millennium. But after 2014 more and more fresh carcasses were being found. One study showed at least 385 elephants had been poached in Botswana in 2017 and 2018. If this seemed a low figure in a land of some 126,000 elephants, the prospect of increasing and intense poaching was not encouraging.

Drought, too, was bringing agonising death. Harrowing images of

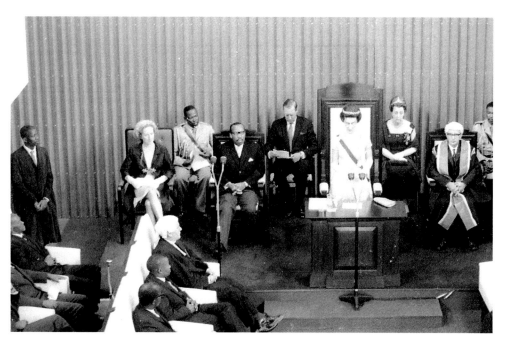

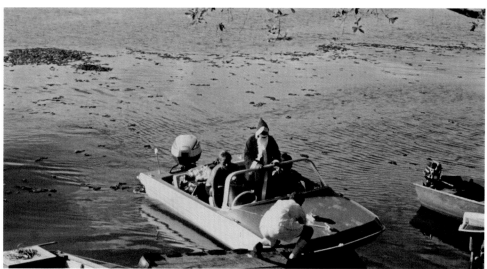

Top: Princess Marina, Duchess of Kent, addressing Botswana's new Parliament in 1966. She represented Queen Elizabeth II in independence ceremonies.

Above: Santa Claus arriving by river for Christmas festivities at the Chobe National Park in the mid-1960s.

Left: Elephant, buffalo and lion are Chobe's main attractions. Crowned plovers are among diverse birdlife.

desperate animals struggling in deep mud to reach water were a heartbreaking reality.

In 2019, with Seretse's marriage well in the past, a matter concerning sexual relations was once again in the courts and headlines. This time it was about gay sex, declared legal. Quite a few gays in other African countries where being homosexual was a criminal offence could only sigh with envy.

Burundi

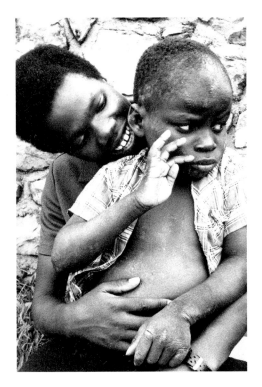

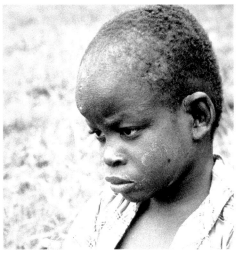

Left and above: Mass killings – genocide – was a national tragedy more than once. Yet an odd story of a so-called 'ape boy', here with a carer, also caught world attention.

■ BURUNDI – a small country neighbouring Rwanda in the Great Lakes region in the immense continent of Africa, was part of a duo called Ruanda-Urundi in pre-independence times. Historical differences between the two main peoples, Hutu and the traditionally dominant Wa-Tutsi, their role inflated under colonial rule by Belgium, meant endless conflict, coups and assassinations, leading in the 1970s and afterwards in both Rwanda and Burundi to gruesome genocidal massacres of Tutsis and of any Hutus supporting them.

The years 1972 and 1993 marked appalling slaughter. Hundreds of thousands died, also in Rwanda and, even when the slaughter eased, conflict and coups and killings continued. The United Nations assumed peacekeeping operations until 2007. The most prominent leader to emerge was Pierre Nkurunziza, a politician who became president in 2005 and was still in that post ten years later.

For all the horror, daily life went on with all its crises and intrigues. And out of the mists and legends arose, in 1975, an enigma concerning a small boy who was among forty children in the care of a Catholic orphanage. Most were survivors of chaos, broken homes and families. This boy's family, according to the orphanage staff, missionaries and many Burundians, was a troop of apes.

The story was that peasant farmers observed a small creature, slower than the rest, in trees near the shores of Lake Tanganyika and realised it was human. The men chased and caught what proved to be a hairy, dark-skinned small boy and took him to a hospital in the capital, Bujumbura, where he languished, apparently dumb and deranged, for three years in the hospital's mental wing. Missionaries, believing he stood a chance of normality, moved him to the orphanage and set him down among normal children. But reports on the 'ape boy of Burundi' didn't go away and, finally, in January 1976, I went there because – perhaps – it was a story.

Journalists and photographers in troubled Burundi were not welcome. Science keeps a distance from feral child tales. Jane Goodall, who I approached for an opinion, said it was highly unlikely chimpanzees would have adopted a tiny boy, though it was just possible a troop of baboons could have taken an interest in him. Any comment would have to wait until the child had been medically examined. I took the child's photo and, assured he was in good hands, left for home. A couple of years later, his story led to formal medical examination. The conclusion: poor treatment in infancy, brain damage, and autism. I knew of other wild child sagas from Rome's Romulus and Remus to the 'wild child of Aveyron'. All had met with scepticism. I was just a little sad that this one too finally hit the dust.

photographers in troubled Burundi were not welcome

Cameroon

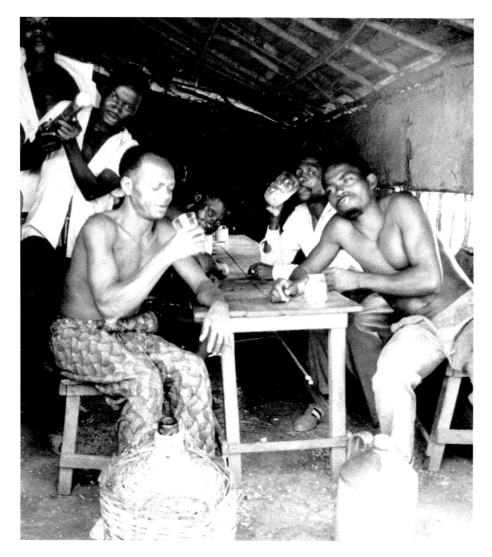

■ CAMEROON – Back in 1919, when the prizes won by the victors of World War I were still being awarded, even as the war's horrors and losses were stark in memory, authority in a small corner of Africa observed a seemingly minor change. A so-called 'London Declaration' decided that Cameroon, a modest territory on the west coast, would have two administrative zones – one, 80%, would be French, the remaining 20%, British. English became the official language in the

Above and overleaf: Scenes at a bus station I've long forgotten – this was 1963.

smaller zone; French was spoken everywhere else.

In 1960 French Cameroon won its independence with the respected Ahmedou Ahidjo as president, a position he held until 1982, when he was succeeded by his prime minister, Paul Biya. (By 1972 the country had became a 'unitary' state.) In

subsequent years only three events caught the world's attention: the discovery of oil, now a major export, the eruption in 1986 of a murderous bubble of carbon dioxide in Lake Nyos which killed 1,700 people, and the classification in 1998 of Cameroon by Transparency International as the most corrupt country in the world. Logging, legal and illegal, cut into the large natural forests across the decades.

In the early 1960s I was making a slow overland journey from South

Africa to England, hitchhiking each step of the way. I can still remember the smiling greetings I was given as my driver of the day introduced me to family and friends in his village in what was officially anglophone territory. "Welcome," everyone said. "Welcome."

I soon realised this one word was the extent of most people's English, yet to this day the language issue has been the source of national tension. In 2016, particularly, protests arose over the imposition of French into English-speaking areas.

But it is not this, or the news – occasional border troubles with neighbouring Nigeria or terrorising activity by the militant group Boko Haram or city crises in the two largest Cameroon cities, Yaoundé, the capital, or Douala, the main port – that made the headlines. Often it was the skills and cunning of Paul Biya, who, while taking long holidays in Switzerland, succeeded in hanging on to the presidency well into his 80s. Even more visible was his wife, Chantal. A striking woman 37 years younger than her husband, and taller, she was photographed (though, alas, never by me) in flamboyant designer clothes and extravagant hairdos – huge wigs in a variety of colours and styles. Yet how things have changed since my youthful pre-internet travels: Cameroon's Chantal, her First Lady outfits and her hair are on Instagram.

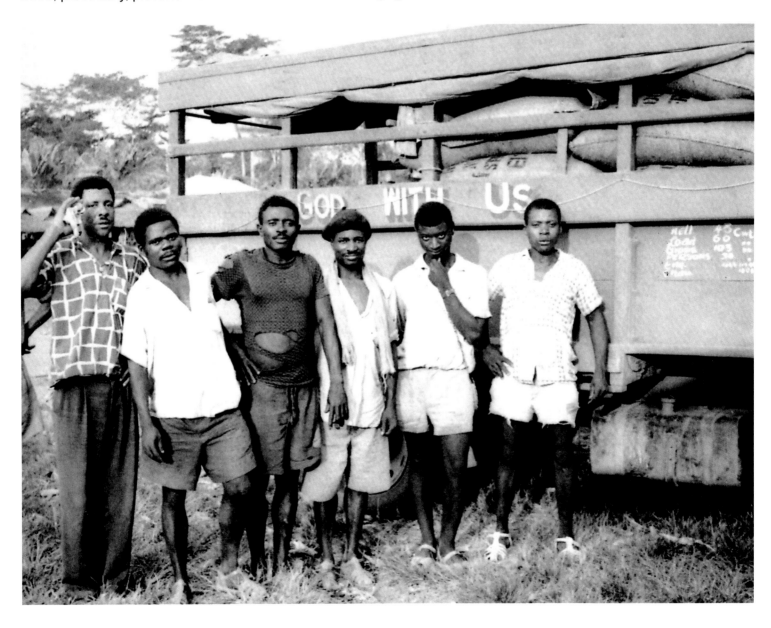

Central African Republic

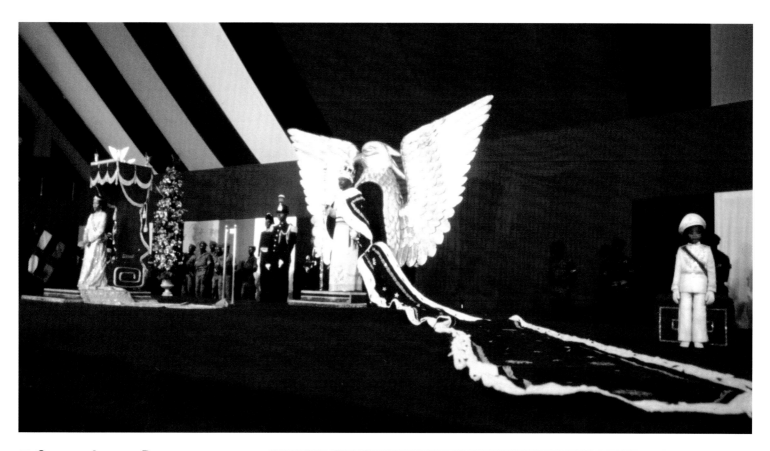

■ **CENTRAL AFRICAN REPUBLIC −**
Because diamonds are the country's
prime export it might be supposed
that the C.A.R. is rich. In reality, it is
one of the poorest nations in the
world. Much of the economy from
transportation to communications to
basic industry is a shambles. Incom-
petence and corruption rule. Most of
the population survive by subsistence

Above: Self-declared Emperor Jean-
Bédel Bokassa, his wife Catherine and
small son Crown Prince Jean-Bédel, jnr,
in a glittering and bizarre 1977
coronation in Bangui.

Right: Bokassa's personal cavalry
featured in gaudy coronation parades.

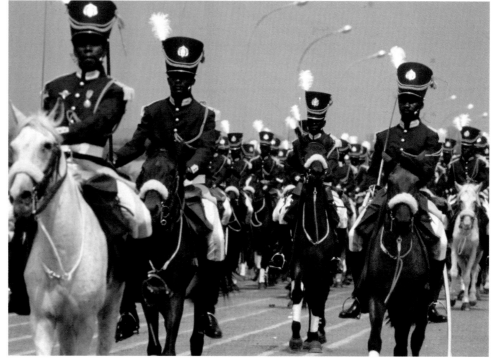

Above: Normally dressed women in Bangui.

Right: Barebreasted rural women in Bokassa's parade.

agriculture. French-run from the late 19th century when it was Ubangi-Chari, the territory became a part of French Equatorial Africa, then attained independence in 1960. Lacking good governance, the C.A.R. is a deeply sad example of a state gone horribly wrong. Conflict between Muslim and Christian groups developed into a ravaging civil war. In 2018, when any shreds of stability had almost completely evaporated, the International Red Cross reported that half the population needed humanitarian aid.

In early 2019 reports indicated the 'Russian-backed' government, led by President Faustin-Archange Touadéra, had agreed a peace deal with no less than fourteen rebel groups. President Touadéra had considerable negotiating experience: academically a mathematician, domestically a man with two wives, he was also a former prime minister. The deal was announced by the African Union, raising hopes for an end to the years of brutality. Peace, however, was not to be. Even as Russian mercenaries were employed to train the national army, attacks by one or another armed group forced tens of thousands of people to flee their homes. According to UN figures, the number of internally displaced people was more than 642,800, refugees at least 574,600.

Yet, for a brief moment, back in December 1977, the images – as I recorded them in Bangui, the capital – were of gold and glitter, gleaming palaces, gilded carriages, fleets of luxury cars, extravagant wealth. The occasion was the coronation of an emperor, a small man in lustrous robes on a shining throne in the shape of a massive golden eagle. Ludicrous, and certainly immoral, but oh, what a show it was.

The emperor, Jean-Bédel Bokassa, was a onetime sergeant in the French army, his idol Napoleon Bonaparte. As an army commander he had ousted the Republic's first president, David Dacko, in 1965, then made himself president-for-life in 1972. Wanting more, he pronounced his country an empire and himself emperor. Brutality was a constant. He fed his critics to

his crocodiles, or supposedly ate them himself. Schoolchildren, around a hundred of them, who had protested against an order to wear costly uniforms made by a factory owned by Bokassa's wife, were killed in a cruel assault – charges confirmed by Amnesty International. Finally, when he was on a trip to Libya, and only two years after his gaudy crowning, Bokassa was overthrown. David Dacko, his predecessor as president, was restored to power, insisting that the French had been most helpful.

The country's suffering would endure. As the years rolled by, workers were unpaid and strikes became common. The Ugandan warlord Joseph Kony and the Lord's Resistance Army caused disturbances and terror. Strife arose between Christians and Muslims – even a papal visit could not bring peace. As to Bokassa, he found exile in the Ivory Coast, then decided in 1986 to go home. Back in the C.A.R., he was tried and sentenced to death for murder and embezzlement, a sentence

commuted to life imprisonment. Freed after seven years, he died aged 75 in 1996. In 2010, the 50th anniversary of independence, Bokassa was officially rehabilitated. There are even some who recall that, as the leader responsible for building the country's university, an airport and handsome boulevards, he actually did some good.

Democratic Republic of the Congo

■ **DEMOCRATIC REPUBLIC OF THE CONGO** A name that implies democracy and the people's will is something of an irony for this huge, troubled territory in the heart of Africa. Moreover, the word Congo can be confusing. Is it the mighty river that winds across the great belly of the continent? Or the formerly French-ruled Republic of Congo, so-called Congo Brazzaville, that sits like a

Right and below left and right: 1963 – The arrival of the Congo riverboat, on its way downriver, brought huge excitement to riverside villages and to local traders (in beer, crocodiles, and much else). As so often, women did most of the work – paddling the canoes, bargaining goods and prices.

top lip at the northern mouth of the river? Is it the land the tyrannical former president, Joseph Mobutu, dubbed Zaire? The Kongo empire of ancient history? The Congo Free State, the horribly abused property of Belgium's rapacious King Leopold II, greedy for the profits from rubber, diamonds and slaves? In truth, the sorely benighted D.R.Congo, fabulously rich in resources, an ailing and capricious giant curled around a mighty river, has a cruelly perturbed past.

My own first view was as traveller making the 5-day riverboat passage in 1963 from what was Stanleyville in the east, now Lubumbashi, to Leopoldville, now Kinshasa, in the west. The Congo had become

independent in 1960, with Patrice Lumumba its heroic prime minister. He was murdered a year later, the country already in turmoil. For me the riverboat journey, lively and peaceful, was shared with Congolese passengers eager to trade their cargo, which included live crocodiles, for cash or Primus beer.

As we chugged slowly westward I thought of the adventurer Henry Morton Stanley, known most of all for his encounter with the rather more noble missionary explorer David Livingstone. Stanley completed the first exploration of the Congo river in 1877. He had worked as foreign

Right: Stanley, newspaperman and explorer, won fame but his statue was torn down soon after this 1963 photo, along with another statue of the greedy and ruthless King Leopold of Belgium.

Below: The first live gorilla I met face to face was held by a science institute in a small enclosure. At least he had a tree to climb.

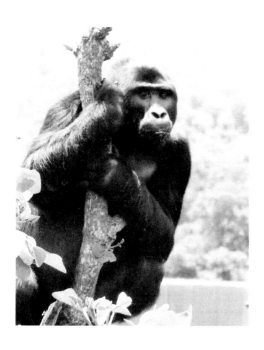

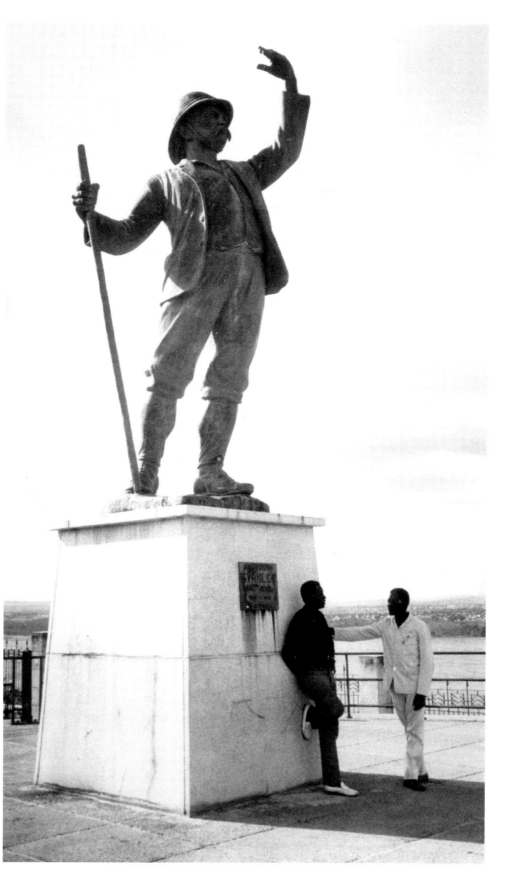

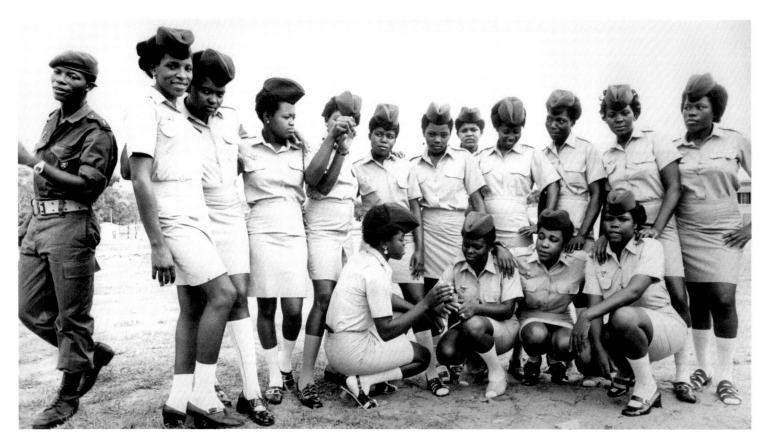

correspondent for the *New York Herald*. As explorer, he saw his mission as one 'to pour the civilisation of Europe into the barbarism of Africa'.

After its hasty and unprepared independence, the Congo went from crisis to crisis. Among the most challenging was the secession of mineral-rich Katanga, the country's easternmost province, deftly orchestrated by the ambitious politician Moïse Tshombe. To sustain his leadership he hired a force of mercenaries which, for all they were called *affreux*, the horrible ones, proved insufficiently formidable to combat the national army. With the defeat of Tshombe, the mercenaries were re-hired by the Congo's recently installed President Mobutu. Amid plots and counter-plots the band of mercenaries retreated to Bukavu on the shore of Lake Kivu –

where in July 1967 I headed with an *Observer* correspondent and photojournalist Don McCullin of *The Sunday Times* to cover their siege.

The mercenaries, commanded by Colonel Jean 'Black Jack' Schramme, did not do well. Three months later they were forced to lay down their arms and a humiliated remnant was eventually flown to Europe by the International Red Cross. On this second mercenary episode we were a small group of journalists. We had entered Katanga, with difficulty, from northern Zambia but there were no pictures, no story.

With Mobutu there came a period of relative peace. American President Richard Nixon praised the Congo's stability. A decade after independence chaos and anarchy seemed to have vanished. Confidence was restored.

Above: These women with their (male) commander were members of a tough parachuting corps in the Mobutu era.

Mobutu completed the transformation in 1971 by bestowing on the country – and the river and the currency – a new name: Zaire. His own new name was Mobutu Sese Seko Kuku Ngbendu Waza Banga (meaning 'all-powerful warrior who, by his endurance and will to win, will go from conquest to conquest leaving fire in his wake'). I would see him quite frequently in his leopardskin hat, unsmiling and dour, at all-Africa gatherings.

Photos I did in 1971 for *The Times* showed tranquillity and progress – in schools and the university, a hospital, a bank, supermarkets and a women's paratroop unit in the national army. In Shaba (Katanga's new name) I pho-

tographed mines, their open pits and production. Sadly, by 1977 the positive images were out-of-date. The wealth had substance – and Mobutu himself ensured a vast share of it for himself – but the price of copper, a vital product, had fallen, and misgovernment and greed took over. In 1978 Zaire was bankrupt and owed billions. A cleanup by the IMF (International Monetary Fund) was unsuccessful. Extensive smuggling and corruption remained a way of life.

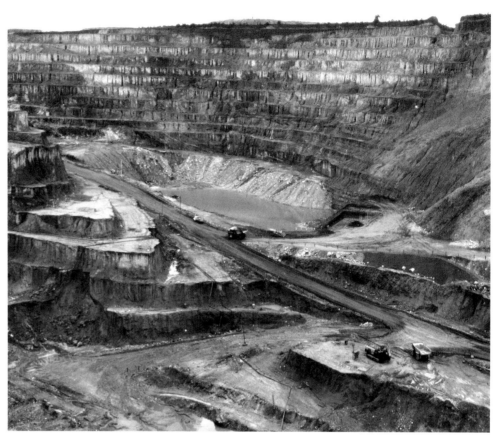

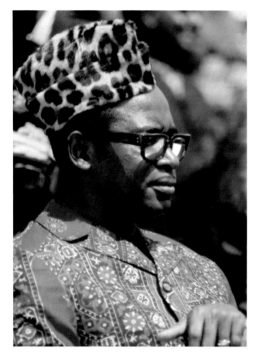

By 1994 Mobutu's power – and health – was fading. By 1997, oddly pressed by forces from tiny Rwanda and Burundi, he was gone. A new rule began under Laurent-Desiré Kabila. Assassinated in 2001 – shot by a bodyguard – he was succeeded by his son Joseph Kabila. In the east incessant wars and rebellions killed thousands. Kabila's grip on power staved off, for a time, new rule. Elections early in 2019 produced

Above: Kipushi open pit: high-grade copper is just one of the minerals in the eastern Katanga region, renowned for its wealth

Left: An army officer who became a ruthless and greedy tyrant, Mobutu was president of Zaire, as he renamed the Congo, from 1965 to 1997. Forced out by a small rebel force, he was dead three months later of prostate cancer.

Right: The Inga dams are an ambitious project that include three dams on the Congo river with a fourth projected. If completed, the hydropower would be the largest hydro-electric power generating facility in the world.

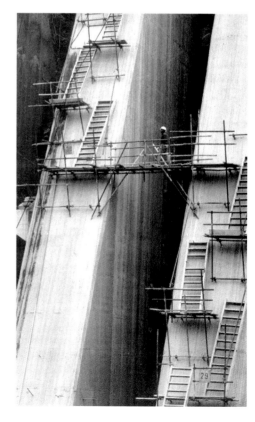

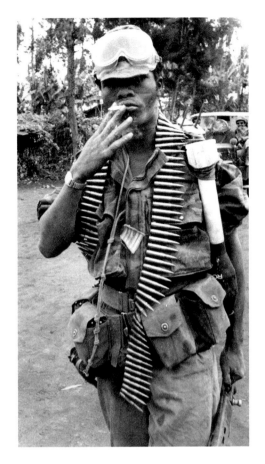

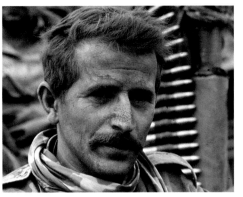

Left, above, below and right: Mercenaries of several nationalities, employed in the 1960s by both Mobutu and rival leaders, were more nuisance than serious opposition. Their target, under white leaders who included a Belgian planter, Col.Jean 'Black Jack' Schramme *(right)* was the wealth of Katanga. They were markedly unsuccessful. Finally, remnants were removed by the Red Cross. The dusty face *(above)* is that of a German who was suffering from toothache.

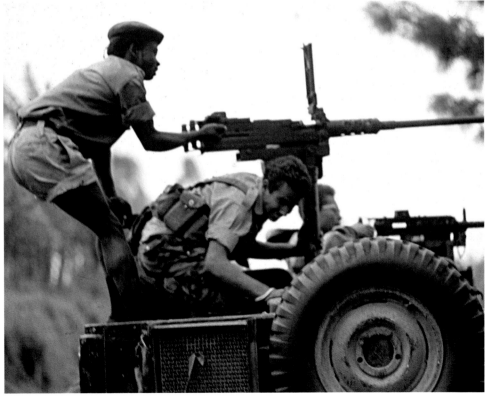

contested results but also a new president, Félix Tshisekedi, the son of a longtime politician and former prime minister, Etienne Tshisekedi.

The election was the first peaceful transition of power since the D.R.Congo became independent from Belgium in 1960. In a year of hope even the horror of Ebola seemed likely to have an end when experimental treatments proved successful. Yet distrust of the government, rumours that Ebola was a political invention, that the treatment involved witchcraft and the theft of body parts, slowed recovery. Even as cobalt, a vital element in electronic devices, and other minerals are providing a healthy boost to the economy, uncertainty seems to be the Congo's fate and destiny.

Djibouti

DJIBOUTI – was France's last colony in Africa to become independent and, in 1977, I was there to record the raising of the new country's flag and colourful celebrations surrounding the installation of Hassan Gouled Aptidon as president. A French officer had lowered the *tricolore* in a discreet sunset ceremony in the gardens of the French High Commissioner's *Résidence*, a significant moment marking the end of French sovereignty in Africa and 115 years ruling this small outpost of empire on the Horn of Africa. Once, it had been French Somaliland, then the French Territory of the Afars and Issas – the Afars proudly nomadic, the Issas related to the wider region's Somalis. But if the *tricolore* flew no more, the French

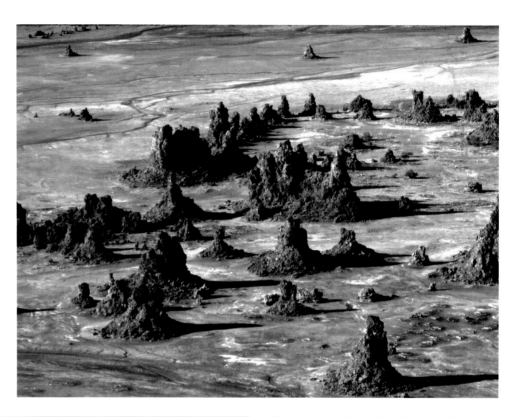

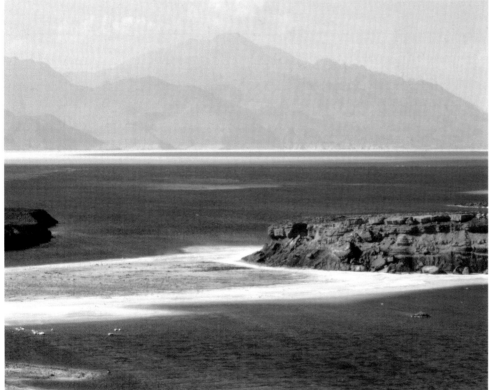

Above and left, overleaf top and bottom right: The small nation on the Horn of Africa, now a 'geostrategic location' used to be the French Territory of the Afars and Issas, There to cover its independence in 1977, I found amazing landscapes – Lake Abbé with its lime-encrusted hillocks, the salt-rich Lake Assal (within the so-called Danakil depression, contender for the lowest place on earth), deserts and wild lands inhabited by the Somali Issas and their rivals, the Afars.

were still there – and are still prominent in all their former possessions.

The importance of Djibouti then and now, when other formidably larger nations have established a presence, is its location at the foot of the Red Sea, with the Suez Canal to the north and the Indian Ocean to the south.

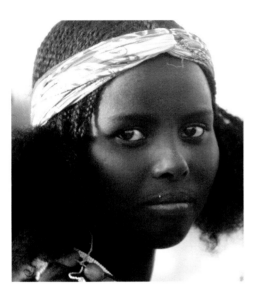

Above: The young woman belongs to a nomadic Issa community.

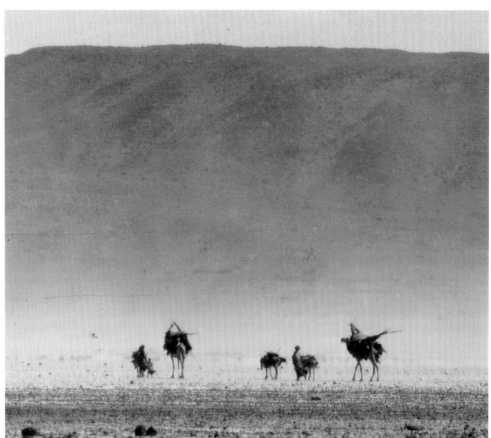

German warships patrolled in 2002 to support American troops in Afghanistan; American platoons were also quartered in Djibouti. In 2016 Saudi Arabia, just across the Red Sea, set up a military base in Djibouti, as did China the following year. Before all this, a single-track railway connecting Djibouti with Ethiopian capital Addis Ababa had been the prime external link. A brand new Chinese-built railway replaced it in January 2018.

Around independence I had had an enjoyable time exploring the small territory, photographing Afars as they herded their goats and cattle across the parched landscape and meeting well-educated Issas in the capital. The Foreign Legion was present too, 2,000 men of 64 nationalities; an

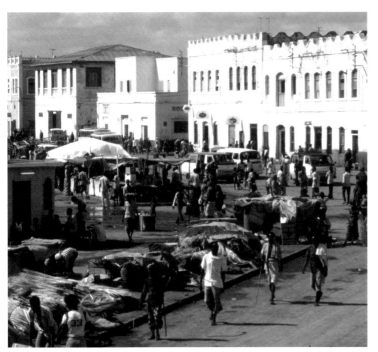

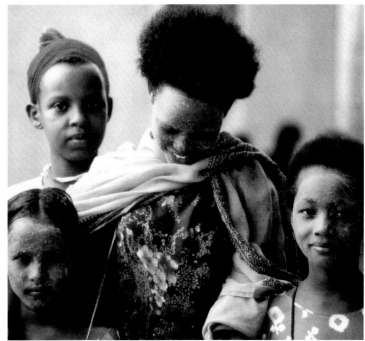

Above: This is in the 1970s, a small town with a pleasing Muslim-oriented style.

Top right: The group of girls are masked in a yellow potion which, they told me, is good for the skin.

Right: Independence in 1977 meant parades and celebrations which included these tall and handsome Issa women.

English *légionnaire*, a little homesick perhaps, presented me with a badge with the Legion's insignia, a token I still possess.

In 1999 President Aptidon announced that he would not run again. In his place his nephew, Ismael Omar Guelleh, whose qualifications included heading both the cabinet and the secret police, was elected and in 2003 a coalition supporting him won multiparty elections. In 2008 the coalition won every seat, 65 of them, in national elections (the opposition chose to boycott the elections). In 2010 parliament approved a constitutional amendment permitting the president to run for a third term. In 2016 President Ismail Omar Guelleh, although at first stating he would quit, won a fourth term. Afars, always in the minority, expressed dissent but, along with other opposition, were easily bypassed in the urge of greater powers to maintain stability.

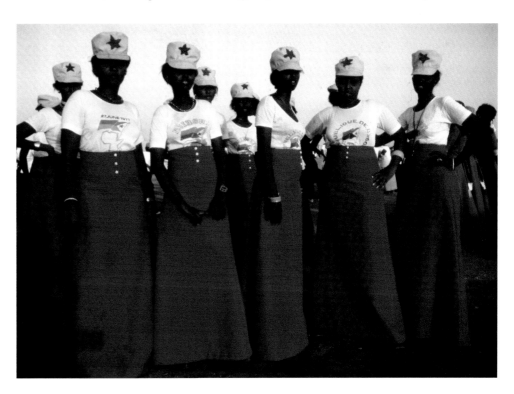

Eswatini

■ **ESWATINI**, since 2018, formerly Swaziland – The million or more people of this tiny, landlocked country within South Africa, an absolutist monarchy ruled by King Mswati III, suffer totally anachronistic lives through the whims and caprices of their king. They are poor, they are sick – more than a quarter have HIV/Aids – and they are hungry. Exceptions include the king's wives, 15 at the last count, who delight in their status and are treated to shopping expeditions in Dubai.

In the early years of the 20th century Swaziland was a British High Commission territory. In 1921 King Sobhuza II, heir in a longstanding monarchy, succeeded to the throne. He ruled to his death in 1982, a popular king, guarding his power but initially creating a panoply of laws through a constitution,

a council, a political party and, with independence in 1968, a parliament (in which he controlled every seat). Bored by other people's views, he soon abolished the lot and, by 1977, ruled through traditional tribal communities. For neighbouring South Africa, Swaziland, to its profit, provided holiday resorts, casinos and entirely legal opportunities, denied by *apartheid* laws, for sex across the colour line.

While political parties and people power and even an opposition theoretically functioned after 1977, in practice the king did what he liked. One example: in 2002 the current king, Mswati, bought himself a $45 million jet aircraft even as parliament voted to cancel the order.

The country's name change to eSwatini, announced during

Above left and right: *A tiny kingdom entirely within South Africa, it used to be Swaziland until its ruler changed the name. Though I was there quite often in the late 1950s as youthful traveller, I found none of my photos. So this is me with Dwarsh, a little Swazi-born baboon my Johannesburg relatives adopted and kept in their suburban garden.*

celebrations of the 50th anniversary of independence in 2018, was meant to inspire the Swazi people to national pride. It means 'land of the Swazis'. Mswati explained that he was tired hearing Swaziland confused with Switzerland. Both are small countries with mountains. All the same, he must have been in extraordinarily ignorant company.

Ethiopia

■ ETHIOPIA – The only country in Africa to have escaped colonisation, Ethiopia is significant in many other ways. For the beauty of its high central plateau, its intriguing culture, for an astonishing history that includes the legendary Queen of Sheba and even as a landmark in medicine – for it was here that the vile disease of smallpox was vanquished once and for all.

I first arrived in Ethiopia in 1962 as a young and very lucky hitchhiker, having caught a ride in Nairobi with two South Africans who were making their way overland, as I was doing, but with a well-equipped Land Rover. Perfect for a large part of the appalling road through scrub south of Addis

Ababa, a week's hard journey. In subsequent years I would return again and again at times of terrible drought and social revolution, for the decline and fall of Emperor Haile Selassie, and to record, for *National Geographic*, the systematic eradication of smallpox. But the positive impressions of that first experience have endured.

So have my memories of the extraordinary Haile Selassie who ascended the throne of Ethiopia in 1930, the 225th reigning monarch in an ancient dynasty according him the title Conquering Lion of the Tribe of Judah. For decades he was, despite his small size, Africa's most commanding figure. His rule preceded the independence move-

ment by nearly forty years. He was a figure easy to criticize – for despotism and censorship, the high level of illiteracy, the wide lack of sanitation, continuing feudalism, including perhaps a failure to constrain the authority of the Coptic Orthodox Church and the slow rate of land reform.

Below: Emperor Haile Selassie, born in 1892 in a rural corner of Abyssinia, as Ethiopia was then, became a dynamic ruler who balanced traditional authority with modernisation. He brought Ethiopia into contemporary African politics and, despite controversies, won international respect. His downfall, and murder, provoked worldwide repulsion.

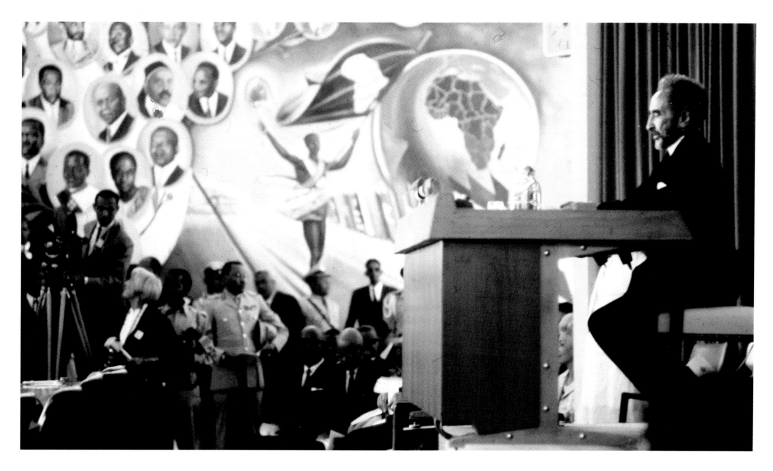

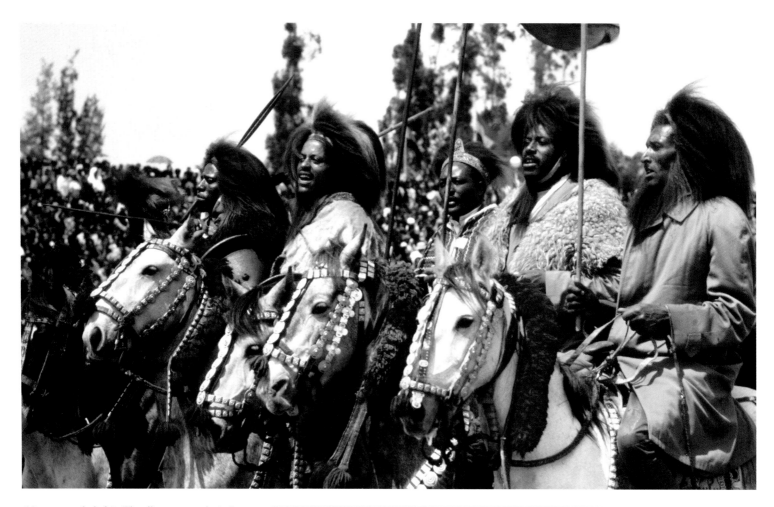

Above and right: The lion-mane hairdo reflected one of Haile Selassie's titles as 'the lion of Judah'. Civilians as well as military took part in anniversary celebrations and colourful parades.

Yet he instituted change, provided a constitution and a parliament even if it was one that dared do nothing without his approval. He created an airline, pursued modernisation, advanced education and expanded infrastructure. He established relations across the world and committed himself to the cause of a united Africa. So dexterously did he raise his country's stature that Ethiopia became the continent's capital and figurehead.

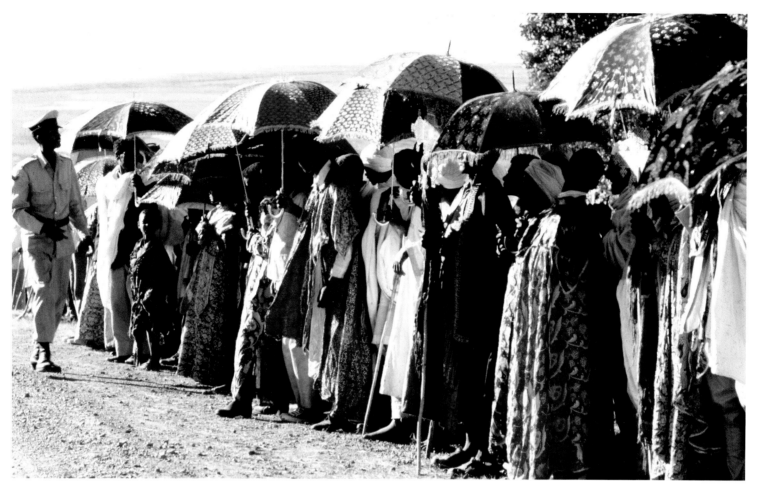

Above and below right and far right: *Ethiopia's Orthodox church dates to the 4th century. The strongest religion in the country, its churches, priests, their* colourful robes, umbrellas and large crosses, are conspicuous on most national occasions and in rural life.

He was for decades His Imperial Majesty Haile Selassie I, King of Kings, Emperor of Ethiopia. His fall in 1974 was no mere shock headline or left turn by youthful revolutionaries against autocracy but a climactic moment. Not just an era passed with the Emperor; it was a sundering of African history.

A military coup, a revolution that introduced Marxism where colourfully robed Coptic priests had predominated, was the focus of world cameras as events rolled towards the

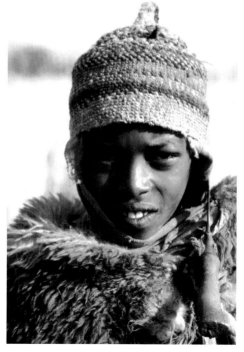

21st century. Prime strong man after 1977 was Colonel Mengistu Haile Mariam – in 1987 his power confirmed in an election that made him President. But in 1991 he was ousted. Ethiopia was no longer a tamed one-man-rule country. Regional and ethnic differences brought conflict – the Ogaden asserted its Somali nature, Eritrea its long-held urge for a separate independence, Tigré (or Tigray) demanded rights and power. In 1994 a new constitution accepted ethnic realities.

In 1995 Meles Zinawi, a solemn anti-military politician, brought relative stability as prime minister, but died in

Below: Emperor Haile Selassie, still dominant in his eighties, yet the signs of age and fading power are visible.

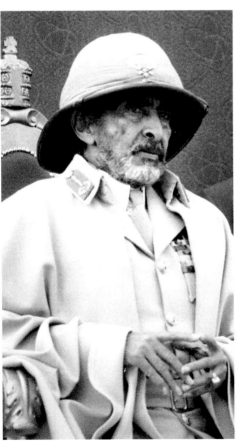

2012. Ethiopia had suffered terrible loss of life from famine, and political instability exacerbated discontent. In 2018, to everyone's surprise a young Oromo man, Abiy Ahmed, a southerner, beat all opposition to become prime minister. He promptly began a programme of reforms, released political prisoners, signed peace deals with Ogaden leaders and not only ended the long war with Eritrea but gave up Ethiopian claims to disputed territory. In a further development, parliament voted in a woman, Sahle Work Zewde, as president. It was, though, Abiy Ahmed who won significantly wider notice when, in October 2019, he was awarded the Nobel Peace Prize.

In a footnote to shocking national events and the happier signs of peaceful progress, came an item of

Above: Officers of the Dergue, the Marxist-Leninist committee that overthrew and murdered Haile Selassie, ruled Ethiopia for a dozen years after 1974. Mengistu Haile Mariam, at left, initially chairman, ordered numerous assassinations and, though he became president, was unable to prevail over rebellion, appalling drought and famine. Forced out of power in 1991, he fled to Zimbabwe.

news regarding the almost forgotten Emperor Haile Selassie. Imprisoned after his downfall, he had died, it seemed, in 1975, in unknown circumstances, though it was believed he had been suffocated in his bed. In 1992 his remains were discovered under a palace toilet. In 2000 they were given honourable burial in Addis Ababa's Holy Trinity cathedral.

Gabon

■ **GABON** – Independence arrived in 1960 in the same way as other French-ruled countries in Africa, via French colonial rule early in the 19th century, participation in the French Equatorial Africa group of nations, close links with French business and currency. The first president, Leon Mba, died in 1967 and was succeeded by Albert-Bernard Bongo (later, after converting to Islam, Omar Bongo), who held the position until his death in 2009, when his son, Ali, was elected president.

The election results were contested by opponents of the succession. Ali Bongo however was still president into the 21st century, gaining a second seven-year term in 2016. By then he had loosened ties with France and formed other alliances, including with India and Singapore. A brief coup attempt to unseat him in 2019 failed within days. I assume the young soldiers involved lacked sufficient influence and money to combat the wealthy and far-reaching Bongo power.

When I was young a name much more famous in Gabon was Albert Schweitzer, a theologian, doctor –

Top right and right: Albert Schweitzer, who founded in 1913 a renowned hospital at Lambaréné on the banks of the Ogooué river in what is now Gabon, held the status of semi-saint when I first passed by in 1963. Respect for him faltered as his paternalist views went out of date. He died in 1965. The hospital, however, modernised and well managed, survived and now serves the population from miles around.

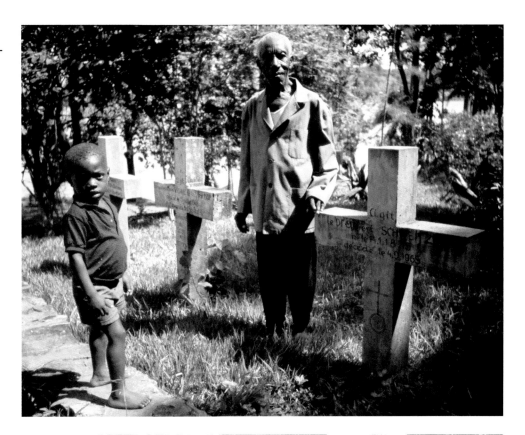

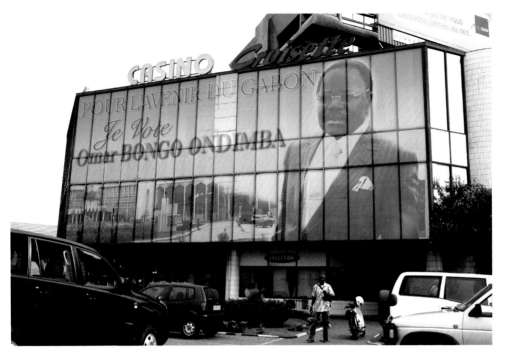

and organist – who was renowned for his good works and the hospital he founded at a village called Lambaréné. He was courteous to me when I stopped by in 1963 but I found his famous hospital unimpressive. I learned afterwards that Dr Schweitzer's paternalistic views on the Africans he treated were no longer accepted without criticism. After his death, aged 90, two years later – he was buried with respect and reverence in the hospital grounds – I was assigned to photograph the modernised hospital and its new management. One vital aspect, I noted, had been retained: patients' families were made welcome.

The most interesting aspect of Gabon for me was the development of its national parks, yet even park status was insufficient to protect wildlife, especially elephants, from poachers. My favourite memory of Gabon is of a handsome lowland gorilla, a silverback, within a rehabilitation project in Loango park's Evéngue island.

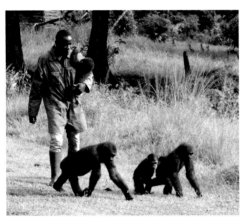

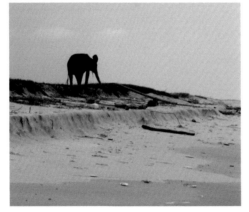

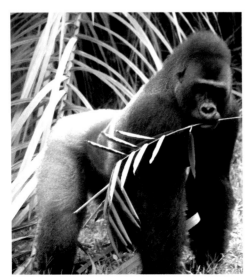

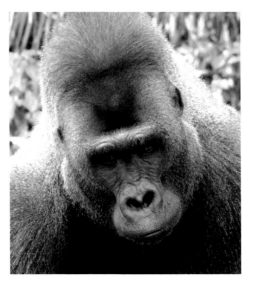

The Gambia

■ THE GAMBIA – A quirk of memory for this tiny country in West Africa, nearly all of it river, is of a ride in an elegant Rolls Royce. The Gambia was a British protectorate at the time, its governor, or chief administrator, and the owner of the Rolls a kind man called Gordon Edwards. Tourism lay in the future. Solitary travellers like me were rare. I was a fortunate guest in a little visited upcountry town, Bassé. To travel onwards – I was heading north – meant catching the *Lady Wright,* a crowded riverboat that would take me to the capital, then known as Bathurst. The boat not only carried cargo including sheep, it was also a travelling post office. In Bathurst, soon to become Banjul, there were still hansom cabs and cricket on the green.

In 1965 the Gambia became independent, with David Jawara as prime minister. Five years later the Gambia was a republic, Jawara an elected president. All ran smoothly until 1994, when David Jawara was toppled in a military coup led by Lieutenant Yahya Jammeh. Single-party rule eased to a tightly controlled multi-party state. Freedom of the press became an issue, with a new media law. The heat rose when a leading editor, a critic of the law, was murdered in 2004.

President Jammeh, increasingly erratic, and autocratic, announced that homosexuals and human rights workers would be executed, and in 2013 that he would withdraw the Gambia from the 'neocolonial' Commonwealth. Elections in 2016 brought defeat for Jammeh and his

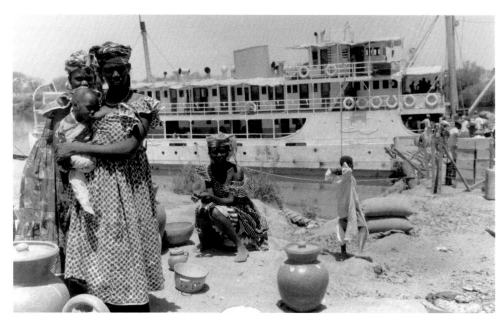

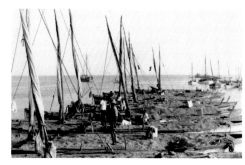

party, a result he initially rejected. The new president, Adama Barrow, a successful property developer, was obliged to swear his oath of office in the Gambia's embassy in neighboring Dakar in Senegal. With Jammeh gone, his departure encouraged by military intervention from furious neighbours, Barrow was installed in January 2017. Sadly, personal tragedy would mar his political success when his 8-year-old son, Habibu, was bitten by a rabid dog and died.

As for longtime former President Jammeh, in comfortable exile in Equatorial Guinea, investigations

Above: Groundnuts, or peanuts, was the sole agricultural product I saw when I travelled through the Gambia back in the 1960s. Now, nuts remain the prime money earner and subsistence farming still supports much of the population.

showed that over the years he had plundered almost $1 billion from government funds, excluding the cargo plane full of luxury goods that accompanied his departure. With the Gambia's economy dependent, literally, on peanuts and tourism, I wondered how he had managed to steal so much.

Ghana

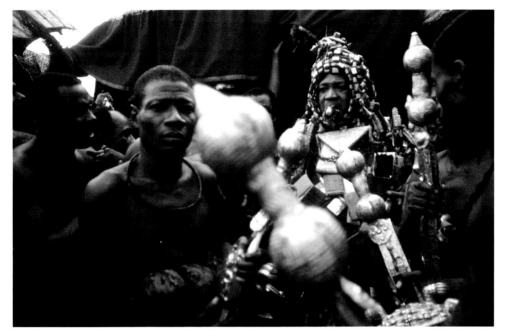

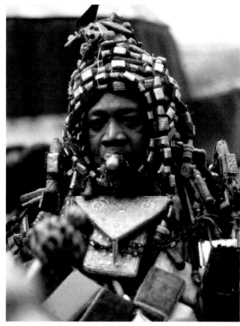

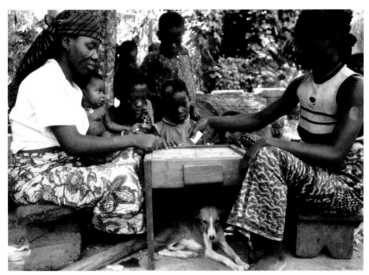

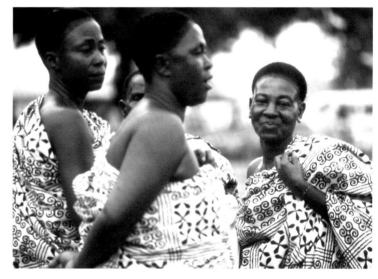

■ **GHANA –** is a hardworking, exuberant and immensely cultured society. I loved the highlife music its popular bands played in Accra and admired the wit and style of traditionally dressed Ghanaians. A nation of several ethnic groups with the Asante, or Ashanti, predominating, its one common factor across the centuries

Above left: Rural women playing a board game called oware, popular in various versions across Africa.

Top left and right and above right: To Ghana's predominant ethnic group, the Ashanti, or Asante, cultural heritage is vital, their royalty – even with entirely modern professional skills – descended from

centuries past when authority resided in a golden stool. So when one Asantahene, or paramount chief, dies, another takes his place in a highly ritualised enstoolment ceremony lasting days. Women, wives, a 'queen mother' have important roles. The Asantahene being enstooled in these 1970 images is Nana Mathew Poku, then a 50-year-old barrister.

has been the lure of gold – benign evidence in the splendid artifacts that appear on ceremonial occasions, less appealing in the countless unlicensed mines drawing hopeful diggers, including many Chinese, from across the world. Ghana's name before Kwame Nkrumah, an imperfect visionary, brought about independence in 1957, the first black state on the continent to free itself from colonialism: Gold Coast.

Nkrumah, with all his skills as politician, brilliance as orator, imagination as thinker with an urge towards nonalignment in foreign relations, was fiscally naive. His signal achievement was the mighty Volta Dam project, yet failure dogged all too many other enterprises. With each reverse, he became more oppressive and dictatorial. During a visit to Peking (as Beijing still was) on a Vietnam peace mission, he was deposed, with ease, by army officers.

A sequence of army officers took on the rule of Ghana. A National Liberation Council was headed by Lieutenant-General Joseph Ankrah. Soon there was a countercoup, which surprisingly brought in a civilian government led by the much admired Dr.Kofi Busia. He too, accused of economic mismanagement, was to be booted out by the military, now under Colonel Ignatius Acheampong. In 1979 a new name entered the lists: Flight Lieutenant Jerry Rawlings. In 1992, with a new constitution and a multi-party system, he was elected president.

The first years of the 21st century brought in peacefully elected presidents, first John Kofuor, then John Atta Mills – and the discovery in 2007 of oil, with production starting in

Above and below right: US Ambassador to Ghana in 1975 was Shirley Temple Black, world-famous once as child

filmstar, an image that, as diplomat with intelligence, skill and charm, she brilliantly overcame.

2010. Gold was tidied into one giant merged mining company. When President Mills died in 2012, he was briefly succeeded by John Mahama, who lost in the 2016 elections to opposition candidate Nana Akufo-Addo.

Politics and the economy was one thing, or perhaps two, great golden partying another. I tried to follow government affairs but what excited me more was the strikingly visual change of leadership among the Asante. With the death of the paramount chief, or Asantahene, in 1970 came the ritual enstoolment, or installation, of a new one. (The symbol of Asante authority is vested in a solid gold stool.) The old chief, said to be the eighteenth in a dynasty going back to the 17th century, had reigned for 35 years. The

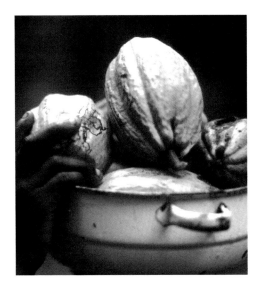

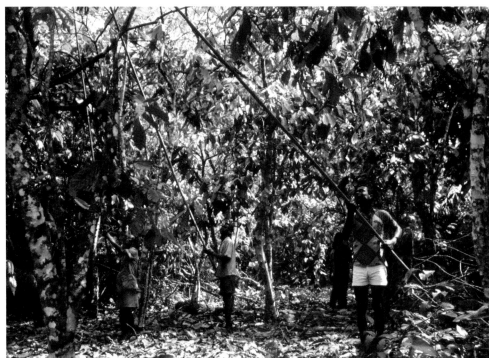

Above & right: Cocoa pods are cultivated on trees by many farmers; the extracted beans are spread out to dry and ferment (when the chocolate flavour develops).

ceremonies marking the accession of his successor, Nana John Matthew Poku, a 50-year-old barrister in private life, whose royal name would be Otumfuo Nana Opoku Ware II, were properly grand, thrillingly exhilarating and – with the splendid display of kingly regalia – gorgeously colourful.

There was another personality in Ghana who charmed and dazzled me – and very many others – in those years. Shirley Temple Black, once world famous as a curly-headed child film star, had been appointed the US ambassador to Ghana, a role in which she was brilliantly successful. She was forthright, intelligent and capable. At the most heavy-going diplomatic receptions, the liveliest conversations revolved around her short figure – always in vivid African-style gowns. Initially, the appointment of a former Hollywood actress aroused curiosity and criticism. Not only did the diminutive Mrs. Black confound her critics, she won the respect of Ghanaians

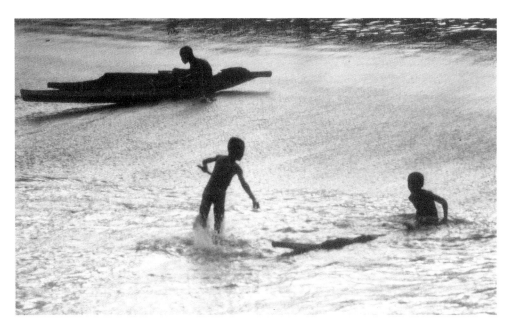

Above: On a beach in Accra, the capital, where fishermen keep their boats, small boys surf and play

and of her own staff, much of it black American and initially antagonistic.

Ghana has had other celebrations, other ambassadors, since those I

photographed and I would love to have returned. I note that in 2019 former president Jerry Rawlings, white-haired and distinguished, was still a celebrity, that power still lies with the rich and rotund, that there is still music in the streets, and laughter.

Guinea

■ GUINEA – In Africa's pre-independence era the name of Ahmed Sékou Touré was widely known and respected. In 1958 he was the only leader in what was French Africa to opt for instant independence rather than choose one of General de Gaulle's offers to the French African territories for a status without full autonomy. As a result, Guinea was instantly – and ruthlessly – abandoned by France. To the degree, a poor joke went at the time, that France even took back the ink in the inkpots. There were several benefits in 'cooperation' agreements available to the countries which had deferred independence (as it turned out, for barely two more years). Guinea received none of them.

Only in 1980 did Guinea, in dire economic straits but with its pride and independent spirit intact, cautiously return to the fold. Sékou Touré, president since independence, a devout Muslim and strongly socialist, was still there and had ensured that no new-era superpower had been able to dominate Guinea. He ruled his country from 1958 until his death in 1984.

He is also remembered for another remarkable political act. When President Kwame Nkrumah was unceremoniously deposed in Ghana in 1966 he was promptly welcomed by Sékou Touré who even pronounced him, 'as a universal man', a co-head of state.

Subsequent decades have been severely troubled by instability, military

Above: A post-colonial image of torn down statues I caught beside a beach in Conakry, Guinea, in 1963.

coups, assassinations, and Ebola. Guinea is theoretically rich in minerals from bauxite, iron ore, uranium and diamonds, yet most people live in poverty. I had passed through Conakry, the capital, in 1964 – luckily escaping rabies when I thoughtlessly nurtured a kitten that turned out to be rabid. Of the few other memories I have, the strongest is of colonial statues I found hauled down and lined up on the seashore. A powerful image, it seemed to me then and now, of the passing of an era.

Ivory Coast

■ **IVORY COAST (CÔTE D'IVOIRE)** – For a long time, from the 1940s on to the 1990s only one name signified power and authority, prosperity and stability in this leading member of the French African community, and that was Félix Houphouët-Boigny. Starting as union organiser, he went on to become president and was still president when he died in 1993. Briefly there during his long rule, I witnessed none of the chaos that came afterwards.

Laurent Gbagbo, a historian, had entered politics in 1990. He made it to the presidency in 2000 but was always a contentious figure. Pushed out in 2011, he was obliged to appear before the International Criminal Court to face charges of crimes against humanity. (An irrelevant detail: in power he was a jolly-looking fat man; power gone, photos showed a gaunt, desolate figure.) In 2019 he was acquitted (and again fat).

In the intervening years the Ivory Coast, with economist Alessane Ouattara as president, experienced mutinies, ethnic riots and religious crises as Muslim fought Christian – Al Qaeda jihadists had entered the fray causing widespread death and destruction. Everything that *le vieux,* the wise old man, President Houphouët-Boigny, stood for had vanished. Through it all, cocoa beans were a prime national product. Yet even here disaster was forecast in its effects on the vanishing rainforest.

Above: *Two dreadful photos from 1963. What on earth was I thinking? Desperation is probably all it was, the sheer* frustration, *I can only suppose, of rushing through an interesting country. And perhaps because I can't find anything better.*

Kenya

■ **KENYA** – is an exquisitely beautiful country that gave me much joy and where I lived and worked for around twenty years. It was so integral to my being I believed I would live there for ever. I think of it as Kenyatta's Kenya, meaning Jomo the father, not Uhuru the son, though Jomo Kenyatta was not the only powerful leader or even the only president during my years of covering events.

It happened once that I was photographing New York's Wall Street for *The Times* (a job photo editors in London had given me because I was going there). A New York Stock Exchange public relations man was puzzled. 'Why does *The Times* have an Africa-based photographer doing Wall Street?' 'Because I have the right experience', I replied, 'coming from one jungle to another.' In fact, Africa was my beat at that time for nearly every story I worked on, and I delighted in the range this offered.

Jomo Kenyatta's immense achievement, as was Nelson Mandela's in another, South African context, was to maintain racial peace and harmony in the face of African land hunger, fierce tribalism and determined British settlers. Empire-building sagas like that of the Uganda Railway, with its man-eating lions, adorned Kenya's early modern history.

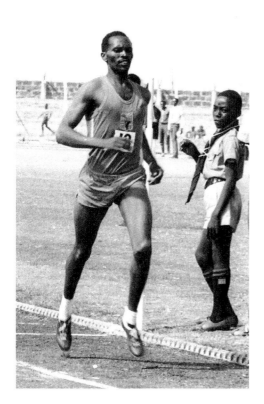

Above: *Kipchoge Keino at a local event in Nairobi. Born in 1940, Kenya's great distance runner, first in a long distinguished line of prizewinning athletes, won four Olympic medals, initially gaining fame, and gold, for the 1500 m race he ran at the Mexico Olympics in 1968.*

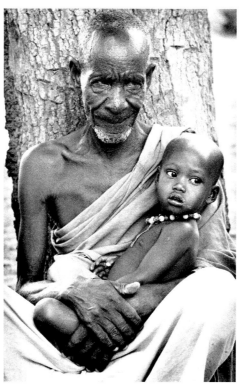

Above: *Of Kenya's more than 40 tribes, the Koro Koro are a small pastoral group living in the eastern Tana river region. This photo of an elder and his grandson reminds me that Kenya's population has more than doubled- – to 50 million – in the last 25 years.*

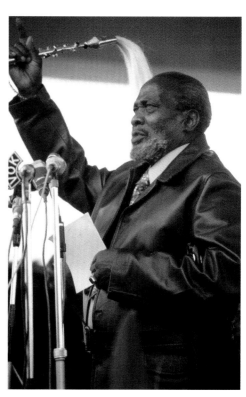

Above: *Jomo Kenyatta with fly whisk – an image of the extraordinary leader who brought Kenya to independence in 1963 and led the nation as prime minister, then president, until his death in 1978.*

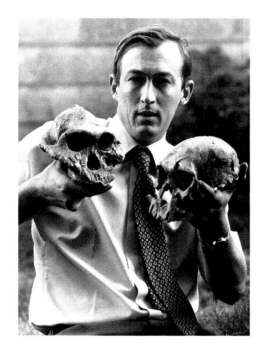

Above: Richard Leakey, paleoanthropologist, in 1978 with two of his team's most important finds, a beetle-browed Australopithecus (left) and a 2-million-years-old hominid, listed as 1470. It confirmed coexistence theories of the origins of man

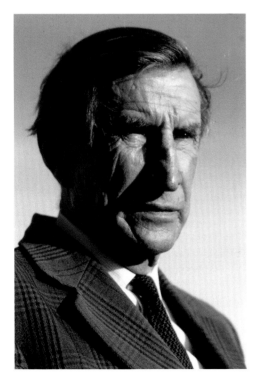

Above: Lake Rudolf, in northern Kenya, now better known as Lake Turkana after the people who live on its shores, is also, for its colour, the Jade Sea. A wild area of crocodiles, scorpions and vipers, the lake shores are renowned for the discovery of numerous hominid fossils.

Left: The great Wilfred Thesiger was a man of many accomplishments. A military officer, a knight of the realm, a fine photographer and splendid writer. Above all he was an explorer in an old tradition, in his element in such hostile environments as Arabia's Empty Quarter. I did this pic when he was in Kenya on a project with another superb writer, The Observer's Gavin Young.

Right: American born and educated, Cynthia Moss in 1968 began studies on elephant social organisation, population dynamics and other fields. The Amboseli Elephant Research Program she founded became the world's longest running research programme. My photo shows Cynthia in the early years of her study when she could already recognise more than a hundred individual elephants.

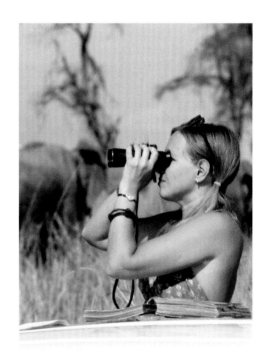

Right, top and centre: Betty Leslie-Melville with Marlon, one of the Rothschild giraffe she and her husband rescued and which roam the grounds of their house, Giraffe Manor, on the wild outskirts of Nairobi. Since the death of both Jock and Betty, Giraffe Manor has become a hotel where guests can enjoy the spectacle – as Betty and Jock did here – of giraffe looking in through the windows.

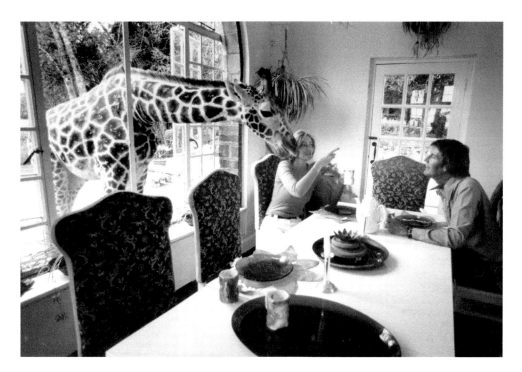

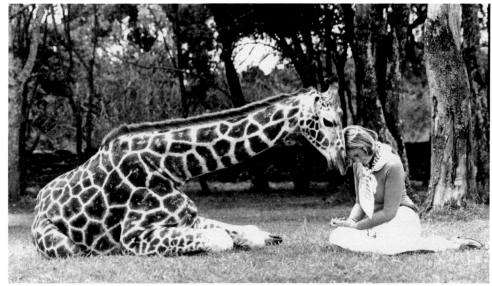

The line (not the costly new one opened in 2017) ran from steamy Mombasa on the coast through cool Nairobi, reached in 1899 when the city was little more than a swamp, through magnificent green highlands on to Lake Victoria and into Uganda. Its object was, as a British commissioner put it, to open up the interior – 'white man's country'.

White settlers, among them a few fortunate aristocrats and many adventurers, came in droves, and were awarded large areas of fine farm land. An Asian community grew from the 30,000 Indians imported to build the railway. Africans – 'natives' – were pushed aside whether they were farming Kikuyu, nomadic Maasai or from any other of Kenya's more than forty major ethnic groups.

Jomo Kenyatta brought Kenya to independence in 1963 only three years after being described as a 'leader to darkness and death' by the British governor. He had earlier been charged and detained for leading a secret society, Mau Mau, whose members attacked farm-owning Europeans – that is, whites. (When the Mau Mau 'emergency' ended more than 13,000 Africans, mainly Kikuyu, were dead and 80,000

Right: Kenya-born Daphne Sheldrick spent her entire life working with wild animals but is best remembered for her work in rehabilitating young elephants.

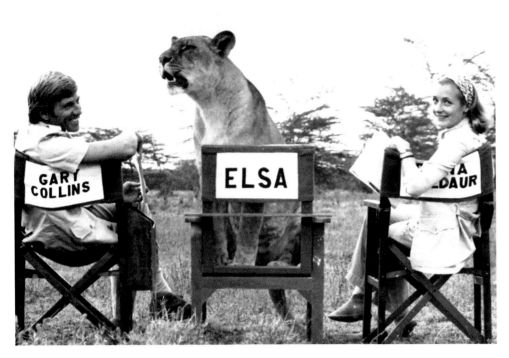

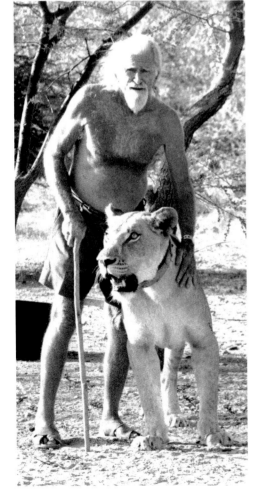

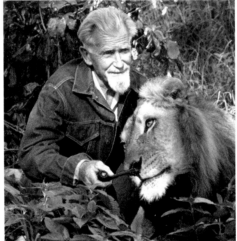

Joy and George Adamson were famous personalities in Kenya. Their personal campaigns to let animals live free lives began with the story of Elsa, the lion cub. Photos show Joy with a cheetah **(top right)**, George with his beloved lion, Boy, at home at Elsamere **(left)**, and much later with lions at Kora in northern Kenya **(far left)**. A rare photo shows Joy and George together at Elsamere **(below)**. Finally, a photo **(top left)** of a lion 'playing' Elsa for an American television film starring Gary Collins as George and Diana Muldaur as Joy.

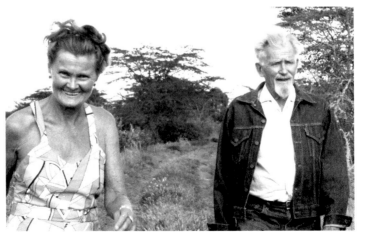

had been interned in prison camps. The number of whites killed: 32.)

My own assignments barely touched this aspect of history. I photographed the leading politicians frequently – Jomo Kenyatta and his Luo rival, Oginga Odinga, and other politicians, and the noisy, agitated funeral of the assassinated politician, Tom Mboya. Paleoanthropologist Richard Leakey and 'oldest man' were frequent subjects. So were visiting VIPs such as Germany's Willy Brandt or, in a rather different category, Hugh Hefner. British royalty came by – I joined the British press in photographing Prince Charles on safari and Princess Anne among African schoolboys. Wildlife, conservationists and white hunters were my basic material, every animal and bird a thrill, every human personality enthralling.

My Kenya beat included the marvellous Maasai Mara reserve with its annual show-stopping wildebeest migration. Another fabled landscape was the Amboseli National Park where elephants roamed, their family life closely studied by scientists and researchers including a good friend, Cynthia Moss, who could recognise each and every elephant she saw. Backdrop to many photos was snow-capped Mount Kilimanjaro, across an invisible frontier in Tanzania.

The immensity of Tsavo was also an elephant domain protected for years by warden David Sheldrick, who pointed me to one of the oddest moments of wildlife behaviour I ever encountered – and oddest photo I ever made – wild ostriches, attracted by glittering badges, lining up behind drilling rangers. When David died of a

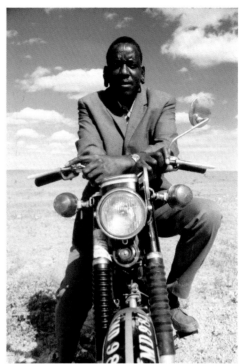

Kenya was always full of surprises. Who would expect to see camels employed in anti-poacher patrols? (above) Or the tradition-minded Maasai riding motorbikes? (right) Or Kikuyu train drivers? (below) But there they were, vivid examples of dated perceptions and imaginative and changing modern times.

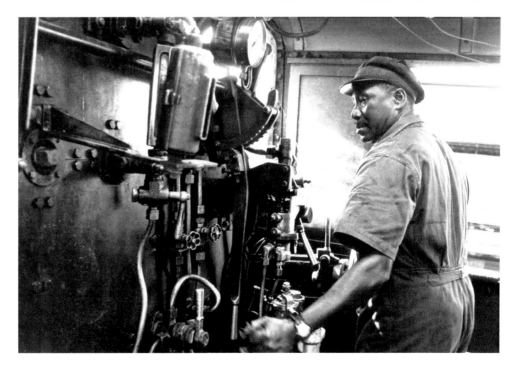

heart attack, his wife Daphne, a dedicated protector of wild animals, launched a Wildlife Trust in his name. It included rehabilitation and an elephant orphanage within the Nairobi National Park where visitors could see infant elephants affectionately tended by African guardians.

Joy and George Adamson, arguing constantly, were also part of the local scene, their work with cherished lions, leopards and other wild animals a

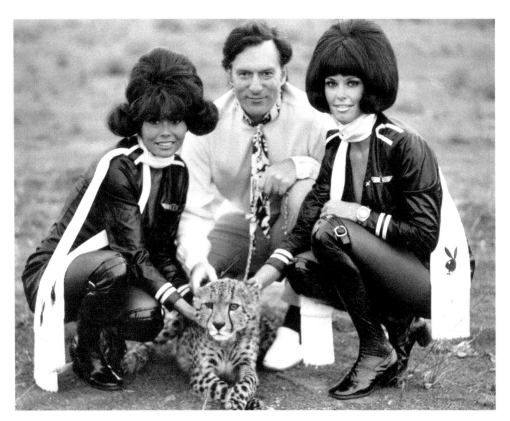

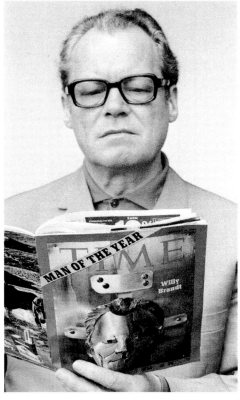

Kenya has always been a charismatic destination for the rich and famous (and for those wanting to be rich and famous). Among celebrities I photographed were Hugh Hefner of Playboy fame who arrived with his absurdly dressed Bunnies posing here with Schniff, a cheetah from the Nairobi animal orphanage (top left). The UK's

Princess Anne made a striking image as she dutifully sat among Kenyan schoolboys (below). The German chancellor Willy Brandt came on holiday just as Time magazine pronounced him Man of the Year (above), and the unappealing Henry Kissinger, then the US Secretary of State, showed up to attend a conference (far left).

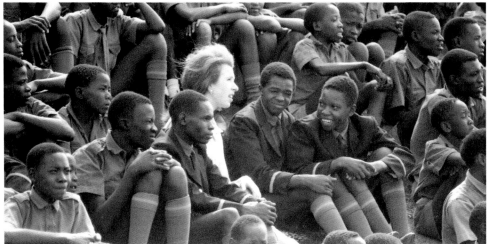

source of fascination. I was quite frequently called upon to photograph them at Elsamere, their home on the shores of Lake Naivasha, or in the wilder, northern Meru National Park where George in old age would walk with 'his' lions. Both George and Joy died violently, as did several other leading Nairobi personalities, almost as if they were in an African drama. Perhaps they were.

Jomo Kenyatta died in 1978 and was succeeded by Vice-President Daniel arap Moi. Being neither Kikuyu nor Luo (he was a Kalenjin), he maintained a skilful balance for 24 years. In 1992 he was replaced following landslide elections by Mwai Kibaki. Appalling violence marked elections in 2007 and left widespread tension. Corruption, always present, became a major issue. As did Al-Shebaab militants, mainly Somalis, historically a formidable presence at Kenya's northern border. Islamists, in one form or another, did much damage in murderous attacks on hotels and shopping centres.

In 2013 Uhuru Kenyatta, son of Jomo, won the presidential election, his win confirmed in two repeat elections in 2017. His principal opponent was Raila Odinga, son of Oginga Odinga – dynastic roles playing out in echo of a former era.

Looking on from a distance, observing the devastating decline of elephant and lion and rhino numbers through poaching and sharply rising human populations, it seemed to me that the good times were past.

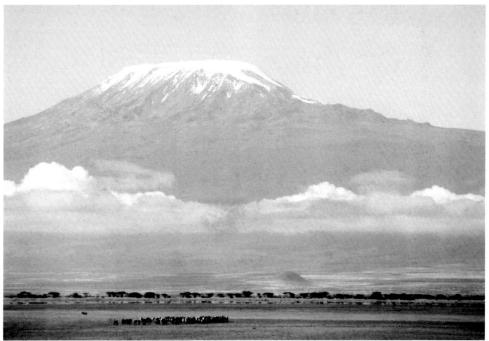

Not only was Kenya's fabulous wildlife remarkable, so too were its landscapes and natural features. Mount Kenya, Kenya's highest mountain (5,199 m, 17,057 ft) and the weird plants on its slopes were a magical sight **(top left)** *An immense dome across an invisible frontier in Tanzania, Mount Kilimanjaro, Africa's highest mountain (5,895 m, 19,340 ft* **(above)** *was always amazing And then there were lakes, forests and thrilling trees, among them the mighty sacred fig, or to the Kikuyu, mugumo.* **(top right)**

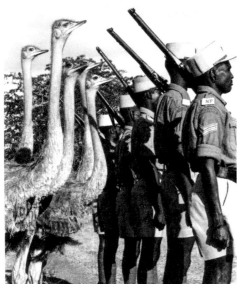
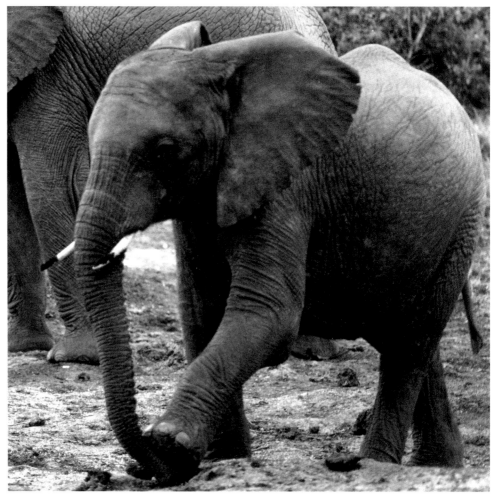

*Colour shows Africa in its glorious variety but in the 1960s magazines were still mostly using black-and-white. Hence **these photos** in b/w of a pensive lion in the rain, long-necked and long-legged giraffe, a leopard guarding its kill in a tree and a young elephant seemingly about to trip on its trunk. In a serendipitous moment wild ostriches in Tsavo, enticed by shining badges, line up behind drilling rangers.*

Lesotho

■ LESOTHO – Its character is defined by its people, the Basotho, whom I remember superficially for the colourful blankets in which they wrapped themselves and the charming straw hats most men wore. Theirs is a tiny kingdom, an 11,583 square-mile (30,000 sq.km) enclave entirely surrounded by South Africa. I knew it first as Basutoland, a place of hills and quiet beauty. It was in fact the British Crown Colony of Basutoland and it became independent on 4 October1966, taking Lesotho, meaning 'the place of the people who speak Sesotho', as its name.

The king then was Moshoeshoe II (pronounced Mo-shesh-way) yet the transition years were mightily troubled by leadership and political disputes in which the most prominent politician was Leabua Jonathan. Moshoeshoe's son, Letsie III, argued strongly for constitutional rights on behalf of his father. Upon his father's death in a suspicious road accident, he was accepted as king but deprived of any executive power. Politics and power is party-based. And while Lesotho is nominally a sovereign state and member of a range of international bodies, it is in practical terms dominated by South Africa.

Main natural resources are diamonds and water – supplied to South Africa and 'returned' in electricity. While many Basotho are engaged in modest agriculture there is also a significant manufacturing industry. Overall, this is described as 'moving from a predominantly subsistence-oriented economy to a lower middle income economy.'

Diamonds, in imagination anyway, are much more glamorous and some handsome stones have been found. In 2014 US$300 million worth of diamonds were marketed. One precious gemstone, a 603-carat (120.6 grams) white diamond was optimistically dubbed 'Lesotho promise'. Other aspects of life, according to official reports, are less sunny. There is an awful lot of sexual violence.

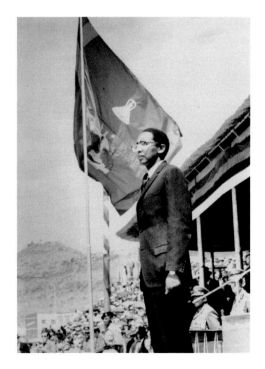

Above left to right: *The British Crown Colony of Basutoland, as it was, became independent as the kingdom of Lesotho in October, 1966. Small but with a distinctive identity the country and its Basotho people were represented by two markedly peaceful symbols: a conical straw hat and a colourfully patterned blanket. Actual party politics, however, was less than pacific. The king, in this independence day photo, was Moshoeshoe II, descended from a long line.*

Liberia

■ LIBERIA – Memories are haphazard, photos negligible. I was there in transit in my long trans-Africa trek back in the 1960s. I knew that Liberia had been independent since 1847, with a constitution heavily copied from the United States' historic document. Somehow, in Monrovia, I attended a press conference given by a cigar-smoking President William Tubman in his luxurious Executive Mansion. A day later I experienced a rather more traditional event: trial by ordeal, known too as a sassywood trial, involving a young village girl accused of theft.

A medicine man was produced, and a bowl of greenish-liquid, and a long rusty needle. The needle, injected into the wrist of a certainly innocent customs officer, caused no injury. A repeat performance into the wrist of the girl's brother produced a drop of blood – and a babbled report that he had seen his sister stuffing something down her dress. Rather than take the test, she confessed. The trial was illegal, yet clearly commonplace, and effective.

In northern Liberia hospitality came from a kind American couple who tended lepers and stayed in touch with the world through a radio station with the call sign ELWA, Eternal Love Winning Africa. Easy to mock but I did not, then or now. Love was the force that sustained them and the lepers, for all the mangled hands and feet.

Dreadful deeds occurred in Liberia in later years. A sergeant, Samuel Doe, brought about a coup in 1980 and won a presidential election. In 1990 he was executed by a group led

Left and above: In 1963 the presidential palace in Monrovia looked like this. I did get inside and saw a luxurious interior but seem to have no photos. The kids were great, though. Appalling violence came later.

by Charles Taylor, whose leadership was accompanied for many years by strife, horror, civil war and instability. He at last faced justice in 2007. In 2005 came positive news: the election as president of Ellen Johnson Sirleaf, the first woman in Africa to be elected head of state. In 2011, not only was she re-elected, she was awarded the Nobel Peace Prize.

Liberia would undergo further pain from the terrifying Ebola disease but

peace was returning. In 2016 United Nations peacekeeping forces left; they had governed the country through civil wars and too many deaths. In 2017 a former professional footballer, George Weah was elected president. He was a skilful striker, the first African player to win the Ballon d'Or, the player who scored over 150 goals for Monaco, Milan and Paris Saint-Germain. Would these successes be enough to help him lead Liberia? Many Liberians hoped so.

Malawi

MALAWI – It's hard to remember but there was, around the 1960s, a Federation of Rhodesia and Nyasaland, a colonial construct for sure but with good intentions.

With the failure of ideals came the breakup. Northern Rhodesia became Zambia, and Nyasaland, with independence in 1964, became Malawi. David Livingstone, missionary explorer, had once famously been linked to this central African territory. In the late 1950s, and for more than thirty years afterwards, the best-known name was the unglamorous and increasingly tyrannical Dr. Hastings Kamuzu Banda.

Dr. Banda had earned a doctorate in academe but was also a doctor of medicine. It was from a medical practice in northwest London that he entered African politics, arguing against the Federation, and was persuaded to return – to Nyasaland, as it was. He had been away for forty-two years. He became leader of the Nyasaland African Congress and, in 1963, prime minister. In 1964, six years after his return, Nyasaland was independent – as Malawi, a name chosen by Dr. Banda – and two years later the nation was a Republic and

Dr. Banda president, the only candidate for the job, and soon president-for-life.

As president, Dr. Banda ruled with a heavy and restrictive hand, despite a constitution providing civil rights and liberties. Opponents disappeared, rigid censorship was imposed, a conservative dress code was in force and the public aggressively policed

In July 2014 Malawi celebrated fifty years of independence

Above and below left and right: *The freshwater Lake Malawi is the lovely dominant feature of this landlocked country in central Africa. But as the British protectorate of Nyasaland became, via a Federation of Rhodesia and Nyasaland, independent Malawi, it was a tyrannical doctor in a 3-piece suit, Hastings Kamuzu Banda, who was dominant. After full independence came in 1964, President Hastings Banda ran the country as a rigidly controlled one-party state until, weak and feeble, he was voted out of power in 1994. He died in 1997.*

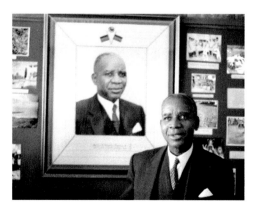

by militants of the Malawi Young Pioneers – who also usefully provided a loyal bodyguard. His official portrait was everywhere and no poster, photo or image could be placed above it.

Foreign countries found Banda merely eccentric, in part for the three-piece suits he always wore. He was also unusual as an African leader for recognising the Portuguese regime in Mozambique (through which he saw access to seaports and the ocean). Even more controversial was his policy of recognising South Africa and establishing diplomatic relations despite its *apartheid* policies.

Dr. Banda fell ill in 1993 and died, in a South African hospital, at the age of 99, leaving a huge fortune which was soon being fought over. In 1994 presidential elections had been won by Bakili Muluzu, who won a second term five years later.

Subsequent presidents, one a woman named Joyce Banda (no relation), faced a range of challenges including drought, Aids, corruption, decisions regarding homosexual relationships, border disputes, even treason.

In July 2014 Malawi celebrated fifty years of independence. The president, now Peter Mutharika, glumly observed Malawians were on average poorer than they had been under colonialism. Almost the only news the world noticed was about the pop star Madonna and her adoption of two Malawian children. What many happy vacationers notice, though, is Malawi's grandest natural feature: its big, beautiful, deep lake, the southernmost of the Rift Valley's great lakes.

Mauritania

■ **MAURITANIA (ISLAMIC REPUBLIC OF MAURITANIA)** – I can claim only the briefest acquaintance with this Sahara nation on Africa's great western bulge. A land rarely in the world's eye, it's where black Africa meets Arab Africa in a great desert emptiness. In my youthful trans-Africa trek from South Africa 'home' to England I arrived here only because the direct, northbound route across the Sahara was temporarily closed because of troubles in Tindouf blocking the way through Algeria. What troubles, specifically, I never knew. If the wider world was then concerned with phosphates – later, rewarding mineral resources were iron ore, gold and oil – my own preoccupation was with keeping moving.

*Two photos only from an agreeable passage through Mauritania back in 1963: of a family group (**opposite**), where evidently mother is in sole charge, and (**above**) of a set of rails that suggest a limitless Sahara desert.*

This was not difficult. Trucks crossed the desert regularly and few got lost. The ride was rough and desert nights were uncomfortably cold. My eyes were frequently glued shut by grit and sand and, since passengers included sharp-hoofed goats, I would end a journey looking like one big bruise. A blue-skinned bruise, moreover, as in these lands were the Tuareg 'blue people', Berbers whose robes were dyed with indigo, which rubs off. Yet two of the most

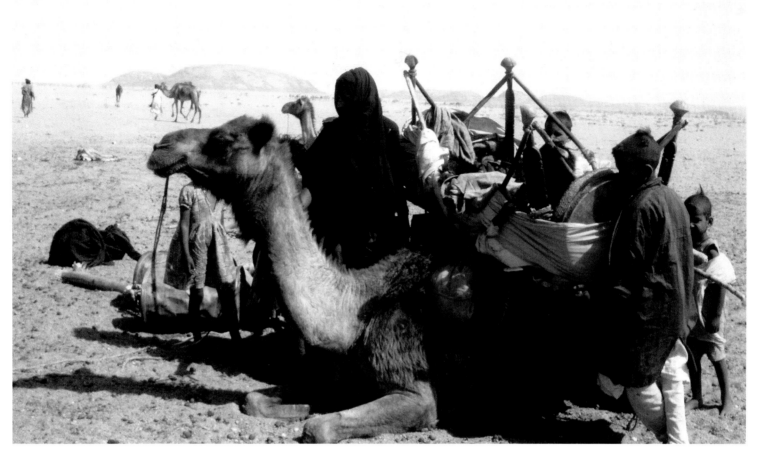

pleasant weeks of my starry-eyed safari I spent as the guest of a Mauritanian commandant in a military outpost, enjoying roast goat and mint tea picnics in grottoes carved by the wind into fantastic shapes.

For the early part of the 20th century Mauritania was French, administered from Senegal. With independence in 1960 Mauritania, as well as Morocco to the north, tried to claim what was then Río de Oro, Spanish Sahara, now Western Sahara (see below). A militant force, the Polisario Front, rejected both claimants.

In 1979 Mauritania did a deal with the Polisario Front, giving up its claim – which Morocco soon took over. Government suffered several coups. Predominant figure was President Mohamed Ould Abdel Aziz who, in 2014, won a second five-year term in elections and was regarded as an ally of the West in countering Islamic terrorism. France, concerned with jihadist terrorism, conducted military operations.

In 2019 President Abdel Aziz stepped down after eleven years in power. It was the first time in many years that opposition groups took part in a presidential race. Mauritania's electoral commission said Mohamed Ahmed Ould Ghazouani, a close ally of the outgoing president, had won. This was not news that most of the world, with other concerns and priorities, even noticed.

What was noticed, however, was that slavery, theoretically illegal after 2007, continued to be practised. I had stayed in a Nouakchott home where the householder's wife was 12 years old and a black slave did all the work. In an unequal society where long tradition favoured northern Arabs over southern Africans it seemed that more time was needed to break old, bad ways.

Morocco

■ **MOROCCO** – Scarcely Africa at all except in the far south where Sahara desert sands dominate, Morocco in the early 1960s, when I arrived there in a desert-crossing truck, was ruled by King Hassan II, blotting out his youthful playboy image. I found the south starkly beautiful, far more than the north with its renowned cities and medinas. Perhaps because, journeying northward from what I thought of as the real Africa, I had reached tourist country and was mugged.

A Muslim society from Islam's beginnings in the 7th and 8th centuries, Morocco politically has been frequently involved with militant activity in Africa's northwest corner. Spain's colonial presence in what's now Western Sahara

*Left and below left: The transition from bleak Sahara to snug villages and date palms brought me to beautiful places in the foothills of the Atlas mountains. The villages at times were described only as casbah; the village in the photo, left, below, is Tinerhir. **Above** is the striking Todra gorge, now well trodden by tourists.*

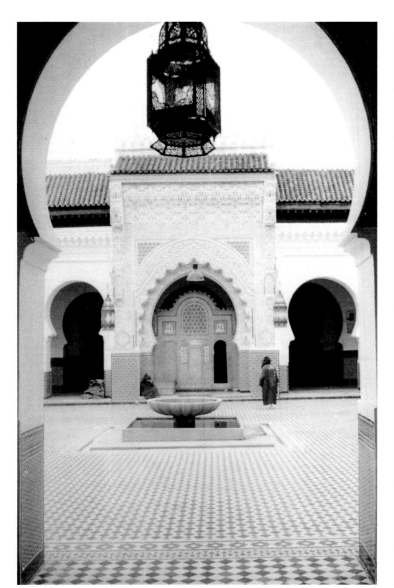

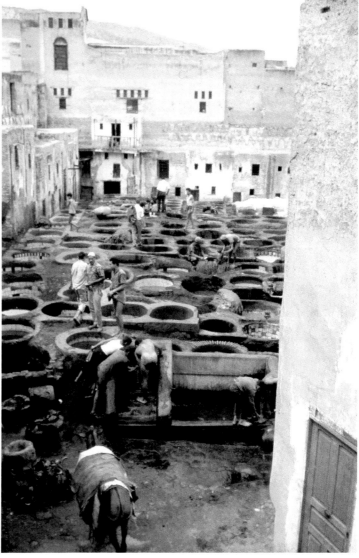

(see below) and the two Spanish enclaves of Ceuta and Melilla caused border problems across the centuries. If Casablanca meant no more for much of the Western world than a classic movie, for Moroccans the city was hit too often by crises from earthquake to terrorism. Marrakesh too, renowned for the colourful Djemaa-el-Fna square, its thriving souks and alleys, palaces and mosques, hidden courtyards and cosy riads, experienced Islamist bombings.

In 1999 Hassan's son became king as Mohammed VI. The popularity of

Above, left and right: Souks, an ancient culture and glorious architecture are the essence of Fez, an exquisite city. In 1963, perhaps a little tired after a long journey from the south, I managed only photos of a handsome mosque and the historic dyepits.

royalty dwindled as people's expectations rose. King Mohammed and conservatives successfully held on to power with a new constitution and reforms – insufficient reforms to Western eyes. Sex outside marriage

and abortion are crimes, though those targeted tend to be activists, journalists and people the state wishes to intimidate.

Friendly relations with Spain are maintained through trade links, and Mohammed juggled his government to overcome social and economic failings. Most Moroccans earn a living from agriculture, the phosphates that I'd heard of in the 1960s are still earning, and tourism for the most part is good for the country and a delight and pleasure for travellers.

Above and left: *A thrilling city, Marrakesh has much culture and a famously entertaining Djemaa-el-Fna square. The memory of my 1963 visit is coloured by being mugged. This was the only place in all Africa I experienced anything but courtesy and hospitality*

Right: *Tangier was the last stop in Africa after I had hitchhiked from South Africa. Starting in 1962, it took more than two years. The journey, an extraordinary experience, gave me an awareness of Africa's spectacular diversity and provided a foundation for the years to come when I was a professional photojournalist.*

Mozambique

■ MOZAMBIQUE – The first experience I remember having in Mozambique was eating its splendid Portuguese food. Prawns piri-piri, so succulent, so mouth-tinglingly delicious. They became the first thing I sought whenever I got to Lourenço Marques (now Maputo), an easy journey from Johannesburg where I was living when, young and hopeful, I left home and England. For whites in South Africa, or Europeans as we were called, Mozambique in the 1950s was holiday heaven. The Portuguese had been there since Vasco da Gama dropped by in 1498 on his epic voyage to India. Portugal would in time have a mighty empire across the globe which would last for four centuries.

Portuguese culture brought fine building as well as an interesting cuisine. Harder realities, however, imposed. In a society, in a continent, ruled by injustice, the hunger for independence was fierce and, under the banner of the Front for the Liberation of Mozambique (FRELIMO) and other independence movements in Angola, West Africa, conflict became the norm. A brutal guerilla war brought

Right and overleaf top and bottom:
Parades and celebrations marked independence in Maputo (formerly Lourenço Marques) in June,1975, after years of a bitter war between 'freedom fighters' of the Mozambique Liberation Front, FRELIMO, and coloniser Portugal. The huge portrait is of Samora Machel, the socialist military commander who became the first president.

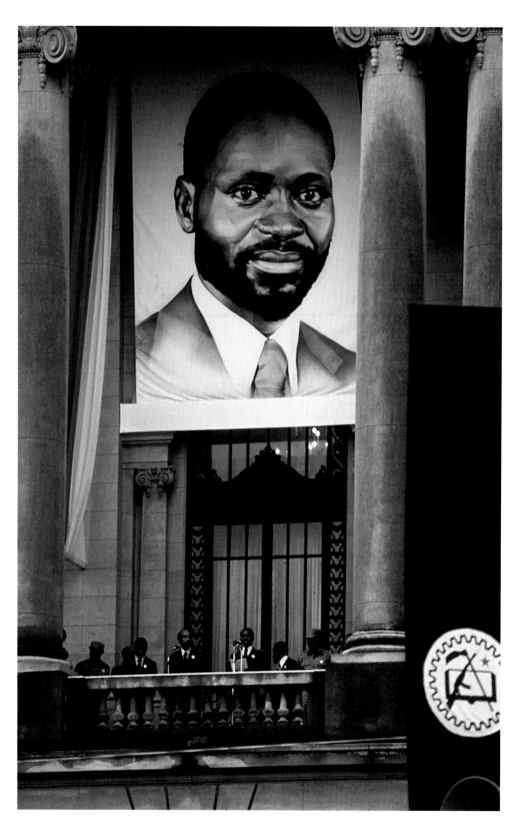

widespread death and injury. Eduardo Mondlane, freedom fighter and intellectual, was assassinated in 1969 by means of a parcel bomb. (Today a university in Mozambique is named after him.) From Lisbon, Salazar's bigoted vision prevented progress – until enough was enough.

In April 1974, army officers rebelled. Their so-called Carnation Revolution (celebrating crowds placed blooms in army gun barrels) caused the collapse of Portuguese rule in all its territories. With Samora Machel as president, revolutionary-minded and strongly socialist, Mozambique became independent on 25 June 1975. I had initially been refused entry (I never found out why) but made it anyway to photograph this joyful event.

Not everyone celebrated. The Mozambique National Resistance party (RENAMO), backed by white-ruled South Africa, provoked a long and unhappy period of civil war which only ended in 1992 but simmered on as legal opposition for decades. President Machel died in 1986 in a mysterious plane crash blamed on RENAMO, and was succeeded by Joaquim Chissano. (Machel's widow, Graça, later married Nelson Mandela.) FRELIMO gave up its Marxist-Leninist policies but continued, through elections, to hold power. One of

Chissano's achievements: getting Mozambique an invitation to join the Commonwealth.

In 2005 Armando Guebuza became president; then in 2014 Filipe Nyusi

was elected. In 2019, a year in which Pope Francis came by, President Nyusi signed a 'peace agreement' with Ossufo Momade, the RENAMO leader, requiring the party's armed wing to disarm. Yet Mozambique remained in difficulties not so much through politics or corruption or even, in the north, incidents of Islamist violence, but repeated heavy flooding which devastated vast areas of the land and caused much loss of life.

In need of good news, Mozambicans could look to their renowned Gorongosa National Park. Grievously damaged in the 16-year civil war, animal numbers depleted by carnage, the park has been restored to life and vigour. A policy known as 'collaborative management', which partners African wildlife authorities with nonprofit organisations and philanthropists, has proved to be a sturdy backbone for wildlife and social revival.

Wildlife populations are thriving, surrounding villages aided (and educated), new rangers trained and watchful. Photos, not mine, show armed women in a conservationist role. I'd seen many armed women on parade on Independence Day. Working for their nation in a well-managed wildlife park seems to me wonderfully positive and worthwhile.

Nigeria

■ NIGERIA – where powerful kingdoms and caliphates were prominent in the history of Nigeria, the Islamist Boko Haram, originally a small religious sect, has been the destructive force in recent years. The case of the 200 schoolgirls kidnapped in the northern town of Chibok in 2014 still resonates. Yet from May 1967 to January 1970 it was the Biafra war, a civil war arising from the secession of three states in Nigeria's southeastern region and declaration of a republic called Biafra, that shocked the world. Before the war ended many died, among them more than a million Igbo people in the breakaway region from starvation, and a friend and colleague, Priya Ramrakha, a fine photographer working for *Life* magazine, who was shot in an ambush.

One positive legacy of the Biafra tragedy was the creation of the French humanitarian organisation, *Médecins Sans Frontières* (Doctors without Borders). French doctors, among them Dr.Bernard Kouchner, appalled at the suffering, were active in providing medical aid during the war, along with many others. The doctors, including Kouchner, believed that a new aid organisation was needed that would ignore political and religious boundaries and prioritise the welfare of victims. *Médecins Sans Frontières* since that time has grown into a vital and courageous medical organisation that saves lives in hotspots the world over.

With the largest population of any country in Africa, over 186 million in

2019, Nigeria has considerable wealth in oil but also a wide range of problems – though none to do with settler colonialism as exemplified in Algeria, Kenya, South Africa and Zimbabwe. There is no dualism of rich white versus poor black, rather marked ethnic division and fierce rivalry over land use. Drought causing environmental devastation forced nomadic Fulani, a cattle-herding people, on to lands worked by small farmers, the result clearly catastrophic. Religion, Christian in

Above and overleaf: *Passing through Nigeria in 1963 I seem to have taken very few photos.A pity as this country is not only enthralling but has the largest population in all Africa. These two images show a calabash carver, a considerable artist, and a few of the faces that found me strange and comical.*

the south, Muslim in the north, is also a considerable force. Fatalism is widespread – I had first entered Nigeria as young traveller in the 1960s aboard a *tro-tro*, a truck converted to open-sided passenger bus, its painted slogan 'With God's help transport'.

The British arrived in Nigeria soon after the 1850s and, empire in mind, governed for decades through local leaders. With independence in 1960, when almost invariably the phrase 'Africa's richest and most populous nation' accompanied any mention of Nigeria, the ruling elite was an uneasy coalition of tribal powers. Military coup followed military coup until 2010, when Goodluck Jonathan, a civilian vice-president, inherited the presidency, confirmed in subsequent elections.

Unfortunately, his optimistic name did not herald good times for Nigeria, either economically, administratively – chaotic government provoked frequent fuel shortages despite oil wealth – or against violent rebels. In 2015 a former military leader, Mohammedu Buhari, overthrown in 1985, was once again elected president. Quietly, stability emerged and the economy grew – in 2019 it was larger than regularly top-ranking South Africa.

Elections that year reaffirmed President Buhari's rule but did not bring satisfaction or ease the frustration of all too many Nigerians, especially the unemployed young.

'I'm 25 years old and it's not getting better,' a *New York Time*s journalist quoted a man with a business degree. 'When will it be better? When I'm in my 40s or 50s?" The difficult answer is that nobody knows.

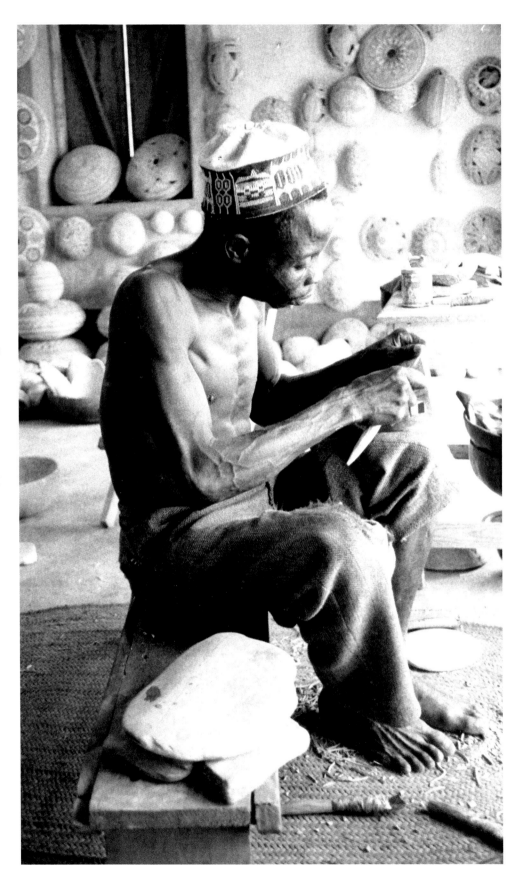

Senegal

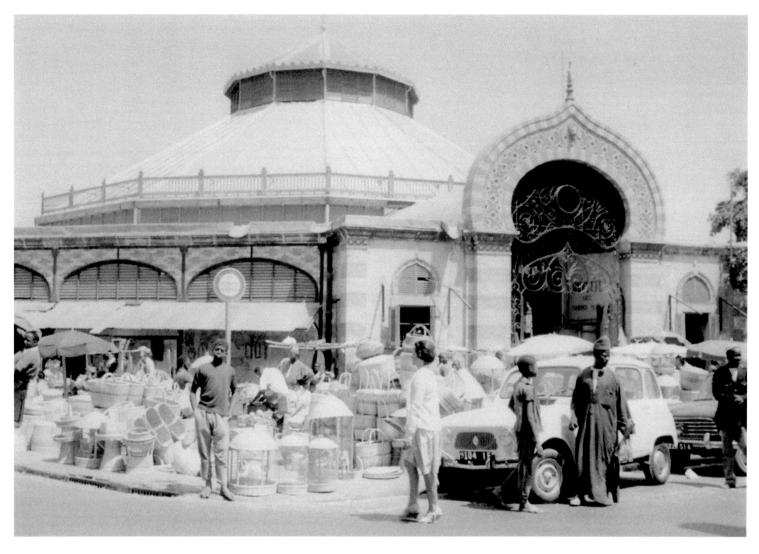

■ SENEGAL – On the bulge of Africa's west coast, Senegal has a different significance for different people. To French intellectuals it is the country that nurtured poet Léopold Senghor – who was also its first president post-independence. They admired him so much, he was elected to the Académie Française, a highly select group of eminent literary figures limited to forty luminaries known as 'the immortals'. He was the Académie's first black member. (They are still rare. In 2019

Above and overleaf: 1963 saw me in transit during a long trans-Africa journey, with pathetically few photos to show for it. Oh, what I missed! The two here show a market in Dakar, the capital, and a glimpse of the offshore Gorée island, once the heart of a monstrous slave trade.

the only black was Haitian-born Canadian writer Dany Laferrière.)

Senegal to black Americans, specifically a tiny island called Gorée close to the capital Dakar, is the

place, part fact, part myth, where millions of slaves were held in dark cells before being shipped off to the Americas and many other countries – 400,000 to the United States alone. A place of deep emotion, the 'House of Slaves', a building on Gorée's shores with its open 'Door of No Return', has been visited by thousands including Barack Obama, Stevie Wonder and a pope, John Paul II.

To bourgeois French, Senegal is a haven for cheap holidays in tropical

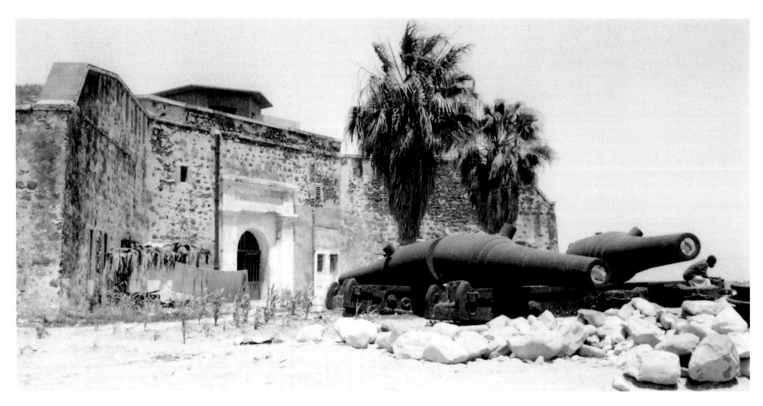

warmth and sunshine. To the Senegalese it is a largely rural country with an agricultural economy that also produces and exports fish, groundnuts and phosphates, chemicals and cotton. To me, as youthful solo traveller in Dakar, the lively capital, in 1964, it was a brief stopover between the Gambia to the south and Mauritania to the north in a long overland journey from South Africa to London.

Dakar was more than a dynamic city. It had been in effect the capital of all French Africa, an empire of fifteen countries. A couple of *quartiers* were elegantly French, other areas poor, crowded and noisy. Senegal, in which the great tribes of Wolof and Fulani were early arrivals, was for many years a trading-post society where Dutch, French and British were quarrelsome players. In 1864 it became a French colony. Yet even before that, in 1848, French citizenship was granted to Senegalese in the four main population centres.

This was the beginning of France's *évolué* system by which Africans could acquire citizenship by divesting themselves of their own customs, learning French – and French standards of civilisation. By the end of the 1930s there were more than 80,000 *évolués.* By 1946 all Senegalese were declared French citizens, a fond gesture not offered to the less favoured. From Senegal came the first African deputies to the French Assembly. Léopold Senghor was himself a French deputy at the start of his career, which saw him become socialist, nationalist and ardent pan-Africanist as well as cultivated poet and writer promoting a philosophy he called *négritude.* (Roughly, this meant all Africans everywhere shared an identity.)

In recent years the most prominent Senegalese politician was Abdoulaye Wade first elected as president in 2000. Senghor supposedly nicknamed him 'the hare', respected for its cunning. Wade was also affectionately called 'old man'. He was still president well into his eighties. Finally, to all-round relief, he gracefully accepted his successor, a social-minded, multilingual geologist, Macky Sall. President in 2012, he was re-elected in 2019.

France's connection with Africa changed but never ended. In my African life, as traveller and as photojournalist, I saw it in manifold ways. As to Senegal, I note that in the town of Saint-Louis I was given lodging in a war victims' hostel, l'Association des Amputés et Mutilés de Guerre de Sénégal. Regrettably, though I have tried to evoke images suggested by the horrifying name, I haven't the slightest memory of how this came about or what it was like.

Sierra Leone

■ SIERRA LEONE – In a curious echo of the sassywood trial I experienced in Liberia, another trial in Sierra Leone, very soon afterwards, crossed my path. I was merely a happy traveller, not yet in the news business. What took me to the courtroom I no longer recall. The first case involved a man being sentenced by the African magistrate to a stay in 'Her Majesty's Hotel' – prison – for 'exposing his John Thomas'. Then came the day's main case.

Fifteen men and a woman were charged with ritual murder. It was alleged that they had kidnapped a Jehovah's Witness, killed him, cooked him – sending only the fat across the border to Liberia, where they could get good money for it – and eaten him. For me it was significant that everyone in the dock was so old as to be senile, except for one man who, it was said, had been hired by the others to do the physical work. Was this case exceptional? Apparently not. But while the penalty could have been hanging (itself a barbaric heritage from mother England), the trial was in its early stages and I never learned the verdict.

Sierra Leone, with its heritage including shiploads of freed slaves, was already independent when I passed by in the early 1960s. Subsequent years seemed to be a replay of highly dramatic horror movies involving coups, countercoups, plots, rebellion, mass rape, mutilations, murder, betrayal, treason, war, civil war, a United Nations presence, and rescue operations by British forces.

In 2006 the unpleasant Charles Taylor, warlord and president in Liberia, was arrested in Nigeria and brought to trial in the Hague for war crimes and atrocities in Sierra Leone. In 2012 he was convicted, with a 50-year prison penalty. Other militia leaders were tried in Freetown. In another horror, Ebola struck and was beaten back. Elections were held, and were challenged. All I could think was oh, the pity of it all.

Below: The harbour at Freetown, named for its past role as haven for escaped and returned slaves. Sierra Leone's name, meaning Lion Mountain, comes from a Portuguese mariner. Modern times have not brought contentment.

Somalia

■ SOMALIA – 'There's a man in the bar who says he is Winston Churchill…' The man speaking to me was an American journalist, and yes, Winston Churchill was in the bar. Not, however, the legendary statesman but his grandson, working as a correspondent in British television. Living in Kenya at the time, the closing years of the 20th century, I was dispatched frequently to Somalia for one story or another.

I recall photographing fake Cubans – real Cubans and Russians had been there. Much more interesting to me was the eradication of smallpox and the remarkable detective work it involved.

There was a long, continuing story in Ethiopia's Ogaden, most of it an arid trackless waste swept by fierce winds, inhabited by Somalis insistent that the Ogaden desert was theirs. There were often 'incidents' in Mogadishu, the capital, where most visiting journalists would lodge in the Southern Cross Hotel, better known to them as the 'Sweaty Crotch'. Most of these events occurred under the rule of Muhammad Siad Barre, a military man who had taken power in a coup in 1969 and lasted until he was ousted in 1991. Wars had been bubbling and simmering for years. Somalis claiming a 'Greater Somalia' were not to be stopped. Much meaner attacks, bomb blasts irrespective of target, came later.

The Horn of Africa centuries ago was the territory of sultanates. With the arrival of the colonial era, well-armed French, Italians and British

staked claims. Liberation movements asserted themselves, largely to no effect. But Somalia is unusual in Africa in that its society consists of a single fiercely nationalistic people. Loosely divided by clans and sub-groups, they are a proud and handsome people whose women have never been veiled. With one language, one religion – Islam – and a unitary culture, the large majority are nomadic herders, their life centred around their camels and other livestock.

With Siad Barre gone, militant attacks grew. The United States sent troops to maintain order (a code name that became famous: Blackhawk Down), followed by a United Nations peacekeeping force. Both failed, with a shocking number of deaths on all sides. Various attempts were made, without success, to form a stable central government. Old liberation movements were replaced by new Islamists, Al-Shebaab the most dominant. Pirates based on Africa's coast subjected shipping, small and large, to ransom demands, with violence, and were harrowingly successful.

The tide began to turn as the 21st century opened. Forces from Ethiopia,

Left top to bottom: *Water is the priority in a severely dry landscape. The Ogaden, geographically in Ethiopia, setting of two of the above photos, is nevertheless a Somali inhabited region; the photos of the man walking with his camels and of the young girl fetching water from a dirty pond are from a village outside Mogadishu, the capital.*

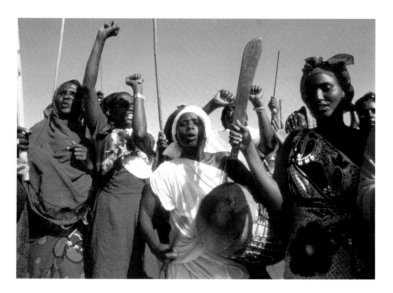

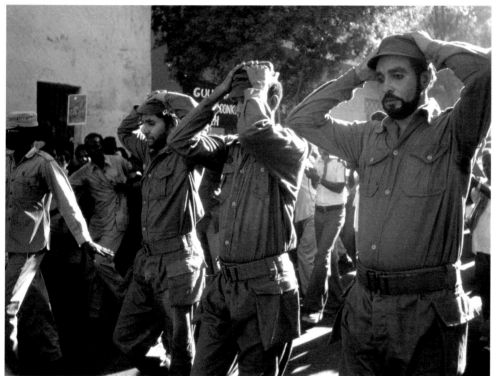

*Siad Barre was president from 1969 to 1991. He took power in a military coup and was removed from power in a coup. His rule, far from democratic, included dramatic moments. Thanks to Cuba's Fidel Castro, Cuban aid came to Somalia. The three men being paraded in Mogadishu, however, proved to be 'fake Cubans'. (**left**) The camels in Mogadishu harbour (**top right**) were most likely shipped out to be food for another Islamic country. The demonstrating women (**top left**), were laid on for the visiting press.*

the African Union and Kenya were able to curb Islamist groups and win back towns they had taken over. Even as a level of normality grew in Mogadishu, Al-Shebaab retained its power to surprise with sudden attacks in both Somalia and Kenya causing numerous deaths. UN Secretary-General António Guterres declared in 2017 that conditions in Somalia were close to becoming a success story. Almost simultaneously, truck bombs were causing mayhem and death in Mogadishu. But not despair.

Somalis, with anarchy a permanently hovering black cloud, have a working federal parliament. Since 1960 there have been nine presidents. The current president, as I write, is Mohamed Abdullahi Mohamed, better known as Farmajo. He has had an American education and is an active tweeter. Perhaps he will be more fortunate than his predecessors. One way or another, Somalia, and Somalis, will survive and thrive.

South Africa

■ SOUTH AFRICA – was the first 'foreign' nation I landed in as an innocent and eager young woman. This was in 1956, when *apartheid* was the cruel national policy. Its injustice I observed, and loathed, at once – but even then I saw it as absurd. How could so common an errand as going to the post office involve segregation? Yet, in its separate queues and counters, it did. And in all its savagely repressive laws – some sixty of them with thousands of restrictions touching on every aspect of daily life from land ownership to jobs to education to sexual relationships – racial discrimination

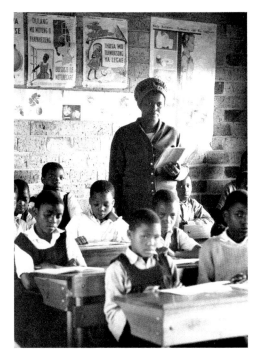

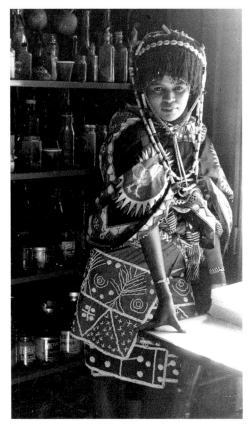

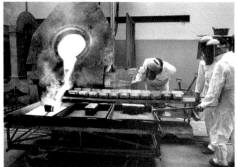

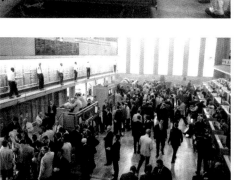

This page: Different stories, times and places but all long ago. The lady witchdoctor was a hardworking business woman whose name was Sarah. She put on this gear because, she said, her customers liked it. Bobby Kennedy was not a welcome guest in apartheid South Africa in 1966 and I only saw him as he arrived. On another occasion, I had been assigned to do Johannesburg scenes, hence the mines and gold pouring, the Stock Exchange and a school. The photo of the Cape Malay children in Cape Town comes from a story on Cape Dutch houses.

This page: Some photos from South Africa's lovely Cape province in 2014: city architecture in Cape Town, African penguins in the Boulders Beach colony, the museum commemorating Cape Town's historic District Six, a church in the graceful town of Stanford, brightly painted houses in Cape Town's Bo-kaap district.

was ferociously institutionalised to ensure white domination in every actual and potential area and activity.

Only after 1990, when President F.W. de Klerk began to negotiate a peaceful settlement with long-imprisoned ANC (African National Congress) leader Nelson Mandela, were the discriminatory laws abolished. Yet land ownership and land use problematically continued to favour whites well into the 21st century. Whether in gracious city suburbs, the Cape's renowned wine lands or agricultural and grazing terrain, black South Africans are sparse.

In the 1950s I was not a photographer but had a pleasant job as editor of the house magazine of Central News Agency, an organisation of retail shops dealing in books, magazines, stationery and other goods. Editorial prerogative allowed me to choose the photos that appeared in the magazine's pages. So, though profoundly shocked, I sought Ian Berry's permission to use his photos of the Sharpeville massacre on 21 March1960, when 69 black South Africans were killed and 178 injured by police during a peaceful protest against pass laws that defined

where they could and could not go. It was a pivotal introduction to the power of photography.

Ian Berry became a member of Magnum, one of the world's most eminent photo agencies. In the 1960s his photos, or those I saw, ran in *Drum*, a magazine published in Johannesburg for an African readership. Other inspiring photographers were Peter

Magubane and David Goldblatt. A good friend and superb photographer too was John Goldblatt (no relation). And when for a time I worked Saturdays to learn sub-editing at a *Drum* sister publication, an undistinguished tabloid called *Golden City Post,* my friendships expanded to include several first-rate black journalists including Lewis Nkosi and Nat Nakasa.

South Africa for me was the place where I emerged from adolescence, where crucially I grew up to awareness and sensibility. To the north, all Africa was in a state of change and I was fortunate to see history in the making. In South Africa, to my continuing regret, I missed the celebrated moment when, on 11 February 1990, Nelson Mandela appeared with his wife Winnie after his release from 27 years in prison.

By then I had long been a photo-journalist. Stories I did in South Africa, among them on gold mining, on a glamorous woman witchdoctor, on the post-*apartheid* Cape, reflected aspects of all that was happening. Yet in South Africa I missed the big picture – and, as time went by, many others.

Jacob Zuma became president, then Cyril Ramaphosa. It was painful to see how troubled South Africa still was, how corruption and disillusion was affecting Mandela's ANC (African National Congress), that poverty, unemployment and crime remained prevalent. South African triumph in the Rugby World Cup 2019, the Springboks led for the first time by a black captain, brought rare unity to all South Africans. It was a wonderful heady moment. Like most of the world, I watched from a distance.

Sudan

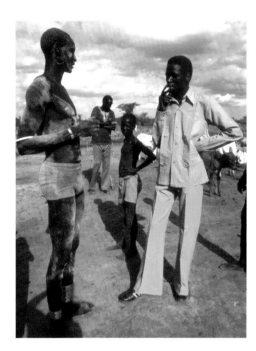 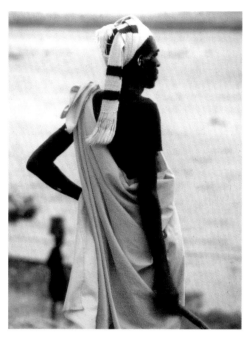

■ SUDAN – For a long time Sudan was the largest country in Africa – until, in July 2011, with the southern third (more or less) redefined, it became two countries. The arrangement was accepted by the Muslim north as the population of the new South Sudan was Christian or animist and the differences had been the source of endless conflict. Even after the split there were tensions, mainly to do with oil revenues from new and flourishing finds.

Curiously, although as traveller in 1963 I had enjoyed a thrilling passage southward on the Nile from Khartoum to Juba, and then, as the guest of a judge, toured the south, I had seen no trouble anywhere. Not yet a sharp-eyed journalist, I didn't know there

was a story, so hadn't seen one.

Ancient history remembers the Nubian kingdom of Kush. In the era of its empire the British ruled in alliance with Egypt, the formal word 'condo-minium'. Independence arrived in 1956, with military coups soon follow-ing – led by General Ibrahim Abboud in 1958, an Islamist revolutionary force in 1964, and Jaafar Numeiri in 1969. A coalition government was elected in 1986, led by Sadiq el-Mahdi, a hand-some young academic with a name familiar to the Sudanese. His great-grandfather had laid siege to Khartoum in 1864, killing the renowned British soldier General Charles Gordon in the subsequent battle, a death notoriously avenged by Lord Kitchener.

The photos above precede the division of Sudan into two countries. These are from the south. The suited bureaucrat is actually a relative of the tall man in briefs who, in

another photo, poses between the horns of one of his cows. The man in pink waiting for a ferry, to me had a wonderful sense of style.

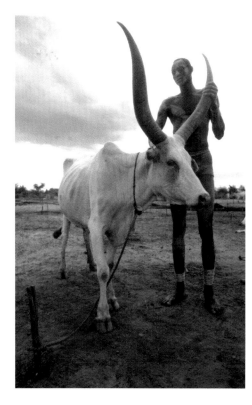

The rule of the polite and well-educated Sadiq el-Mahdi, unfortunately, did not last. He was ousted in 1989 and replaced by a National Salvation Revolution; in 1993 General Omar al-Bashir was appointed president. At first, things looked good – a new constitution won widespread approval in a 1998 referendum. But challenges arose, most of all in the western region of Darfur, where government fought rebels and refugees in their thousands fled into Chad.

The word 'Janjaweed' became all too widely known as horse-mounted militias systematically riding down and killing unarmed villagers. So extensive were the murderous depredations that they came to be described as genocide. Omar al-Bashir was named by the International Criminal Court and an arrest issued in 2009 for war crimes. He was still travelling freely years later and, though opponents boycotted elections, he was re-elected president in 2015. Still, people were not happy. In 2019 he was finally taken down, not because of the horrors of Darfur but by hungry citizens protesting high bread prices. A military council replaced him, not – or anyway, not yet – the civilian government people were hoping for.

It took time, angry demonstrations, protests ending in massacre. Then, in August 2019, newspapers published a photo of former president al-Bashir behind bars inside a cage of a Khartoum courthouse. No bogeyman was revealed, yet things were moving. The military council and civilian

*Below left: Cotton was a major agricultural product. The photo shows a bulk-carrying train. Along with Nile river traffic, cargo-laden trucks **(top left)** handled distribution across the vast country.*

***Above and below right:** Scenes like the cattle camp proclaim the Dinka people's close relationship with their cattle.*

opposition leaders had agreed a power-sharing agreement. Under the deal Sudan would be governed by a 'sovereign council' in which civilians would hold at least five of eleven seats. The agreement would lead to full democracy after three years. Yet a week is a long time in politics. In three years anything could happen.

Tanzania

■ **TANZANIA** – Still British-ruled Tanganyika when I was first there, much of the world is dazzled by this spectacularly beautiful country. With so many natural wonders, from Serengeti and the Ngorongoro crater and their amazing wildlife, to the woodland splendours of the huge Selous reserve, to stunning Mount Kilimanjaro, to the gorgeous Indian Ocean coast, Tanzania is like a rare jewel in Africa.

How fortunate I was, too, that in my years living and working in Africa there was so much beauty, so much wildlife to see. Conservationists and anti-poaching featured in many of the stories I did. Tragically, for all their efforts, there has been a terrible decline in the number of almost all species, together with a loss of habitat and a sharp increase in human population.

Tanganyika became independent in 1961, with Julius Nyerere, an idealistic socialist, as prime minister. In 1963 the country became a republic and Nyerere president.

That year, too, the offshore island of Zanzibar, a historic 'gateway to Africa' with a useful treasury in cloves, attained its own independence (see also ISLANDS, p.358). The following year, in a violent leftist revolution, the island's ruling sultanate was overthrown and the tough, ambitious Abeid Karume and his Afro-Shirazi party took over. Zanzibar promptly merged with the mainland, and Tanzania was born.

Zanzibar has always had an influence out of all proportion to its size. Karume's dictatorship created

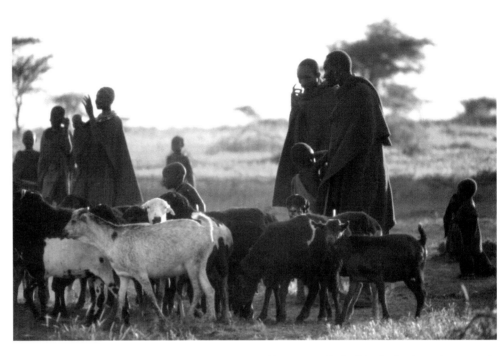

Above and left: Much the best known of Tanzania's more than a hundred ethnic groups are the Maasai, probably because of their distinctive appearance and costume. Then again, they live close to wildlife areas outsiders love to visit.

only turbulence and fear. Although formally a part of Tanzania, the island made its own laws, issued its own passports, and went its own erratic way. Communist countries lavished funds on the island. Russians, Chinese, Bulgarians, East Germans and Cubans came by, as did President Nasser of Egypt. Karume frequently embarrassed Nyerere with his overbearing style until, in 1972, he

was assassinated by an angry young soldier whose father had been executed. Aboud Jumbe, a dignified and conservative figure, was now in charge, and a true union began to emerge, based on mutual respect and constitutional law.

President Nyerere in 1967 had announced an 'Arusha Declaration', a national policy of socialist economic self-reliance. Unfortunately, it was not a success. The poor joke was that Nyerere himself was Tanzania's only socialist. But, much admired for his philosophy and honourable intentions, he ruled until 1985, when he retired.

Far left and left, top and bottom: The charismatic presidents Julius Nyerere of Tanzania and Kenneth Kaunda of Zambia with the Chinese Minister Fang Yi at the launch in 1975 of the Tan-Zam railway, a heady moment. Financed by China (its first foreign aid project at that time), built by Chinese engineers in association with Tanzania and Zambia, the railway linked the Tanzanian port of Dar es Salaam with Zambia's Copperbelt. From the start, however, the line, though a remarkable feat of engineering and construction, suffered operational difficulties and never reached its potential.

Long known as *Mwalimu*, teacher, and a symbol of struggle against colonialism, he died in 1999. Subsequent presidents have not had his charisma or socialist ideals.

In development terms, a large goldmine was discovered, and respectable gas reserves. Corruption raised its ugly head. Politicians rose and fell. International voices protested when President Jakaya Chikwete, who had won elections in 2005, ordered that a highway be built slicing through Serengeti, a Unesco World Heritage

Below left: Patrick Hemingway, son of the renowned writer Ernest Hemingway. His long experience in East Africa included professional hunting. In the 1960s he was a teacher of conservation at Tanzania's Wildlife Management College. (below) Fidel Castro of Cuba, on the other hand, was just visiting a fellow socialist President Julius Nyerere

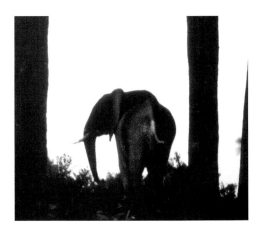
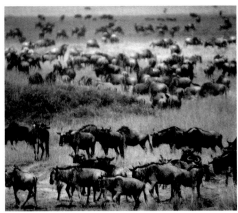
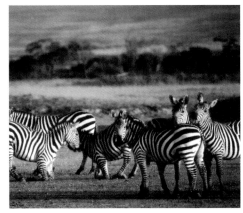
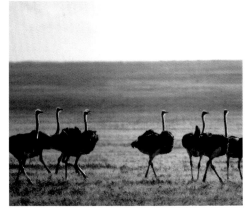

park. Environmentalists won that war but battles over surfacing the existing track continued. In another bitterly controversial environmental issue, in 2018 President John Magufuli, elected in 2015, announced the signing of a deal to construct a dam and power plant in the Selous reserve.

Wildlife is incontestably losing out in the face of land hunger and highly charged politics. So too are the Maasai, a pastoral people prominent in Tanzania and Kenya, whose lives and culture are dependent on cattle. In my African era I frequently photographed Maasai herding their beloved cows, but also Maasai who had adopted more progressive lifestyles. Optimist always, I can only hope that a balance can be preserved and that the wild glories of Africa will survive.

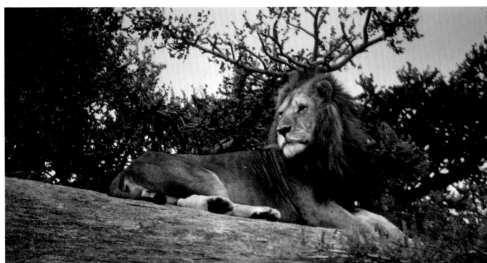

For most visitors Tanzania's greatest appeal lies in its extraordinary landscapes and spectacular wildlife. Woodland of the type in the photo (top row) is known as miombo; the baobab is among the most recognisable trees anywhere; the elephant beside the palms is in the huge Selous reserve; massed wildebeest, as they migrate, are one of the grandest sights of the Serengeti; zebras, ostriches and a splendid lion are also denizens of Serengeti.

Tunisia

■ TUNISIA – Its north African location on the shores of the Mediterranean has been central to Tunisia's identity from 1,000 years BC, when Phoenicians settled there, to modern times, when tourist security comes up against Islamist terrorism. The grand city of Carthage, a powerful enterprise even before Romans arrived in 146 BC, is glamorous even now. Arabs were conquerors in 600 AD, then Berbers moved in. Tunisia in 1600 or so became part of the Turkish Ottoman empire, until the French arrived in 1881, loftily declaring a French protectorate in 1883.

Modern politics and independence urges began in 1934 with Habib Bourguiba, a lawyer who, on an uneven path that included spells in prison, became

Above and right: North Africa was no distance for the Romans of ancient Rome and their buildings there remain strikingly impressive. Among them is the town of Dougga with its great Capitol and the great Colosseum in El Djem. The warrior's head is in the ruins of Carthage, a city founded by Phoenicians, sacked by Romans and now a suburb of Tunis.

the statesman who brought the country to independence and himself to the presidency in 1956. World War II had intervened with numerous movies telling the colourful story of desert warfare and the ultimate victory of Allied forces. In 1981 Bourguiba was still there, winning the first multi-party elections since independence by a

Below left and right:The Bardo museum in Tunis, regarded as one of the finest Mediterranean and/or African museums, is setting for this funerary design. Even Tunisian handicrafts, this display in Sidi Bou Said, are of a higher quality than most.

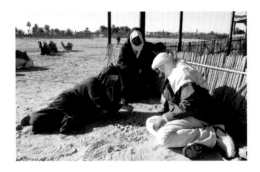

In Douz, in Tunisia's far south, the Sahara desert, camels and Berbers set the mood. To pass the time, camel attendants (above) play a form of chess. The town also boasts a popular Thursday market where everything from clothing to fresh produce, grains,

spices and livestock is sold. The ancient city of Kairouan is the setting for north Africa's holiest shrine, the Great Mosque (below). Photos show the colonnade of arches outside and the pillared interior where a man prays at the mihrab.

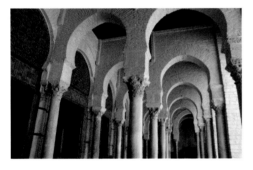

landslide. Age took its toll however and, in his 80s in 1987, he was deposed by his prime minister Zine al-Abidine Ben Ali.

Ben Ali had the toughness and skills to remain president well into his fourth term, which he won in 2004. But the celebrated Arab Spring of 2010, prompted by high unemployment and too many restrictions, was on its way and in 2011 Ben Ali was forced into exile. Terrorism and the killing of tourists had already arrived in 2002 with a synagogue bombing, and would get worse as hard-nose Salafi Islamists

Right: The north of Tunisia faces the Mediterranean. The south is framed by the starkly beautiful Atlas mountains leading to the inhospitable Sahara desert.

became stronger. Among their objectives was a sharp cutback of women's rights – women had in fact gained equality in 1956.

The Arab Spring had begun in December 2010, when Tunisian street vendor Mohammed Bouazizi set himself

on fire to protest the arbitrary seizing of his vegetable stand by police due to his failure to obtain a permit. What followed was an intense campaign of political and social movements across much of north Africa, not just Tunisia – where it eventually led to free and fair elections. Four organisations calling themselves the Tunisian National Dialogue Quartet even won the Nobel Peace Prize in 2015.

In sad contrast with evolving efforts towards peace and stability, Islamist terror attacks continued – in March 2015, at the Bardo museum in Tunis, 21 people, mainly tourists, were killed. Barely three months later, on a sunny beach in the resort centre of Sousse, 38 tourists were shot dead by a solitary gunman. Legal protests and demonstrations became part of a pattern under the egalitarian government of Bejo Caïd Essebsi, a distinguished and experienced politician elected president in 2014 at the age of 88. Alas, much mourned, he died in July 2019, at the age of 92. An academic, a retired law lecturer, Kais Saied, somewhat to his own surprise, was elected president. Inland, life continues more or less normally, markets are held, goats and sheep sold – and many splendid Roman ruins lie in waiting for the return of tourists.

Uganda

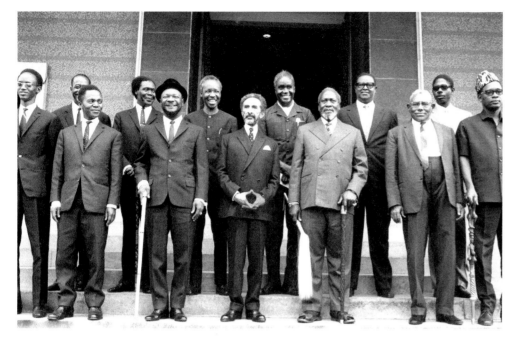

■ UGANDA – 'The pearl of Africa', as Winston Churchill called it in 1908 in a frequently quoted phrase, was his compliment to a land he found of great beauty and variety. And so it was, and is, but poor Uganda has suffered some awful times and terrible leaders. Big bad Idi Amin is the figure most remembered as brutal president, but he is not alone in having brought death and chaos upon his country and its peoples. Even years later, in 2019, when President Yoweri Museveni, claiming progress and stability in Uganda, stood for election for the sixth time, there has been a price to pay. He had come to power in a coup in 1986 and had never left.

Museveni and Idi Amin – and Milton Obote, who Idi Amin usurped – were fully aware of Uganda's traditional kingdoms, Buganda, Bunyoro, Ankole and Toro, which had existed since the middle ages. In their lust for power they

simply rode roughshod over them. King Mutesa II of Buganda, or more properly Kabaka, was actually briefly president when Uganda, a year after independence in 1962, became a republic with Milton Obote as prime minister.

Mutesa's full name and title was Sir Edward Frederick William David

Walugembe Mutebi Luwangula Mutesa II. For the irreverent press he was King Freddie. Banished by Obote – who simultaneously abolished the historic kingdoms – he died in exile in London. Museveni, once in power, saw advantages in reinstating a new Kabaka, Mutesa's son Ronald, and

This page and far right: Idi Amin was the monstrously cruel and despotic ruler of Uganda from 1971 to 1979. My photos covered the coup that brought him to power, events during his rule and finally his fall. He appeared in a variety of roles – robed as university chancellor, as family man, as military man bedecked with medals he had awarded himself. It is an irony that the unassuming Yoweri Museveni (**opposite**, after Idi Amin's downfall) who became president in 1968 has not relinquished power and is still head of state.

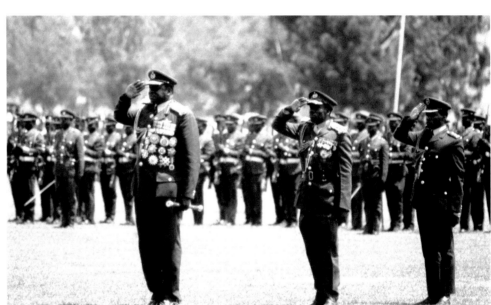

reviving the other kingdoms, albeit without allowing them any real authority. In practical terms it was only a distraction in a country that had seen much grief.

The Uganda I first knew was a land that valued tolerance. I recall visiting refugee camps where victims of racial hatred in neighbouring Rwanda and Burundi were receiving warmhearted care. Uganda also respected freedom of speech and the press. Among publications published in Kampala, the commercial capital, was *Transition*, a respected forum of dialogue and discussion founded and edited by the Uganda-born Rajat Neogy. Paul Theroux, then lecturing at Makerere University, was a frequent contributor. But as Obote began to encounter criticism, he became vengeful. In 1968 Neogy and a highly regarded academic, Abu Mayanja, were charged with sedition and locked up.

Milton Obote was attending a conference in Singapore when, in January 1971, he was deposed. Never much liked, his removal was cause for celebration – as was the arrival of the widely popular Major General Idi Amin Dada who replaced him. It was a shining moment – a bloodless coup

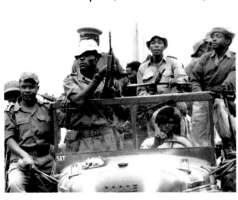

with a new leader promising to rid the country of corruption and nepotism, promising to organise general elections for a democratic civilian government and then go back to the barracks. Britain, formerly the colonial power, recognised the military regime within a week. Years later, the British and other governments persisted in seeing sunshine and peace when it was clear that numberless vicious murders had mounted to a hideous genocide.

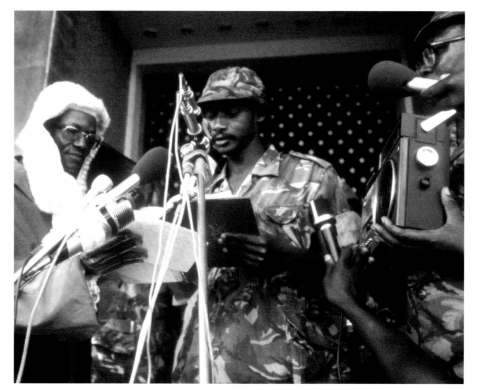

At the beginning, no-one could have predicted the horror that was to come. Idi Amin, good at boxing, a simple soldier, was also cunning. Many of Obote's ministers were murdered, or disappeared. Well-known people died; a handful of names expanded and the death list, in the end, numbered an estimated 300,000 people.

In 1972 Idi Amin, finding that his government was low on funds, and keen to divert attention from the slaughter and disappearances, announced that the entire Asian community, some 50,000 people whom he blamed for the financial crisis – in fact, they successfully ran Uganda's trade at almost every level – had ninety days to leave the country. Up to that moment, and even afterwards, Idi Amin's eccentric cables and mes-

sages to the outside world, to prime ministers, to Soviet and Chinese leaders, to the Queen, had raised howls of laughter. Yet the Idi Amin era was never funny.

I had covered the coup that installed Idi Amin for *The Observer.* Eight years later, *The Observer* would run my pictures of his successor. Idi Amin was gone, courtesy of Libyans and subsequently hosted in exile by Saudi Arabia. The army that had forced him to leave was a modest array of anti-Amin troops marching in from normally pacific Tanzania. Yusuf Lule, a mild-mannered former head of Makerere University, took on the presidency of Uganda but lasted only 68 days. Godfrey Binaisa, a lawyer who succeeded him, held the post for almost a year. Drummed out by the army, he was succeeded by the formidable former president Milton Obote, who had been impatiently waiting the call in Tanzania. But again

Obote was deposed and again a military man, the pugnacious Tito Okello, won the top job. Yet, like a spinning top, he too was gone within a year, pushed out by army rebels who installed Yoweri Museveni as president.

This was in 1986. Museveni survived, thanks to a populace badly needing respite. In 1996 and again in 2001 Museveni was elected and re-elected president, leading a government that functioned without political parties. Even when parties were restored he won – in 2016 he was elected to a fifth term of office. An opponent, as he had been before, was a determined politician, Kizzy Besigwe. But these were not peaceful times. Among disruptors, probably the worst was the Lord's Resistance Army, a ferocious Islamist group that operated in several African countries. Ugandan forces fought back, often well beyond national borders.

A domestic issue that caught the world's attention was a controversial 2014 anti-gay bill passed by Parliament increasing punishment for homosexual acts to include life imprisonment. Then again, the rights of women, the status of women, the respect for life in general, stayed at shockingly low levels. This troubled, intolerant Uganda was not the one I once delighted in.

Western Sahara

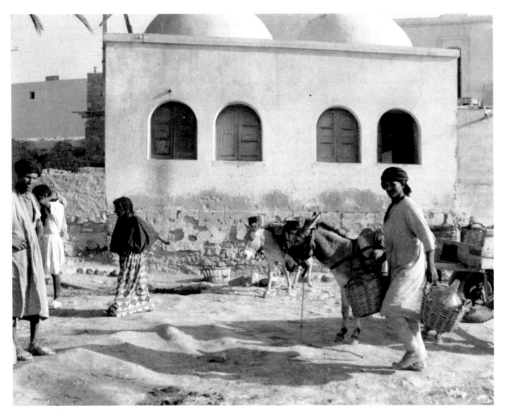

disputed territory with Morocco administering the western, coastal side and Polisario the interior desert to the east. The Sahrawi Arab Democratic Republic, a member of the African Union and supported by several countries, is generally ignored in the wider world.

The question of security arises now and again. For hardy cyclists who took part in TDA Global Cycling's first expedition around the West African bulge towards the end of 2018, a 6220 km (4113.4 mi) route which started in Casablanca and ended in Cape Coast, Ghana, the challenges were physical or occasionally mechanical, never political. Even as more than forty 'tired but happy' cyclists completed the route, registration was open for 2020.

■ **WESTERN SAHARA** – In the early 1960s the country appropriately called Western Sahara was a dusty, gritty, colony Spain had marked as its own in the 19th century. It was so Spanish that the small hotel where I stayed served Spain's traditional finger-shaped doughnuts, *churros,* for breakfast. I had last eaten them in Seville. The territory was called Río de Oro, or Spanish Sahara. But it wasn't Spain that dominated that wild desert. Who really rules over it hasn't been decided even now.

Mauritania is neighbour on the entire eastern and southern frontier. It is, though, Morocco to the north which has been truculently proprietorial since 1975, and bitterly contests determined counterclaims from the Polisario Front, a guerilla movement based in Algeria

supporting the self-declared Sahrawi Arab Democratic Republic (SADR). At issue are not only the independence of indigenous Sahrawis but mineral rights below ground and fishing offshore.

The temporary solution: a fortified buffer strip the full length of the

*A Spanish colony **(above and below left and right)** when I passed by in 1963, the desert country is a place riven by post-colonial urges. Even with a new name it is formally described as 'disputed territory'. My old photos show how it was.*

Zambia

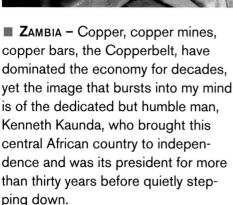

■ ZAMBIA – Copper, copper mines, copper bars, the Copperbelt, have dominated the economy for decades, yet the image that bursts into my mind is of the dedicated but humble man, Kenneth Kaunda, who brought this central African country to independence and was its president for more than thirty years before quietly stepping down.

Britain had in 1953 crafted a Federation of Rhodesia and Nyasaland which consisted of Northern Rhodesia (now Zambia), Southern Rhodesia (now Zimbabwe), and Nyasaland (now Malawi). In 1960, with an eye to independence and the dissolution of the white-dominated federation, Kaunda formed UNIP, the United National Independence Party. By 1963 the Federation was disbanded and in 1964 independence won. Copper, discovered in the 1920s, was the economic basis for Zambian development across the years. Nationalisation and

keeping UNIP the sole legal party, Kaunda determined, was the path to stability and progress.

It was not an easy path. Inevitably, there were objections. Power meant constant vigilance. On assignment to do a story on 'a day in the life' of Zambia's president, I saw that Kaunda

How glorious was the mighty Victoria Falls (left) named by the missionary-explorer David Livingstone. Today (as I write these captions) drought rules, the flow of water is but a trickle, the great cliff stark and frightening. If climate change has become a world headline, industry continues along much the same lines as in the past. (above left and right) The world still wants copper (and other minerals). Money rules.

preferred to keep informed of world and national news, not from any personal aide, but by close attention to the BBC World Service. Invited to accompany him on a tour outside the capital, Lusaka, I enjoyed a cheap thrill in the drive as all side roads were closed so that the president's convoy could pass unimpeded. (True power, perhaps, but scarcely worth a candle.)

In Kaunda's era, memorably, China took on what would become a massive role in Africa. Zambia, an inland nation,

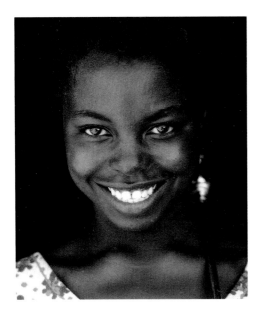

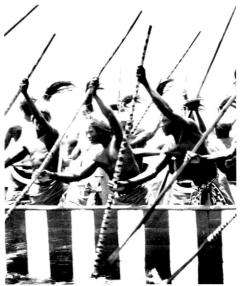

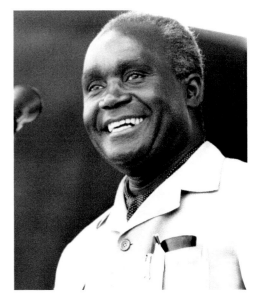

Above: A young woman with an umbrella gave me a smile that made my day, and a glowing photo.

turned to the Chinese to build a railway, the Tan-Zam, from the Copperbelt to the port of Dar es Salaam in Tanzania. Even the labour employed was largely Chinese. Photographing the launch in 1975, attended by distinguished leaders from the nations involved, I remember the hosts' embarrassment when African schoolchildren laughed at the Chinese dignitaries' highpitched manner of speech.

By 1991, KK's time was up. A multi-party constitution was adopted, new parties formed and Frederick Chiluba, leader of the Movement for Multi-Party Democracy, elected president. Greater democracy did not however bring peace. In subsequent years there were power plays among ambitious politicians, Zambia was affected by strife among neighbours that led to a huge inflow of refugees and a land hit by flood and drought.

In 2001 Levy Mwanawasa, a lawyer, was elected president, the

circumstances contested. Oil was discovered, the Chinese expanded their interests in a mining investment zone, former president Chiluba was found in a UK High Court action to have conspired to rob Zambia of not much under $50 million. President Mwanawasa died in 2008 after suffering a stroke. In his brief rule he was credited with attempts to battle corruption. Briefly, Vice-President Rupiah Banda became president.

In 2011 Michael Sata was elected president but ill health was rumoured and he died in 2014. In 2011, too, the Lozi people in Barotseland in western Zambia, agitated for secession. They are best known elsewhere for their colourful annual Ku-omboka ceremony involving the moving of their king from a flooded Zambezi plain in grandly adorned canoes. A 2015 election brought in Edward Lungu as president. Active in politics, he appointed a woman, Inonge Wina, to be vice-president, the first woman to hold the post.

Kenneth Kaunda, born 1924, is 95 years old, as I write. Out of power, he lived quietly though fought back – and

Above centre and right: Kenneth Kaunda was president of Zambia from independence in 1964 until he was defeated in elections in 1991. He had previously been a schoolteacher and retained a modest, though buoyant, personality. Politically, he aimed to be fair and just but, confounded by events, turned government into a one-party state, eliminating opposition. The photo, centre, is a glimpse of the Barotse Ku-omboka ceremony, normally an annual event when the Zambezi river floods and the chief moves house.

won – when it was suggested that, as his parents were from Malawi, he was not truly a Zambian. Zambia's mines and natural resources, led by copper and cobalt, but also including uranium, gold and other such treasure, are still productive. Not to be forgotten either is a natural resource that draws tourists to the southern border with Zimbabwe: the marvellous, magical Victoria Falls, named for the British queen by missionary-explorer David Livingstone, or by the local Africans more poetically as Mosi-oa-tunya, the smoke that thunders.

Zimbabwe

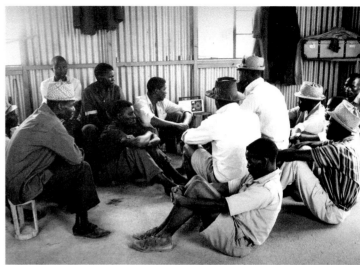

■ ZIMBABWE – A city, a state, mysterious ruins dating to between the 11th and 14th centuries are listed as a Unesco World Heritage Site under the name Great Zimbabwe National Monument and are described as testimony to the Bantu civilisation of the Shona. Even before Unesco, the importance of the ruins was recognised as they have been legally protected since 1893. Just as well, probably, for there were many voices in the 1960s, the voices of Rhodesian white settlers, declaring African people were incapable of such building.

On 11 November 1965 white Rhodesians, impatient that black African countries had won independence from Britain and they had not, announced their own UDI, unilateral declaration of independence. In Salisbury, the capital (later Harare), the streets were oddly silent as Prime Minister Ian Smith broadcast Rhodesia's declaration to the nation. This was bloodless rebellion, treason in the name of the Queen, but there

were no flags, no banners, no celebrations, no joy. African leaders had been detained in prison camps. Whites stayed at home.

Harold Wilson, the British prime minister, pronounced UDI illegal and ordered sanctions. Neighbouring South Africa, its *apartheid* rule firmly in place, saw to it that Rhodesians never ran short. Vociferous white voices continued to demand white rule. Britain, having lost control of its colony, was unable to act forcefully at what was called its "kith and kin" or to transfer power to a dominant African

Above left: It's the day of a fake independence, UDI, the unilateral declaration of independence in 1965. In what was still Salisbury, two policemen stand watch over Africans listening to the broadcast.

Above right: Africans detained by white rulers in a prison camp called Wha Wha.

Left: Ian Smith headed the party that declared the 'fake' independence.

group within the country. A temporary settlement came in 1978 with the partnership of Ian Smith, an African bishop, a reverend and a tribal chief, a neat scenario which soon failed.

At the end of 1978, a long slow war had brought atrocities on all sides. The two main African leaders, Joshua Nkomo leading ZAPU (Zimbabwe African People's Union) and Robert Mugabwe of ZANU (Zimbabwe African National Union), though formally linked by a Patriotic Front, had always been divided. Mugabwe's men operated from

Above: On a Salisbury street (the capital before it became Harare) white women chat while African women sit in the background. The separate groups were symbolic of the Rhodesian society.

Top right: Post-UDI garden party.

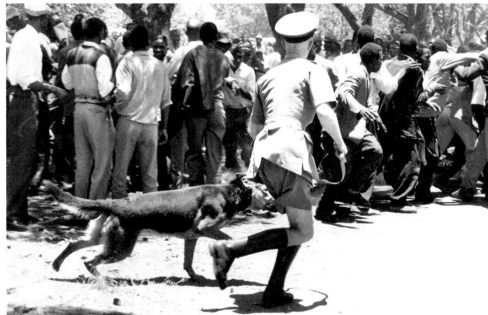

Above and left: Salisbury, a policeman with a dog moves along Africans who are demonstrating peacefully; elsewhere, two young boys playing with a toy gun appear to be threatening Africans on the street.

bases in what had become Marxist Mozambique and had gained control of the countryside. Nkomo's followers had their hopes pinned on the towns. Resolution came, to everyone's surprise, in settlement talks organised under a new Tory leader, Margaret Thatcher. Subsequent elections gave Mugabwe's party an absolute majority. A true and joyful independence was celebrated on 18 April 1980.

Above: Stone ruins in southeastern hills are all that remain of Great Zimbabwe, a city built by ancestors of the Shona people dating to the 11th century and lasting until the present day. They gave a name and inspiration to the modern nation.

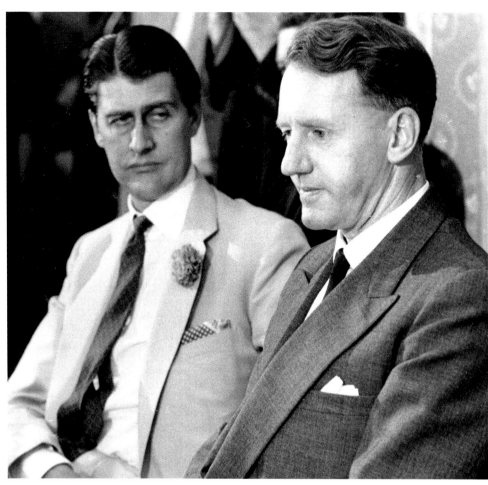

Above: Ian Smith **(right)** with PK van der Byl.

Robert Mugabwe held power for thirty-seven years, first as prime minister, then as president. By 1999, as economic difficulties increased, he had introduced land reform and, as well as legal action for landless Africans, encouraged squatters to seize white-owned farms. A new opposition party, led by Morgan Tsvangirai, began to contest Mugabwe's rule. In time, Tsvangirai achieved a brief partnership but was frequently physically assaulted and always outmanoeuvred (much as Nkomo had been). Protests at rigged elections went nowhere. Food shortages arose. Inflation caused huge fluctuations in what became surreal currency.

In 2013 a new constitution was approved in which presidents were limited to two five-year terms. Mugabwe, now in his 90s, won a seventh term of office and his party three-quarters of seats in parliament. In 2017 he was forced to resign. The military had stepped in to stop his unpopular wife from taking power. A former vice-president, Emmerson Mnangagwa, became president and was narrowly elected in 2018. Stabilising the economy and encouraging investment were his predictable objective. Progress was slow. Citizens suffered economic crises and brutal crackdowns. But there was also good news – at last – in the discovery of potentially large oil and gas deposits.

The death of 95-year-old Mugabwe in September 2019, during a visit for medical treatment in Singapore, brought mixed tributes. Was he a hero, the leader of a liberation struggle against white minority rule? Or was he a despot who crushed his enemies and brought poverty to his people? The debate did not last long. The people of Zimbabwe who had suffered in the past had a future to work for.

Part 2

Antarctica

See also, under ISLANDS Falklands and South Georgia

ANTARCTICA – Remote, harsh, the coldest, driest, windiest continent. No indigenous or permanent population (excepting a plethora of penguins), no citizenship, no government, no sovereignty…yet the icy white continent has enthralled travellers, scientists, explorers, writers, mapmakers and dreamers for a very long time. In the second century A.D. the Greek geographer Ptolemy wrote of *Terra Australis Incognita,* 'southern unknown land'. In the 20th century so many countries laid claim to it that an Antarctic Treaty was signed on 1 December 1959, to preserve its serenity. The first principle: the Antarctic shall be used for peaceful purposes only.

The Treaty went into effect in 1961, establishing Antarctica as a scientific preserve where all military activity is banned. Twelve nations were the original signatories – Argentina, Australia, Belgium, Chile, France, Japan, New Zealand, Norway, South Africa, United Kingdom, United States and the USSR. All of them were active during the International Geophysical Year (IGY) in 1957–58, the first substantial multi-nation

Left, top to bottom: A hilltop in the Antarctic peninsula is a dramatically set 'rookery' to a small colony of gentoo penguins; it's a long walk home for a gentoo to its own social group way up the hill – a challenge penguins face all the time; gentoos have a striking glacier as backdrop to their chosen refuge.

research programme in Antarctica. By 2019 there were more than fifty signatories, each accepting the basic rules of the Treaty, as well as new agreements made as the years passed.

These included the management of tourism, collection of meteorological data, the preservation of historic sites, the conservation of plants and animals, and more. As the Antarctic Treaty System matured it became recognised as one of the most successful international agreements, a unique example of peaceful cooperation.

It has had to cover a wide range of needs and happenings from the three airfields operated by the United States to human births—the first, Emilio Marcos Palma, born 7 January 1978, to Argentine parents.

Additional agreements covered matters not already specified. A Protocol

on Environmental Protection to the Antarctic Treaty, for instance, was signed on 4 October 1991, by 31 countries. Its most notable feature was the banning of commercial mining. Of all the active countries, partners almost, it is notable that the UK, an original signatory to the Antarctic Treaty, has played a leading role in developing the Antarctic Treaty System ever since. It's a curious fact, too, that although most of us who make it there are no more than tourists, in Antarctica we are so affected by its extraordinary quality we badly want it to endure. And that, in the nature of things, will need work.

Alarming reports have been published in *Nature*, *The Guardian* and elsewhere that ice in the Antarctic is melting at a record-breaking rate and the subsequent sea rises could have catastrophic consequences for cities around the world. Professor Andrew Shepherd, from Leeds University and a lead author of a study on accelerating ice loss, said: "We have long suspected that changes in Earth's climate will affect the polar ice sheets." A report in 2018 in *The Guardian* by scientists in the UK and

Above left and right: The ocean is rarely far away; it takes only a hop and a skip for a penguin to move from land to water; penguins and people are equally minuscule in the context of the Antarctic.

US found the rate of melting from the Antarctic ice sheet had accelerated threefold in the last five years and was now vanishing faster than at any previously recorded time.

Ice in various shapes and forms – glaciers and icebergs, icy ridges, hidden crevasses, snow, rock, mountain, a volcano (Mount Erebus), chill winds, freezing ocean–give travellers today a glimpse of Antarctica as explorers found it. And wildlife, amazingly, is still there. Whalers, largely based on South Georgia island, caught and killed, between 1904 and 1966, more than 40,000 blue whales, nearly 88,000 fin whales, 26,700 humpbacks and thousands of sei whales and sperm whales. Earlier, in the 19th century, commercial sealers and hunters slaughtered vast quantities of fur seals for their skins and elephant seals for their oil. Once the carnage was

halted, populations of these splendid animals began to grow.

The Falkland islands, as well as South Georgia and many other islands (see also ISLANDS, p.306), are deemed to be destinations for Antarctic voyagers and provide their own inimitable wildlife observation experiences with stunning penguin 'rookeries' (six species) and a host of other spectacular birds, including albatrosses, petrels, shags and cormorants, skuas, gulls and terns, all thriving in the far south's extreme conditions.

With human activity in Antarctica more or less controlled, nature is the one exacting element to be challenged, understood and curbed. Nature is not to be subjugated or mastered. From the first explorer's sighting in 1820 to the more than forty scientific stations active today it is entirely clear that Antarctica, visibly pummeled and pulverised by gigantic climatic forces, is a continent to be treated with the utmost sensitivity.

Scientific studies range from glaciology to insect survival. Antarctic midge larvae, it was revealed in a study by Nicholas Teets, can live for

nearly two years underground. For more than half their lives, about eight months of the year, they are totally frozen. They can also survive immersion in water. As so often, the big question was if there are any strategies that might apply to humans.

Getting there, with the South Pole as most coveted target, was the prime aim of the first explorers, heroic figures to most of us. Roald Amundsen, the Norwegian who first reached the South Pole on 13 December 1911, won a race against the British explorer and naval officer Robert Falcon Scott, who led two expeditions and tragically died, with all his companions, on the second (1910–1912). For the British it is understandably Scott who is the greater hero.

Few Westerners are aware that a Japanese army officer, Nobu Shirase, led an expedition to the Antarctic in that era – and even encountered a team from Amundsen's ship, the *Fram*. But as the Amundsen-Scott stories entered the realm of legend, Shirase's voyage, except in Japan, faded to footnote.

A name that has not faded is that of the Australian geologist, Douglas Mawson, more concerned with advancing scientific knowledge than racing to Poles. He had already been a member of an expedition led by the Irish-born Ernest Shackleton when he led the first true scientific expedition (1911–1914). He is honoured today through the naming of the Australian Antarctic research station on the continent's eastern coast, an early permanent base in Antarctica.

Sir Ernest Shacklelon as Antarctic explorer is remembered not only for his personal courage and leadership but for one extraordinary episode late in his career. Enthralled by polar voyaging, he led three expeditions. On his Trans-Antarctic expedition launched in 1914 his ship, the *Endurance*, was crushed by ice. When it sank, the mariners took to three small boats and eventually reached uninhabited and remote Elephant Island, off the southern tip of Cape Horn.

With rescue unlikely, Shackleton and five men took off in a lifeboat and, eleven days later, reached South Georgia Island, dominated by whaling stations. On 25 August 1916, he returned to Elephant Island to rescue his remaining crew. It had been an absence of nearly two years yet not a single member of his 28-man team had died. Still gripped by polar fever, Shackleton set off on a fourth expedition to the South Pole in 1921. On 5 January 1922, he suffered a heart attack aboard ship and died. He was buried in South Georgia.

Expedition leaders are by no means the only heroes in the grand Antarctica story. In 1768 Captain James Cook crossed the Antarctic circle and only stopped when solid pack ice blocked his way. A Scot, Captain James Weddell, in 1823 was also confounded by gales and pack ice, though the sea, and a seal he 'collected', were named after him.

The continent had already been sighted, on 27 January 1820, by Fabian Gottlieb von Bellingshausen, a Russo-German commanding a Russian expedition of two ships. James Clark Ross, a highly skilled navigator in the British Royal Navy, had explored the Arctic when he led a scientific expedition to Antarctica in 1839–1843. The Ross Ice Shelf, Ross Sea and Ross Island –

Above: A gentoo penguin makes its way across the snow, a short little creature, wide and perhaps a little unbalanced.

Below: Chinstrap penguins in a small Antarctic colony.

Above: An Antarctic shag poses on an iceberg in the Southern Ocean.

where the United States maintains the largest of the research stations, McMurdo – are named after him. (The US also operates the Amundsen-Scott South Pole station.)

A young British adventurer, Apsley Cherry-Garrard, who volunteered for a Robert Scott expedition and was taken on as assistant biologist, is best remembered for his thrilling account of Antarctica in his remarkable book *The Worst Journey in the World,* first published in 1922. His main objective, he recounts, was to collect emperor penguin eggs, a task a good deal harder than it suggests. Cherry, as he was in his youth, was also among the team that found the bodies of Scott and his companions in their tent.

Then there was Edmund Hillary, the New Zealander renowned for being the first to climb Mount Everest, reaching the summit together with Sherpa Tensing Norgay, perfectly timed for the historic moment of Queen Elizabeth's coronation in 1953. He also led the New Zealand part of the Commonwealth Trans-Antarctic expedition of 1955–1958, arriving at the South Pole, the first to get there overland by motor vehicle, in a tractor.

Now, there are heroic solo walkers. Two men, separately and unaided, traversed the Antarctic continent in 2018. Colin O'Brady, 33, an American, was the first to do it, taking less than two months, dragging a sled with his supplies, walking and ski-ing 921 miles (1,482 km) in 54 days. Louis Rudd, 49, a captain in the British army, was only a few hours behind him. It was an achievement as rigorous as it had ever been. Rudd dedicated his expedition to a fellow British army officer, Henry Worsley, who had died

Above: *Ice castles, two blue icebergs, rise high in the Southern Ocean.*

while attempting an unassisted solo crossing of Antarctica in 2016.

My own particular hero among all those brave souls is Frank Hurley (1885–1962), a hugely talented Australian photographer whose career included war photography in both World Wars and documentary films. His first taste of the Antarctic was as official photographer on Douglas Mawson's 1911–1914 expedition, working with the heavy camera equipment of the time. Then, from 1914–1917, he was with Ernest Shackleton and recorded the crushing and sinking of the unfortunate *Endurance* and the epic saga of the marooned crew. His skill, courage and determination in extreme conditions were unparalleled. His spectacular Antarctic photos are still thrilling today.

Antarctica, for all its eminent explorers, myriad scientific studies, enthusiastic visitors, pulsating activity, libraries of exciting books, will always leave questions unanswered. As Craig

Welch wrote in *National Geographic* (November 2018), 'As Antarctica hurtles toward the unknown, scientific knowledge is still sparse.'

For instance, there is the 'Antarctic Convergence', explained as a boundary, a meeting place of ocean waters where northern waters differ markedly from southern waters. This is a place where nutrients rise from the seafloor making the point of convergence a productive area for algae, krill and other creatures that form the bottom layer of the Antarctic food chain.

Its position varies from time to time. It cannot be seen. The surface of the sea doesn't alter. The main change is in the temperature of the water and in its salinity, usually detectable by a ship's instruments. It is shown on maps as an uneven ring encircling the whole continent. Science sometimes calls it a 'Polar Front'. Perhaps, like photosynthesis, where plants convert light energy to chemical energy to fuel growth, it is only one more of nature's amazing tricks. It is surely also pure polar magic.

Part 3

Asia

ASIA. The largest of the seven continents has a long history and an extraordinary wide-ranging culture that includes several magisterial civilisations, Chinese, Persian and the Indus Valley among them. What it does not have is a finite border. Europe, a complex organism itself, is to the west on maps yet it is part of the same landmass. Oceania is to the east but with no defined boundary. To the north lies the Arctic Ocean. The tip of the Malay peninsula marks the southernmost area. The highest point on Earth, Mount Everest, is there, as well as the lowest land level in the Dead Sea.

Lake Baikal is another intriguing physical wonder at 1,620 metres deep, with the lake bottom at 1,165 metres below sea level. Landscapes are dramatically varied, rivers forceful and profoundly affected by a capricious climate. Travellers delight in exquisite beaches, benign bays, blue waters and numerous elegant temples and churches. Asia is home to tigers, orangutans and other fabulous wild creatures – and is also the source of much of the vicious trafficking of wildlife 'products'.

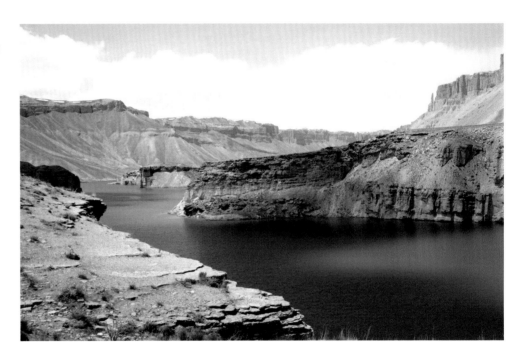

With the largest human population of any continent, Asia is recognised as the liveliest and busiest, the leading trader, the centre of more religions than any other, the catalyst for commerce and exploration. The Silk Road was not myth but a route, a connection, enabling the spread of wealth, prosperity, goods and ideas. Not all ideas have been welcomed. Conflict has arisen too often. War, in places, has riven societies and destroyed whole communities. Asia is

Above: In Afghanistan vivid blue lakes are a surprising sight in the Band-e Amir National Park – and, in the context of the nation's violent history, a reassuring haven.

also the continent of Mahatma Gandhi, leader of India's independence movement against British rule. A trained lawyer, albeit one with a humble manner who chose to live in extreme simplicity, he died violently by assassination, yet all his life he was a man of peace.

Afghanistan

AFGHANISTAN – A landlocked mountainous country endlessly beset by invasions, assaults, massacres and assassinations, as well as brutal acts of nature, drought and flood. Afghanistan is often admired for the proud and independent spirit of its mainly Muslim people, and viewed by some with an almost romantic fervour – a mood reflected in scores of books and movies and helped along by sagas relating to the snow-capped Hindu Kush.

Invaders long ago included Alexander the Great around 328 BC and Mongols led by Gengis Khan in 1220. In the 19th century Afghanistan was at a crossroads of power-hungry empires, Russian and British the most assertive. From this rivalry arose the expression 'the Great Game', which stuck and was popularised by Rudyard Kipling in his novel *Kim,* though through the years a great deal of unsporting blood was spilled.

The British in the 1840s, having involved themselves in ruling the country, did not do well and were heavily defeated in a retreat from the

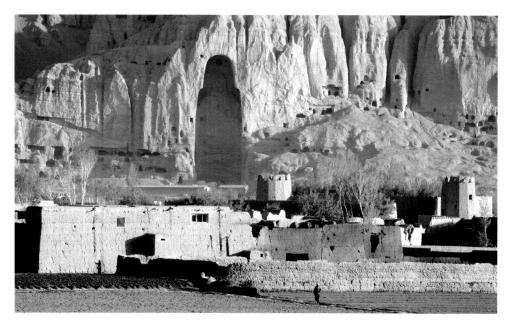

capital, Kabul. Afghanistan was a monarchy then and for some time later, and with Zahir Shah as king after 1933 there came a period of relative peace. In 1953, unfortunately, the prime minister, Mohammed Daud, seeking economic aid from the Soviet Union, initiated an era of infighting and invasions.

In 1979 the USSR invaded in strength and attempted to form a communist government. For five years,

Above: Empty spaces in Bamiyan cliffs are a reminder of the dynamiting in 2001 by the Taliban of the two giant Buddhist statues they held.

Below left: In the Panjshir valley a portrait of assassinated hero Ahmad Shah Massoud is displayed over a bridge.

Below right: Caves in Bamiyan's sandstone cliffs provide family homes.

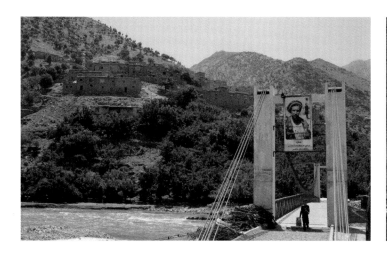

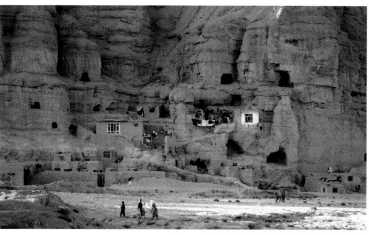

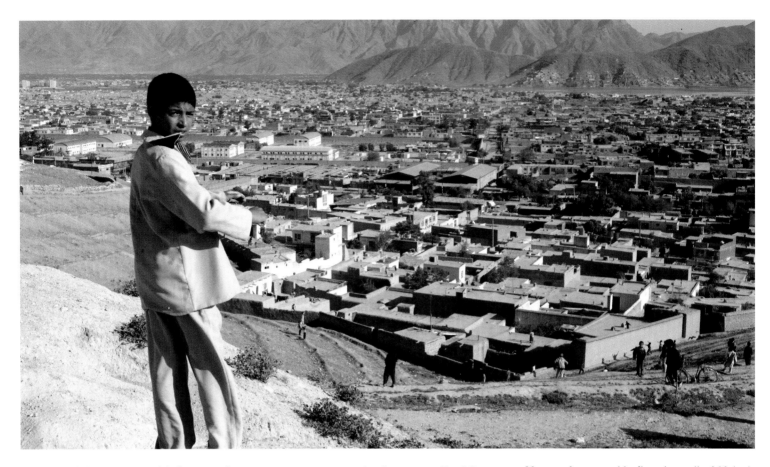

a thuggish bureaucrat, Mohammed Najibullah, headed the Soviet-backed regime. Opposition arose from local forces, the *mujahideen* – supported, in 1986, by the United States. By 1989 all Soviet troops were gone yet neither peace nor prosperity lay ahead.

Instead, from the *mujahideen* fighting forces, mainly Tajik, whose leader was the courageous and widely admired Ahmad Shah Masood, national power was seized by the militant Taliban, a group which proceeded to impose its extreme Sharia beliefs on the overwhelmed nation. Smalltime thieves lost their hands, women lost any independence they had gained. The name of Osama bin Laden began to be heard around the world. In March 2001 shocking images showed the destruction in the northern town of Bamiyan of

two monumental 6th century Buddha figures carved into a sandstone cliff, dynamited on orders of the Taliban, who pronounced them idols.

In September 2001 Masood, who opposed the Taliban, was assassinated. Two days later came 11 September 2001, widely known as 9/11, and four coordinated air attacks on the US causing the collapse of New York's World Trade Center towers – electrifying in frequently repeated images – and the death of nearly 3000 Americans as well as the citizens of many other countries. Sole blame, US authorities concluded, lay with Osama bin Laden and the Al Qaeda organisation he led. In response, Americans began intensive bombing in Afghanistan.

In the years that followed, Hamid Karzai headed the government in

Kabul, while US and NATO troops controlled security, fought the Taliban and hunted Osama bin Laden. In 2009, with Barack Obama having replaced George Bush as US president, the number of US military in Afghanistan rose to 100,000. Various attempts that included neighbouring Pakistan, a Taliban backbone, were made to bring peace. In May 2011, in a dramatic raid, Osama bin Laden, hiding in a Pakistan rural compound, was killed by US Navy Seals.

By 2014, when elections brought Ashraf Ghani to the presidency in Kabul, countrywide violence had continued ceaselessly, even as the foreign military presence shifted to

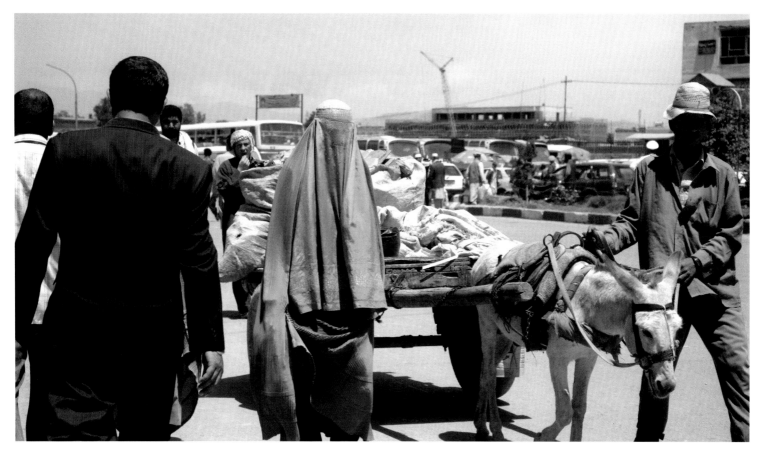

training the Afghan army. In 2019, when the American military presence had been reduced to 14,000 troops, American aircraft were still dropping bombs on family homes, insisting that only combatants were killed.

When President Ghani announced that more than 45,000 Afghan troops had died since 2014, talks were discreetly proceeding in Doha, Qatar, between American diplomats and the Taliban, without the participation of the Afghan government, to end the decades of war. (The toll of American deaths since 2001 is put at 2,300, and of Afghans at 111,400.) Yet violence continued daily, civilians the target, campaigning women not excluded, most of it caused by the Taliban. Yet ever-increasing instances were claimed by the Islamic State –

Above: A couple, probably from a farm, with their donkey cart in Kabul.

Right: A young man and his wife in Kabul's streets. Like all women in public she wears an all-concealing burqa.

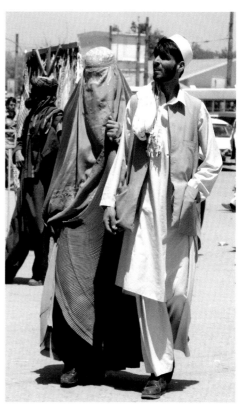

including the ultra-cruel bombing of a wedding party in which dozens died and hundreds were injured.

Soon afterwards, after yet another bombing, this time a car bomb that by chance killed one American among a dozen Afghans, President Trump called off the talks.

They were, however, soon resumed, culminating in a shaky deal. There were many in Afghanistan fearful of the implications of a Taliban-type peace, women – remembering the last Taliban rule – most of all.

Bhutan

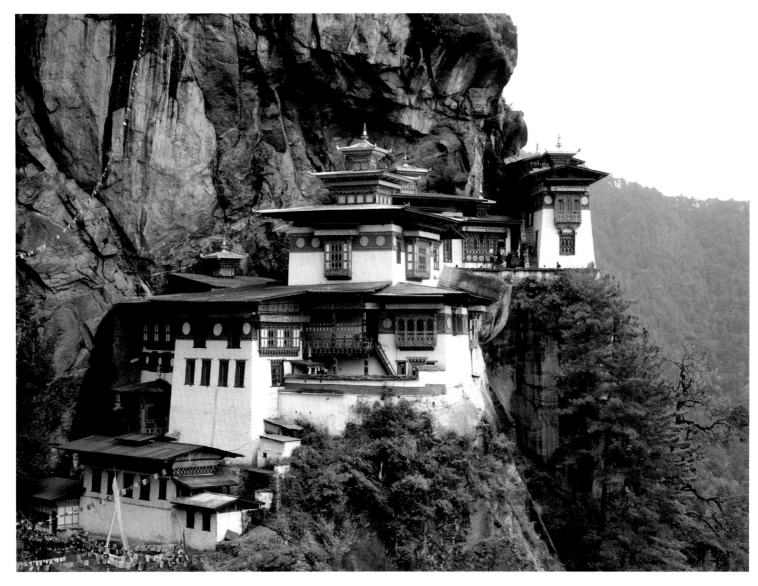

■ **BHUTAN** – The notion of 'Gross National Happiness' as government policy is possibly what's best known about Bhutan, a small kingdom deep in the Himalayas. For all the phrase's beguiling charm there are occasional quibbles. In August 2013 Prime Minister Tshering Tobgay remarked that Bhutan's 'much lauded concept of Gross National Happiness is overused and masks the real problems facing the country like increasing debt, chronic unemployment, poverty and corruption.'

Few visitors will see negative aspects of a society which has a dragon on its flag, a deep respect for its young king, a profound belief in Buddhism (which arrived in Bhutan in the 7th century), enjoys the national sport of archery and appears to be modernising without strong ethnic tensions, though Nepalis, or

Above: Tiger's Nest, or Takstang, a Buddhist monastery spectacularly located on a high cliff near the capital, Thimpu. Bhutan has adopted a similar architecture for its international airport **(opposite)** and other government buildings.

Lhotsampa, of Nepalese ancestry, have been a suffering vocal minority.

Governing a population of about 800,000 is in the hands of an elected

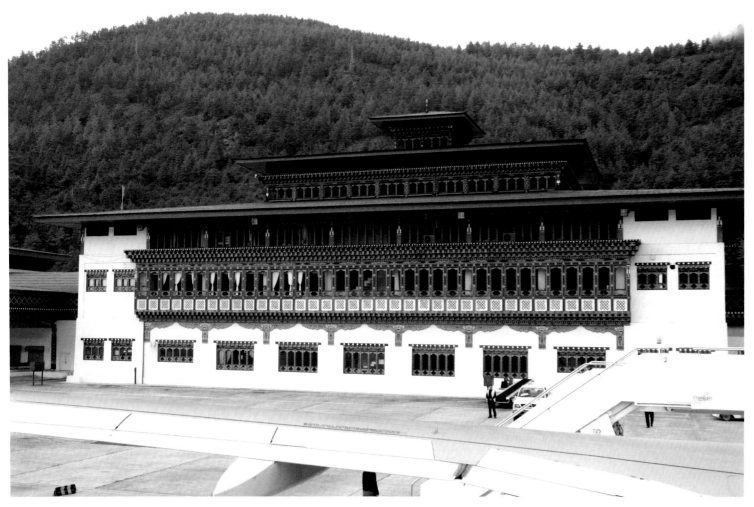

assembly, under a constitutional monarchy which promotes a progressive environmental policy. Human rights are not quite as progressive: homosexuality is illegal. On foreign affairs, Bhutan has bilateral relations with, and the protection of, big brother India and so is able to withstand bad vibes from China. A northern neighbour, beyond a closed border, is 'Autonomous' Tibet, a region of China.

Bhutan's stunning landscape embraces high peaks, forest, rivers and diverse wildlife including tigers. (Rural folk insist, too, on the existence of abominable snowmen.) Hiking and adventure trekking – including a

'snowman trek' – are a popular aspect of burgeoning tourism. Local traditional architecture is elegant, buildings frequently adorned by painted tigers, dragons and penises – the phallus image is believed to provide protection from evil spirits. Fortress-type town halls, or *dzongs,* tend to be gorgeous, the one in Thimpu, the capital, grandest of all.

Of other fine sights the Paro Takstang monastery, known as Tiger's Nest, set on a cliff above the Paro valley, is as astonishing as it is well-known. It's an easy climb up a steepish hill but, thinking to save myself the trouble, I made the mistake of accepting the offer of a donkey

ride. A loose, hard saddle soon changed my mind. Back on foot, with a little effort, I got what I wanted above all, a photo that pleased me.

Few visitors will see negative aspects of a society which has a dragon on its flag

Above: *Two young boys look out of the unglazed window of their farmhouse.*

Left: *Corner of a building in Paro showing traditional art including a phallus, a symbol of protection against evil spirits.*

Opposite top: *Archery is Bhutan's national sport; contests are frequent.*

Right: *Harvesting rice in the Paro valley, Bhutan, one of the few flat areas in the country.*

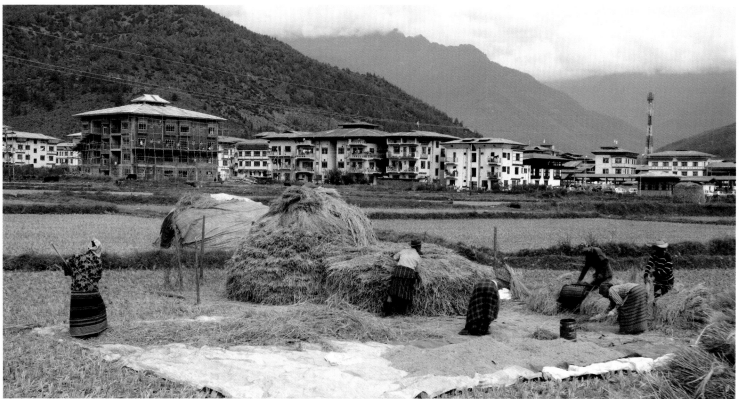

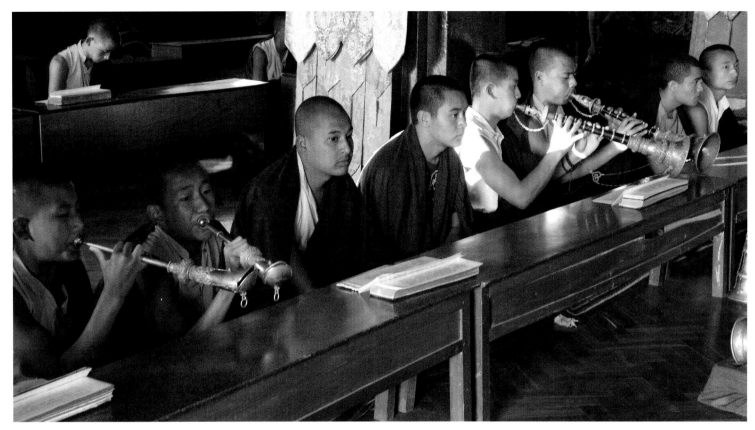

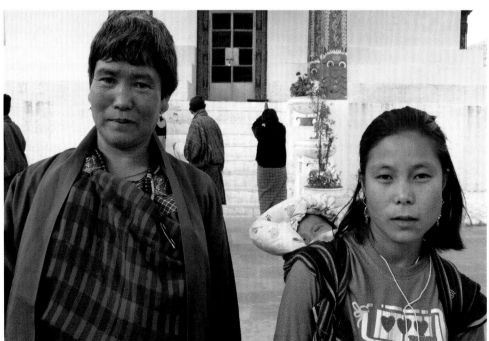

Above: *A Bhutan postage stamp shows a yeti, or abominable snowman, which country folk believe exists.*

Top: *Young monks blow traditional trumpets in a Bhutan monastery.*

Above: *Three generations are among pilgrims at a 'chorten', a reliigious monument near Thimpu, Bhutan.*

China

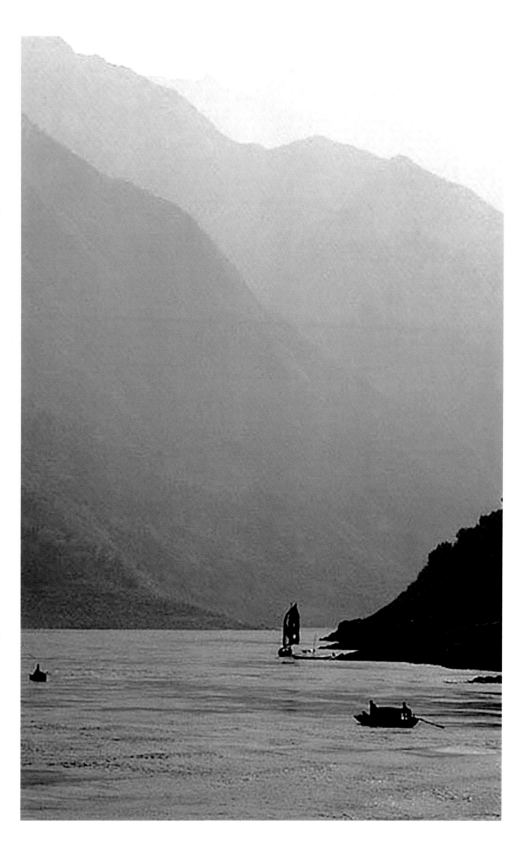

■ CHINA – "China is a big country, inhabited by many Chinese." An observation attributed to General Charles de Gaulle, while entirely accurate, doesn't begin to take in the multifarious realities of China. Total transformation is just one shattering reality. My photos, for instance, date to a visit in 1984 when city people wore drab uniform clothes. Almost the only colour was the brighter outfits of small children in one-child families. There were no personal cars, only bicycles. People looked downtrodden and fearful. The biggest issue was the Three Gorges dam in the Yangtze (or Chang Jiang) river.

Thirty-five years later, when a wealthy and formidable China successfully landed a probe and rover on the far side of the moon, the transformation was staggering. It had been achieved, moreover, in a nation with no free press, no rule of democratic law, no competing political parties and no concern for human rights.

Behind the highly sophisticated global power that is modern China lie historic markers that include Mao Tse Tung's (Zedong's) long rule as founding father of the People's Republic, his Little Red Book, his 'Great Leap Forward' and his 'Cultural Revolution', then Deng Xiaoping's 'Open Door' policy and ultrafast urbanisation.

Right: A pre-dammed view of the mighty Yangtze river, known in China as Chiang Jiang, meaning Long River.

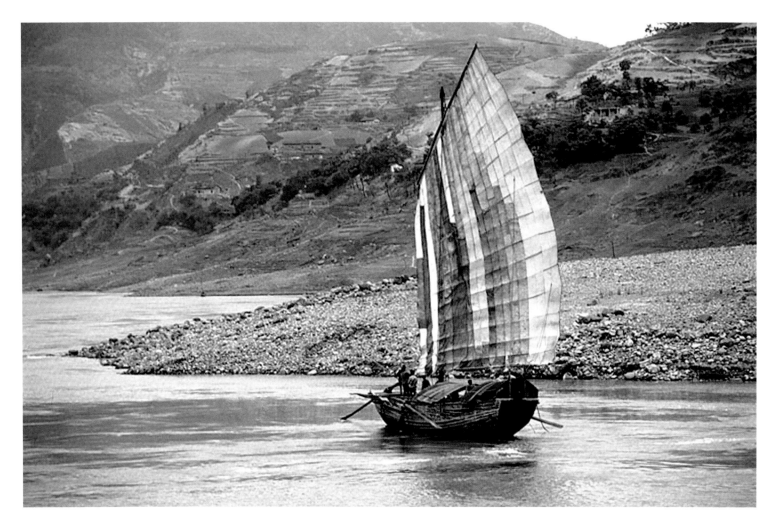

By 2019 the president, since 2013, was Xi Jinping, a politician whose rise to the top had been disciplined, steady and well-rounded, including extensive travels.

The economic 'miracle' arose from China's switch to capitalist market principles, mass privatisation, the opening up to foreign investment (how the West loved those low labour costs!), the migration of rural workers to a multiplicity of new factories, new schools, technical education, high-level engineering. *China Daily* in June 2019 said that China in 2018 had 285 billionaires with total wealth reaching $996 billion. The resulting higher incomes led quickly to status

Above: *A new boat on the pre-dammed Yangtze river.*

Left: *Tending rice in a ricefield beside the Guilin River, or Li Jiang.*

cars, stylish clothes, better food (more pork), foreign holidays, that moon landing – and, as power sources multiplied, appalling pollution.

China has also become a reality as constructor and investor in every continent and very nearly every country. Its close interest in a thawing Arctic, with its potential riches in minerals, drew accusations (from the US) of 'aggressive behaviour'. What I saw in

Above: In a 1984 moment the great Tiananmen Square in Beijing is a meeting place for carers of babies in their prams.

Right: A smiling grandmother with adorable infant.

my Africa years in the 1970s when China – and Chinese labourers – built the Tan-Zam railway linking inland Zambia to Tanzania was the beginning of a multitude of truly global enterprises. Where once shops stocked cheap Chinese toys and household junk, investments are in mining, banking (its loans have grown to be greater by far than the World Bank), real estate, in highest quality electronics, infrastructure including sleek systems of transport, in everything imaginable. And on a vast scale.

Careful management of China by its leaders has included controls that are frequently criticised. When guns and tanks were rolled out against unarmed students demonstrating in Tiananmen Square on 4 June1989, the shock of such a brutal action, the memory of the massacre as troops shot blindly into the crowd, and the crackdown that followed, has never gone away. Years later, the government blandly claimed the measures taken had been appropriate.

Controls reach deep into family life. Family size was one thing, its social

Above: Popular with Chinese as well as visitors − the famous Great Wall.

Left: A cart carries coal from a Datong coal mine in Shanxi province.

Opposite, top: In 1984 visitors were banned from photographing the amazing warriors' pits in Xian so, frustrated, I snatched this picture

Right: In Datong's huge railway yards in 1984 splendid train engines were manufactured; since then China has become a worldwide powerhouse in railway construction

effects not always happy. Freedoms of almost everything are limited, higher incomes the reward. Except when troubled businesses are discovered through close data control and are punished through blacklists that freeze personal accounts and pensions. On an international level trade wars are employed as if in a war game.

Around 2018 a democratic world looked at what was happening to Uighurs and other Muslim minorities in Xinjiang in China's far west. Mass detention? It appeared that perhaps a million people were being held in internment camps or what Chinese officials described as 'education training centres'. The objective: to turn those freethinking people into loyal, Chinese-speaking supporters of the Communist party. The Chinese government predictably was unmoved by the almost global condemnation of its policy. Only a modern plague, coronavirus, unexpectedly extending lethal tentacles to the whole world from Wuhan, could bring peril and insecurity in its wake.

It's something of an effort to recall that the China of present times is positively trifling compared with its past – the civilisations and empires. Were there really 494 emperors? Depending on who were counted, perhaps more. Kangxi was the second emperor of the Qing dynasty and a master in Confucianism, apparently. China was a power in warfare and strategy – the recovered 'terracotta army' in Xian that enthrals tourists is a potent indication. It was the army of the very first emperor, Qin Shi Huang. For the Chinese, the emperor ruled the world and had the power over everything under the sun. History, as so often, appears to be trying to repeat itself.

India

■ INDIA – As with China, numbers are enormous. Unlike China, India is a democracy. Preparations for national elections in April 2019 meant planning for 900 million eligible voters. Total population, according to UN figures, was 1,364,136,554, close to one-fifth of all the people on earth, in human terms an almost unimaginable figure. Yet look at any photo and what you see are individuals, and every state and region has its own history and culture.

Religion, mainly Hindu (after 'partition' and the creation of Muslim-majority Pakistan) is a central factor but there's much to question: the sanctity of cows, the oddities of caste – the nobility of Brahmins, the status of Dalits, formerly Untouchables (India's president, Ram Nath Kovind, is a Dalit, a Supreme Court lawyer selected for the post by an electoral college in 2017.)

In 2014 the rightwing Hindu nationalist Bharatiya Janata Party (BJP) had come to power. One lamentable effect was rising intolerance and an intense anti-press policy provoking attacks on, and even the murder of, journalists. The BJP easily won the 2019 elections, leaving

Top right: Kanchenjunga's peaks at dawn; the world's third highest mountain, it rises to 8,586 metres (28,269 ft).

Right: In 1961 Goa, a Portuguese colony for 400 years, was restored to Indian rule. Portugal's president Mário Soares and his wife Maria Barroso are welcomed during a visit to India in 1992.

many worried that the secular ideals of modern India's founders were lost for ever.

In a larger historical context there are superb arts and a glorious literature, and – another crucial resource – India's influence around the world, whether in philosophy, music, fashion, food, design, or anything else. The role of the British, whose direct rule extended from 1858 to 1947, was a blink of an eye in India's centuries of civilisations and empires – and even then India was always 'the jewel in the crown'.

It is, though, the difficult relationship with Pakistan, rather than bygone links with Britain, that impacts on India most strongly, confirming that the power of religion far exceeds that of politics. Across many years the violent core of nearly every issue has been Hindu versus Muslim – when, that is, it hasn't been the fury of offended Sikhs over the storming of their holiest shrine, the Golden Temple in 1984. A

consequence of that, shockingly, was the assassination of longtime prime minister Indira Gandhi by her own Sikh bodyguards. Wars have been fought more than once over Bangladesh, over Kashmir. More than once, too, talks have smoothed things over – until the next time. The spark

may be unrelated, but the fire that burns has a perpetual inner flame.

1984 proved to be a challenging year in India. When a gas leak developed in a pesticides factory, thousands died and thousands more were left disabled. Other grievous events in subsequent years have made the news – terror attacks on hotels, appalling cases of gang rape. By contrast, there is justifiable pride in India's achievements in space and, in 2018, on a rather different topic, an unexpected correction of an ancient prejudice when the Supreme Court invalidated a section of the penal code and gay sex was legalised. Curiously, while homophobia is widely prevalent and physical attacks on transgender individuals common, this is also the society, or culture, of the

Above left and below: *India's National Day parades in Delhi are colourful events involving brightly uniformed troops and handsomely bedecked elephants. This one was in 1992.*

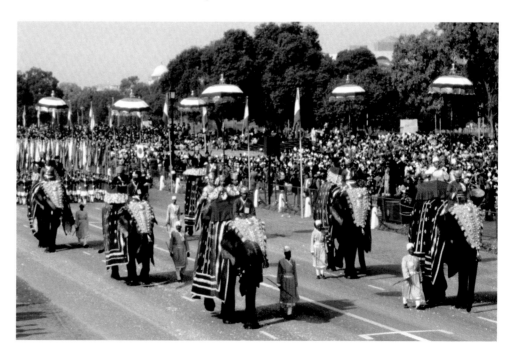

Kamasutra, an ancient Indian text which contains a fulsome chapter on erotic homosexuality. On a different scale, *hijra* communities – a third gender, neither man nor woman – are not unusual even now.

If punishing activities 'against the order of nature', as it has too often been described, is a sad fact in many countries, in the west-coast Indian

Above: *Downtown traffic realities in Mumbai: a bullock cart squeezed by a bus.*

Right: *In Mumbai the so-called Gateway to India viewed from the elegant Taj Mahal hotel where, on a press visit, I was fortunate to be lodged.*

faded but still there are Portuguese-style churches and houses in a pleasing Portuguese architecture.

Elsewhere, in Agra in the northern state of Uttar Pradesh, the fabled Taj Mahal, built by the Mughal emperor Shah Jahan to honour his dead wife, Mumtaz, is probably India's most famous building. But multifaceted India has myriad riches beyond this beautiful tourist-trodden tomb – temples, palaces including the celebrated Hawa Mahal in Jaipur,

Above: In Darjeeling, way up north, the blue trains are famous.

Below: The Rambagh Palace Hotel, one of India's grandest hotels.

Right: An Asian bear, a less than happy resident of the Darjeeling zoo.

state of Goa, formerly a Portuguese colony, it was a capital offence. Then again, Portuguese Goa had a nasty Inquisition, too, which persecuted Hindus, Muslims and anyone practising any belief dubbed heretical. In more modern times, Goa became a popular hippy destination. That era has

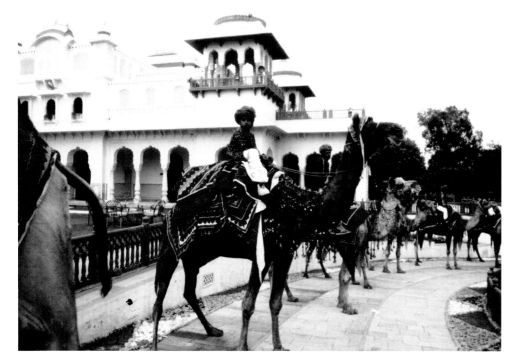

amazing cities, spectacular rivers, and a splendid variety of wildlife. I've seen a little. I wish I had seen more.

Then there is Muslim-majority Kashmir. Since the partition of British India in 1947, when it was divided between Pakistan and India, it has suffered frequent conflict. More than once, talks have smoothed things over – if only temporarily. Following the BJP success in the 2019 elections, Prime Minister Narendra

Right: The impressive Victoria Memorial in Kolkata, dedicated to the memory of Britain's Queen Victoria, functions as a museum.

Below right: In a Kolkata sidestreet, the tomb of the sainted charity worker Mother Teresa may be visited in the Mother house of the Missionaries of Charity.

Modi decided to incorporate the state (actually Jammu and Kashmir) into the rest of India. This involved revoking an article in India's constitution and denying the status of Kashmir's citizens. A shutdown of the internet additionally added to the crisis.

Modi's forcefulness in eliminating Kashmir's autonomy, accompanied by some 4,000 arrests, seemed to outsiders an act of folly, Hindu nationalism gone berserk, a provocation that Pakistan and other Muslim countries could hardly ignore. But with Indian troops standing guard, and with India's considerable economic power weighing heavily, as well as the support of President Trump, noted for his admiration of strong leaders, a tense peace appeared to prevail. Moreover, there wasn't even a Gandhi around to cool things down. Rahul Gandhi, the last in a dynasty that had kept the name and the Congress Party, of which he was president, in the forefront of Indian politics, was so heavily defeated by Modi and the BJP, that he promptly resigned.

Right: A ferry boat on the great Hooghly River where it flows through Kolkata, capital of West Bengal State.

Far right: Brightly painted trucks are the main traffic on the rural roads of West Bengal.

Indonesia

■ INDONESIA – More than 17,000 islands, possibly more than 18,000 – there is no definitive number – constitute the country that was once Dutch East Indies. Some names are familiar: Java, Sumatra, Borneo, Sulawesi, Lombok… Many are uninhabited and others are in the world's eye for reasons not related to people or their culture. For instance, Indonesia's extensive and fast growing palm oil plantations, currently around 12 million hectares, have become hugely controversial as they are seen as a serious threat to wildlife in general and orangutans in particular. (Komodo dragons, or at least those monster lizards protected in a three-island national park, are in fine fettle.)

In 2019 Joko Widodo, or "Jokowi", was re-elected president of one of the only remaining democracies in the region. A popular politician, Jokowi had risen from furniture entrepreneur to small-town mayor, to Jakarta governor and then to the presidency. Improving infrastructure was his main achievement. In the nature of the game, his success was questioned, election results contested.

Indonesian independence began in 1945 with the handsome and beguiling Soekarno. Locked up by Dutch colonists, he was freed – and sought national independence from – Japanese World War II invaders. Japan's defeat did not bring back the

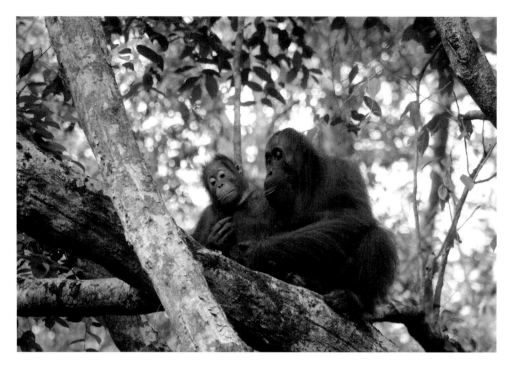

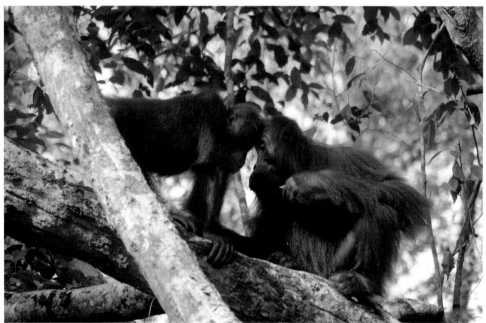

Top right, right and overleaf: Male, female, old or infant, the orangutans I saw in their natural rainforest setting were fascinating. Their intelligence, their relationships with each other, were a joy to see. It is acutely alarming to know they are a highly endangered species, imperilled by illegal logging, palm oil plantations, mining, fire, ill-considered cultivation or mere indifference. *Orangutans forced out of their forest starve to death or are killed as pests. All wildlife in our troubled planet is at risk, numbers declining. It can only be hoped that conservation efforts win the battle.*

Dutch and Soekarno became the country's first and somewhat erratic president, lasting until 1965, when he was ousted in a military coup by the tough-minded General Suharto. Suharto's aggression against East Timor is not forgotten. Invasion of this small nation in 1975 led to occupation which lasted until 1999 and gave rise to many thousands of deaths.

An entirely natural disaster, the 1883 eruption of the volcano Krakatoa, in the Sunda Strait between Java and Sumatra, killed more than 36,000 people and was one of the mightiest in history. The volcano, still live, is closely watched.

Then there is Bali, a lively tourist destination, popular for its beaches, forests, temples, rice paddies and appealing landscapes. Java is the administrative centre but can also boast of the Borobudur temple, a handsome Buddhist complex with fine statuary. Sulawesi is best known for coral reefs and dive sites. Sumatra, with a population close to 40 million people of diverse cultures, is a rich ecosystem with rugged terrain, rubber, mines, coffee and numerous oil palm plantations. Its wildlife includes the

Sumatran tiger and orangutans, both species critically endangered.

It was orangutans that took me to Indonesia. I saw them in Borneo, in a region Indonesians call Kalimantan, in a jungle setting, a protected park beside a river with craft that brought to mind Humphrey Bogart and his 'African Queen'. What a joy! These amazing animals are so lithe and loose-limbed yet it's their patent intelligence and expressiveness that to me is their most captivating faculty.

That I have seen little else of this sprawling island nation, that I have missed out on critical elections, matters to me less than it should. More than somewhat alarming, however, was the news in mid-2019 that, because Jakarta was overwhelmed, and even sinking, Indonesia would build a £27 billion new capital – in Kalimantan in Borneo. Initial world reaction was alarm over pollution and for forests. I could only think of the orangutans.

Above: Currency, when I was there, was confusing.

Left and below: Like some kind of 'African Queen' the locally crewed wooden craft called klotoks, beds and food provided, ferry visitors through the Tanjung Puting National Park in Borneo's Central Kalimantan region to areas where orangutan may be seen.

Iran

■ **IRAN** – A short walk in the ruins of Persepolis is enough to show that Iran's grandest moment was way back in the past. A short walk in Shiraz or any other city is enough to reveal that the harshness of Iran's current leadership is not reflected in the warm conviviality of the Iranian people. Both walks leave many questions on everything from the idiocies of world politics to the ideals in art and the power of religion. What to make of a government that ruthlessly sentences women to decades of imprisonment and lashing for non-violent behaviour that would be normal elsewhere?

Iran's long history includes such dramatic highlights as Gengis Khan and his Mongol forces invading what was then Persia in 1220 and, a few centuries later, the arrival of the Pahlavi dynasty. Some older generations may still recall Shah Mohammed Reza and his beautiful wives – the Egyptian princess Fawzia the first, a marriage that ended in divorce; the stunning Soraya, the second, who sadly failed to bear children; and Farah Diba, who had four children and outlived her husband.

A major issue in the 1950s, when oil became economically significant, arose over the Shah's nationalistic

Above: At Naqsh-e-Rostam tombs in sandstone cliffs once held Achaemenid rulers, most notably Darius the Great.

prime minister, Mohammad Mossadeq. Too nationalist for some, he was removed in a coup orchestrated by the British and Americans. Then in 1979, his modernising policies having infuriated the Shia clergy, the Shah himself, and his family, were ousted, to be replaced by the long-exiled figure of Ayatollah Khomeini. The Islamic Republic of Iran was declared and, the same year, militants took 52

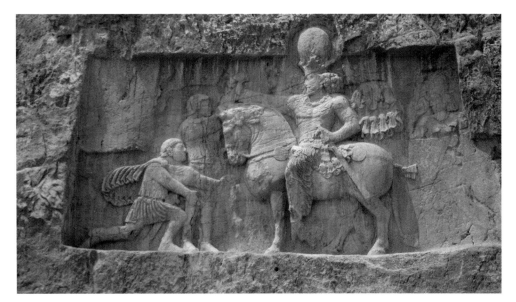

Top: *Below the tomb of Darius is carved a striking relief.*

Above and left: *At the vast archaeological site of Persepolis doorways, splendid carvings, early Persian empire art still stand among palace ruins.*

Americans hostage inside the US Embassy. (Famously, they were released only after 444 days.)

Years of fury and bitterness were to follow, starting with eight years of outright war between Iran and Iraq. In Iran moderates contested fiercely conservative leaders. In 1989 Ayatollah Khomeini issued a *fatwa*, an order to kill British author Salman Rushdie for blasphemy in his book, '*The Satanic Verses*'. Iran's uranium enrichment provoked crises and sanctions. Iran's restless youthful population battled an obdurate clergy. Women, especially, though few rejected the compulsory head scarf, showed a sophisticated public face. Somehow, Iranians found a balance that disregarded authoritarian arrests of political dissidents (more than 7,000 according to Amnesty International) and included a warm welcome for visitors.

Most travellers to Iran in the period around 2019 would have been aware of the huge disconnect between relaxed visits to impressive sights and the American president's wilful destruction of the working nuclear deal between Iran and the US and five other nations. Tourists could delight in the glorious cities of Esfahan and Yadz, enjoy agreeable stays in comfortable hotels and interesting meals in well-run restaurants even as US administration hawks attempted to strangle Iran's economy.

It may have been politic for them to declare Iran's Islamic Revolutionary Guard Corps, its leading military force, a terrorist organisation but it might also have led to the belief that President Trump, as he had before,

was only maliciously revoking the achievements of his predecessor, Barack Obama. Scarcely a revelation, it is a matter for despair when whole countries and the lives of millions of people are affected by one crude man's pique.

Unfortunately, the hostile positions taken by the US and Iran got worse. Many countries had accepted that the nuclear deal was flawed. Only the US, through President Trump, rejected it completely. Vindictive sanctions led to volatile exchanges of high-risk tanker snatching. Iran's support of Houthi rebels in Yemen against Saudi Arabian (and British government) siding with the weak government, didn't help. The high-powered American military, according to reports, was considering which of its weapons to employ – cyberwar, increased sanctions,

missiles? For all the billions spent on 'defensive' weaponry, few of the dead or injured were combatants.

That could not be said of Major-General Qassim Suleimani, Iran's most prominent military leader, at the head of its Islamic Revolutionary Guards Corps' Quds Force, and in charge of intelligence gathering among other roles. When he was killed at the beginning of January 2020 in a drone strike ordered by US President Donald Trump near the Baghdad International Airport in Iraq, it was widely assumed the assassination would reap a mighty vengeance. In fact, the response was relatively low key. Iran, moreover, already suffering from crippling sanctions, found itself in an invidious position when it had to admit that its forces had, 'in a disastrous mistake'

Above left and right: In Shiraz the Eram botanical gardens has a fine pool while the coloured glass windows in the winter prayer hall of the Nasir al-Molk mosque set it apart from the city's other mosques.

unintentionally shot down a civilian Ukrainian aircraft, killing all 176 people on board.

On a rather different note, my own good fortune in Iran was to be acquainted with a leading film director. His kindness and initiative brought me together with some of the Iranian seamen who had crewed the dhow which, decades earlier, had been at the centre of a story I did on the last days of dhows that appeared in *National Geographic.* The older sailors were gone. The younger men, barely more than boys when I had sailed with them across the Indian

Ocean, were now living peacefully in a small Gulf town.

What a joyful and amazing reunion, not even marred by my having forgotten the Swahili language, East Africa's *lingua franca,* through which we had largely communicated. Now I was warmly received, meeting children and grandchildren. And I saw too how, in a replica dhow firmly fixed ashore, lateen sail raised, the small community of sailors, with drumbeats, tambourines and shanties, still celebrated their seafaring history.

Left: *In Shiraz, schoolgirls with their chador-clad teacher visit the gardens and tomb of much-loved local poet Hafez.*

Below: *A Zoroastrian sky burial site (no longer used) in Yadz bears the compelling name 'the towers of silence'.*

Above: Camels on an uninhabited plain on Qeshm island; habitations and industry are elsewhere.

Opposite top: Boatbuilding an Indian-style craft on Qeshm island.

Opposite left and right: Aboard a replica dhow in Kong, on Iran's Gulf coast, old sailors gather for a celebration.

Right: Rihanna, a young and entirely modern Iranian woman, tries on a mask worn by local Muslim women.

Israel

■ ISRAEL – Discounting the Jewish calendar, the kings Saul, David, Solomon and other personalities and events in ancient history, it all began with the Balfour Declaration. This was a letter, a document, issued by the British government in 1917 in the name of the United Kingdom's Foreign Secretary Arthur Balfour, announcing support for a 'national home for the Jewish people' in Palestine, then an Ottoman region with a minority Jewish population. A proviso was that 'nothing shall be done which may prejudice the civil and religious rights of existing non-Jewish communities in Palestine'. Nothing specific there, yet this first public expression backing the Zionist cause would have lasting consequences.

In realignments after 1918, at the end of World War I, Palestine was granted to Britain, leading in time to a badly-handled 'mandate' in which Britain tried with excessive force to control immigration. World War II (1939–1945) brought the horror and depravity of the Nazi Holocaust and a flood of refugees, some having to face British barricades. From chaos, barbarism, desperation, survival and hope, Israel was born, and independence proclaimed in 1947.

The origins of Israel are an enthralling story. What followed – the independence war, the Six-Day War, the Yom Kippur War, the flight, or expulsion, of thousands of Arabs, the arrival of thousands of traumatised Jewish immigrants, the outrage of the Munich Olympics murders, more conflict – were all staggering events

that, as in any saga, involved heroes and villains, leaders noble and unsavoury, citizens who grew rich with success, and farmers and kibbutzniks who struggled in poverty.

What characters there were – the founding father David Ben Gurion, the hard-nosed Golda Meir, the wise Yitzhak Rabin (assassinated in 1995 by a Jewish fanatic), the pugnacious Shimon Peres, the tough, controversial Ariel Sharon, clever Menachem Begin – and these were just the prime ministers. There have been bold gen-

Above: A yeshiva class? Boys getting religious instruction look as naughty as young boys anywhere.

erals, brilliant writers, clever financiers and scientists. Israel grew and flourished, technically brilliant, always defensive, often belligerent, forever watchful, frequently cruel.

Words, places, became issues and symbols – Gaza was one, West Bank settlement another. Palestinians hungry for freedom of movement and the right of return have fought in

intifadas and at conferences. Who remembers Yasser Arafat and the Oslo Declaration, an attempt at peace? What keeps the Islamist group, Hamas, so ferociously aggressive? Barriers and walls have been raised. Permits, blockades and checkpoints control and restrict. Back in 1947 the UN proposed partition and separate Jewish and Arab states. In 2007 a conference agreed a two-state solution as the basis for future talks. Yet a two-state solution has faded as the decades rolled by, and some 400,000 Jewish settlers built homes and communities where Palestinians hoped to live.

In 2009 Benjamin Netanyahu, leader of the rightwing Likud party, formed his first government. By 2015 he was assembling his fourth government, a coalition. In 2016, the year Donald Trump was elected US president, the US, with its baffling Christian evangelical congregations always a supporter, agreed to provide Israel with a military aid package worth $38bn over the next ten years, the largest in US history.

In December 2017 Trump recognised Jerusalem as the capital of Israel, contrary to international convention, and the US soon afterwards moved its embassy from Tel Aviv to Jerusalem. In March 2018

Top left: *Jerusalem – a place with a long history and many beliefs.*

Centre left: *In Jerusalem Jewish men gather at the Western Wall.*

Left: *A museum, the shrine of the book, houses the Dead Sea scrolls.*

Trump recognised Israeli sovereignty over the Golan Heights, territory Israel seized from Syria in 1967 and later annexed. (Gratefully, Israel re-named the area Trump Heights.) No other country followed.

In late April 2019 despite corruption and other charges against him, Netanyahu won elections yet again. But only just. And elections later in the year, also indecisive, favoured opposition centrist Benny Ganz, a retired general. In fact, for a time it was a weird stale-mate. In the wings: former defense minister, the ultranationalist Avigdor Lieberman and more than 50,000 Haredim, ultra-Orthodox Jews (for whom military service is deferred, to the fury of other Israelis). Watching closely was Ayman Odeh, leader of the Joint List, an Arab-Palestinian party and the third-largest block in the Knesset, Israel's parliament, as well as the pow-erless Palestine Authority, nominally governing the West Bank. Netanyahu's boldest promise: annexation of the West Bank with the historic two-state solution totally bypassed. Whatever comes next, Israeli politics, democratic and always gripping, will continue to be world news.

Before Trump had capriciously altered US policy on Israel, leaving Palestinians in despair, their dream of statehood dead, I had passed by on a short photo visit for a travel publication. No war was raging, nor even any of the frequent exchanges of hostilities between Palestinians and Jews. The name of my helpful guide was Shalom, meaning peace, a good omen. I enjoyed the wine made and bottled in the Golan Heights, was impressed by the Western Wall and the piety of men and women praying

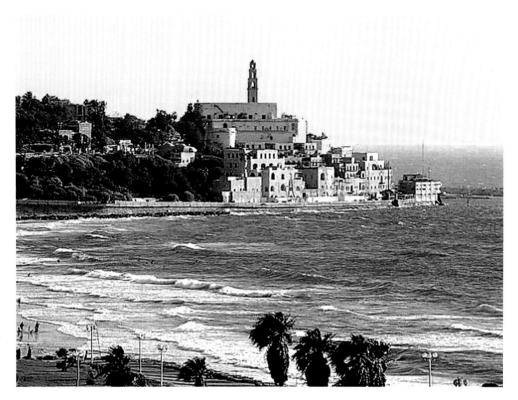

there – separately. I had put a toe in the diminishing Dead Sea, photo-graphed places viewed as historic or holy, and had tried not to offend either Palestinian or Jew. I saw normal daily life and a rich culture. Yet with no shortage of injustice, this was not a land at ease with itself.

Top: *In Tel Aviv, looking towards Jaffa.*

Above: *Herod's aqueduct in Caesarea.*

Top left: *The Dead Sea Works extracts potash, magnesium and other minerals. Environmental issues have been raised.*

Top right: *On the shores of the Dead Sea an all-white Venus is covered in the natural mud said to be good for the skin.*

Above: *The miracle of the loaves and fishes – a mosaic in a Byzantine church.*

Right: *Packed housing east of Jerusalem; then and now, a fraught society.*

Kuwait

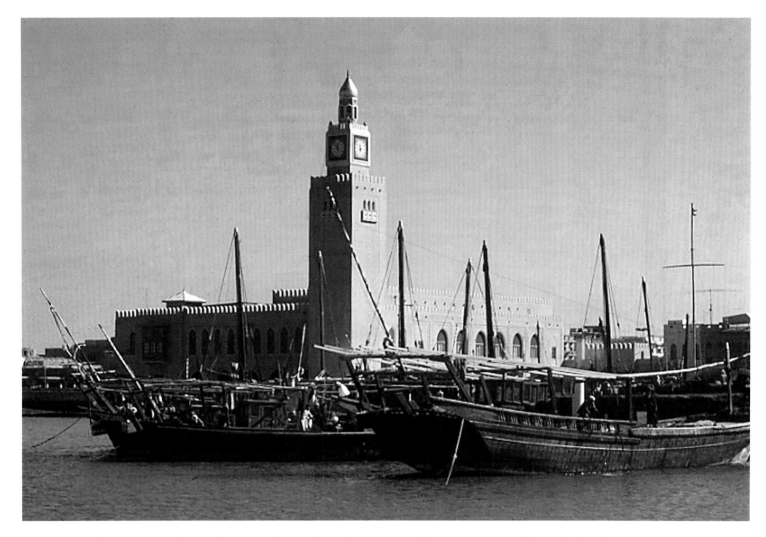

KUWAIT – On any map Kuwait is tiny, barely more than a speck at the top end of what was the Persian Gulf, and then occasionally the Arabian Gulf, and is now mostly just the Gulf. Kuwait faces the vastness of Iran on the Gulf's eastern shore, with Saudi Arabia as outsize neighbour to its south and Iraq another, regrettably rancorous, neighbour wedged between them. Crucially, Kuwait is at the point – hub, we might say today – where two historic and vital rivers, the Tigris and Euphrates, reach the sea.

Once, Kuwait was part of the Ottoman empire. Then it became a protectorate as the British empire took over, as it had the habit of doing at a time that now seems more distant than it is. Trade gave Kuwait life. Oil gave it riches.

From 1961 Kuwait has been independent, yet a critical moment in the world's eye came in 1990 when Iraqi troops, commanded by the domineering Saddam Hussein, invaded and took possession, claiming historical rights. They were

Above: Seif palace and port.

not there long. By February 1991 a US-led force, with UN backing, had pushed them out. (Saddam Hussein himself was toppled, by Americans, in 2003; weapons of mass destruction, never found, were the frequently stated reason for war.)

The al-Sabah dynasty, rulers of Kuwait since the 18th century,

Above: A boatyard in Kuwait.

Right: A carpenter works with a bow drill.

Below: Repairing a lenj, *or* lansh, *a word deriving from launch.*

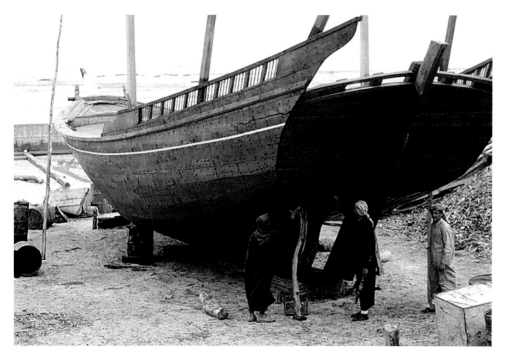

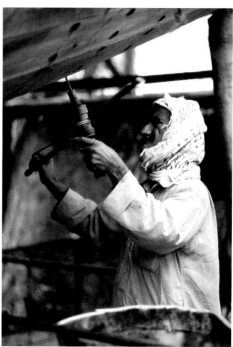

members of parliament, winning seats in national elections. By a constitutional court rule, women MPs were allowed to dispense with traditional head covers.

The low status of women, normally covered in a long black *burka* in public, I thought might explain why, during my own visit in 1973, I was addressed as 'Sir' in my hotel. I was in Kuwait at the start of a story for *National Geographic* on the disappearing Indian Ocean dhow

continue a judicious hold on power through a formal government and parliament. In 2005 a woman, the first, was appointed to a cabinet post. In local elections the following year women voted; none were elected – but in 2009 three women became

trade. I aimed to be aboard one of the last trading dhows to sail from the Middle East to the African coast – in practical terms from Dubai to Mombasa. But first I was looking into Kuwait's dhow history, and then planned to get myself, by dhow, to Dubai. It was a notion that shocked officials. 'Don't you realise,' one said to me, 'that most sailors have never seen even the finger of a woman. Why don't you fly?'

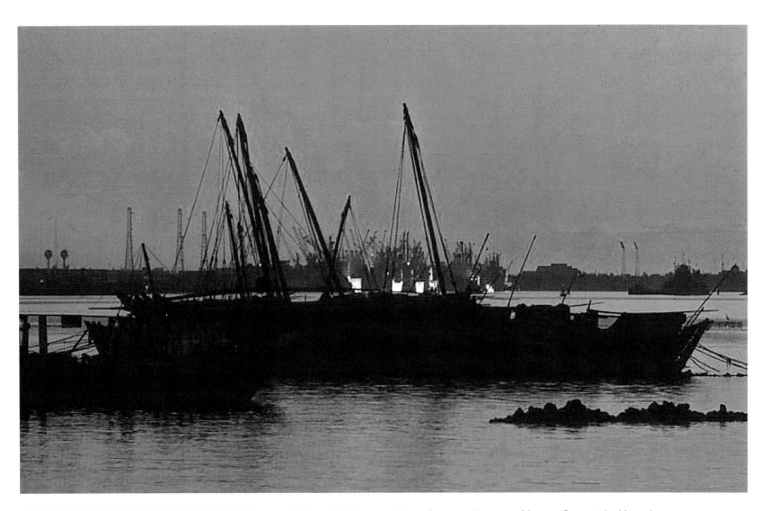

With a little help, I found a small dhow in Seif harbour – *lenj* or *lansh*, as they are called – and was accepted as passenger. Her name was *Aziz*. Teak hull shining with shark oil, jackstaff tipped by a model aeroplane, a rocket painted on the strake, she was a 94-ton double-ender, with a 70-foot deck length, a tall raked mast and a yard, three tree trunks lashed and bound together, that ran nearly the length of the ship. Her cargo: high-piled crated airconditioners and refrigerators. Captain and crew spoke Farsi and Arabic. For my passage I bought supplies from the *souk,* every item – from mat and blanket and coolbox for my film to nuts, raisins and an English-

Above: Sunset in Kuwait.

Left: Two of the crew aboard the dhow Aziz, an airplane on the ship's stemhead.

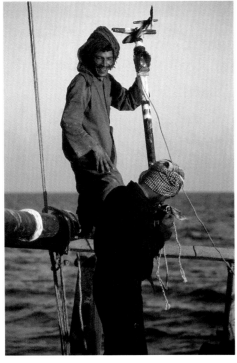

Arabic phrasebook – imported from different countries. Kuwait was already linked to a wider world.

In Kuwait City I had found an eclectic ambience compounded of Islam, oil and a great deal of money. Foreign-born residents far outnumbered Kuwaitis – and still do. More than 3 million in a population of 4.5 million are expatriates. Politics veered from reform to conservative – and would in later years be affected

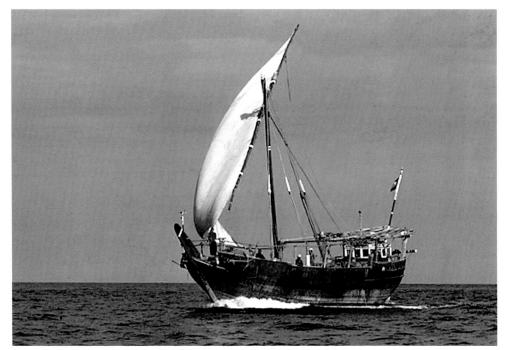

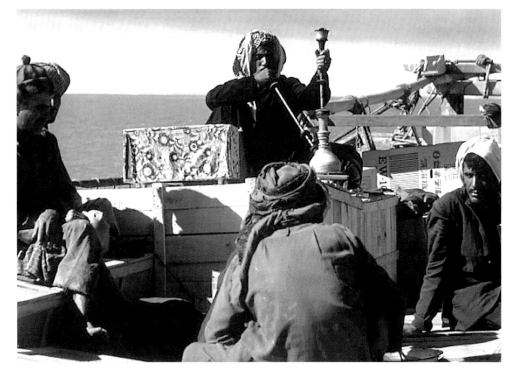

Top left: *The dhow Aziz under sail in the Gulf.*

Top right: *A painted rocket on a strake adorns the dhow Aziz.*

Above: *Dhow sailors relax with a hookah at sea.*

by the fanatical ambition of Islamists. In my short voyage to Dubai I saw endless flaming sunsets – flare after flare of burning gas, red-lit buoys and tanker wharves, and tankers far bigger than whales.

Much has happened in recent years, massive financial development and cultural expansion that I have only read about. I observed that the Kuwaiti dinar is (in September 2019) the most valued currency in the world. Photos show remarkable new buildings, including the Sheikh Jaber al-Ahmad Cultural Centre, often called Kuwait's Opera House. Kuwait's popular culture apparently is far more open and ahead of any other Gulf country. There are good roads, two million cars, dramatic and handsome water towers (Kuwait water depends on desalinisation) and, hooray, 363 species of birds as well as five protected areas, mainly lagoons and salt marshes. Then and now the Gulf is a sea beyond price.

Mongolia

■ **MONGOLIA** – Like somewhere in outer space, Mongolia has seemed in imagination to be out of this world, a place, a country, entirely different from any other. I was there long ago, before the internet, before easy communications. When I got home to irritated demands for a reply to some urgent query and said 'Sorry, I was in Mongolia,' I was promptly forgiven – and even envied. Who, then, ever went to Mongolia?

Now, Mongolia is a land engaged in social growth and economic development, in mining – copper, gold and coal, problematic in a newly environment-conscious world – and which welcomes business and tourists. Most of all to the vivid spectacles, national sporting events that include sturdy horses and skilful riders.

About half of Mongolia's population of just over 3 million lives in the capital. There are few well-known Mongolian personalities. A couple of athletes have made it internationally, and sumo wrestlers, and a politician or two. The most widely known name associated

Top left: A statue of Joseph Stalin was prominent in front of the National Library in Ulaan Bataar. It was replaced in 1991 by a cultural and literary figure.

Top right: A glimpse of the vast Gobi desert.

Right: The schoolgirl uniform in 1984 included white aprons; perhaps in some schools it still does.

Above: *Riding with a long stick, a Mongolian herdsman in the Gobi desert.*

Below: *Tourism has arrived: in a tourists' camp, the yurts are for foreign guests only.*

with Mongolia is Gengis Khan, a warrior (locally known as Chinggis Khaan) who in the 13th century forged one great empire from disparate tribes and made himself a legend. In the 17th century came Inner and Outer Mongolia, the effect, it seems, of Chinese expansionism.

Mongolians, few and heavily outnumbered by their giant neighbours, fought for their own identity. In 1924 a Mongolian People's Republic was proclaimed. Yet this was the era of an expanding Russia, too. So Lenin, Stalin and inevitably Marx and revolution are in the national story.

In 1939 Japan invaded, its army eventually defeated by Mongolian – and Soviet – forces. In the 1960s the UN approved Mongolia's membership and there began a new era of world recognition and diplomacy. In 1986 it took Gorbachev, Russia's open-minded leader, to bring detente with China and the removal of Russian troops from Mongolia. From here on it was, more or less, democracy and national politics.

Stalin's statue was still a prominent feature of Ulan Bator, or Ulaan Baatar, the capital, when I visited in the 1980s. Perhaps it is still there. Lenin's statue, I believe, has been removed. What was also there, and what is still there, is a wealth of dinosaur bones in the Gobi desert, and Mongolia's spectacular steppe, a landscape of great empty plains, dotted by nomadic herders and their yaks and family yurts, the distinctive tents of a distinctive people. The capital is growing and modernising. The land, bleak, cold and unchanging is gloriously eternal.

Oman

■ OMAN – There was a time, in the 19th and early 20th centuries, when Oman, situated south of the Gulf in the Arabian sea, ruled a maritime empire reaching across the Indian Ocean to the island of Zanzibar and the port of Mombasa on the East African coast. It introduced cloves to Zanzibar and benefited from an abhorrent but well established slave trade. When in 1963 I caught a glimpse of the sultan of Zanzibar in his Rolls Royce, it was the last flicker of a fading heritage. Revolution in the island saw him gone before year's end.

Sultans, however, have retained their titles and authority in Oman. In 1973, when I was aboard a dhow off the coast of Salalah in Dhofar, southern Oman, with Mombasa my destination, Sultan Said bin Taimur, feudal and isolationist, had recently been overthrown by his liberal son Sultan Qaboos. The *nakhoda*, captain, of my dhow had brought a cargo of goods to be delivered to Salalah. With a new modern harbour not yet complete, everything – from cans of fruit juice to wooden shutters, doors and bedposts to bags of cement – was ferried ashore in stitched surf boats. These were open longboats, with not a nail in them, the planks literally sewn together.

Unloading cargo by surf boat was picturesque but impractical. If the wind was high and the sea swollen, as it often was, the boats did not put to sea at all. Each boatload had to be pushed manually to the beach. Boatmen were never dry. Nor was much of the cargo. Moreover, Oman was at war – the forces of Sultan Qaboos, aided by

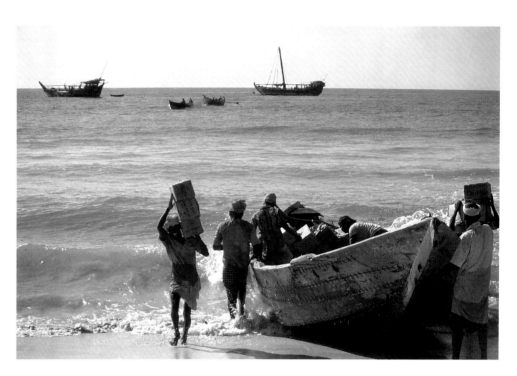

Above: Unloading cargo across Salalah's surf using stitched boats; this is the 1970s before a new harbour was built.

Below: Moored in the bay a beautiful ghanjah, a dhow with a carved stern.

British officers among others, were fighting leftist rebels supported by South Yemen. As battleground, western Oman had the aura of an old British movie, yet there was much bloody action and injury. The British government maintained a discreet silence on its role, and the war never made headlines, even when the rebels were ultimately vanquished.

Sultan Qaboos became the longest serving ruler in the Middle East but was by no means the richest. Oman had oil but not in the stupefying abundance of neighbouring states. While Muscat, the capital, grew fast with handsome buildings and luxury hotels, social tensions, unemployment and low pay have been challenging issues. Even a sanctuary

for reintroduced oryx was cut back to allow oil drilling (and lost Unesco World Heritage status in the process).

Determined to maintain stability in the face of declining oil revenues, Qaboos' rule was relatively tolerant and democratic for an absolute monarch – all citizens over 21 had voting rights, though in reality women's status remained low. He brought reforms in health care and education and pardons for troublemakers (but not all). It was not an easy balance. Yet when Qaboos died, aged 79, at the beginning of 2020 many tributes honoured him for his skilful and quiet diplomacy. Without a direct heir, he was succeeded by a cousin, Haitham bin Tariq al Said, who had long experience in government and administration. He promised to maintain continuity of Oman's carefully neutral foreign policy. At home he had a troubling economy to contemplate.

Above: *Off Salalah a local fishing boat called a bedeen.*

Below: *Boats on a beach In Muscat, Oman's capital.*

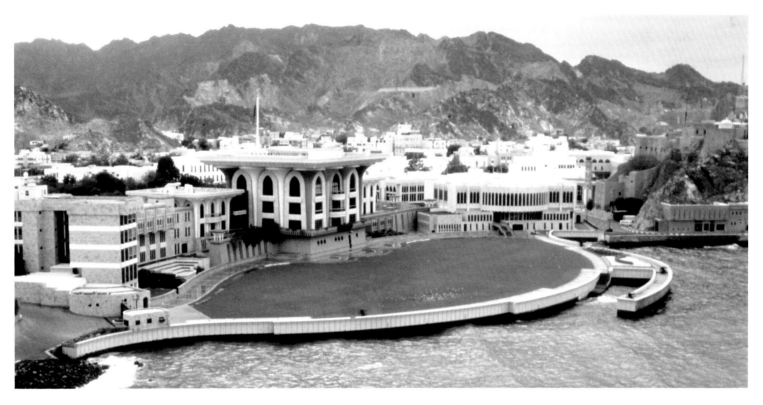

Above: *Sultan Qaboos ruled when I was there; his Muscat palace was handsome.*

Below: *The large and glamorous Bustan Palace Hotel in Muscat; tourism is now a serious industry in Oman.*

Above: *A smart if not large shopping mall in Muscat, old fort above.*

Russia

■ RUSSIA – Tatars, Mongols, the Golden Horde, Ivan the Terrible… Russia's early history seems like a bad thriller – but so perhaps do more recent events. It's only the actual suffering of large populations that turns farce to tragedy. A long story, closely watched, has affected many millions, from serf to oligarch, Cossacks to communists, priests to poisoners, bolsheviks to battling armies, powerful tsars, murderous dictators, a soviet empire, a stunning heritage.

The story of the Romanov family alone extends from the early 17th century to 1917. The bloody execution in Yekaterinburg in July 1918 of the entire family of the last tsar, Nicholas II, his wife Alexandra and their five children – all of them shot and bayoneted by bolsheviks – was only one horror in the revolution that brought in Lenin and his political heirs, yet it changed everything. The Stalin era is another lengthy saga covering tragic famine, mass slaughter and the heroics of World War II – leading to the frequent doomsday dramas of the Cold War. A look at science evokes a frightening arms race, Sputnik, the first satellite to orbit the earth (1957), and Yuri Gagarin, the first man in space (1961). Gagarin had barely landed when the

Top right: *Military marching men in Moscow's Red Square display high leg precision*

Right: *With Lenin's tomb attracting queues of visitors guards keep watch in Moscow's Red Square*

Cuban missile crisis (1962) took the world to the brink of nuclear war.

Nikita Kruschev, rotund and easy to caricature, was the Soviet leader at that terrifying moment. His backing down led to Alexei Kosygin becoming prime minister and eventually to the dour leadership through the 1970s of Leonid Brezhnev. From 1985 on Russia showed an entirely new face, that of the smiling reformer Mikhail Gorbachev who introduced the world to *perestroika*, opening up the economy, and to *glasnost,* opening up political reform. Their unintended effect: destabilisation and the collapse of the Soviet Union.

On 25 December 1991 Gorbachev resigned as president of the Soviet Union, suddenly transformed into fifteen separate states. Boris Yeltsin became president of an independent Russia. Western nations saw democracy defeating totalitarianism and capitalism succeeding where socialism failed. And if it wasn't quite that, it was an almighty social, political and economic earthquake.

The Yeltsin years saw much chaos. A falling rouble, hyperinflation and the rise of the oligarchs. A maverick Chechnya, breakaway Baltic states. Still, a referendum in 1993 approved a new constitution giving the president lavish powers. And Russia, in nationwide elections, clung to communism. What the world saw was a leader in difficulties, even apparently in holding his drink. Frail, ill, in 1999 Yeltsin appointed a strong man from the spy world, Vladimir Putin, formerly of the KGB, as prime minister.

We would get to see quite a lot of

Right: The iconic domes of St. Basil's cathedral in Moscow's Red Square.

Above: *A view along the Moskva river.*

Below: *Across from the Kremlin in Moscow's Red Square there's the famous GUM store for keen shoppers.*

Putin – as president he won election after election (and when it wasn't his turn he put a pal, Dmitri Medvedev, in the job). We'd see him knocking out oligarchs he didn't like, or bare-chested in a variety of manly sports on television. Frequently in attendance at world conferences, he seemed to be a survivor, a small, mild man who had somehow succeeded in crushing his enemies, militarising his society and creating a personality cult. He certainly caught attention, however, when he observed in an interview that liberalism had 'outlived its purpose' and was in effect obsolete.

Recent years have provided some none too friendly experiences. In 2006 a critic of the Kremlin, Alexander Litvinenko, died in London of polonium poisoning, apparently administered by Russian security officials. In the same year a courageous journalist, Anna Politskovskaya, who had reported on numerous controversial topics from the Chechen capital, Grozny, to the absence of human rights, was shot dead in the building in which she lived. In 2018 the poisoning of a retired Russian spy and his niece in the rural English city of Salisbury provoked a monumental diplomatic row. And in the US charges of meddling in the presidential elections that brought Trump to power produced another rumpus.

A news addict, I followed as much as I could the thrilling stories that came out of Russia – which includes a few of those written by eminent Russian authors. As photographer, I was nowhere near any of them. The glimpses I have had of this huge and endlessly surprising country have been peaceful, social, cultural and scenic.

Right: In Moscow a Space pavilion shows off Russian successes.

Centre right: Inside the fabled State Hermitage Museum in St. Petersburg.

Below right: Still Leningrad when I was there but proudly boasting in the Petrodvorets palace complex Peter the Great's splendid fountains.

Below: Beside the Neva river in St.Petersburg great sights including the museum of Anthropology and Ethnology of what was then the USSR.

Above: Lake Baikal in Siberia is the largest freshwater lake in the world, and the deepest; this is at its southern end.

Below: Wooden cabins from earlier times on the shores of Siberia's Lake Baikal; a view in 1984.

Singapore

SINGAPORE – Few countries have been founded in odder circumstances. The founder of Singapore, Sir Thomas Stamford Bingley Raffles (1781–1826) was an Englishman, born in a ship off the coast of Jamaica, whose first job, age 14, was as clerk in the office of the East India Company in London. On the way to a posting in Penang he learned Malay, the main language of the islands and states in the Malay region. Deeply involved in the British conquest and administration of Dutch-held Java, keenly interested in social and economic reform, in 1819 he hit upon Singapore island as useful trading post and a way to avoid Dutch taxes on British ships. He became Lieutenant-Governor of Java but, struck down with a brain tumour, died young. His name lives on, however, in a lighthouse, a renowned hotel, schools, streets and a striking skyscraper among many others in the modern state.

In 1826 Singapore, along with Malacca and Penang, became a colony under British rule, a status raised to Crown Colony in 1867. Migrants from China, India and across Asia began to settle in Singapore. Trade boomed. By 1922 Singapore was Britain's main naval base in eastern Asia. During World War II Singapore was bombed and invaded by Japan. With Japan's defeat in 1945 it returned to British rule. Singapore self-government arrived, along with the eminently skilled and farsighted Lee Kuan Yew as prime minister, in 1959.

For a couple of years, from 1963 to 1965 Singapore was a member of the

Above: On a stylish modern complex the Raffles name endures.

Right and opposite, top left: Mixed architecture is a feature of Singapore.

Federation of Malaysia. It was not a successful alliance, however, and in 1965 Singapore became independent, a republic, and member of the UN. The state's reputation as financial centre grew markedly under Lee Kuan Yew's guidance. After 31 years in power, he stood down in 1990. Still influential, he lived quietly until, aged 91, he died in 2015. For the funeral of this true founding father, hundreds of thousands lined the streets.

Party politics became a refrain, with the People's Action Party predominant and repeatedly reelected. It helped,

Above: Chinese art and influence is everywhere in Singapore.

Above right: Normal daily life goes on behind the sophistication and riches of stimulating Singapore.

Left: Beside a waterside restaurant a board display includes the popular Singapore Sling.

perhaps, that after 2004 Lee Hsien Loong, son of Lee Kuan Yew, was prime minister. In 2017 a woman, Halimah Yacob, a Muslim who had been a popular Speaker for four years in Singapore's parliament, was elected president. Or, as some joked, selected. She was the sole eligible candidate and not everyone was happy. But Singapore is tightly controlled and run.

Laws are conservative. Fake news – 'false statements' – are banned, as is gay sex. Drug dealers are executed.

For the British, the most exciting story in the recent past (1995) was the collapse of the distinguished Barings merchant bank, provoked by the calamitous dealings on the Singapore Stock Exchange of a derivatives broker, Nick Leeson. For tourists and residents Singapore offers a range of entertainments, museums, churches and mosques, a zoo, quality hotels, interesting food, local beer and, yes, cocktails that include the once fashionable Singapore Sling, created a good few years ago by the bartender in the Long Bar of – where else? – Raffles Hotel. When I tried to visit this iconic landmark, it was, alas, closed for renovation.

Turkey

■ **TURKEY** – The lush life in an Ottoman empire of fabled sultans and their harems of beautiful bejewelled women has been portrayed as comedy or fiction in movies. The gaudy sagas, however, are based on reality. A sultan's power included the quantity of wives and concubines he owned as well as the might of his armies and the wealth in his treasury. The imperial harem was an institution with rules and rankings, a female household guarded by eunuchs, or castrated slaves.

For visitors to Topkapi, the spectacular imperial palace and its outbuildings – today a museum – which are the tourist highlight in Istanbul, Turkey's most felicitous city, a sultan's life and the role of his harem is made clear. Dating to 1459 when construction began, Topkapi was built to the order of Mehmet II, who conquered Constantinople, ending the Byzantine empire, and founded the Ottoman empire. It was the principal residence of some thirty Ottoman sultans until 1856.

Various attempts to change and modernise the vast realm did not go well. What finally sank the Ottoman empire was its alliance with Germany and Austria in World War I. Postwar partition of the defeated empire led to a national movement that ended not only foreign occupation but the historic sultanates. In 1923 Turkey became a republic, with the vigorous statesman Mustafa Kamal Ataturk its president. Five years later his government, dropping the constitutional link with Islam, was

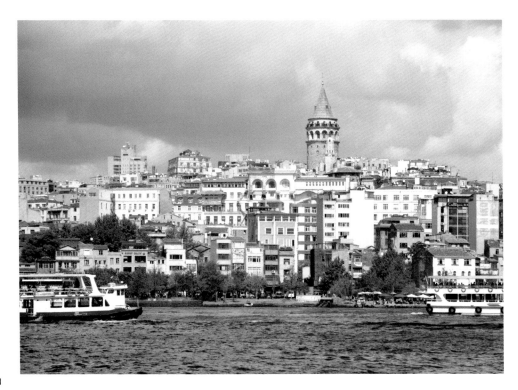

Above: In Istanbul one of the city's great views is towards Galata. Not so long ago, all this was Constantinople.

Below: The souk in Istanbul is large and always busy. Trading has gone on for centuries.

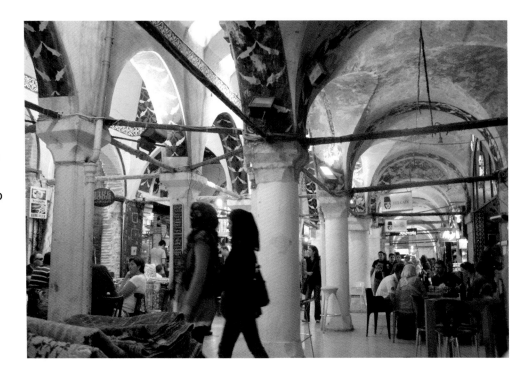

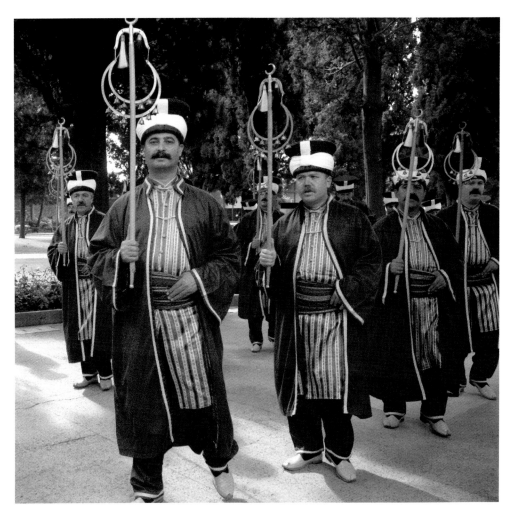

secular. In 1930 Constantinople became Istanbul.

With the death of Ataturk in 1930 Turkey began another transformation, with political parties (ended by military coup in 1960) and, in 1952, NATO membership. In 1965 Suleyman Demirel became prime minister, a post he would hold several times. Turkey was back in the headlines when, with a military government, it invaded northern Cyprus in 1974, ten years later recognising a Turkish republic there (the only country to do

Left: The historic janissaries, or sultan's household troops, are recalled in displays in Istanbul's tourist-filled Topkapi.

Below left: Seen from a gallery, Hagia Sofia is spectacular.. Now a monument, it was built in the 6th century as a cathedral

Below right: The ceiling of Istanbul's great Blue Mosque is famed for its exquisite designs.

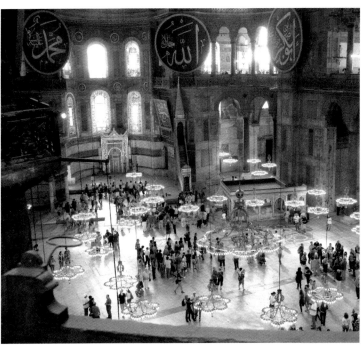

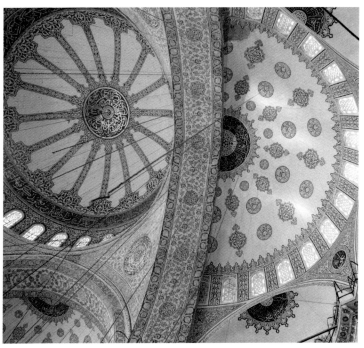

so). In following years Turkey took up arms against the Kurds, a people with no state of their own, yearning for independence. A rebel group calling itself the Kurdistan Workers Party (PKK) have fought a long, hard battle, suffering many thousands of deaths – and a life sentence for captured leader Abdullah Ocalan.

Through the years there have been other issues: the 1915 Armenian genocide – accepted by most historians, denied by Turkey; joining the EU, or not; anti-terror laws; blocking migrants heading for Europe; the teaching of the Koran; the teaching of the Kurdish language; the role of the military. With the arrival in power in 2002 of the Justice and Development Party (AK), politics had taken on a new look. The head of the party, Recep Tayyip Erdogan, won a seat in 2003 and Abdullah Gul, prime minister, obligingly resigned to make way for him – and in 2007 was rewarded with the presidency. And in slow but steady strides, via arguments over headscarfs and contesting views on secularism, Islam returned – though not, absolutely not, the Islamist

Turkey took up arms against the Kurds, a people with no state of their own

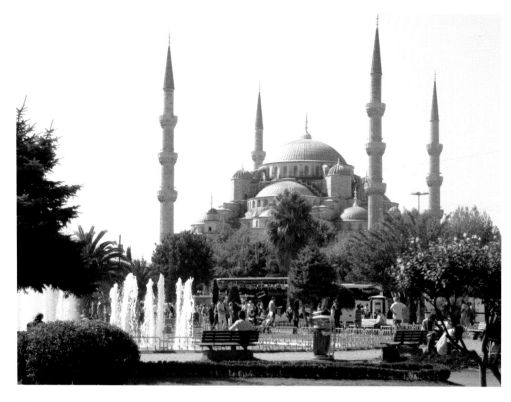

Above: The Blue Mosque and gardens.

Below: The trad Dolmabahce mosque on the Bosphorus shore has the stark Ritz Carlton hotel standing tall behind it.

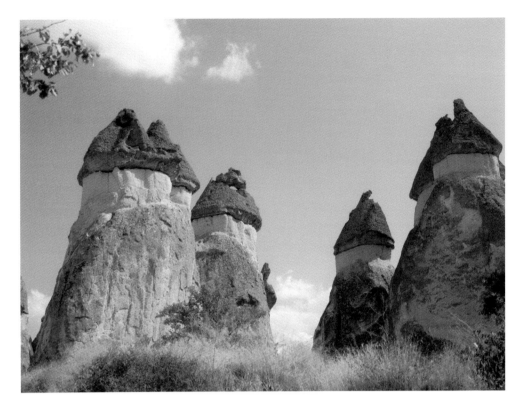

Above: The so-called fairy chimneys are an odd feature of the Cappadocia landscape where balloons float above

Below: Ballooning over Cappadocia's strange landscape of tufa and volcanic ash cones thrills vast numbers of tourists

State which Turkey radically opposed in Syria. In 2014 Erdogan, in a popular vote, was elected president.

A coup attempt in 2016, if that is what it was (Erdogan saw an exiled rival, Fethullah Gullen, as its source) brought savage repercussions. In an almighty purge, judges, soldiers, journalists, police, were sacked in the thousands. And though Erdogan won a new term in snap elections in 2018, his increasing autocracy hardened opposition. A new mayor elected for Istanbul in June 2019 was not the candidate he had chosen. (He cancelled the result.) A highly respected academic and university professor was imprisoned for signing a petition supporting a peaceful resolution to a historic conflict with a Kurdish group. Of the petition's signatories nearly 700 were put on trial and more than 450 removed from their posts. The big question was how long would Turks put up with it all.

Touring Istanbul and its splendid sights, taking boat rides up the Bosphorus, flying over Cappadocia in a balloon, continued to delight visitors, including me.

Turkey is a big country with people, their food and culture, stretching across Anatolia and the Black Sea region. Odd things happen in travel: I got lost up the Bosphorus but, fortunately, was found. In an Istanbul hotel, though I was travelling solo, I was awarded the honeymoon suite with its huge round bed. Trivial experiences, in no way historic. I covered nothing of any impact. So I can do no more than regret that the contradictions in Turkish politics and inconsistencies in foreign relations have been causing alarm.

United Arab Emirates

UNITED ARAB EMIRATES (UAE) – Although Alexander the Great was in the neighbourhood some 300 years BC, the United Arab Emirates is not well-known for its history. Its culture has sprung from maritime trading, its traditional architecture, such as the wind towers, from need, almost every other building from Western architects, some of them brilliantly imaginative. The discovery of oil in the 1950s was the catalyst for change and the fastest, most exuberant, most extravagant development the world has ever seen.

In the era of British empire, the small countries of the Persian Gulf and their ruling emirs were known as the Trucial States, their link with Britain mainly to control piracy. Initially, the group included Bahrain and Qatar; later, these dropped out. In 1952 the emirates formed a Trucial Council, which developed in 1971 into the independent United Arab

Above: Dubai's great creek, its dominant natural feature.

Below: Wind towers brought cool air before there was airconditioning.

Emirates. The UAE federation consisted of Abu Dhabi, the biggest, Ajman, the smallest, Dubai (which would become much the best known), Fujairah, Sharjah and Umm al-Qaywayn. A year later, tiny Ras al-Khaimah was in.

Not perhaps a familiar name yet it was one of Ras al-Khaimah's sons, Ibn Majid, a seaman and navigator, who piloted Vasco da Gama from Malindi, in East Africa, to Calicut in 1498, perhaps the most significant of all voyages in that era of discovery.

Overall ruler of the UAE for many years was Sheikh Zayed bin Sultan al Nahyan of Abu Dhabi, re-elected UAE president in 1986, his fourth term.

Benign and respected, he was particularly admired for avoiding the Middle East arms race and creating welfare systems in which every social, medical and educational service was

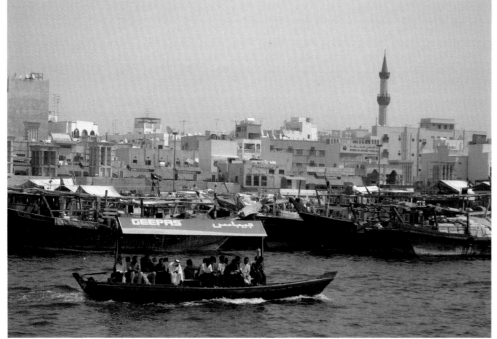

Above: Dubai's port in 1973 before oil money changed everything.

Left: An abra, a ferryboat, crossing the creek.

free. Modernisation and expansion saw the UAE change from desert communities to slick, streamlined states, with free education and health care – yet religious and family customs were preserved and closely guarded.

At a wedding I was invited to in Abu Dhabi, all the Bedu traditions were on display. Men friends of the two families, in tailored jackets over long gowns, danced in lines in a dignified manner to the rhythm of

Above: *With the Burj al Arab architecture became more fanciful.*

Below: *Oil money brought monster hotels like the Atlantis with its luxurious suites and more than 1500 rooms.*

drums and tambourines. Small girls in long flowing dresses danced too. Catering the next morning involved the slaughter of five camels for the feast, the little girls watching quite undisconcerted. There were many pots of coffee, numerous platters of fresh fruit.

Wedding guests arrived every hour, the women covered from head to toe in black. Once inside the family's walls, they threw off the black robes to reveal exquisite gowns in embroidered silks and satins and an abundance of jewelry. Yet for all the finery, every woman wore a stiff black mask that covered half her face. As for the bride, she was not seen at all but remained in her room, attended by women relatives.

In 2006 the UAE held elections and also introduced laws to reduce dependence on foreign labour.

Through all the rapid construction, virtually all workers came from other countries, creating a huge imbalance in local and foreign populations. Workers' living conditions came in for heavy criticism. A Dubai state-owned company at one stage appeared to have financial problems – resolved, it seemed, by a handout from Abu Dhabi of $10 billion.

In Dubai to do a story on the last of the ocean trading dhows, I was enthralled by the wooden ships that crowded the great *khor*, or creek. There was no glamour or sophistication when I was first there in 1973. Growth came later, including bizarre projects – luxury villas on islands scooped from the sea, ski slopes and ice rinks, a sail-shaped hotel, the world's tallest building, streets of skyscrapers.

Gulf amity broke in bitter 21st century politics that saw the UAE,

along with Saudi Arabia and Bahrein, remove their ambassadors from Qatar, a country not a member of the UAE, a hostility that intensified amid charges of terrorism. Qatar, which was quietly sending funds to sustain the Israel-blockaded Gaza, also developed its own urbane and cultivated society with the addition of art galleries and an elegant museum.

When the UAE joined with Saudi Arabia in 2016 to attack Yemen, a grievously suffering people were hit by even more tragedy. What a strange, uneven picture: here was a corner of the world with wealth beyond the dreams of Croesus, where wonderful art and culture and architecture bloomed and foreign visitors were encouraged to shop, spend and have fun – yet was also tarnished by cruel and mean-spirited acts of war.

Nor, apparently, was all well in the normally invisible domestic life of the emirs. At least two young princesses had attempted to escape, and been caught and brought back, and a wife (who was also the daughter of a Jordanian king) had made it to London and was seeking a forced marriage protection order. In the unhappy legal wrangling few facts were made public. I'm aware this is an irrelevant item of gossip. It was what couldn't be seen that, as it is so often, was interesting.

Top left: *With the Burj al Dubai, buildings grew tall, then taller.*

Top right: *Shopping, as in the Emirates mall, became a big thing.*

Left: *New wonders included snowy slopes in a Dubai shoppng mall, all built in the desert.*

Uzbekistan

■ UZBEKISTAN – Most people around the world who think of Uzbekistan will think first of the glorious blue domes adorning historic mosques in Bukhara, or renowned Samarkand, or perhaps the ancient name of Tamerlane, the place where he was born, Shakhris-abz, linked to an almost mythical empire. The past was most memorably celebrated in 2007, when the Silk Road city of Samarkand marked its, yes, 2,750th birthday.

Most Uzbeks, however, are more likely to think of the late president Islam Karimov, who came to power as head of the Communist party in 1990. He controlled or banned all opposition to cling on until 2016, when he finally

Above: With four domed towers, this is a 17th-century madrassa in Bukhara.

Below: In Bukhara sights include centuries-old tombs.

Above: A 14th century astronomer Ulugh Beg (or Ulughbek), gave his name to Samarkand's observatory and, later, a university.

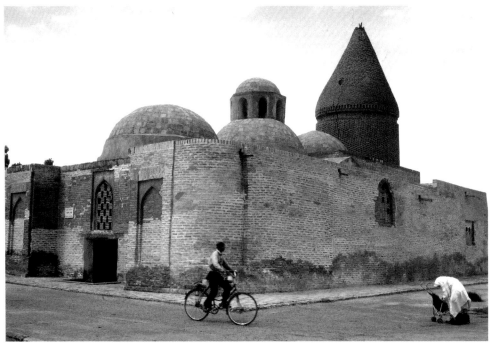

Left: What young couple doesn't want a fine setting for wedding photos? This is in Bukhara.

Above: Registan Square in Samarkand.

Below: Shakhrisabz was once a great city in central Asia.

lost to the only adversary he couldn't overcome, death itself.

Stalin's dominance in the 1930s had one sad effect on the country. An earthquake in 1966 had another, destroying much of Tashkent, the capital. Various 'incidents' brokered by militant 'Islamists' also caused unrest, most violently in the eastern town of Andijan – as did demonstrations against not entirely credible trials. A more modern catalyst for trouble was a Russian-owned mobile phone operator which lost its licence. Investigations involved a Karimov daughter and her business activities. Thoroughly 'woke', she took to Twitter to respond.

With the passing of President Karimov, Prime Minister Shavkat

Mirziyoyev won presidential elections and promptly established improved relations with neighbouring states. He also sought measures to open up the economy and eased some of Karimov's repressive laws. And as soon as he could, he fired – or pushed aside – Karimov's most powerful ministers.

It was a long time ago that, as a tourist, I visited Uzbekistan. If civil rights have not been too wonderful in recent decades, the finest buildings retain their grandeur and a warm welcome is promised in 'delightful Uzbekistan, the land of the sun' as one promotion puts it. And under a new president, optimism reigns.

Vietnam

VIETNAM – Even now, years after it was all over, the 'American War', as some Vietnamese call it, is not forgotten. Even counting only the photojournalists who died, the tally is grievous, as many as 135, including the war's Indochina origins. Robert Capa is perhaps the best known, Gilles Caron and Larry Burrows other eminent names. A woman, Dickey Chapelle, died, and all too many more. Photographers who survived the war and made powerful images of its horrors include Horst Faas, Don McCullin, Nick Ut, Eddie Adams, Philip Jones Griffiths and Cathy Leroy.

The impact that photographs of the Vietnam War had on so many of us will explain why I precede my bald historical note with this modest 'in memoriam'. My own photos were made in peace, not war, but even during my travels I could not ignore those great photographers.

As to earlier history, Vietnam for centuries was dominated by neighbouring China (and even now territorial arguments persist). In the mid-19th century France ruled over a colonial region called French Indochina which tolerated Vietnamese dynastic reigning families. From 1926 to 1945 Nguyen Phuc Vinh Thuy was the last 'Emperor of Annam'. After the end of World War II, on 2 September 1945, the Vietnamese revolutionary

Top right: Remembering the 'American war', at Cu Chi tourists may enter the tunnels built by the Vietcong.

Right: A boat centre on the Mekong River.

Above: Vietnamese women wait to guide tourists to a Mekong River site.

Left: At Hoi An a boat returns home as night falls.

leader Ho Chí Minh declared Vietnam independent from France and established a communist state. The outraged French fought back but were defeated in 1954 in the pivotal battle of Dien Bien Phu.

What followed were the complexities, and deadly hostilities, between communist North and West-leaning South Vietnam, and the active involvement from 1965 of the US and, for the communists, of China and the

Soviet Union. Battle after battle raged between communist and non-communist forces. The number of dead mounted to millions – from massive bombing and village massacres, from campaign injuries and cruelly damaging 'Agent Orange' herbicides. With American combat troops gone in 1973, the climax came with the fall of Saigon in 1975. Then, finally, reunification as the Socialist

Right: How most people get around Saigon – by bike.

Below: No-one forgets: outside the War Remnants Museum in Saigon, changed in1975 to Ho Chi Minh City. (Both names are used.)

Far below: Ho Chi Minh's vast mausoleum in Hanoi.

Below right: A café on a Hanoi street.

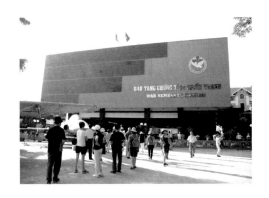

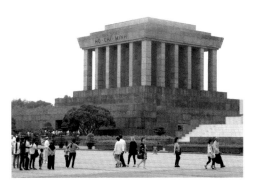

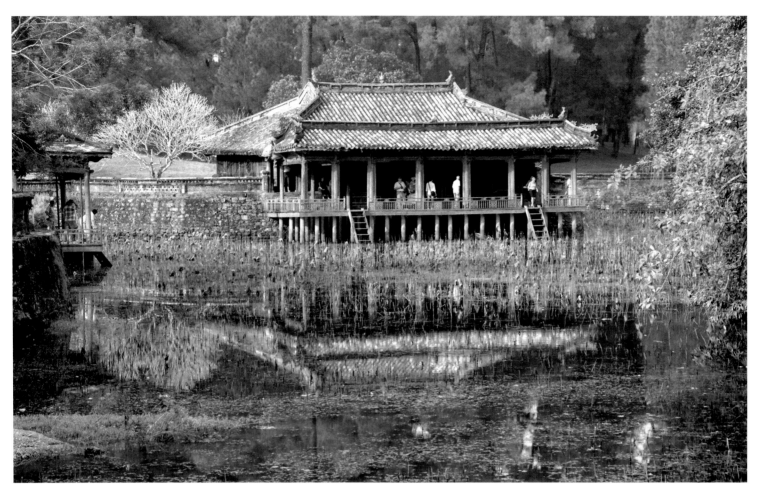

Republic of Vietnam, Ho Chi Minh's objective from the very beginning.

A simplistic account, I realise, and even amateur historians will know the harrowing fuller story. The postwar Vietnam that I visited was bustling with activity – and traffic, open and welcoming to visitors from all nations, eager to recount its history, both ancient and recent. Remarkable scenery with surprisingly few scars

Above: *Hué Where an emperor, Tu Duc, has his royal tomb, gardens in Hué include a pavilion beside a peaceful lake.*

Left: *Hanoi University students celebrating in Hanoi.*

could be viewed from north to south. Saigon became Ho Chi Minh City. Tunnels used by the wartime Viet Cong, the imperial palaces in Hué, quality hotels and restaurants and street food – a huge variety of places, projects and sights became tourist territory.

A new constitution in 1992 improved economic freedoms. Relations with the US were re-established in 1995 and diplomatic and economic links developed. The communist ideals that brought, and won, the war, were in place but polished to a near-capitalist shine. Reports of corruption and fraud became frequent. The adjustment, or compromise, has not been easy. The internet arrived but is bound by many restrictions. Bloggers confront limitations. Liberal attitudes are on show, glamour on sale at handsome hotels, glorious views on offer at Ha Long Bay and cultural souvenirs everywhere. Yet the government and administration is resolutely communist. Democracy and a free press are not on the cards.

Top right and right: *Ha Long Bay, on Vietnam's northern coast in the Gulf of Tonkin, is famous for the limestone islets jutting from its waters.*

Yemen

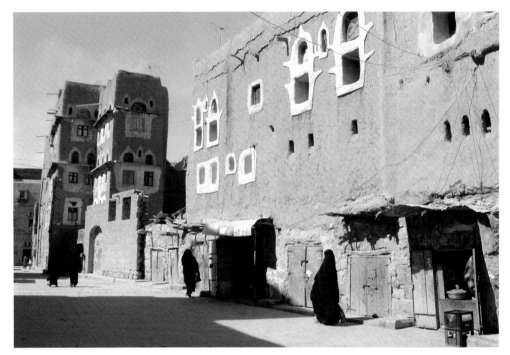

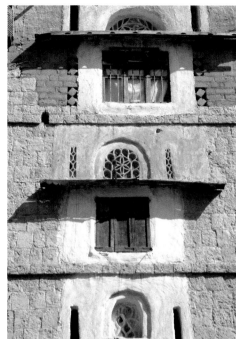

■ **YEMEN** – Yemen's relatively recent history includes British rule over Aden in the south (1840–1967) and an uneasy national unity afterwards with Ali Abdallah Saleh as president of the Republic, his rule lasting from 1990 to 2012. Between 2000 and 2008 Al Qaeda was active in several attacks. Where camel caravans once crossed deserts with myrrh and frank-incense, kidnappings were common. Afterwards came the disturbances of an aggressive Islamic State.

Through these periods of crisis and violence Sana'a, the ancient capital inhabited for over two thousand years, once the land of the legendary Queen of Sheba and *felix* Arabia, fortunate Arabia, to the Romans, carried on more or less regardless. Souks remained scented with spices, women covered from head to toe in black *abayas* glided silently through narrow alleys.

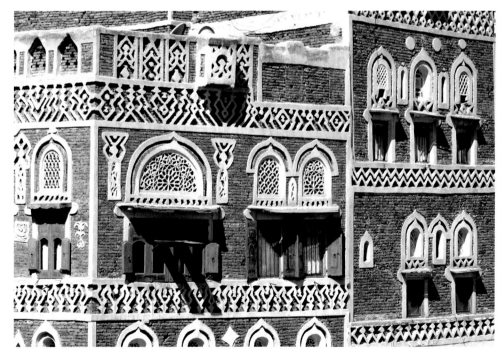

Top left, top right and above: Artful, mud-based buildings in Amran, art in windows, and highly stylised architecture in Sana'a, the capital.

The extraordinary tower house architecture of old Sana'a, dating to before the 11th century, is of a style unique to Yemen. Listing the city as a World Heritage Site in 1986, Unesco marvelled at the 'density of rammed earth and burnt brick towers rising several stories above stone-built ground floors, strikingly decorated with

Right: In a Sana'a market, two salesmen with the sexy garments women might wear under their concealing abayas. The men are wearing curved knives, called jambiya, a standard part of male attire.

Far right: Boys running through an alley; every city in Yemen has similar tall mud-brick buildings.

Below: Shibam, a Yemen city, has been nicknamed 'Manhattan of the desert'.

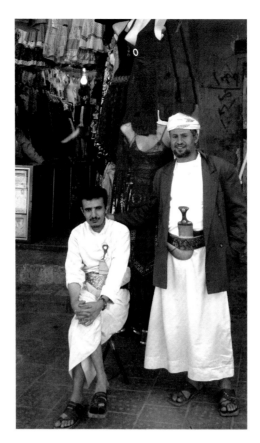

geometric patterns...' Then, in 2015, the city, 'an outstanding example of a homogeneous architectural ensemble' was newly listed as in danger not only from the intrusion of modern elements but from airstrikes.

Architecture is not the only victim of airstrikes. In a vicious war, normal civilised behaviour gave way to brutal inhumanity, causing the death of more than 85,000 children from famine, widespread cholera, heavy casualties from those airstrikes, and bringing millions to the brink of famine and disaster.

The two factions in the war launched in 2014 had a long history of enmity. One side, the ruling but exiled Abdrabbuh Mansur Hadi government, successor to Saleh, supported by a Sunni coalition, was led by Saudi Arabia and the United Arab Emirates (with the UK and US onside). Opposing them were a longstanding but chaotic Shia force of Houthi rebels which controlled the main ports and much of the territory and was supported by Iran – though only morally, Iran insisted, when Houthis apparently extended their attacks into southern Saudi Arabia and to tankers at sea.

Stuck in the middle have been the ordinary citizens, mainly small traders

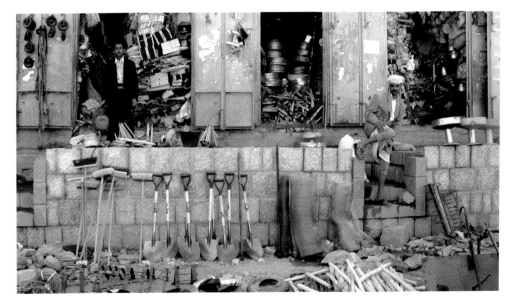

Top left: *Wadi Do'an, a village in the Hadhramaut region.*

Centre left: *Knives are out as men dance in celebration of a friend's wedding in the town of Thula.*

Left: *A hardware store, or farm tools shop, in the small town of Amran.*

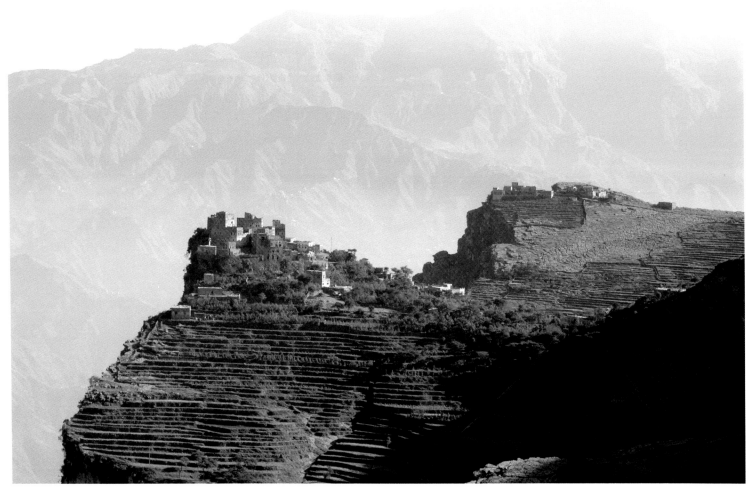

Above: Stunning view of perched villages in the Haraz mountains.

Right: Remarkable architecture in a remote setting, a town of mud-based buildings, several storeys high, rising from a rocky hill.

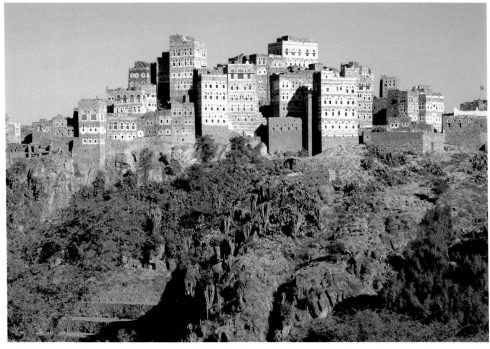

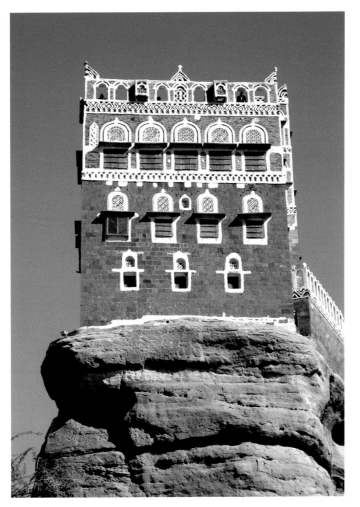

and farmers, their prime solace *qat*, the heavily consumed green leaf stimulant, *Catha edulis*. The United Nations was the leading, if not sole, arbitrator and tenaciously came up with one plan after another for a ceasefire. With considerable justification, suffering Yemenis held out hopes that the US could bring a stop to the horrifying scale of attacks. Or even the European Union, whose members had reportedly sold $875 billion worth of arms to the Saudis and the UAE (far exceeding humanitarian aid). But it seemed that nobody cared enough to do anything.

In 2008, the day before I left for a visit to Yemen, my guide phoned to check that I wanted to come. A tourist had been shot during a trip to the Wadi Hadhramaut, a historic valley in the northeast. Yes, I wanted to come. A grinning policeman with a primitive rifle was imposed as protection for part of my visit. All went well. Yet Yemen, so old and so beautiful, with its fabled capital, embattled towns, the spectacular Haraz mountains and terraced valleys, hardworking ports and suffering people, has hardly seen a day of peace.

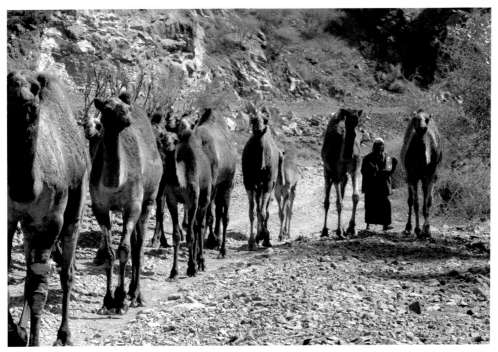

Top left: *An incongruous 'rock palace', Dar al-Hajar, in Wadi Dhar, near Sana'a.*

Left: *A camel caravan on a rural road in Wadi Sara.*

Europe

EUROPE – On maps of the world in daily use Europe is dead centre, clearly by implication the most important continent of the seven that constitute our planet. This is northern hemisphere gamesmanship. The earth is round. On a globe, though, turn it just a little one way or another and Europe's importance is minimised, even though its size and irregular shape stay the same. Maps, and there are many of them, might include natural features – mountains and volcanoes, forests and broad plains. Pride, competitiveness, nationalism, greed, history, all are greater factors in world mapping than actual geography.

How to consider relativity on both globes and maps? China for sure, its image enhanced by its great size, ancient empires and expanding tentacles, might be justified in seeing itself as the pivot round which the world revolves. Russia again, so big, such a grand blend of Asian and European, is a candidate for most impressive. And then there's an outlier, Canada, reaching from its metropolitan west to distant icy wastes… but nobody, not even Canadians, would make such a claim.

Above: *A sunny image includes the colour and stars of the EU flag.*

Some countries and leaders would aggressively dispute Europe's prominence, especially if it is measured by military might. The massively well-armed United States would not accept that any other nation is ahead of it on almost any scale. Power has led at times to an ugly arrogance, provoking a variety of responses – fear, regret, contempt and mockery among them.

Then there is the matter of political change. In Europe, the European Union achieved genuine lustre for its achievements in many fields, most notably and admirably in bringing peace and amity where there had been appalling destruction and war. But while some European states were still hoping to be allowed access to the Union, within the EU enlargement fatigue became evident – some states uneasy at the prospect of bringing in new members at a time when there were concerns over how to deal with diminishing democracy.

Within so large an organisation inevitably issues arose, provoking a good deal of disquiet. Early on it was, almost comically, wine lakes and cheese mountains. With the Common Agricultural Policy a monster at the heart of the EU dishing out close to 40 per cent of its huge budget, many countries and real rural needs were funded towards good health. Yet the very rich, as well as more modest landowners, have also been able to profit, sometimes hugely, from the generous subsidies.

The system awarded British landed gentry, including Queen Elizabeth, many hundreds of thousands of pounds on their farms. Serious abuse of the EU

subsidies, however, came most of all from leaders of some Eastern European countries, their profiteering dubbed with names like 'agricultural Mafia' and 'crony capitalism'. It was seen as something of an irony that the prime minister of Hungary, Viktor Orbán, handed out EU subsidies even as he loudly criticised the EU for interference in Hungary's internal affairs.

Migrants have also been an all-consuming concern. I found it shocking that the EU actually paid Turkey to stop refugees from entering Greece, and funded the Libyan coast guard to return migrant boats to north Africa. More shocking was the populist view that migrants, refugees, were an invasion force, a blight. (Over in the US, Trump policies were as callous and awful.) And did political parties matter any more? The new division was between populist and anti-populist. Older standards, with democratic rights at their heart, were passé. Strategy was easing out ideals, consumers had replaced citizens, allies had become rivals.

The United Kingdom's desire to leave the EU, a tiresome Brexit, also brought unintended consequences. Division in traditional parties, weariness, bitter resentment and anger, affected the entire nation. Separately, a hardening of views, especially among the more rightwing leaders, saw increasing fragmentation and a creeping darkness in the otherwise thriving landscape.

Yet in the end, based on a distinctive singularity, diverse culture, extraordinary variety (more than forty nations), the general harmony in what has been a remarkably successful union, cunning politics, wealth, explorer's instincts (or colonial outreach), Europe is convincingly the world's foremost continent.

Albania

ALBANIA – In the mists of time this small Balkan country, perhaps the least known in Europe, was Illyria, its shores on the Adriatic and Ionian seas. Across centuries of conquest it fell into the Ottoman empire. Twentieth-century disruptions brought monarchy under the self-declared King Zog (1928–1939), brief but influential Italian rule, a long, grim Communist dictatorship under Enver Hoxha (1944–1985) and finally and at last, democratic government.

Enver Hoxha, though accepting economic aid, first from the Soviet Union, then China, and in his last years the US, kept Albania isolated throughout the forty years of his egocentric rule. Even now, the landscape still includes remnants of the many thousands of domed bunkers he installed to forestall invasions, which never happened. In 1967 he pronounced Albania an atheist state.

Above: Painting the capital's buildings in bright colours was the idea of Edi Rama, artist and politician, elected city mayor in 2000, and prime minister after 2013. The simple motive: to cheer things up.

Today the population is largely Muslim in a relaxed and undogmatic style – for one thing, no burkas.

Following the death of Hoxha in 1985, Albania began to open up – to democracy and political parties, to a free press. Leka, the son of King Zog, who had died in France in 1961, attempted a return in 1997, but Albanians weren't interested in a revived monarchy and he was rejected, though allowed after 2002 to live with his family in Albania. (I tried, for a long time, to pursue a story with a tantalising rumour of King Zog's gold. Sadly, it got nowhere.)

Party politics grew heated and competitive. Democrats and socialists

vied for power in a context of the collapsed Yugoslavia and the creation of new states (Serbia, Croatia, Kosovo) and many refugees. In 2013 Edi Rama, leader of the Socialist Party, became prime minister. He had been mayor of Tirana, the capital, and was best known for his policy of encouraging city buildings to be painted in a variety of vivid colours. As Albania welcomed tourism (promotion had begun around 2011), the nation also made progress on the path to EU membership. The signs seemed good, most EU members seeing no difficulty, while others expressed doubt, worrying about crime and corruption. In Tirana, political haggling, involving President Ilir Meta, was rife.

Few Albanian politicians are well-known internationally. Renowned the world over, however, was the diminutive Albanian-born Catholic missionary-nun proudly acclaimed in

Above and below left: In the southern Albanian town of Gjirokaster there is a wild medley of architecture.

Below right: Tirana's central square honours Albania's national hero, Gjergi Kastrioti, a 15th century military commander known as Skanderbeg.

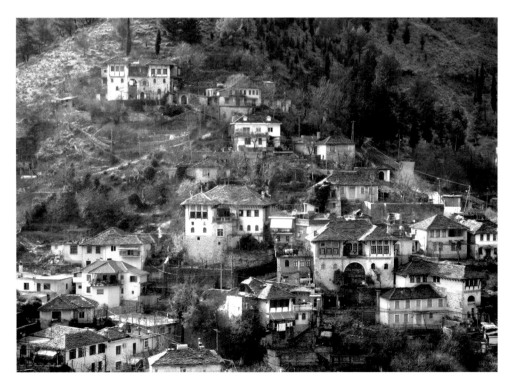

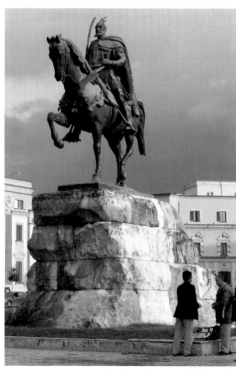

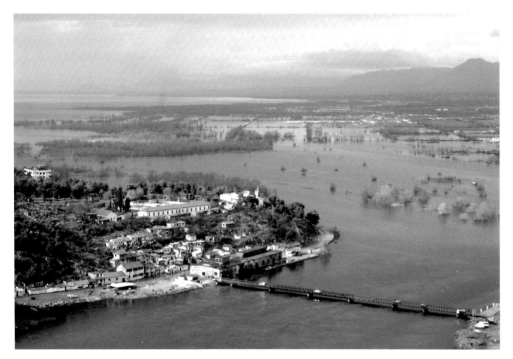

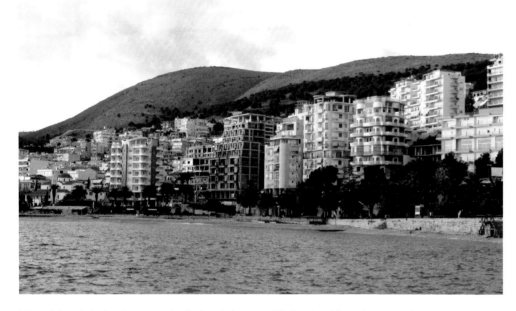

Albania's 'Mother Tereza International Airport'. In the south, Butrint, where Julius Caesar founded a colony, has been recognised by Unesco for its past civilisations. A visitor known at least to British enthusiasts was Edward Lear, the 19th century 'nonsense' poet and artist; the pleasant city of Berat has a museum in his name.

Albania's currency is based on the lek. Its language has dialects outsiders can rarely speak or understand. Its national symbol is a double-headed eagle, its national hero a 15th century nobleman and military commander called Skanderbeg, who fought and won battles against the Ottoman empire and, in effect, founded a unified Albania. There are museums to him and a statue in Tirana's main square. He is still widely honoured. Enver Hoxha, communist dictator with an iron grip, is also commemorated. A statue or two can still be found. His home in Gjirokaster, formerly a house-museum, has been transformed into an ethnographic museum.

For myself, as I travelled, I delighted in Albania's culture, its towns and castles and spectacular icons, especially those in the citadel above Berat by Onufri, a 16th century Albanian artist. Not everything was ideal: smokers were tolerated in restaurants, roadsides were frequently

Top: Albania's landscapes include alpine mountains, historic towns and, at Shkodra, this alluring lake.

Right: Looking down to the town of Gjirokaster, the hilltop castle is graced by a rainbow.

Above: Saranda, a resort town on the Ionian sea facing the Greek island of Corfu.

deep in litter, drug-dealing gangs were supposedly everywhere (though I never saw them). I felt I had crossed centuries and civilisations. And Albania, I saw, was moving ahead – fast. In a family I met, on the eleventh birthday of their young son, I learned of the gift the boy was hoping for: his very own laptop.

Above: *In Butrint are ruins of both Greek and Roman cities.*

Right: *An ethnographic museum today, this was the home in Gjirokaster of Albania's longtime communist dictator, Enver Hoxha.*

Andorra

■ **ANDORRA** – A tiny, vibrant country deep in the Pyrenees mountains, total area 180 sq miles, or 468 sq kms, with France to the north and Spain to the south, Andorra is a tax haven with a parliament, a constitution, and two heads of state. One is the president of France, whoever it may be, the other the bishop of Urgell, from La Seu d'Urgell, a modest town in Catalonian Spain. This odd arrangement makes Andorra a co-principality, a status that, along with first-rate skiing in winter, hiking in summer and year-round duty free retail trading, has proved highly successful.

The traditional economy included sheep grazing Andorra's green pastures and mountain slopes and, with scant agricultural land available, a little wheat, tobacco, potatoes and grapes. Several fine churches even suggest rural plenitude and grace. A harder reality is that tourism (mainly shoppers in the millions stocking up on cheap booze and electronic devices), construction and banking predominate.

Although not a member of the EU, Andorra uses the euro as currency. Andorra's roots, and independence, go back to Charlemagne and his son Louis I, who granted local inhabitants a charter, a feudal arrangement leading in the 13th century to two princes, one Spanish, one French, assuming authority. Barring a brief altercation with Napoleon in 1789, the system worked well, ignoring World Wars in which Andorra stayed neutral, all the way to 1993. In that year a new constitution reduced princely powers and created separate legislative,

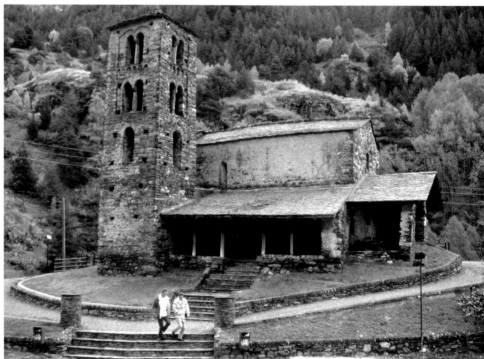

Top: Snow-capped mountains and splendid scenery attract hikers.

Above: The romanesque church Sant Joan de Caselles, tucked into mountains, dates to the 11th century.

executive and judicial branches of government. Actual governing is handled through contesting political parties, Democrats (on top, as I write) and Social Democrats.

There's no airport but roads are good and travel easy. I've driven from France through Andorra and its bustling capital, Andorra La Vella, and on south into Spain, the part within the principality taking not much more than a few minutes. But I have also loitered, stayed to explore, walked a trail or two, taken a few photos – and, from choice, kept away from gleaming spas and crowded supermarkets. But the temptations are many and I do have a tax-free souvenir – a large wooden hand-carved farm fork, great for gardening.

Above: *Tax-free shopping is a big draw for tourists but they often have to get through busy traffic first.*

Left: *Known for ski resorts and tax-free shopping, the tiny Pyrenees principality also has its quiet places.*

Below: *A shopper's delight, Andorra also offers seasonal beauty.*

Below, centre: *Winter with its snows is prime time for skiers.*

Below right: *Mixed building styles are to be found in Andorra's small spaces.*

Austria

■ AUSTRIA – Music, art and architecture, the Danube river and the Tyrol mountains, castles and palaces, Mozart, Schubert and Strauss, Sigmund Freud, Gustav Klimt… Austria and its handsome capital, Vienna, are known for so many superlatives that Europe, the whole world, would be greatly diminished without them.

The Habsburg dynasty, lasting from 1276 to 1918, was the foundation of Austria's imperial splendour. It would be the (Austrian-born) Adolf Hitler and his Nazi regime that, in the 1930s, imperilled its beauty and cultural riches. Many Austrians were proud to be associated with the rise of the odious Hitler – who incorporated Austria into Germany in 1938 – and many approved of his loathsome racism. Some 65,000 Viennese Jews died in Nazi concentration camps; more than 100,000 were exiled. Post-war realities – Vienna's 'liberation' by Soviet troops and the occupation of Austria by Soviet, British, US and French forces – were profoundly shocking.

Well into the 21st century, rightwing politics infected Austria's government and parties even as democracy prevailed. The career of Jörg Haider, a notorious far-right politician, was halted only when, in 2008, he was killed in a car crash. Sentimentalists mourning older times had their moment when Otto von Habsburg, son of the last emperor, was ceremoniously buried in the imperial crypt in 2011. Greens took heart when a Green Party member, Alexander van der Bellen, won presidential elections in 2016 – in

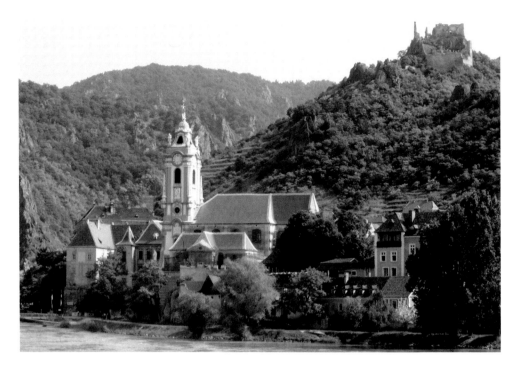

Above: Durnstein, beside the Danube in Austria's Wachau valley, is also notable for the hilltop ruins where Richard the Lionheart was imprisoned in 1193.

Below: The impressive Schönbrunn Palace in Vienna, said to have 1441 rooms, was the summer home of Austria's Habsburg rulers.

fact, won twice, as his first victory was annulled.

Migration became an issue when, as in other European countries, huge numbers of migrants, refugees and asylum seekers sought refuge or, in long lines, were just passing through. Rightwing politics, influenced by the Nazi past and the Russian present, were at work too, as coalitions formed and collapsed. Prominent on the political scene was the baby-faced Sebastian Kurz, leader of the conser-vative Austrian People's Party. Also notable were Pamela Rendi-Wagner, a Social Democrat, and the far-right Norbert Hofer of the Freedom Party.

At a markedly different level, there are the contented tourists, some 20 mil-lion of them every year, enjoying Austria's many scenic and cultural attractions: the strains of Strauss in a Vienna park, Schönbrunn palace and its formal gardens, schnitzel and Sacher-torte – my own delicious slice I ate with greedy appreciation in Vienna's Hotel Sacher. I have also cruised along the Danube in undeserved comfort aboard an elegant German-operated riverboat – where I learned there are still national, or anyway linguistic, sensitivities. A smartly uniformed officer had offered to show me round the ship. Unsure whether this kind gesture was aimed at me or at all the passengers, I asked: 'Will there be a crowd?' The officer, to my surprise, reacted furiously and stormed off. What he had heard, it appeared, was not 'crowd' but 'kraut'.

Top left: In Vienna St Stephen's cathe-dral, dating back to 1368, stands in romanesque glory opposite a trendy glass-fronted hotel in the central square

Top right: A tempting display of Viennese chocolate goodies in a shop window.

Left: Horse-drawn carriages called fiacres wait for tourists in Vienna's city centre.

Right: The bizarre facade of Vienna's Hundertwasserhaus, a much admired apartment house, reflects the taste of its architect Friedensreich Hundertwasser.

Croatia

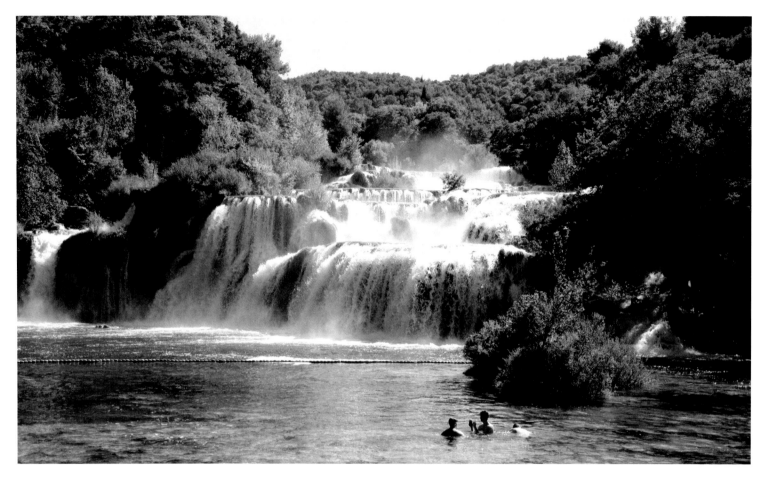

■ CROATIA – Yugoslavia, bundling together six different countries, came into being in 1918. A kingdom to start with, after World War II it became a socialist state. A portly politician, Josip Broz Tito, ran Yugoslavia as his own communist fiefdom until his death in 1980. With a slow messy crash, in 1992 Yugoslavia began to fall apart. Croatia was the second country (after Slovenia) to break away, but critical in all the appalling events that followed were the ambitions of Serbia under its president Slobodan Milosevic.

Bosnian Serbs fought Bosnian Croats. Years of war, tumult, disaster and the 'ethnic cleansing' of Muslims

passed before a cautious peace, involving a NATO-led peacekeeping force, was established. Croatia, for its part, in 1995 successfully won back territory Serbs had captured, causing the exodus of thousands of Serbs. But finally Yugoslavia was removed from the map and the prime villain in the narrative, Slobodan Milosevic, was gone too. Charged and put on trial for genocide, he was found dead in his cell in 2006.

Croatia's 'father', conservative nationalist Franjo Tudjman, elected president in 1992, was re-elected in 1997 but died in 1999. A liberal was voted in though in subsequent years

Above: Krka Waterfalls in Krka National Park attract many visitors, including swimmers.

the presidency – and politics – shifted and changed. In the first years of the 21st century, war crimes charges were sporadically levelled, accusations of mafia-type corruption repeatedly made – yet in 2006 Croatia made it to membership of the EU as its 28th member. And in 2015 a woman, moderate conservative Kolinda Grabar-Kiratovic, was elected president. A year later a centre-right coalition government was in office.

Through all the shadows and grim echoes of the past, tourism was

building up and blooming in Croatia. Zagreb, the capital, is a fine big city, and Dubrovnik a Unesco heritage site. There are other appealing towns – Split, with an unusual palace, is one – as well as numerous quiet islands, captivating parks and the gorgeous Adriatic coast to explore. During a visit, I had the good fortune to spend a few days aboard a gulet, a pretty, traditional wooden sailing boat, my only lament that the three-man crew (one of them the cook) hardly ever raised sail, plainly preferring the ease and convenience of placid motoring.

Above: A long history and coastal situation, including the distinction of being an island, has placed Trogir firmly on the tourist path.

Right: Sibenik, as well as a pleasing location on the Adriatic shore, has attractions that include a 15th century cathedral.

Top: *Croatia's Adriatic coast is studded with memorable towns; Primosten is one of them.*

Above: *Split, Croatia's second city, after Dubrovnik, has a rich cultural heritage (and a lively nightlife). In its Archaeological museum a sarcophagus displays 4th century sculpture on a 'Good Shepherd' theme.*

Right: *A* gulet, *local style sailing boat, is among craft moored in a tranquil bay along Croatia's alluring coast. Travelling by* gulet *meant that I saw little inland.*

Czech Republic

CZECH REPUBLIC – The news in 1993 that Czechoslovakia had broken in two wasn't quite as alarming as it sounds. Carving up continents and countries was not new. There was more celebration than shock when, out of one country came two, Slovakia and the Czech Republic. Moreover, one trusted man – Vaclev Havel, writer, dissident, articulate politician – was there, as first president, to ensure the republic's birth went well.

Of course it wasn't easy. The events of the 'Prague Spring' were still fresh. Alexander Dubcek, the reformist who had tried to bring change to Czechoslovakia was a name everyone remembered. And what of the invasion by the Warsaw Pact's half million troops and the occupation of the country? What of the tens of thousands of Jews murdered in death camps? A small number of brass-plated paving stones, 'stumbling stones', record their passing. Yet, almost incredibly, the country was now free and independent.

Opinions stretched from far-left to extreme-right. When communists later provided the votes for a pact between two opposing parties, it appeared to be a look back to an uncomfortable past. Although the communists remained outside that coalition, the agreement marked a return to influence for the first time since the 1989 'Velvet Revolution' that ended the communists' 41-year rule of Czechoslovakia. But no government lasted. President Havel himself, in poor health for years, moved away from politics in 2003 and died, much mourned, in 2011.

Above: *How many carol singers know that 'good king Wenceslas' was a real person, killed moreover by a jealous brother? For Czechs he is their patron saint and, on horseback, a conspicuous statue in Prague's main square.*

Party politics was endlessly contentious. Democracy prevailed yet, across the republic, so did hardship and a sense of injustice. As one journalist asked: 'If the economy is thriving, why are we so poor?' The transition from state socialism to capitalism in the new republic, with the overthrow of communism in 1989, had won high praise, with the bonus that the Czech Republic relatively soon afterwards gained membership of NATO and the European Union. But economic difficulties and disagreement between politicians were also present and brought acrimony and crises. Most conspicuous politician: Prime Minister Andrej Babiš, a wealthy businessman. Too wealthy for some. In June 2019 thousands took to the streets to protest his alleged corruption.

There was also good news. With peace and stability, tourism boomed. A visit to Czechia, as the republic began calling itself, could take in a range of splendid castles and small towns across Bohemia and in Moravia and Silesia. Quality food, wine and the always popular beer, was everywhere yet, for almost everyone, Prague, the capital, was paramount.

Among the world's most visited cities, Prague has drawn such large crowds to its prime sights – the Charles Bridge spanning the Vltava

Top left: *The pedestrian-only Charles bridge in Prague is lined by saints and, as significant sight, often teeming with tourists.*

Centre left: *In Prague the river Vltava, bisecting the city, is a vital presence*

Left: *Poppy fields in wine country near Valtice.*

river, Prague castle and the Old Town square – that at peak times it is quite difficult to move. Some visitors, thrilled to be in Prague, don't know what country they are in. Understandable, perhaps, because the Czech Republic has hosted many peoples under different names. Czechoslovakia itself arose from the Austro-Hungarian empire after World War I – Tomas Masaryk, president from 1918 to 1935, is still honoured today.

Fortunately, Prague, with its long history, has a multitude of intriguing streets, fine buildings in a remarkable range of architecture, splendid museums, churches and, yes, cemeteries – the old Jewish cemetery visually and emotionally notable. An obscure detail from the past, I was enchanted to learn from a cousin, Nicole Segre, then writing a book on the Trans-Siberian Railway, was a frieze on a building opposite my Art Deco hotel, depicting members of the Czech Legion who had – for reasons that escaped me – been included with Allied forces in Siberia. But with such

Above: Bratislava castle, veiled in mist, sits solidly beside the Danube.

a rich heritage, many stunning buildings, international institutions, educational establishments, arts, sciences and hi-tech centres, even – predictably, as movie set – Prague undeniably deserves its popularity.

Below left: The old Jewish cemetery in Prague is regarded as an important historic monument. Some 100,000 bodies are said to be buried beneath the headstones.

Below: This is wine country, South Moravia, and the Colonnade on a high hill, built in the 18th century by a prince to honour relatives killed in war, looks over vineyards and the town of Valtice.

Denmark

▧ **DENMARK** – Once, it was the Vikings, their seamanship, explorations, boldness and cruelty that defined Denmark's character and earliest history. Now, in a changed world, it is *hygge* that supposedly dominates culture, a word that roughly means cosy, comfortable, contentedness. During the centuries in between Denmark, small, Nordic, and largely peaceful, battled only with neighbour Sweden to decide which would be the region's top dog and, in the 20th century, with the German confederation over duchies on the border. Denmark stayed neutral

Right: *Christianshavn, an area of islands in Copenhagen, is seen as hip today.*

Below: *Copenhagen's most famous sight, the Little Mermaid on her rock.*

Above: Fredensborg Palace, the summer home of Danish royals.

in the two World Wars yet was invaded by Hitler's troops in 1940, leading to a grim five-year occupation.

Livestock farming and dairy production had been under way before WW II. After the war, those of us in Europe discovered Danish butter and bacon. Denmark's tradition of furniture making came in useful when, in the 1960s, Sweden's IKEA founder, on to a brilliant idea, sought suppliers. Another fact that might surprise the British, with their enthusiasm for royalty and deep respect for their own Queen Elizabeth II: Denmark's monarchy is the world's oldest, dating

back more than a thousand years. One early king was Harald Bluetooth whose name has leaped ten centuries into the digital era.

Denmark's queen, Margarethe II, is head of the constitutional government, and though her family owns quite a few castles, her role is almost entirely ceremonial.

Party politics means only that, as no party is dominant, coalitions are inevitable and the politics is in forming them. Corruption? Hardly any. Transparency International has put Denmark at or near the top of its index for years. No society is perfect, however, and

even benign Denmark experienced a banking and money laundering scandal which drew headlines in late 2018.

Keen travellers (and scientists) will know that Denmark's temperate climate does not extend to two autonomous territories that fly the Danish flag – Greenland the best known and where the fast diminishing Arctic ice is closely watched, the Faroe islands the other. I had thought the Faroe islands to be bleak and desolate until I saw a restaurant had

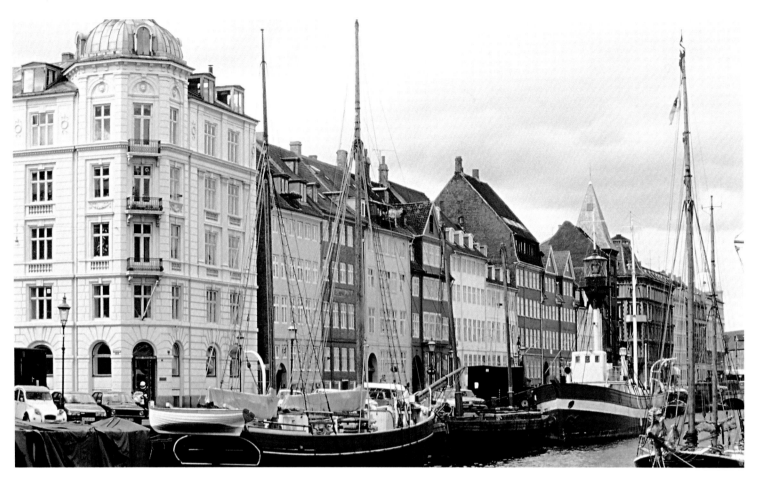

Above: *Nyhavn, a corner of Copenhagen delights the eye.*

Below: *Copenhagen's Gammel Strand offers visual and other treats.*

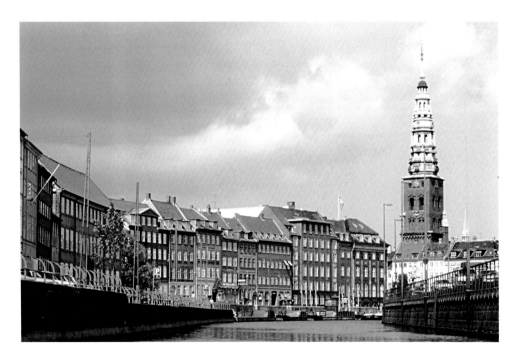

been awarded a Michelin star. For island lovers, Denmark also rules over more than 400 other islands. It's possible (I don't know) that the Danish reputation for a high standard of living may not extend to the remoter islands.

Copenhagen, the capital and foremost city, has itself grown over two islands. Visitors delight in its grace and charm, in the two most famous sights – the Tivoli Gardens and a bronze mermaid on a rock – and the almost fairy tale royal castles whose guards, not actually toy soldiers, wear storybook uniforms. Then again, this is the country of storyteller Hans Christian Andersen, author of *The Little Mermaid* and *The Ugly Duckling*. Curiously, Andersen himself was not a happy man but then real life stories do not, sadly, always end happily ever after.

France

FRANCE – France is indisputably the greatest, grandest, most beautiful, most cultured nation in Europe. (I live here, so I would say that, wouldn't I?) Its landscapes, monuments, museums and churches thrill millions of visitors. Its renowned writers – among them Victor Hugo, Honoré de Balzac, Marcel Proust, Albert Camus, Alexandre Dumas – have enriched world literature. Its film makers – Jean Renoir, Jean-Luc Godard, François Truffaut and more – have given us glorious movies whose riveting actors themselves are icons. Its artists – Monet, Manet, Cezanne, Renoir, Van Gogh (by passionate association), Gauguin, Degas, to name but a few, are household names.

Listing a few of France's most creative figures is merely a reminder, a taste, of what France is about. For the huge number of visitors who head to Paris or tour the regions, culture is topped by food – *cuisine* a more glamorous word – and wine. For the French, what life is mostly about is a good deal more basic and, recalling the 1789 Revolution and its far-reaching effects, always has been. In this bewitchingly misleading land, the contrasts between the glorious and inglorious are to be found almost everywhere.

To the north of Paris, on the city's outskirts, is the suburb, or *commune*, of Saint-Denis. It is by no means the prettiest part of Paris. It is known mainly for a large football stadium, and for an appalling act of terrorism in 2015 that caused 130 deaths. Its residents are mainly low income and

Right: France's iconic Eiffel tower in closeup.

Below: The Vieux Port in Marseille.

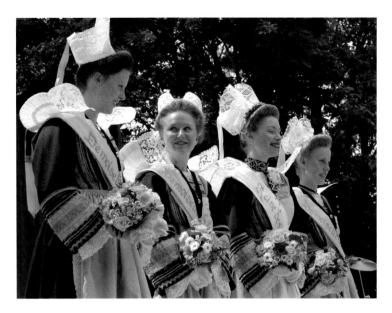

Above: *Young Breton women wearing traditional coiffes are on stage during a fête.*

Above: *Le Corbusier's famous chapel in Ronchamp.*

Above: *A* gabare, *riverboat, adds to the appeal of La Roque-Gageac in the Dordogne.*

Right: *St Michael's church high on a rock in Puy-en-Velay.*

from all races. Yet here too is an exquisite Gothic basilica, a cathedral with a magnificent rose window, which holds the mortal remains of nearly all France's kings and queens. Among the tombs of forty-three kings is that

of Clovis, who lived from about 466 to 511 AD. He is significant because, from northern France, or Gaul, he conquered and united a cluster of minor 'Frankish' kingdoms and so is recognised as France's first king.

Saint-Denis in a way is a down-to-earth cosmos of France's variety, and the basilica a capsule of its beauty and long history. Possibly it stands too as an unstated emblem of a France changed by Islamic terrorism. Vicious

attacks across France undeniably changed the public mood.

Politically, France has been a monarchy, the dominant ruler of empire, a republic – shifting easily from centre-left to centre-right but encompassing opinions both far-right and extreme-left. Its leaders have included a 'sun king', Louis XIV; an emperor, Napoleon Bonaparte; a general, Charles de Gaulle; and a mixed bag of citizen-republicans. It has experienced war – and not, for the most part, Joan of Arc excluded, been good at it. In peace, France has thrived, turning its gorgeous assets from north to south – Brittany and Normandy to Nice and the French Riviera – into havens of lovely landscapes, agricultural bounty, fine food, the arts and civility.

France consists not only of *chateau*-filled regions like the Loire, the challenging mountain ranges of the Alps and Pyrenees, impressive wine domains in Burgundy and Bordeaux, thousands of picture-postcard villages, nurtured nature parks, beaches Atlantic and Mediterranean, rivers that are host to small boats and comfortable cruisers, but also distant islands – Réunion, Corsica, Martinique and more – that once were colonies and then were handily transmuted into well-managed departments of France, in theory like any other.

Culture extends from ancient cave art to Versailles, monuments from medieval cities to the Eiffel Tower, hallowed academic institutions to technical colleges, fun fêtes from garlic fairs in the peaceable Gers to the renowned sporting events – cycling in the popular Tour de France, tennis at Roland-Garros. The French are also good at football and rugby (played in Paris in the Saint-Denis

Above: *La Ferme aux Grives, one of my favourite restaurants in all France, is a Michel Guérard inspiration in Eugénie-les-Bains.*

Below: *In the impressive Basilica of Saint-Denis in Paris's northern suburbs are the tombs of centuries of French kings and queens.*

stadium) and have won the Six Nations Championship outright seventeen times. And whatever the sport, wherever it happens, Les Bleus are welcomed as heroes.

Not everyone is a hero. Politicians are almost never heroes. Some are thoroughly unscrupulous. Presidents especially have had to accept their broadly fluctuating ranking – up for a time, down most of the time. Among the most interesting and impressive, in my years, anyway: the clever socialist, François Mitterand, president from 1981 to 1995, and Jacques Chirac, president from 1995 to 2007. Chirac, who died in September 2019, to affectionate tributes, is still remembered for apologising to Jews for the appalling treatment they suffered from France's Vichy government during World War II, and for refusing to take France to war in 2003 in the US-led invasion of Iraq without a UN mandate.

The president, as I write, is a centrist, Emmanuel Macron, who came to power without the benefit of any political party, although he promptly created one, *En Marche* (roughly, On the Move). Noted for having a wife considerably older than himself, then for handily beating both far-right and far-left candidates, notably the ultra-

Top left: *A producer of Armagnac, southwest France's very own brandy.*

Top right: *Dressed up cows are the stars of the annual Transhumance when cattle*

(and sheep) move from one season's pasturage to another.

Above left: *One of the spectacular Landes beaches in southwest France.*

Above right: *The mighty Pyrenees, viewed from the Pic du Midi, accessible by cable car.*

right Marine Le Pen, who promptly changed the name of her party, National Front, to National Rally, President Macron soon attracted criticism for what was seen as elitist behaviour. French workers, skilled and in jobs, or quite often unemployed, have shown themselves to be suspicious and wary. Their lives are not easy – and in their view got worse when smoking was banned in bars. At least, from the bloody Revolution and its busy guillotine to the trendier *gilets jaunes*, 'yellow vests', and their street blockades, they have always, like mean-spirited and violent anarchists, enchanting singers and the articulate media, had a voice. Here's mine: *Vive la France!*

Top left: *A field of sunflowers in the French countryside in summer.*

Top right: *Of all France's gorgeous chateaux this one, Azay-le-Rideau, is a particular gem. Its architecture is described as early French Renaissance.*

Above: *Man fishing, dog in boat, a moment in the wonderful marshland of the Marais Poitevin.*

Right: *In a catlover's home it's not just the cat, it's the curtains too.*

Germany

GERMANY – Beyond any measure, music is irrefutably the greatest treasure in Germany's cultural armoury. The wealth of classical music that Johann Sebastian Bach and Ludwig van Beethoven and other celebrated German composers gave to the world was an incomparable gift to civilisation itself. Johannes Brahms, Felix Mendelssohn and Robert Schumann are also among an exalted elite who contributed to the world's 'food of love' (as Shakespeare put it). And what a

Above: *Passau, a city in Bavaria, is where three rivers meet – the Inn, Ilz and the renowned Danube. It's also where many migrants have entered Germany.*

huge and turbulent figure Richard Wagner was in the harmonies and complexities of opera. It was another, fiercely antisemitic, facet of his personality, as is well-known, that troubles music lovers. This was a composer much beloved by Hitler, from 1933 Germany's murderous chancellor.

German youngsters today, in a vastly changed world, mostly prefer rap and hip-hop to the classics, and Germany's history, before the 19th century, was a patchwork of many minor kingdoms and German-speaking states where classical composers were not yet known. For two centuries up to 1918 the kingdom of Prussia was the most prominent Germanic nation in the region (an era in which Jews had a prominent role, their story brilliantly portrayed in Amos Elan's

The Pity of it All). And, yes, Prussia's enlightened despot, King Frederick III, fought quite a few wars, enhancing his authority. Much the most damaging were the two that came later, World War I and World War II.

The first World War was sparked by the assassination in August 1914 of the Austrian Archduke Franz Ferdinand and his wife, and continued largely for reasons of raw nationalism. WW II sprang from German resentments at the conditions of the Versailles treaty that had ended WW I, together with Japanese imperialism, failures in the League of Nations and the world economy. Appeasement, too, failed in a fascist, militaristic context. In WW II, among many horrors, Hitler's deeply entrenched anti-semitism led to a cataclysmic Holocaust in which six million Jews died and which impacted the world with effects that last to this day.

Victory in 1945 went to the Allied nations, USA, UK, France and Soviet Russia. Hitler had committed suicide, shooting himself in the bunker where he had retreated. His friend and colleague, the equally monstrous Nazi Josef Goebbels was chancellor for one day before he too killed himself and his wife, but not before poisoning their six children.

Postwar Germany was divided into four zones. The Russian-occupied zone, mainly in the east, would, along with a 'share' of Berlin, the capital, become a heated issue where communism ruled. Yet by 1949 Germany had evolved to two countries. The zones run by the Allies became the Federal Republic of Germany, or West Germany, the Soviet zone the German Democratic Republic (GDR). The

Above: *The baroque St. Stephen's cathedral in Passau has a famous organ, once the world's largest, with 17,774 pipes.*

Below: *In Germany's Black Forest is Donaueschingen, the source of the mighty Danube river, known here as the Donau.*

famous Berlin Wall, an 'iron wall' built in 1961 to stop East Germans defecting to the West, became a symbol, most of all when it fell in November 1989. Gratifying free peoples everywhere, the GDR was dissolved and Germany dramatically unified on 3 October 1990 as a fully-fledged Federal Republic.

Since that eventful day, if East Germany, despite huge sums spent on renovation and social aid, remained economically behind, the unified nation has taken a significant, and frequently leading, place among European and the world's progressive nations. Konrad Adenauer had been chancellor in West Germany, as was the memorable social democrat Willy Brandt, and then – for more than eight years – Helmut Schmidt.

Elections after unification, on a party political basis, produced other clever chancellors, Helmut Kohl the first. Gerhard Schröder, born in 1944, held the post for more than seven years. Then, elected in 2005 and still in the post in 2019, though close to retirement, the redoubtable Angela Merkel, a pragmatic physicist from East Germany. As her chosen successor stepped down and national politics shifted to the right, many Germans began to worry.

Germany of course is much more than its politics. Travellers will know which leading city they want to visit – Berlin, perhaps, for its history, importance and vital role in WW II, Cologne for its magnificent cathedral or Hamburg, grand port and city – or fabled landscapes like the Black Forest, the Rhine Valley or King Ludwig's Bavarian castles. Beer lovers might want to attend the colourful annual Oktoberfest in Munich. Crudely defined, the range extends from schnitzel to shlock.

There is a huge culture here – classical music the most sublime part

Above: Near the Black Forest a solitary farmer is at work on a barn rooftop.

of it – yet I have worked or travelled very little in Germany. In part this may be because my mother, an excellent piano player who loved music, had a strong bias against all things German. I do not share this bias but all the same have few photos in my files.

Gibraltar

■ **GIBRALTAR** – Not an independent country, yet so independently minded, so historically, geographically and geologically odd, so peculiar altogether, Gibraltar, I decided, merits an entry into my Europe list. Sometimes just called the Rock, for obvious reasons, and located where the southernmost tip of Spain meets the Mediterranean, Gibraltar is designated a British Overseas Territory. Spain likes to maintain a permanent claim, yet the Rock, a massive limestone spur, has been a British possession since 1713 and, occasional quibbles notwithstanding, is likely to remain in British hands.

History includes myth, with Gibraltar as one of the pillars of Hercules. As gateway to the Mediterranean, Gibraltar has seen a Moorish presence, the fleets of centuries of sailors, and fiercely fought naval engagements between Spain and England. In World War II engineers at the Rock expanded its many interior tunnels for use as protection and storage. Currently, as well as long existing fortifications, there is a permanent British Army garrison and a Royal Navy base. As I write, Iran is protesting the seizure of an Iranian oil tanker by Royal Marines from Gibraltar as 'piracy'. Another contemporary issue: Brexit.

Gibraltar, with areas of residential housing for a population of 35,000, is well geared for tourism. It has a busy

Top right: There are few pretty spaces in the crammed territory of Gibraltar.

Right: Guarding the Rock: a submarine in Gibraltar waters.

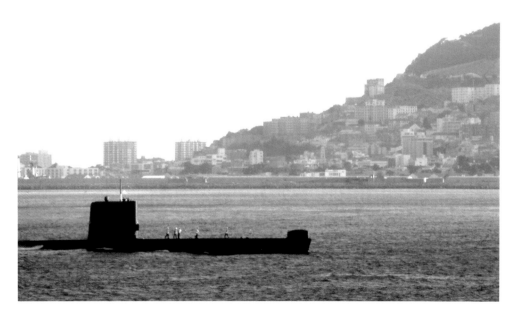

Top left: *The Rock as bastion.*

Above: *A busy street that could be anywhere.*

Top right: *The rock's own legendary wildlife, Barbary apes.*

modern town with main-street shops and markets, bars, hotels and restaurants, a variety of celebrated guns, cannons and other historic leftovers, a cable car, a cunningly lit cave to explore, an Upper Rock nature reserve and troops of managed but wild macaques, or Barbary apes, skilled at extracting treats from tourists.

It's thought they came originally from the Atlas mountains, imported by the Moors. A popular legend has it that, as long as there are macaques on the Rock, a British presence is assured. They were certainly there in the 18th century, there when I passed by quite a while ago, there now (a population of about 300). There was a moment in Winston Churchill's time, apparently, when numbers were down to an alarming seven. It doesn't seem now as if either the macaques or the British face a serious threat.

Greece

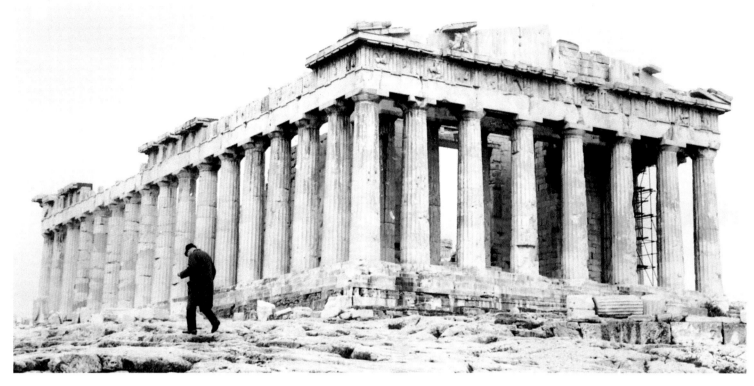

GREECE – The ancient Greece of Aristotle and Homer, it might be argued, is far better known than the modern Greece of Kyriakos Mitsotakis, prime minister (as I write), or his predecessor, leftist dynamo Alexis Tsipras, who won praise for his transformation into an 'establishment politician', or Yanis Varoufakis, former finance minister. The matchless architecture, art and sculpture of ancient Greece is widely admired and extensively copied. A considerable part of it, most famously the Elgin Marbles, is in museums outside Greece.

The Greeks of long ago had their favourite gods and heroes – Heracles for one, Perseus another. Stories were woven around them – *The Iliad*, *The Odyssey*, an entire branch of world literature – and for anyone travelling in

Above: The Parthenon in Athens in 1971. Most photography then was black-and-white. Even for travel I often worked with black-and-white.

the Greek islands, or perchance walking around the Mediterranean (as has my indomitable writer friend Joel Stratte-McClure), wonderful tales abound. Of all true Greek heroes the most illustrious was Alexander the Great, a bold conqueror whose armies marched across every country within hundreds of miles; his empire extended over three continents.

Scholars are particularly enthralled by Classical Greece which began around 480 BC, a time of temples, discovery and the founding of democracy. The last major period, called Hellenistic, ran from about 300

to 30 BC, when the Romans, who greatly appreciated Greek art, were taking over. Most of ancient Greece was dispersed in small city-states. Athens was one, enduring and expanding to become Greece's capital today – with the iconic Parthenon, temple of Athena, gleaming majestically on the Acropolis hill.

As to modern Greece, beginning, say, in the 19th century, things have not been too encouraging. All Europe can warmly congratulate Greece on the beauty of its landscapes and islands and on its splendid culture but, by contrast, across too many years Greece – to borrow an expression – seemed to have lost the plot. In World War II Greeks fought bravely against communists (and royalists). By 1952 the nation had moved on to a

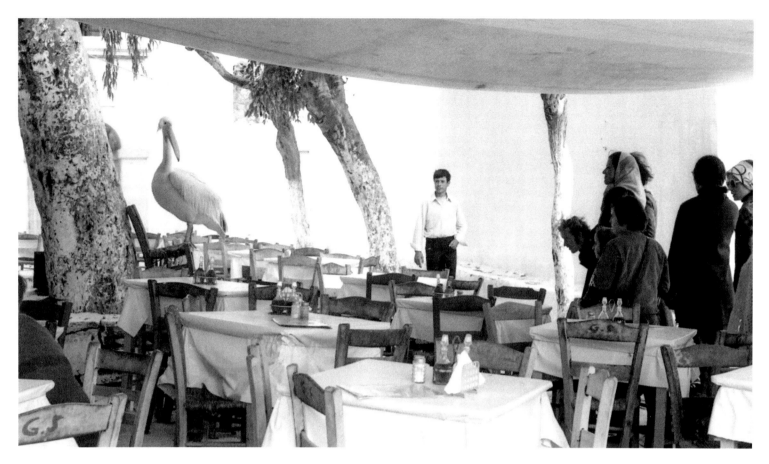

parliamentary democracy. In the early 20th century Greece seems to have had difficulty in deciding whether or not it wanted to maintain a monarchy. Finally, it didn't, though only in 1973.

Greeks didn't much care for the regime of colonels which had installed itself in 1967. In 1975 a new constitution established parliamentary rule – no royalty, no military. But new difficulties arose from a different direction – in Cyprus, in 1974, involving the colourful President Makarios (removed, he was exiled without too much suffering in the Seychelles) and an invasion by Turks who planted themselves in northern Cyprus. Then, too, with the breakup of Yugoslavia in 1991, there was the issue of Macedonia. A Greek province or a whole new country? The dispute was resolved in 2019, when the new coun-

try became North Macedonia. (So much hot air and anger for that?!)

Refugees and migrants in recent times have been a serious and troubling issue. People and lands were hit by fire and flood. The worst and longest lasting crisis, however, was about money. In 1981 Greece joined the European Union and was immediately subject to its financial rules. But Greek debt grew way beyond what was permitted, and the whole issue dominated Greek lives, through austerity measures, strikes, bailouts and a 'debt-swap' for more than thirty years. Eurozone ministers were still helping out with loans in 2018, when at last political stability was within reach. Probably, the big question is how long can one live on debt relief. For ever? I wonder what the ancient Greeks would have done.

Above: A restaurant in Mykonos. A pelican, its name Petros, had become famous. Soon it had imitators.

Below: A poor attempt to show the passage by night of the good ship Illyria through the Corinth canal.

Hungary

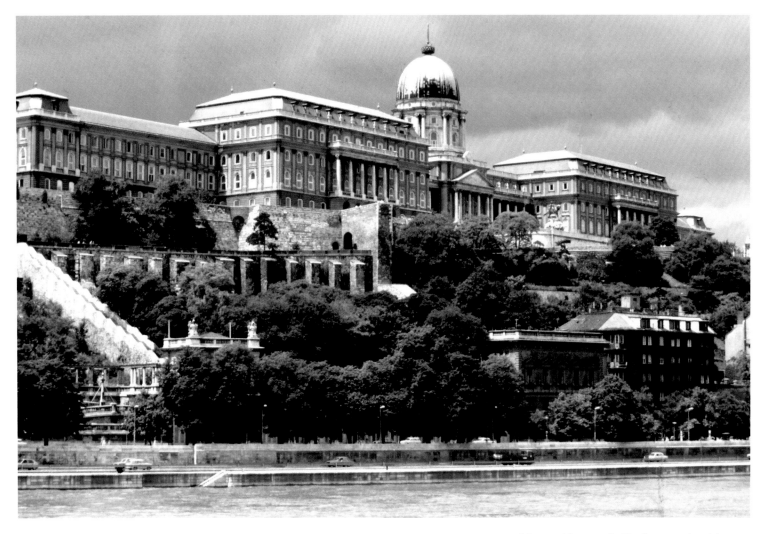

■ **HUNGARY** – Every Hungarian I ever knew, nearly all among my parents' cosmopolitan friends, was clever and charming. The world's most famous Hungarian is almost certainly the clever George Soros (I don't know if he is also charming). George Soros entered world consciousness for his currency speculation against the British pound in 1992 that earned him billions. Hedge fund management enhanced his wealth.

Through his Open Society Institute, Soros, a keen philanthropist, has supported numerous humanitarian projects. They range from battling disease and poverty to promoting democracy. The Hungarian government led by rightwing Viktor Orbán viewed him with utter loathing, attacked him ferociously for his organisation's appeals for greater tolerance towards migrants and refugees, and has done everything it could to blacken his name. Orbán was clever, too. He successfully organised his country into the EU, and took its benefits, but infuriated more liberal colleagues with his rants against what

Above: *Hungary's Parliament, beside the Danube river.*

he called a 'globalist elite'. An anti-semitic tone was strong.

Hungary, an inland country in southeastern Europe, has a long history of coping with individuals and forces its leaders have seen as enemies – Ottoman Turks in the 16th century, Habsburgs in the 19th century, communism in the early 20th century. Its most traumatic moment, though, was on 4 June 1920, when the

Trianon peace treaty, drawn up after World War I, sliced away two-thirds of its territory and nearly half its population to the benefit of Czechoslovakia, Romania and Yugoslavia. Sadly, hoping to side with victors, Hungary made a bad mistake later in joining up with Nazis. In 1944 Jews and gypsies were deported to concentration camps.

Post-war Hungary brought Soviet occupation and dedicated communist János Kádar as government leader. A factory worker initially, he rose to become the party's general-secretary.

Above left: Fisherman's Bastion, *a popular sight, and viewpoint, in Budapest.*

Above right: Budapest city buildings.

He held the post from 1956 – after Soviet tanks rolled in to squash a hopeful revolution – to his retirement in 1988. His years in power were controversial. He introduced reforms, sought loans that raised the standard of living but was never quite forgiven by anti-communists for siding with the

Soviets at the moment when he had a choice. He died in 1989, but when grave robbers broke open his tomb some years later and stole his body, the gruesome act was interpreted as political revenge.

Soviet forces were gone by 1991. Old communists and liberals formed a coalition planning free market policies. In 1998 a centre-right coalition under Fidesz party leader Viktor Orbán was elected. Yet it was not until 2010, after years of different governments and economic uncertainty, that Fidesz

and Orbán were unmistakably back. Their landslide victory led to a new constitution with pronounced rightwing elements. Hungarian voters approved. In 2014 Fidesz won again, though international monitors pointed to restrictions on the opposition. In the same year, Prime Minister Viktor Orbán stated that liberal democracy had had its day, and spoke of Russia, China and Turkey as successful 'illiberal' states that were worthy of emulation.

The EU was not pleased and threatened to suspend Hungary. Yet Orbán's repressive right-wing stance, calculated to retain basic democracy while simultaneously keeping a lock on power, was part of a nationalist urge in several countries. Migrants had been a catalyst. By 2019 migration itself had become, with all too many deaths, a world crisis and grievous tragedy.

By contrast, mass tourism, as in so many other places, was inescapable – for Budapest, anyway, a historic and imposing capital where travellers came in their thousands – and where, in 2019, a 'green' centre-left Gergely Karácsony was elected mayor, defeating the Fidesz incumbent. All the world was curious. Yet old habits die hard. I recall, from a visit long ago, that even in their public baths the clever Hungarians relax over a game of chess, and the habit, apparently, is still there.

The Szechenyi Baths is still the place to go. The baths, broadly medicinal with indoor and outdoor pools, were once used mainly by older people. Now I see that cool young guys also head into the waters for a game of chess. One grandmaster, I noted,

was only twenty-four. The baths are more crowded than I remember, but I find it reassuring that, in turbulent times, such a good-natured sporting – and intellectual – habit from Hungary's past is still going strong.

Top: On the Danube's Margaret Island in Budapest diversions include swimming where there's a wave machine.

Above: A gig in Budapest's famous Vaci Street.

Ireland

IRELAND – It seems linguistically perfect, and wonderfully poetic, that the violent conflict that split apart the peoples of Northern Ireland, beginning in the 1960s and ending with the Good Friday Agreement in 1998, should be simply remembered as 'The Troubles'. What an understatement. Outwardly, the disparities appeared to be between minority Catholics, who wanted the North to join with the rest of Ireland, and Protestants who wanted the North to remain in the United Kingdom. But the issue was far more complicated and, with fierce nationalism at its root, had little to do with religion. More than 3,500 people died before the conflict was resolved. Even today trouble is in store for anyone who confuses Northern Ireland with the Republic of Ireland.

Ireland for travellers is a spectacularly beautiful 'Emerald Isle' with stunning landscapes, gorgeous bays and beaches, quaint villages and fine churches. For the Irish it could hardly be more different. Memories of the calamitous 'Great Famine' of the mid-19th century are still strong. Largely due to a blight affecting potatoes, there was mass starvation, forced 'clearances' – loss of homes and land – and, at the least, neglect by the British. A million people died and hundreds of thousands emigrated, many to America. Ireland was changed for ever.

Relations with Britain – from which all but six mainly Protestant northern counties became independent in 1922 – were always fraught. In 1916 nationalists in an 'Easter Rising' had broken away. Punishment was brutal: the British executed seven leaders.

Above: *The southern aspect of Cork's magnificent cathedral. Dedicated to Fin Barre, the patron saint of Cork, it was built in the Gothic Revival style and completed in 1879. Its architect, William Burges, was only 35.*

Eamon de Valera, fiercely republican, later a prominent politician and president, was spared. Irish resentments never ceased. Bombings, shootings, sectarian killings were carried out across decades, mainly by the IRA (Irish Republican Army) and its successors. And there were other issues – abortion, the economy, land use and ownership. It has been something of a surprise when things went well.

As it did when, invited by the (then) Irish president, Mary McAleese, the UK's greatest diplomat, Queen Elizabeth II,

Above: Two surfers have the Inch beach in Dingle to themselves.

Left: Ireland's green landscape comes to life in Slea Head.

Below: The harbour, boats and painted houses of Bantry Bay.

and her husband Prince Philip, in 2011 made a State visit to Ireland. Whether this was 'normalisation' or 'a huge step forward', the visit was held to be a great success. Particularly when two of Ireland's most ardent and articulate republicans, Sinn Féin's Martin McGuinness, who had become deputy first minister of Northern Ireland, and Sinn Féin's leader Gerry Adams, both the political faces for shocking IRA violence, decided that they too wanted to meet the Queen. And how quickly things change: when Sinn Féin, led by a woman, new party president Mary Lou

McDonald, did unexpectedly well in February 2020 elections, almost no-one mentioned the violent past.

Issues of Irish politics and Irish borders remained frustratingly entangled with the UK's Brexit positions. Fortunately, Ireland is about so much more. Fascinating eye-catchers like Dublin doors, or the ever popular blarney stone, all those pubs, the wondrous Skellig Michael, or Dingle, gorgeous horses, fiddles, harps and jigs, or Ireland's brilliant writers – James Joyce, Samuel Beckett, George Bernard Shaw and many others. So much genius, so much colour, so much variety, yet as Beckett himself put it: 'The essential doesn't change.'

Left: *Cork's Lee river.*

Above: *Selling local crafts, a Kerry cottage oozes charm in itself.*

Left: *Main Street, Skibbereen, in County Cork, is alive with colour.*

Italy

■ **ITALY** – Like a long limb embraced by the Mediterranean, Italy is surely the most voluptuous, the most sensuous nation in Europe. Or maybe that thought is merely a reaction to Italian splendour, the seductive cities, its incomparable art, those alluring women (and men), the sunny climate, its irresistible food and wine, its movies. Italy's image is of heat and passion, glorious culture, grand opera, fabled ruins, high fashion. It almost seems rude to mention the mafia, organised crime, the heritage of fascism, misogyny, corruption, Berlusconi, and right-wing politics.

Left: In Rome, where tourists tread, tee-shirts are for sale.

Below left: In the museum on Rome's Capitoline hill is the best known sculpture of the legend of Romulus and Remus and the she-wolf.

Above: A sight in Rome hard to miss: the colossal Colosseum.

Below: A sight in Rome you might not want to miss: the Trevi fountain.

A more distinguished heritage – for other countries, too, not only Italy – lies in the legacy of the Roman empire. Roads and engineering, laws, language and literature, the calendar. The fall of Rome was celebrated. Roman influence endured.

At the end of the 19th century, Italy had a king, Victor Emmanuel II. Victor Emmanuel I had more to do with Sardinia than Italy, and monarchy did not sit too well with Italians. In the early 20th century, Italy in theory also ruled over Libya, Somalia and Eritrea, then a region claimed by Ethiopia, as well as Albania. In 1922, an ambitious politician, Benito Mussolini, had assumed power – calling himself 'Il Duce', The Leader, and inventing fascism on the way. In 1935 he made a grab for Ethiopia and, a year later, was an ally of Nazi Germany. By 1943, in World War II, with Italy's defeat by the Allies, Italian colonialism was over. As, two years later, was Mussolini, captured and summarily executed by partisans.

Postwar Italy saw the end of what had long been a moribund monarchy (though a Milan shopping mall, Galleria Vittorio Emanuele II, bears the former king's name) and the start of a new state with a constitution and widely ranging political parties. Christian Democrats vied with communists, who later called themselves the Democratic party of the left and fought against socialists. In 1972 Giulio Andreotti became prime minister, a job he would hold several times. In 1978 a former prime minister Aldo Moro was kidnapped and murdered by the left-wing armed Red Brigades. Right-wing extremists were equally zealous. And in 1992

anti-Mafia prosecutor, Giovanni Falcone, his wife and three bodyguards were killed by a car bomb.

In 1994, elections were won by the Freedom Alliance, a coalition that included Silvio Berlusconi's Forza Italia. The coalition soon collapsed but Berlusconi, a wealthy media magnate, would be back. In 2001 his party, in a new coalition, was once more on top. And although the centre-left Romano Prodi won the next round, Berlusconi in 2008 gained a third term as prime minister. A slippery survivor of many battles, he did not however win them all. He was also obliged to face a variety of charges in court. Eventually found guilty of tax fraud, he was sentenced only to community service and a two-year ban on holding public office. In 2019, in his eighties, he stood for membership of the European Parliament, and won.

In September 2019 Italy, which had had more than 60 governments in 73 years, acquired a new one in unlikely circumstances. Matteo Salvini, leader of the far-right League Party that had been in a ruling coalition with an irreverent Five Star Movement, decided he had the backing to go it alone. Instead, an irate prime minister, Giuseppe Conte, a law professor, constructed an unlikely coalition of two normally opposing parties, the Five Star Movement and the centre-left Democratic Party, which won a vote of confidence. Conte was now prime minister, Salvini an opposing outsider. For the time being at least, moderation ruled the day.

Populism, all the same, was making it into government almost everywhere. So were new words. Attempting to answer EU demands to lower its debt,

Above: *Closeup of one of Bernini's figures in his spectacular fountain, Fontana del Quatro Fiume in Rome's Piazza Navona.*

Below: *The Ponte Sant'Angelo over the Tiber river was built, in 134 AD, by Emperor Hadrian. It leads to what was his mausoleum and is now the renowned Castel de Sant'Angelo.*

Above: A view towards St. Peter's square.

Right: A fanciful mask, one of the symbols of Venice, displayed at a kiosk.

the coalition government in 2019 had proposed a programme called a 'mini-BOT'. In this case, it meant 'mini Bills of Treasury' (BOT also has several other meanings). Whether the debt or the radical proposal provoked the greater alarm was not clear. But crises larger than politics were also creating havoc. Earthquakes caused damage to historic buildings and villages. And the world's newest problem, huge numbers of migrants, was hitting Italy and its islands hard. The Mediterranean became a sea of small boats packed by traffickers. Countries where migrants gathered were paid to stop them. Rescue ships were banned and penalised. And many, too many, died.

It was still possible in 2019 for sunlovers to dip into Capri and other favourite tourist spots. The classic cities of Rome, Florence, Venice and Pisa, with all their appealing beauty, were coping with invasions of tourists and bulging cruise ships. The cities' dilemma: the tourism industry was contributing massively to the economy. The question of what to do would only become more urgent.

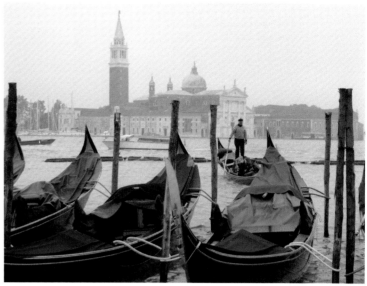

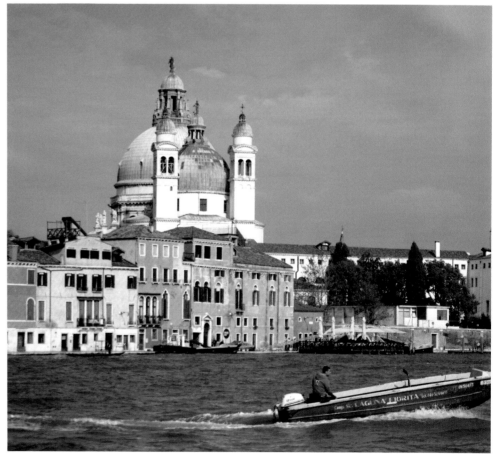

Top left: *Among the lesser Venice canals.*

Above: *A lacemaker on the island of Burano in the Venice lagoon.*

Top right: *One of Venice's most famous views looking across covered gondolas near San Marco to the Church of San Giorgio Maggiore.*

Above: *The San Marco waterfront and Basilica domes seen from the Giudecca, the channel between San Marco and Giudecca island.*

Lithuania

Above: *Lithuania's modern history remains affected by the tragic events of World War II. Vilnius, the capital, has recovered to the degree that contemporary sights – castle, churches, streets – offer visitors a serene view of the city and its society*

■ LITHUANIA – A Baltic country, Lithuania across a thousand years was so entangled with its neighbours, Poland and Russia the two most dominant, that it regards its true founder as Grand Duke Gediminas, who ruled from 1316 to 1341, launched the capital, Vilnius, and helpfully founded a dynasty. A contender for the role of founder might also be Mindaugas, who appears in chronicles as reigning over a kingdom of Lithuania from 1251 to 1263. He was also a grand duke and, moreover, a Christian. It appears that he died by assassination, as did his three successors. Perhaps the deciding factor: with a fine statue in Vilnius's central square, it is Gediminas who is most prominent.

More recent aspects of Lithuania's history are recorded in museums, not a handsome statue. In the years preceding World War II, Soviet Russia ruled over Lithuania – so cruelly that

Above: Looking up towards Gediminas castle.

Right: The Church of St.Anne, distinctive in its flamboyant Gothic style, dates to 1495.

when Nazi Germans invaded they were initially welcomed. Vilnius by this accident of history was primed for collaboration. As war ended with a victory for the Allies, the Soviets were back.

About 240,000 Jews lived in Lithuania at the outset of war, when Vilnius was a cosmopolitan centre of culture. In an immediate roundup, 72,000 Jews were shot at a place called Ponary. Around 15,000 escaped annihilation. Yet the Museum for Genocide Victims, or the KGB Museum, in a large central building in Vilnius shows more of the horrors committed by Russians than by Nazis.

JONAS URBANAS
1920-1946

ADOLFAS UŽDAVINYS-
DOBILAS
1921-1947

BRONIUS VAINORIUS
1919-1945

MATAUŠAS VALICKAS
1919-1945

POVILAS VALOTKA
1924-1946

JONAS VENGLAUSKAS-
KYMANTAS
1919-1945

ROBERTAS VIDOLIS
1900-1945

ELENA VIDUGIRYTE
1919-1947

KLEMENSAS VISOCKIS
1900-1946

JURGIS VOSYLIUS
1910-1945

Some of the Jews' tragic story I found in what was almost a shack.

Lithuanian partisans fought both Nazis and Soviets, yet it was the Soviets – and their occupation – most Lithuanians loathed. The legacy of war was not only those who died or who were deported, but a tragic confusion on who was a patriot and who a brute. Lithuania, when the chance came, was the first Soviet republic to declare independence on 11 March 1990 (recognised by the Soviets in 1991). Conspicuous in Lithuania's moves to independence, and its first head of state, was Vitautis Landsbergis, a conservative politician who was also a fine chess player, an author and notable in the world of music.

Above: Names on stones tell a fragment of the story of the Museum of Genocide Victims in Vilnius.

Today Lithuania is a democracy run by a president and a legislature under the parliamentary system. Getting there was not smooth sailing. The first years of independence saw political scuffling, even an impeachment. In 2004 Valdus Adamkus was re-elected president, a post he had first held in 1998 after a 50-year exile and active career in the United States. (He was also a US citizen, renouncing his citizenship on his return to Lithuania.) For the presidential term following Adamkus a woman, Dalia Grybauskaité, was elected. A regular, and diplomatic, tweeter, her cropped

blonde hairstyle became a familiar feature in EU heads of state photos.

Prime Ministers were less well known. Saulius Skvernelis, prime minister as I write, has been minister of the interior from a background in the police. His party was the Lithuanian Farmers and Greens Union, formerly the Lithuanian Peasant Popular Union. I could only think how pleasant it was that greens, farmers and the police were apparently in harmony in a most unusual trinity. A satisfying notion as my paternal grandmother was born and raised in Lithuania. Her marriage to my grandfather, the circumstances a mystery, took place in London. Considering the unspeakable events of that era, she was fortunate, as am I.

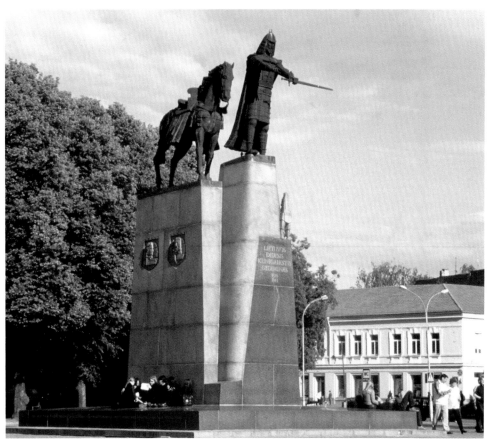

Top left: *The Russian Orthodox Church of St.Michael, in Vilnius.*

Top right: *Centre city monument to the nation's founder, the Grand Duke Gediminas.*

Right: *The Russian Orthodox Church of St.Paraskova, in Vilnius.*

Monaco

■ **MONACO** – The motto of the Principality of Monaco, a sovereign microstate on the French Riviera, is *Deo Juvante* or With God's Help. For the 38,000 or so very wealthy residents, help from any exterior source is not normally required. Monaco has been run by the Grimaldi family since 1297. A constitutional monarchy, Monaco is currently renowned for its tax free status, its Formula 1 Grand Prix street circuit, its popular football club, AS Monaco, and the busy life of its head of state, Albert II, who has shaken the hand of world notables ranging from the president of China to Albania's premier to the pope.

Not so long ago attention was focussed on his father, Prince Rainier, and Grace Kelly, the glamorous actress Rainier married in 1956. The couple had three children, all in the world's spotlight. Grace Kelly's tragic death, following a road accident in 1982, only added to the glare and gossip. Prince Rainier ruled for fifty-six years. When his reign began, in 1949, Monte Carlo, its grand casino and gambling were – for foreigners only – the big attraction. (To this day Monaco citizens may only enter a casino if they work there.) Rainier proved to be a reformer, creating a constitution and governing council, diminishing the role of the casino, turning Monaco discreetly into the tax haven and spotless well-managed city-state it has become.

Surprisingly, there is much to see and do in Monaco's 2.02 square km (0.78 square miles). Shopping and luxury brand-name boutiques may be a commonplace but there are several

Top: Monaco's famous Casino from the gardens facing the sea.

Above: Lights go on at dusk in the Place du Casino, glamorous boutiques and surrounding buildings.

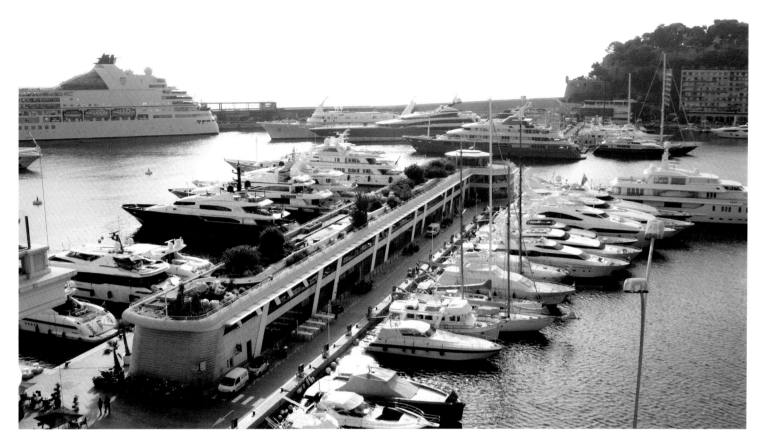

Above: Vessels from yachts to ships tie up in the ports of Monaco.

fine museums and numerous sporting and musical events. I was enchanted to find several appealing public gardens and parks, the mild climate proving beneficial to spectacular tropical trees and plants. Ducks frolic in cunningly wrought streams and ponds. Birds roost in impressively flourishing greenery – all beside closely packed high-rise apartment blocks and gorgeous period buildings in rococo and Belle Epoque style.

Fans of Princess Grace will see that she is not forgotten. Part of the Prince's Palace, once a fortress, is open to visitors. The daily changing of the guard, the prince's *carabinieri* in immaculate white, accompanied by drums and tootling trumpets, seem-

Left and above: Owning an apartment in Monaco is only for the wealthy and even then they don't have much space.

Right: For all its small space, several well tended parks and gardens in Monaco provide a vital touch of nature.

Below: The vitrine of a shop selling expensive watches; there are many ways to spend money in Monaco.

Above: Monaco's Oceanographic Museum is a large and respected museum for marine sciences which includes aquariums for sea creatures from sharks to turtles.

ingly attracts every tourist in town. And of course there are also the casinos, which offer everything from stud poker and blackjack to baccarat and slots. The grand Monte Carlo Casino requires 'proper dress'; trainers and flipflops are not allowed. But anyone can gawp at the exterior sights, admire the Lamborghinis, Bentleys and Rolls parked outside, pause for refreshment at the neighbouring Café de Paris.

For myself, not much of a gambler, it is Monaco's peculiar identity, long history and exotic Mediterranean setting – with the shortest coastline of

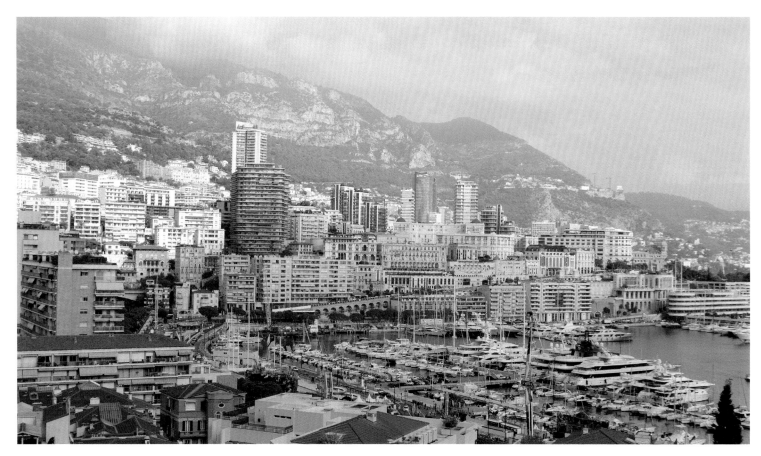

Above: *Squeezed on to a hillside and packed waterfront all Monaco's apartments, yachts, shops, restaurants and casinos.*

Right: *A daily event enjoyed by tourists is the changing of the Guard, or white-uniformed Carabinieri, outside the Prince's palace.*

any country, 2.5 miles, or 4.1 km – that appeals. Good luck to Prince Albert, his wife Charlene (an Olympic swimmer from southern Africa) and all those relatives. And of course the delightful twins, Jacques and Gabriella, born in 2014. Apparently, Gabriella was the firstborn but it is the male, Jacques, who is heir to the Grimaldi throne. Some things never change.

Netherlands

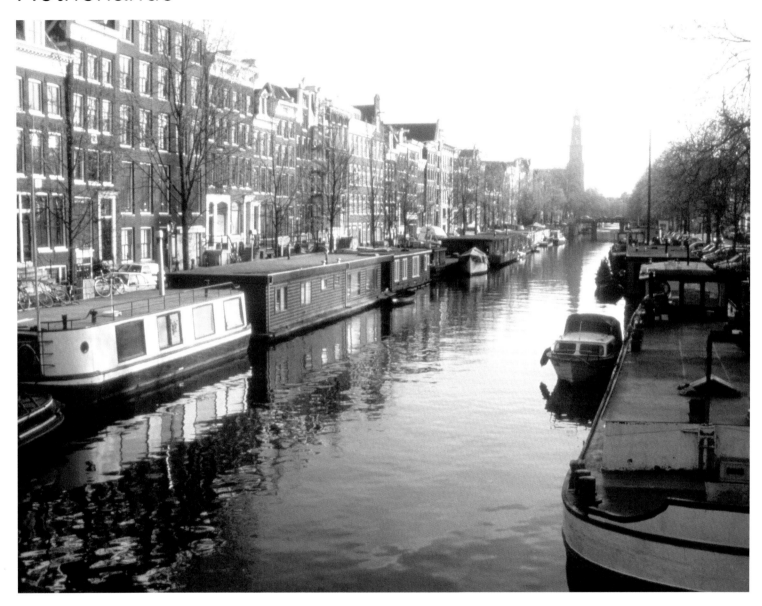

Above and overleaf: The Amsterdam canals are there by necessity but there is also a philosophy in those waters and the serene faces of the houses on their banks.

■ **NETHERLANDS** – Canals, Anne Frank, Amsterdam, Rotterdam, tulips, windmills, cyclists, Van Gogh, Rembrandt, Vermeer... These are the images that come instantly to mind whenever the Netherlands is mentioned. But the briefest study of this small but impressive country shows so much more, especially if a little history is included. In the era of empires the Dutch in the 16th

century were as remorseless as the British and French at land grabbing. Nearly always of course under the label of trade.

The Dutch East India Company was the first of the large corporations that took power as well as goods. In South Africa, Dutch heritage is still strong in the Afrikaans language, Afrikaner culture, including the classic and enduring Cape Dutch architec-

ture, and in many city names. In the United States, many place names from the Bowery and Harlem (Bouwerij, Haarlem) are echoes of the Dutch presence. Even New York was once New Amsterdam. Head to the far east and there is Tasmania, named after Dutch explorer Abel Tasman. At the top end of South America, Suriname, a sovereign nation, still has Dutch as its principal language.

In the contemporary Netherlands, ships, the sea and trade are still vitally important – Rotterdam is the largest port in Europe. As to politics, it has encompassed a wide variety of politicians. They have included the far-right populist Geert Wilders, Liberal leader Mark Rutte (as I write, prime minister in a coalition). There was Labour leader Wim Kok, conservative Jan Peter Balkenende and, until he was assassinated, anti-immigration leader Pim Fortuyn.

Away from politics there is royalty: the cherished Queen Juliana who reigned for thirty-two years after 1948, then – following her abdication – her daughter Queen Beatrix, who also chose to abdicate. In 2013 her son Willem-Alexander, a skilled pilot, ascended the throne, the first male Dutch heir since 1851. As heir he was Prince of Orange, a dynastic title royal heirs have held since medieval times. Orange, sports fans will have noted, is the colour athletes wear in their international matches.

For many, the Dutch artists are the Netherlands' greatest glory, the ultimate grandeur and yet also often homely and personal. Perhaps – like tulips and the other spectacular flower gardens and farms, or the decorous gabled canal-side houses, or even

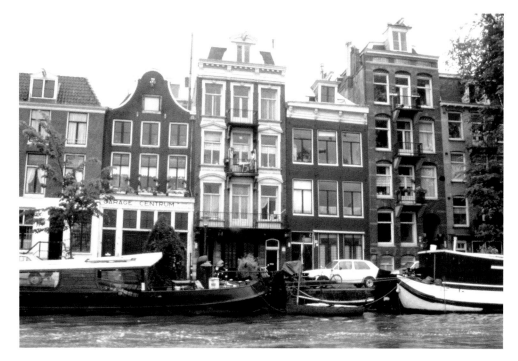

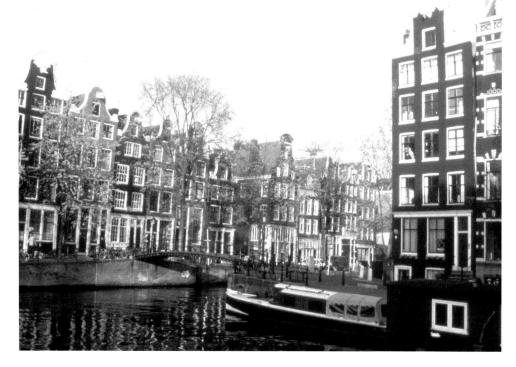

Amsterdam's indecorous redlight district, or all those careful cyclists – many of the masterpieces reveal an appealing lack of sophistication. Equally admirable is the brilliant engineering, the dikes, dams and

floodgates that have kept the sea and unwanted waters safely at bay. The very word 'netherlands' means 'low country' – and flat, too. This amazing country, and its high density population, is a wonder in itself.

Left and below: The Netherlands' famous botanical gardens are in Keukenhof, about 24 miles (40 km) from Amsterdam and cover 32 hectares (close on 80 acres). Dutch tulips, justifably famous, are not the only gorgeous blooms to be found in the elegant gardens and greenhouses

Norway

NORWAY – For an understanding of ice and what it has done, can do and what its absence means, Norway is a good place to look. Most of Norway is south of the Arctic Circle and its coastline is more than 25,000 km (16,000 miles) long. The last ice age, when all Norway was covered with ice, ended about 12,000 years ago. What is there now, the mountains, glaciers and fjords, could hardly be more beautiful.

The seafaring Vikings, to their misfortune, are today heroes in comedy shows, films and books. Their reality, only about 10,000 years ago, impinge not only on Norwegian history but much further afield. More recent heroes are the great polar explorers, Fridjof Nansen (whose almost as famous ship, Fram, can be seen today in Oslo) and Roald Amundsen (a practical man who beat Britain's Robert Scott to the South Pole). Accounts of their explorations and voyages are thrilling sagas in polar literature. Viking longships, carefully preserved, can be seen in an Oslo museum.

While Norway has its own independent character and healthy economy today, it's not long ago since the Scandinavian countries seemed to blur together. Not of course to Norwegians. They have had a constitutional monar-

Above: A bustling harbour and the Hanseatic Wharf, an historic trading centre, are a memorable attraction in Bergen.

chy and parliament since 1905 and a history going back a lot longer. For some of us, Norway became familiar from World War II events. German forces occupied what was theoretically a neutral country and a man called Quisling declared himself head of government. Norway's royal family and government took refuge in Britain.

Post-war Norway, rich after the discovery of oil and gas in its waters, chose a trade agreement but not membership of the EU. Independent-

minded in other ways, Norway's Nobel committee offended China by awarding its Peace Prize in 2010 to a Chinese dissident, Liu Xiaobo. Norway offended conservationists, too, as its whaling policy, as of 2019, continued to include commercial hunting of minke whales. All the world stood in sympathy with Norwegian families, though, when a sickening rightwing extremist on 22 July 2011 carried out a bomb attack and then shot more than seventy people, most of them young and enjoying an island summer camp, in a horrific killing spree.

On a more pleasant note, in 2016 the Lutheran Church allowed gay couples to marry. And in 2019 environmentalists were pleased to learn that Norway's Labour Party said it would stop pushing for oil exploration in the

Top left: A setting sun turns Bergen outskirts to gold.

Left: A major city on Norway's west coast, Kristiansund has a fine harbour too.

Below: It's winter and days are dark but, in northern Andenes, orcas keep whalewatchers happy.

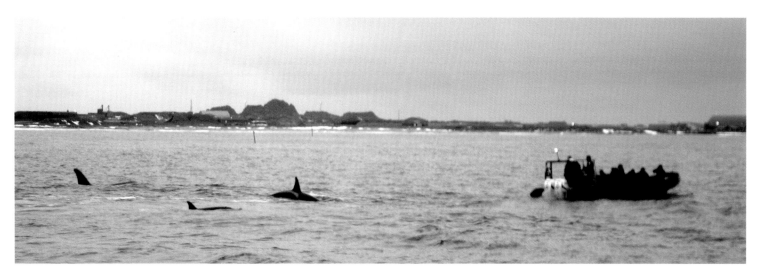

country's ecologically sensitive Lofoten Islands. Norway already pumps more than 1.6 million barrels of oil a day from its offshore areas. The Lofotens are a region of Norway much loved by Norwegians and visitors for their beauty.

I've experienced Norway in winter, when the few hours of daylight meant I saw very little of the landscape I was passing. But I have also had the pleasure of voyaging in summer from Bergen, a historic and colourful city, all the way up the coast, stopping off frequently at small towns and fishing ports. This was a regular day in, day out, mail and cargo voyage. The ship reached Kirkenes in the north – spitting distance from the Russian border – and then turned south for home. Norway didn't disappoint.

Top right: A Norwegian treasure: the shining beauty of Trollfjord.

Right: Scenery to delight the senses.

Far right: Sámi live at Norway's North Cape with reindeer as livelihood.

Below: A monumental globe at North Cape (NordKapp), set up in 1978 on a cliff high above the sea, marks Europe's northern boundary with the Arctic beyond.

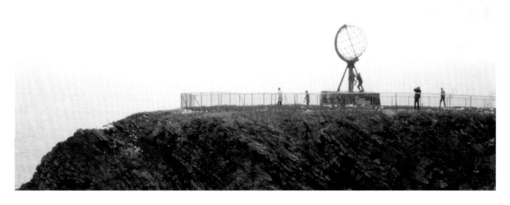

Poland

POLAND – What do Copernicus, Marie Curie and Donald Tusk have in common?

Answer: they are all Poles. Nicolaus Copernicus (1473–1543) was an eminent polymath skilled in classics, canon law, medicine, mathematics and astronomy, and is famous for publishing what was then a wild notion that the planets orbit around the sun and that the earth, as well as orbiting around the sun, turns once daily on its own axis. Marie Curie (who was also naturalised French) was a physicist and chemist specialising in radioactivity. She discovered polonium and radium and won two Nobel Prizes (1903, 1911). Donald Tusk, a politician, was president of the European Council from 2014 to 2019 and, before that, prime minister of Poland from 2007 to 2014.

Any developed country can boast renowned and stellar citizens. But these three struck me as having a special distinction (probably due to my limited knowledge of Poland). Another unusual Pole was Karol Jozef Wojtyla, better known as Pope John Paul II. And who doesn't know the name of Frédéric Chopin, a composer beloved by millions for his revelatory music? Poles would probably add the name of poet Adam Mickiewicz (1798–1955) to a list of national heroes. But no translation of his many works has crossed my path so it's an aspect of Polish culture which, with some regret, I am ignoring.

I am also bypassing the story of Poland's long and complex past, which includes being partitioned by greedy neighbours right off the map.

Top: Fine houses are an impressive feature of Warsaw's Old Town Market Square.

Above: Corpus Christi in Warsaw, a holy day, and many Catholics take part in religious processions.

Yet I cannot ignore Poland's more recent experiences in World War II, the appalling brutality inflicted by Nazis and Russians, the courage of its Resistance – as well as the bravery of the many Poles who joined the Allies,

Above: In Warsaw, the tall Palace of Culture and Science, the style Soviet realism, was a gift to the Polish people from the USSR.

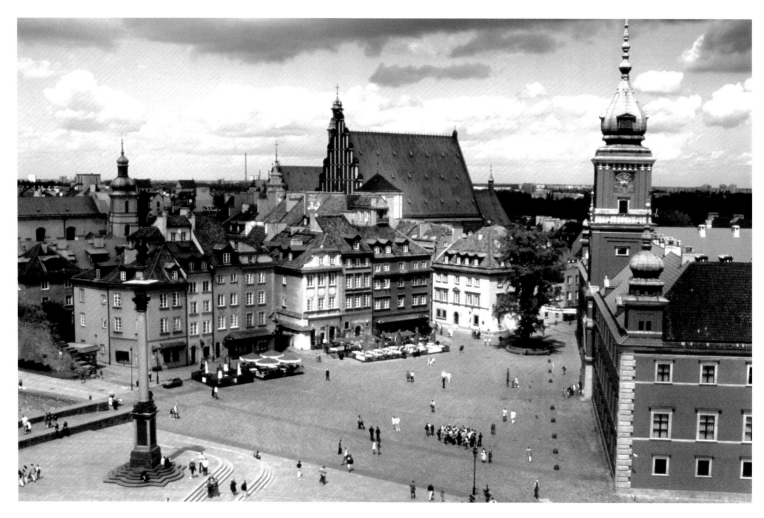

most especially the brilliant Polish pilots who flew with Britain's Royal Air Force in the Battle of Britain.

Poland's modern history, it might be argued, began at the end of World War I, yet Soviet Russia loomed so threateningly Poland made a non-aggression pact in 1932 – and one with Nazi Germany in 1934. Both were futile. In 1939, at the outbreak of WW II, both the Nazis and the Soviets burst in, dividing Poland between them. Russians treated Polish citizens and officers with extreme cruelty – one atrocity, a notorious massacre at the Katyn forest in 1940. Nazi persecution of the large Jewish population was appalling and thorough.

Of a Jewish population of three million, 90 per cent died. About another three million Polish citizens were murdered. Occupied Poland never collaborated with Nazi administration, though Israelis in particular are prone to claiming that they did. Nor did the Polish government surrender (a government in exile was formed in London). The Nazis not only took over Polish land and facilities for their own use, they soon began building camps for the extermination of Jews. These included Sobibor, Treblinka and Auschwitz.

An additional postwar tragedy is in a continuing 'blame game'. Many Poles helped Jews to survive. Some did not.

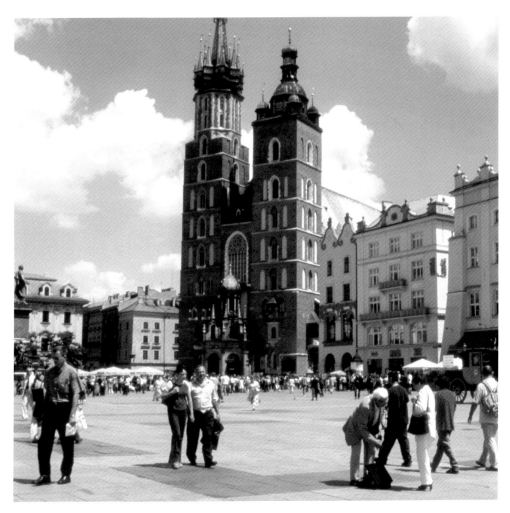

The Polish government in 2018, a right-wing, nationalist 'Law and Justice' political party that has led Poland since 2015, made use of the term 'Polish death camp' punishable by up to three years in prison. Academics and historians, particularly, were critical. For all the sensitivity of the realities, their view was that the Holocaust still needed to be open to free discussion and study.

Warsaw today is not the city of the 1940s because, in a final outrage – as much to punish the Resistance who courageously attempted the still remembered 'Warsaw ghetto uprising' – the Germans destroyed the ghetto and razed the city to the ground. Postwar construction in what was then a communist-ruled country included developments in the major port of Gdansk. From disturbances there in 1980 arose the Solidarity trade union led by Lech Walesa. By 1989 communism was on the way out and, in 1990, Walesa was elected president.

Opposite top: Poland, Warsaw, the old city square.

Opposite left: The Uprising Monument in Warsaw honours the courage of Polish insurgents who fought but failed to end Nazi occupation in 1944.

Above: St.Mary's Basilica rises high in Krakow's Main Square.

Right: Maius University in Krakow; Copernicus studied here.

Above: Orthodox Jews on a visit to Kraków's Jewish Quarter.

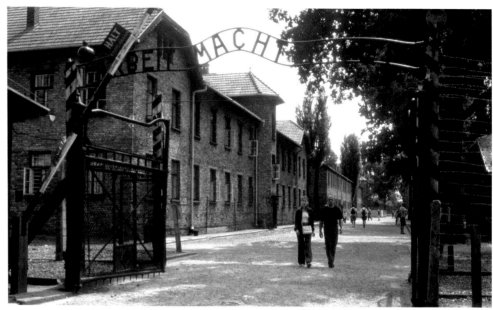

Time marched on. Normal politics was resumed. In 2005 the Law and Justice Party won elections, and candidate Lech Kaczynski became president. In 2006 his twin brother became premier. In 2010, shocking all Poland, President Kaczynski and many members of the government were killed in a plane crash (later ascribed to pilot error). The following year saw the arrival of Donald Tusk, head of the centre-right Civic Platform Party, as premier.

For a traveller there is much to see in Poland – old cities, well-tended parks, historic monuments and buildings that reflect many architectural styles. Kraków, Poland's second city, has an intriguing medieval centre and a 'Jewish quarter'. Oddly, perhaps, tourist tat includes controversially legal Nazi memorabilia.

Not far from Kraków is Auschwitz-Birkenau, now a memorial and museum. During a visit I made there, a thief got a hand into my camera bag and stole the purse containing my cash. It seemed to me a supreme irony that such a petty robbery could occur in a place that suffered the world's most monstrous crimes.

Top, above and right: Now a museum, Auschwitz-Birkenau still holds all the horror of the Nazi death camp that it was in World War II. Photos show the camp's notorious Wall of Death, the bare planks in what was once a dormitory, and the entry gate with the infamous slogan 'Arbeit macht frei', 'work sets you free'

Portugal

PORTUGAL – Macau, Portugal's last outpost of empire, reverted to China in 1999 – but oh, what an empire it was. In Africa it included Angola, Guinea-Bissau, Mozambique and, for a short time, some dozen or so other territories. In the Atlantic, the Cape Verde archipelago was a Portuguese possession; Madeira and the Azores islands are autonomous regions of Portugal even now. In South America, Brazil was the great prize the Portuguese discovered in the 16th century; it became independent in 1822. In Asia and Oceania, the

Above: In Lisbon the Vasco da Gama bridge, honouring a national hero, stretches across the Tagus estuary.

Right: Bom Jesus stairway in Braga leads to a notable pilgrimage sanctuary.

Portuguese had possession of Goa in India and East Timor into the 20th century and, for various amounts of time, more than thirty other cities, lands and islands. Portuguese is still the first language spoken by some 230 million people.

Portugal itself, a small, beautiful and extraordinarily diverse country neighbouring Spain at the western edge of Europe, has had virtually the same frontiers since it became a sovereign kingdom in 1139. Across three dynasties, charismatic kings and queens ruled the land and its vast empire until 1910, when the First Republic was formed. A desperately unhappy period of dictatorship, under the narrow-minded and repressive António de Oliveira Salazar, shut off Portugal from the world between 1932 and 1968. It was only in 1974 – the magical 25 April, a date everyone remembers – that the so-called Carnation Revolution of the 'young captains' set Portugal and its African territories on the road to true democracy and a Third Republic.

Above: In Portugal's Ribatejo region herdsmen called campinos *wear their traditional costume as they show off their skills.*

Right: Aveiro on Portugal's west coast *is a town and lagoon where many of the artfully painted* moliceiros, *flat-bottomed boats, may be found; in the past they were used to collect weed.*

Of the many politicians who have held leading roles in government few are truly distinguished. A habit of rural Portuguese come election time was to conspicuously not vote, knowing that this was the best way to catch the attention of politicians who otherwise ignored them. But among the most memorable leaders was Mário Soares, a dedicated socialist, a lawyer who

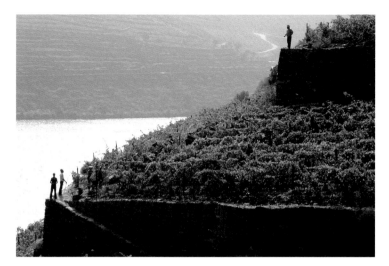

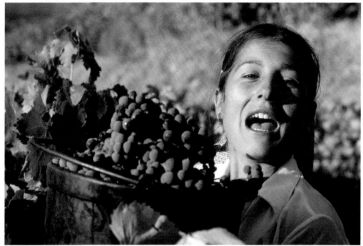

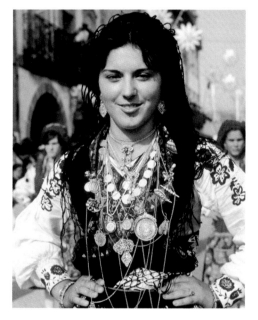

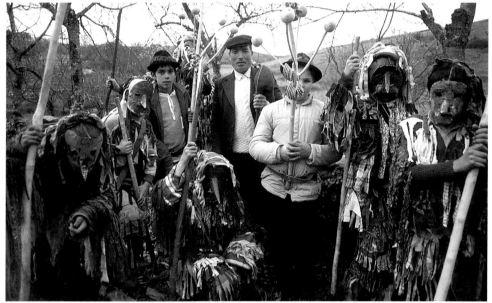

Top left: *The Douro River vineyards, a highly esteemed wine area, covers some 61,000 acres (nearly 25,000 hectares).*

Top right: *A cheerful grapepicker on the slopes above the Douro River whose vineyards are the source of a famous product, port.*

Above left: *For the annual* festa *in Viana do Castelo a woman wears the traditional costume of a bride in black.*

Above: *On the 'Day of the Boys' in the northern Tràs-os-Montes region boys wear masks and rag costumes. Their main activity: mock chasing girls.*

loved books and, in the Salazar era was frequently jailed or exiled. After the 25 April celebrations he was the first constitutionally elected prime minister, serving twice, and in 1986 became the first civilian president since 1926. The military man he succeeded, General António Ramalho Eanes, was also a calm and constructive president.

Portuguese history, along with football, is sacred to the Portuguese. A modest, pragmatic people, they don't boast that they launched the 'Age of Discovery', that in 1522, one of the

ships in the fleet serving Spain but commanded by Fernão de Magalhães – Ferdinand Magellan – completed the first circumnavigation of the globe. Or that they were the first Europeans to set foot in two-thirds of the known world. But they did and they were.

They also have a strong culture that extends from intriguing architecture to

poetry and art – those striking *azule-jos*, ceramic tiles, that adorn so many churches, palaces and fine houses are a distinctive aspect of it. In Paula Rego they have an astonishingly imaginative contemporary artist. Their songs are mostly popular but *fado* (a word meaning fate or destiny) expresses more than any other music the Portuguese spirit of *saudade*, or longing.

Politics, though endlessly verbose, is rarely aggressive. Power has shifted from centre-left to centre-right and back again, and much of the recent past has been under coalition governments. Nominally, power is in the hands of the prime minister, currently socialist lawyer António Costa, shared with the president

(as I write, Social Democrat Marcelo Rebelo de Sousa). No politician so far has been able to stop the terrible fires that every summer consume large areas of forest.

I have a strong affection for Portugal. I lived there for a dozen years after the Revolution and came to value the flamboyant beauty of the country and the sterling qualities of the hardworking Portuguese. To me Lisbon, its Bairro Alto bright with flower-filled window boxes, its bars and *tascas*, was a total joy. I loved too Porto in the north, rising on the banks of the Douro River, the cool, green Minho, the Alentejo plains and their cork oaks, sweltering in summer, and the high Serra da Estrela, snow-capped mountains of the stars,

How delightful were the Algarve beaches (I could easily skip the 35-plus golf courses) and I was impressed by the huge crowds of pilgrims who stoically walked to the Sanctuary of

Opposite, top: The Alentejo region of Portugal once contained vast estates owned by absentee landlords. After the 1974 revolution cooperatives were established. Here too are centuries-old cork oak trees.

Left: Portugal's national horse is the beautiful Lusitano; the photo shows a handsome stallion at a national stud.

Above: Known as the Algarve's winter snow, almond trees are a gorgeous sight when they bloom in February.

Right: Fishing boats on a beach in the Algarve, Portugal's southernmost region where there are many fine beaches and many golf courses.

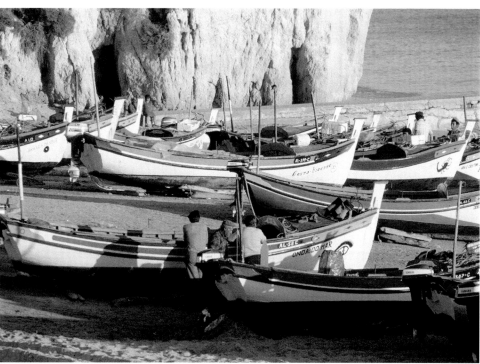

Our Lady of Fàtima. I was lucky enough to be assigned to photograph and write stories on the landscape and its people. And, yes, on Portugal's pousadas too – classic hotels, some of them historic castles in wonderful settings – and on its great seafood, traditional stews and splendid wines.

One of my personal heroes, Alan Villiers, who wrote marvellous accounts of the great sailing voyages he experienced, had made me aware of the quiet courage of Portuguese seamen fishing for cod in Greenland waters. My years in Portugal left me with a huge respect for a down-to-earth people and a continuing appreciation of their captivating country.

Right: Granite is a prime building material in the roughhewn Beira regions; a couple stand in the doorway of their home.

Below: In Miranda do Douro a Christ child in a top hat, Menino Jesus de Cartolinha, marking a 17th century victory over Spanish forces, appears on the patron saint's day.

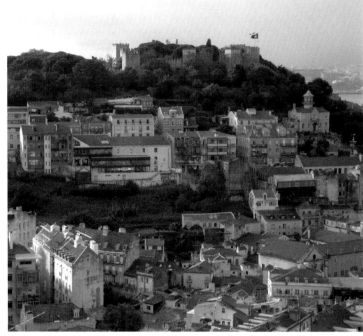

Top left: *Lisbon's Belém tower on the waterfront of the Tagus River estuary.*

Top right: *São Jorge castle on a hill above Lisbon and the Tagus River is a grand sight at dusk.*

Left: *In Lisbon trams still provide much of the city's public transport. No.28, linking the city centre with uphill districts, is a tourist favourite.*

Below: *The Serra da Estrela (mountains of the stars) are a fine sight with their snowy counterpanes in winter.*

Spain

■ **S**PAIN – A many-splendoured nation (to borrow a felicitous expression from author Han Suyin), Spain still has all the qualities of old Europe even as Europe is changing: a long and fascinating history, grace, elegance, good bones (or structure), spectacular landscapes, even land where wild horses roam. And dazzling cities like Madrid, Barcelona, Seville and Granada, and the lovely Balearic islands. All that and a fine culture that extends from food to arts, *paella* to Pablo Picasso.

Looking further, Spain's 16th century *conquistadores* left not only a broad legacy across Central and South America, but also in California and New Mexico in the United States. Christopher Columbus may not any more be regarded as a hero, yet Spanish galleons were big and beautiful (but not invincible). War with the United States in 1898 brought independence to Spain's Latin American colonies.

Another war, the Spanish Civil War (1936–1939), is still remembered as much for the terrible losses, up to half a million deaths, as for the many international figures who joined the Republicans. Nazi Germany and fascist Italy aided the Nationalists who were led by General Francisco

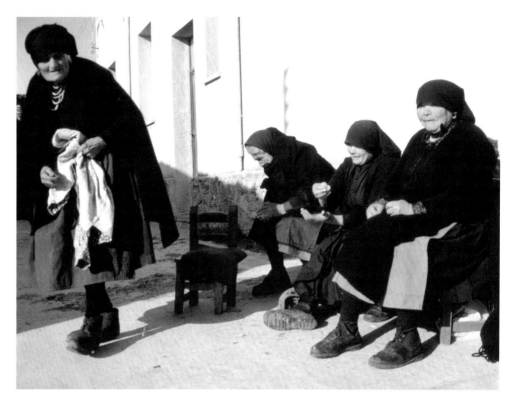

Top right: Many elderly women, not necessarily widows, wearing black.

Right: With the opening of the Guggenheim Museum in Bilbao in 1997 the city was transformed from commonplace Spanish town to major art centre, the museum itself, designed by Frank Gehry, the main attraction.

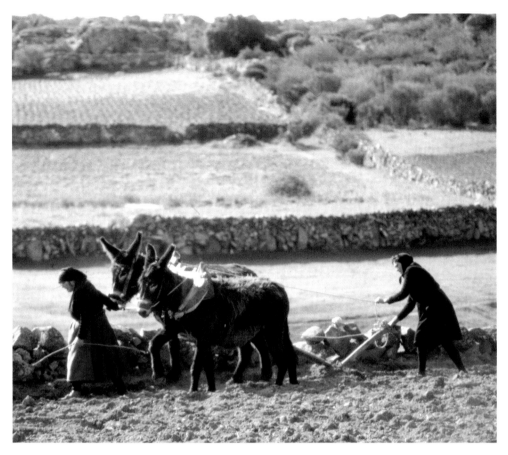

Franco. Regrettably, he won and imposed a dictatorial rule on Spain that lasted until his death in 1975. In an even larger war, WW II, he kept Spain nominally neutral.

In 1969, however, looking to the past as well as the future, he named Prince Juan Carlos, the grandson of King Alfonso XIII, as Spain's king. Juan Carlos publicly supported Franco's rule yet, with Franco's passing,

Top left: *To plant potatoes, two women prepare their field with the help of mules.*

Top right: *Near the Duero River a shepherd tending his flock keeps new-born lambs close for warmth.*

Left: *In central Spain a whole landscape is dotted with olive trees.*

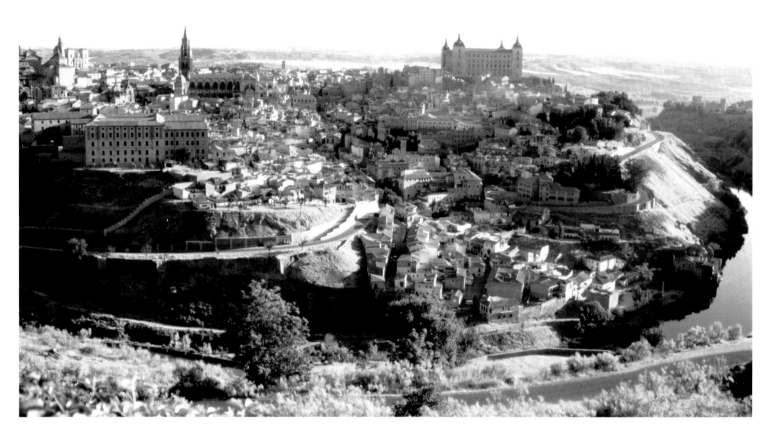

Above left: *For Holy Week, a mother has dressed her small daughter in respectful black.*

Above right: *Semana Santa, or Holy Week, brings out piety and capirotes, the pointed hats worn by penitents in processions of brotherhoods all over Spain.*

Opposite, top: *The city of Toledo, an overall view that was painted by El Greco.*

Far left: *The spires of Antoni Gaudí's extraordinary Sagrada Familia cathedral were under scaffolding, hence a closeup of an impresssive detail.*

Left: *Gaudí's architecture was remarkable even in an apartment block, Casa Mila, in Barcelona.*

immediately set about restoring democratic government. (Franco's remains, it was announced in September 2019, after decades of controversy, were to be transferred from the grandiose Valley of the Fallen memorial to the final abode of his wife, a modest city cemetery.)

In 1981 Juan Carlos dramatically stopped a coup with a commanding address in parliament. The first elections were won by socialists. As time passed, government went to conservatives, back to socialists, on to populists, and on (back?) to hard-right nationalists in the form of a party called Vox, founded in 2013 and rising significantly. In 2019 it held 52 parliamentary seats. More conspicuous were regional urges to break away – Basques initially, and violently, then Catalans. Basques lost the urge and gave up. Catalonia pressed ahead.

Madrid, the capital, rejected every separation effort, punishing defiance with hefty jail sentences, provoking further protests. Monarchy moved on to the next generation, and perhaps became less relevant, with King Felipe VI and Queen Letizia taking the place of Juan Carlos (who abdicated in 2014) and his endlessly patient wife Sofia.

Tourism rolls on, an unceasing tide. Tourists adore Spain, Brits especially. Tourism contributes billions to the economy and the Spanish continue to welcome the regular invasion of their grandest sights, although concerns are growing over what is politely called 'overtourism'. In Barcelona, the works of idiosyncratic architect Antoni Gaudí, who died in 1926, struck by a trolley, are viewed as masterpieces. His mindblowing church, La Sagrada Familia, started in 1882, is possibly

even approaching completion, a suggested date 2026. A building permit, the first, was issued in 2019.

And as the Spanish celebrate, a fiesta is to be found everywhere. Flamenco too is still widely popular. Miguel Cervantes' Don Quixote remains a familiar figure. The poetry of Federico Garcia Lorca is still read. Spain's food, especially the seductive tapas, is as sensational as ever, the wines admirable. One colourful feature of old Spain, though, has begun to dis-appear. Bullfighting, the *corrida*, still a declared 'national heritage', has been coming up against animal cruelty protests. Catalans have stopped the killing of bulls. Younger generations aren't keen, either. But money is a great persuader. The San Fermin *feria* in Pamplona, the bullring of Las Ventas in Madrid, attract crowds and fortunes. There, no change is expected.

Top right: *In an annual tradition, free roaming (but owned) horses are herded into corrals in Galicia in a hectic roundup when foals are separated and branded.*

Right: *On the decline in a few areas, Spanish bullfighting is still regarded as a traditional culture in others.*

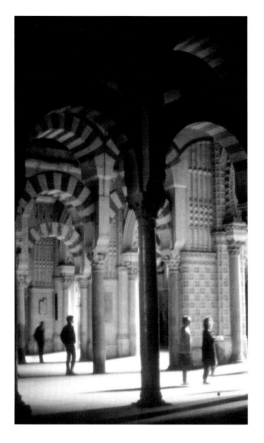

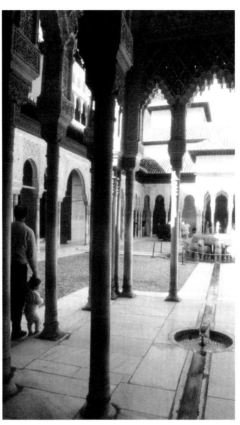

Above: *Cordoba's famous Mezquita cathedral; once a mosque it still retains the interior arches of Muslim architecture.*

Above: *In Granada, the Alhambra's Lions Court at an unusually uncrowded moment.*

Above: *The reputation of Christopher Columbus has taken a knock in some parts of the world yet a tall monument in a small town, Palos de la Frontera, from where his historic fleet set sail, is a reminder of his accomplishments.*

Left: *A domestic moment on the rooftop of a modest house in Palos de la Frontera where the street is named for Cristobal Colon, a.k.a Christopher Columbus.*

Sweden

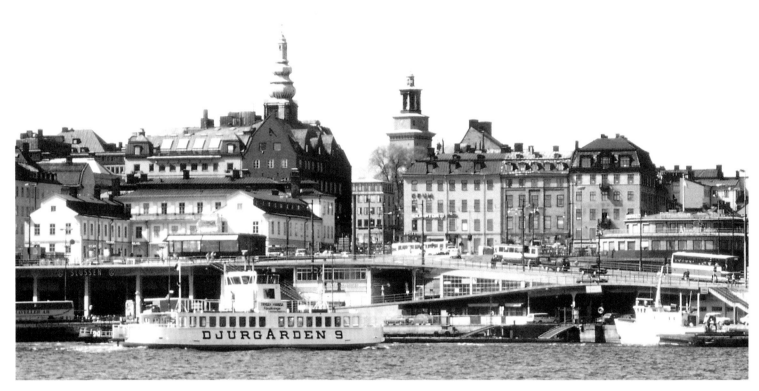

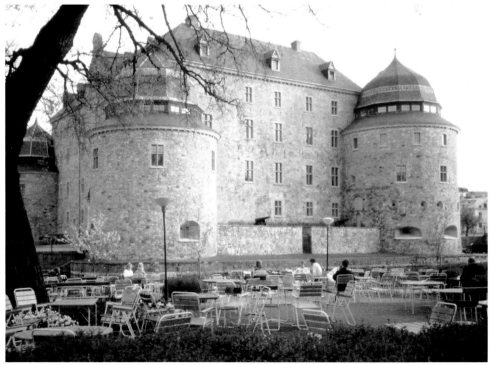

■ **SWEDEN –** The arrest of a hip-hop performer in the Smash festival in Stockholm was headline news in Sweden as I began writing these notes. 'Celebs were rallying for his release… 'Not what might be expected from Sweden's historic capital. Although, come to think of it, why not? Another current story was about archaeologists finding Viking-age boat burials. More relevant, for sure.

Realities don't always match expectations. I had forgotten, until I

Above: *Stockholm, a capital city on the waterfront*

Right: *One of Sweden's many attractions, Örebro castle.*

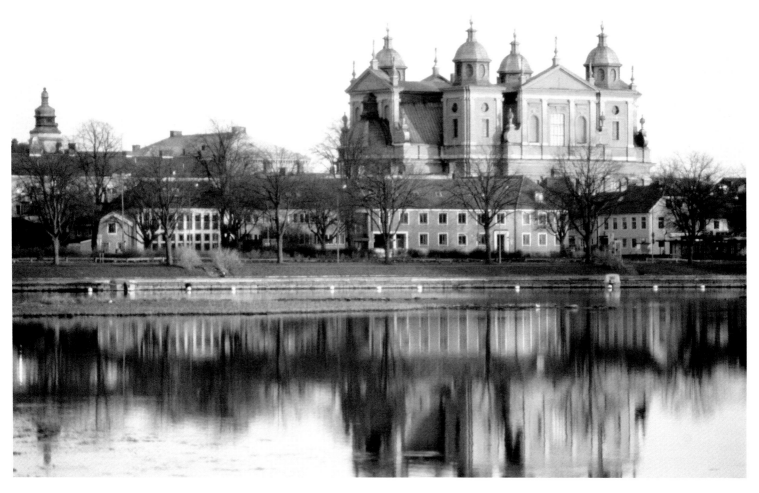

Above: Kalmar castle dates to the 12th century.

read up on Stockholm, which I last visited several years ago, that it is built on fourteen islands. A stalwart, industrialised Scandinavian country with a strong economy, long history and culture that reaches beyond film director Ingmar Bergman, writer August Strindberg, Astrid Lindgren and her Pippi Longstocking, Abba and IKEA, Sweden is temperamentally imaginative yet well-ordered. Constitutionally, the nation is a monarchy where all political power lies with parliament.

The king since 1973 is Carl XVI Gustaf. (I remember meeting him long ago when he was staying in a Kenya wildlife lodge and happily watching elephants.) Sweden has modernised succession – so it is his oldest child,

Princess Victoria, who is heir apparent, not his son, and Victoria's daughter who is next in line. Royals now perform only ceremonial duties – although when Carl Gustaf's youngest daughter, Princess Madeleine, got married in 2013, excited crowds lined the streets to watch.

Internationally, Sweden's role has always been discreet. Swedes maintained a careful neutrality in both World Wars. With a high environmental consciousness, Sweden has also confidently maintained a comprehensive and generous welfare system, financed by high taxes. It also has an

open-minded immigration policy, first called into question in 2010 when a far-right anti-immigration party, Swedish Democrats, won seats in Parliament. As the number of refugees grew, the warm welcome many received weakened. As a newspaper headline put it in 2019: 'Immigrants test Nordic model'.

Riots and violence are not a Swedish tendency. When a violent act occurs, the whole nation reacts in shock. The assassination by a lone gunman of Prime Minister Olof Palme in 1986, never resolved, was not only a matter of mystery but of grief. As was the stabbing of foreign minister Anna Lindh in 2003, an attack in a department store from which she

Above left and right: *Oland's windmills come in various shapes*

Right: *A master glassblower in the fabled glassworks of Orrefors in Sweden's Småland province.*

died. Thanks to my many years in Africa, I still recall the shock when the well-liked Swedish diplomat Dag Hammarskjöld, then UN secretary-general, died in 1961 in a mysterious plane crash in what was Northern Rhodesia, and is now Zambia. (A 2017 report found it 'plausible' that the plane came under attack.)

For visitors, Sweden is a delight. As well as Stockholm, there are sophisticated cities like Gothenburg and Malmö, palaces, museums and churches, and plenty of nature – forests, lakes and coastal islands. To eat and drink there's a wide choice, as well as *smörgasbord* and '*snaps*'. With clear light almost everywhere I went, I found sights to see, things to wonder at. Among them, that 'official' minority languages predictably include Finnish and Sámi, but also Romani and Yiddish.

United Kingdom

UNITED KINGDOM – Four countries, right now. England, Wales (since 1536), Scotland (since 1707), Northern Ireland (since 1922, when the southern counties chose independence). Picts and Celts were the first inhabitants, historians say. Followed by Romans in 45 AD, then Anglo-Saxons, Vikings, Danish and Normans – whose invasion of Britain was described in '*1066 and All That*', a hilarious book by W.C.Sellar and R.J.Yeatman from which much of my generation learned our history.

Ignoring those Normans (the hated French, from Normandy), Brits like to boast that England was never conquered, not by Napoleon nor, in the 20th century, by Nazi Germany. True,

Left: St.Paul's cathedral on a lovely summer's day.

Below: Parliament in London is the striking backdrop of a group statue by Rodin, symbolising freedom, of Burghers in the 1347 siege of Calais.

but to get a clearer understanding of who the English are now, a good example might be a sunny Sunday in mid-July 2019. It was a euphoric day for the English. Their cricket team had won the World Cup for the first time, beating New Zealand in a thrilling final that had sports fans in ecstasy. And who were that England team? The captain was born in Dublin, the family roots

Above and below, left and right: The River Thames at dusk with the setting sun highlighting striking architecture including the Shard.

of several other players were in South Africa, New Zealand, West Indies and Pakistan. 'This is England and it feels bloody fantastic,' a fan enthused. (A poll taken about the same time,

reported in *The Guardian*, found that 16 percent of over 65s believed only whites could be English.)

A point of confusion is how exactly to define who is English and who British. The beloved man in my own life was a total Englishman, all his large family born and bred in the counties. I, however, born in London of European-born parents, am British.

Top left: 30 St Mary Axe is the true name of the commercial skyscraper in the City of London known as the Gherkin, a popular addition to London's skyline.

Top right: A battle at sea is fought on a gallery wall in the Tate Britain art museum on the banks of the Thames.

Above: Rarely seen spritsail barges in a race on the Thames river.

As Londoner, I have practically nothing in common with Geordies, Scousers or Brummies, who hail from parts of the UK unknown to me and speak an accented English not every Brit understands.

As it happens, the way 'proper' English, the so-called Queen's English, is spoken has changed. Announcers in the BBC of, say, the 1950s, tended to speak in an accent that was often described as 'posh'. Now, only the upper class elderly speak 'posh'. (Class, though diminished, remains a social fact.) The rest of us, true-blue English or British-born sons and daughters of generations of immigrants, speak in the accents of schools we attended or regions where we were raised.

Most citizens of the UK have a fond respect for the Queen, active in her nineties, as I write, and rather less

affection for her family. The royal family, however, is a well-managed and adept force. The monarchy is constitutionally protected and its heritage – Queen Victoria and all that – frequently promoted in popular television sagas. None of the present generation is likely to meet the fate of King Charles I, found guilty of treason and executed in 1649.

There is little love for politicians and members of Parliament, and quite often criticism for the more than 700 lords and ladies in Parliament's Upper House, most of them appointed and all of them paid. Their role, in a long tradition, is to provide checks and balances on the decisions of the Lower House. The judgement of both Houses was roundly tested after the 23 June 2016 nationwide referendum on leaving or remaining in the European Union. The immediate result: 51.9 per cent favoured leave.

The Brexit furore that followed, consuming all rational discussion, did no credit to either House or politicians. Here was mayhem, a divided nation, chaos. But what variety! Think of the decent and honourable Theresa May. Think of the arrogant Boris Johnson who, as prime minister elected to power, on 31 January 2020 got Brexit done. Consequences were many, the future uncertain. Reforms are predicted.

All the same, tradition is what the UK is good at – except, it seems, in at least one bewildering aspect. Pubs, which provide not just beer but a social life for a vast population of Brits, are closing in large numbers. Economics, clearly, but a loss that is disruptive and unfortunate. Britain remains proud that it was the world's foremost power in the 19th and early 20th centuries, and business leaders, or the traditionalists among them, like to boast that the UK

Top and above: *A rare journey north of London took me many years ago to the Lake District and its lovely lands and waters.*

was the world's first industrialised nation. Now a joyless decline has hit close to home.

At least they have decent food to comfort them. The school food that I can still remember was so disgusting I wish I could forget it. But I did like fish and chips, and sausage and mash, and some of the pies that were to be had in the pubs of my time. And what joy when Indian food became widely available.

In politics, Brits who are up on their history recall that William Pitt the Younger exceptionally was only twenty-four when he was prime minister in 1783. Yet not even heroes are

sacred. The most illustrious name of all, Winston Churchill, wartime prime minister and inspiring orator, was obliged to give up power when his Conservative Party lost the postwar elections in 1945. (He was back in 1951; he resigned in 1955.)

Happily, bad traditions can be banished and laws updated – most notably as regards homosexuality. If it is impossible to know how many men unjustly suffered prison or disgrace – they include Oscar Wilde and Alan Turing, renowned WWII codebreaker and computer pioneer – the Sexual Offences Act 1967 was incontrovertibly beneficial in decriminalising homosexual acts 'in private between two men'. That Turing's face was to appear on the UK's £50 note from

I once did a story for The New York Times *on Rum, Eigg, Muck and Canna in Scotland's Inner Hebrides because an editor loved the islands' names. Owners would have changed since then but the islands' raw beauty must surely still be the same.*

*Photos show **(above)** Rum island seen from Eigg, **(right)** the hospitable wife of Canna's owner John Lorne Campbell (who bequeathed the island to the National Trust of Scotland), and **(overleaf)** a view somewhere in the islands.*

2019 was poor recompense, it seems to me, for the chemical castration and humiliation he endured.

The United Kingdom is not a perfect society, but it is better than many others and not only in its systems of law and

justice. Britain was once proud of the solid merit and cool-headedness of the young, self-confident administrators who departed its shores to run its empire. Yet the British cultural heritage is richer and more enduring. From that small land, sometimes green and pleasant and frequently cold and rainstruck, has emerged an astonishing wealth of superb literature, fabulous art, marvellous movies and thrilling music.

Shakespeare, the incomparable dramatist, indubitably heads the list but there have been scores of writers and poets who have filled the dreams of generations of the world's English speakers. They might start with Jane Austen, Charles Dickens and William Wordsworth, continue to such as Graham Greene and Evelyn Waugh, include Agatha Christie ('best-selling novelist of all time') and the ever-inventive J.K.Rowling. And in a country that still loves reading, the words on paper or on screens, we all have our favourite authors.

Go to the Proms (short for the Albert Hall's very popular Promenade Concerts, there's almost nothing more British than that) and Sir Edward Elgar is ever-present. The music performed, by excellent orchestras, choirs and solo artistes, will very likely include Handel's 'Messiah' – he was German-born, British by choice. Yet music reaches across an infinite space and, thanks to recording devices, can be heard anywhere.

A few famous Brits: the Beatles composed an amazing number of memorable songs, the Bee Gees had a singular sound that is still heard – as is the breathtaking voice of Amy Whitehouse. David Bowie, in his various personae, hit the stage running. Elton

John is highly regarded for his imaginative style and music. Coldplay, a rock band fronted by Chris Martin, is socially aware and always surprising. And who could forget the Rolling Stones, formed in 1962 and seemingly indestructible? British musical tastes as regards opera are also shown up in the delightfully rural settings of Glyndebourne and Garsington. For mega crowd festivals there's Glastonbury.

In the bright arena of visual art, Brits range from J.M.W. Turner who painted glorious landscapes and seascapes, John Constable, born in Suffolk and in thrall to his own countryside, Sir Joshua Reynolds, admired for his splendid portraits, to the irrepressible David Hockney, whose wide-ranging skills, strong sense of colour and vivid imagination have been on show again and again. And for each design, each work of art, there are countless more artists. In the movie world, too, what brilliant

directors there have been, and are – Alfred Hitchcock, David Lean, Ken Loach, Ridley Scott, Stephen Frears and the artful Danny Boyle. (For sure, someone will say I've missed out Charlie Chaplin and other greats, as well as photographers.)

When I was young, and lived and worked in London, long before I was a photographer, I adored the theatre, plays most of all, but musicals, too. The great actors I saw then I can still see on television reruns and DVDs. But my tastes and habits, like everyone's, have moved on. My life too. It is, though, the UK, which gave my parents a welcome, a new life and security, that I esteem above all – even as I came to know and travel around a wider world. The affection I hold, however, is not based on intimate knowledge. For all my subsequent travels, in England I was rarely further north of London than Hampstead Heath.

Vatican City

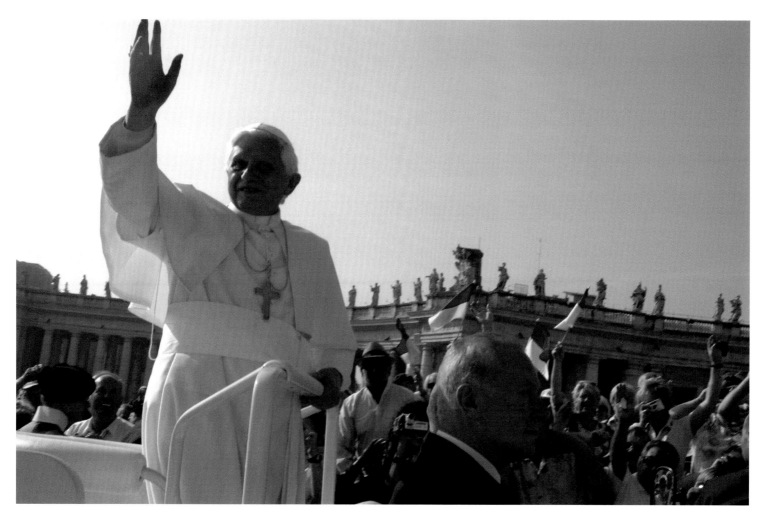

VATICAN CITY – The smallest independent city-state in the world (44 hectares, 108.7 acres), Vatican City has a population of about 800 that includes a few women, about 135 Swiss Guards (whose sole duty is the protection of the pope), some 300 cardinals, priests and other clergy, and currently two popes. One of them is the reform-minded Pope Francis, the other his conservative predecessor Benedict XVI, who retired in 2013 and is a pope emeritus.

In this singular mini-state it is not instant facts or the throngs of visitors that make the strongest impression, nor even that the Vatican is focussed on one particular religion, but the antiquity of the place. In every corner, up every step, down to humid depths, is the realisation – almost casual – of many centuries of a human presence and of the brevity of human life.

Documents record the arrival and passing of 266 popes, their acts, their thoughts, their children, where relevant, their impact. The faithful, it is clear, were remarkable record keepers as well as active employers of builders and artists – and collectors of a great deal of art.

Above: Pope Benedict XVI, who resigned in 2013, held the office of pope when I did a story on the Vatican.

Doubtless someone has the duty of continuing to maintain full records of papal activities. Celibacy may be a prime ecclesiastical obligation, but few will be surprised to read of such events as a 'sexual abuse summit'.

The Vatican enclave, a Unesco World Heritage Site, has as prime showpiece one of the world's largest basilica churches, an elegant Renaissance building said to be built over

Saint Peter's bones, and dominating a broad piazza. Here too is a superb museum that is visited by around five million tourists a year and is always teeming. Among major splendours are the Sistine Chapel with Michelangelo's exquisitely painted Genesis ceiling and Last Judgement wall, accessible through the museum. The chapel has a high roof but isn't all that large. Visitors are pressed shoulder to shoulder and, perhaps in awe, perhaps in obedience to attendants' commands, are unexpectedly quiet. (I regret that I did not take a photo. Many visitors ignore the injunction forbidding camera use and do.)

From the Sistine Chapel it's only a short walk to another impressive chamber, the so-called Secret Library. Which is not the same thing as the Vatican Secret Archives, a vast collection to which only approved researchers are permitted access. Entire sections of the archives regarded as private or controversial are closed. Among the miles of shelving and endless ranks of documents are prodigious quantities of papal correspondence, Britain's King Henry VIII's request for a marriage annulment, a transcript of the trial against Galileo for heresy. and letters from Michelangelo complaining that he hadn't been paid for his work on the Sistine Chapel. Digitisation of the archives is under way.

Top right: Vatican security involves contemporary Rome police and the Pope's colourfully uniformed personal force of Swiss Guards, responsible for protecting the Pope and the Apostolic Palace. The guard was founded in 1506.

Right: Inside St.Peter's Basilica, Rome.

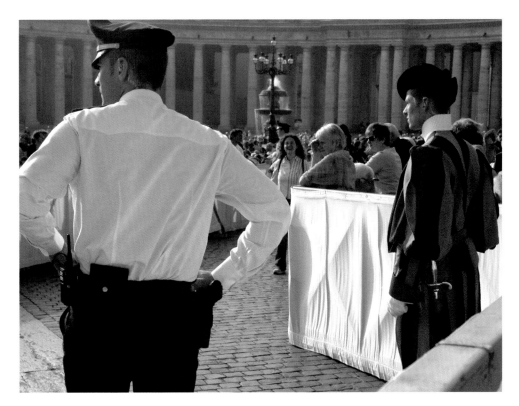

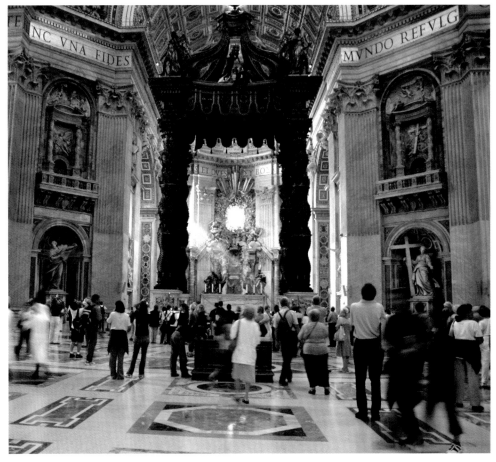

The basilica has two underground levels open to the public. The upper level, called the Grottoes, reportedly contains the tombs of 91 popes. The lower level, the necropolis, contains many more graves, including what is

Top left: The initial tomb of Pope John Paul II. Later (as is normal), he was moved elsewhere. Of 264 deceased popes, around 100 are entombed below St.Peter's Basilica including, it's believed, Saint Peter himself.

Top centre: A fine artwork of the Virgin in glass in one of the Vatican corridors.

Top right: The Vatican museums are rich in art of every kind, all of it collected by one or other of the popes. The figure here is Hercules

Left: The Vatican's spectacular Secret Library.

said to be the tomb of Saint Peter. But who knows? The strikingly plain tomb of the popular pope, John Paul II, who died in 2005, and which I visited soon after his death, was moved a few years later, after he was declared 'blessed'.

Visitors to Saint Peter's Basilica may also climb to its topmost level. Above a rooftop studded with statues are many steps through narrow passageways, ending finally at the cupola of the dome and a majestic view of the piazza and all Rome. There are many more grand sights in the museum. For me, the Raphael rooms with their breathtaking vivid frescoes were the greatest thrill. An irreverent thought came to me as I looked at those extraordinary walls. In another age Raphael, with his acute vision and

Above: The offices of the Curia, the administration organisation that, subject to the supreme authority of the sitting pope, runs the Holy See including the government of the Catholic Church.

wonderfully natural outlook, could have been a great photographer.

Vatican City also includes 23 hectares (56.8 acres) of gardens. From my own visit I recall how pleasant and tranquil they were. Yes, it was a formal guided tour but here at least there were no crowds, no buzz, no selfies. Looking online, I see there are seventeen Marian shrines. I remember only two, one – with an artificial grotto – honouring Bernadette of Lourdes, in France, the other Fàtima of Portugal. In the gardens are many trees, seem-

ingly informally planted, lush greenery, birds and birdsong. I saw a nun sweeping the steps of a modest building. Nearby was the building housing the Vatican's radio station. The imposing palace of the Curia, the pontifical government, is also here.

The gardens date back to 1279, the reign of Pope Nicholas III. There was a big re-landscaping in the 16th century, in the pontificate of Pope Julius II. Now the gardens are adorned by statues and several fountains – and even the shrines keep coming, the latest (as I write) from Ecuador. I have no idea how much time the Pope manages to spend in his gardens – they are his property – but I concluded that, for all his responsibilities, he is fortunate in his gardeners.

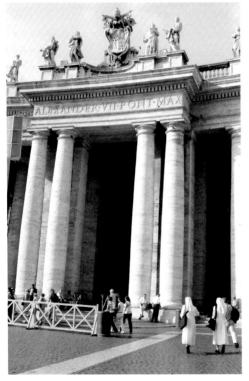

Above: *Visitors to the Vatican may climb to the very top ot the Basilica's dome. It's worth it just for the view.*

Left and far left: *The green beauty of the Vatican gardens is capped by St Peter's graceful dome; in contrast are imposing pillars in St Peter's forecourt.*

Part 5

North America

A T FIRST thought it seems odd that this immense continent was not known to exist by Europeans until the 15th century (although Vikings certainly had made landings). Swiftly chasing that idea is another thought that most of us now take what is 'across the pond' for granted, extract from it what we want and reject what we don't want. This can be put down to technology which has encapsulated every human desire and experience into one hand-held object that replaces the real world with selective imagery and sound. Yet high tech has existed for such a short time. Most of history happened when human destiny was changed by steel and gunpowder and wooden ships and recorded on paper.

In the North American continent in 1587, the first English settlers tried to set up home. They landed on an island called Roanoke off the coast of what is now North Carolina. The first birth recorded, a baby girl called Virginia, was born to the daughter of the colony's governor, John White. With supplies short, he sailed back to England, return-ing in 1590 to find no sign of his family or the colony. Efforts to find the settlers

then and later met with failure. The story went into American legend as 'the lost colony'. The next attempt at English colonisation a few years later in Jamestown was more successful and, when settler John Rolfe married the daughter of an Algonquin chief, Pocahontas, new legends were born.

The first European settler in Canada, in the meantime, was a French mariner, Jacques Cartier, whose home port was Saint-Malo. The French were already aware of

Above: *The Museum of the Rockies in Bozeman, Montana, has a glorious T-rex, nicknamed Big Mike, on its doostep. More magnificent dinosaurs are inside.*

the North American coast through fishing expeditions. Cartier's aim in 1534 was to colonise the land in the name of France and the French king, François 1. This ignored the 1494 Treaty of Tordesillas between Spain and Portugal to share discovered lands between them.

Soon, British expeditions were squabbling with French expeditions. Neither took much heed of the 'savages' already there, although friendly exchanges were made and Cartier took two sons of the local Indian chief back to France. (They were cordially welcomed, instructed in the French language, and returned home on Cartier's next voyage.)

As to Cuba, when Christopher Columbus passed by in 1492, the people he encountered were Amerindians described as Taino. And when, in 1511, Diego Velázquez de Cuéllar arrived with orders from Spain to take possession and form a settlement the Tainos fiercely resisted. Not fiercely enough, as it turned out. The Spanish were there until 1898. Shortly afterwards, Americans moved in.

Mexico belongs in North America geographically, to Central America by custom, to Latin America ethnologically. It is the largest Spanish-speaking country in the world. Some 68 national languages are spoken, of which 63 are indigenous, a look online tells me. Like Canada, Mexico is profoundly affected (afflicted?) by its imperious neighbour, the United States. It has, though, a distinctive quality all its own as well as fascinating ruins from earlier times and cultures. (There's more under Mexico, below.)

Researching North America, I was astonished to learn that the continent, still often described as the New World, encompasses 23 sovereign nations. As I have only visited six of them, I am put in my place as world traveller. If I live long enough I will travel to more of our world's established nations. To me, though I'm told I lack curiosity, this is much more worthwhile than heading off into arid and unwelcoming outer space.

Canada

■ **CANADA** – The largest country in the continent, and second largest by total area, after Russia, in the world, Canada by measures that include most educated, environmental concern and quality of life, often comes out as 'the best'. Could that be because 90 per cent of its land is uninhabited? The low density of its population has led Canada to have an open immigration policy which, in turn, has led to a pride in its diversity and broad acceptance of different religions, lifestyles, ethnicity, sexual orientation and more. It also, under a heading of interesting facts, has a bigger population of bears than anywhere else.

English is the language spoken by most Canadians yet French, not any more quite the fierce political issue it was, is still widely spoken in Quebec

Above: Dating to 1866, Canada's handsome Parliament is in an area of Ottawa, the national capital, known as Parliament Hill.

(an issue not exactly eased when French president, Charles de Gaulle visiting Montreal in 1967 declared '*Vive le Québec libre*'). Toronto, English speaking, and capital of Ontario, is Canada's largest city. Montreal, primarily French speaking, is the second largest. Vancouver, on the west coast in British Columbia, is the most diverse of Canada's cities, with half the 2.2 million population speaking neither English nor French as their first language. Calgary and Edmonton are the biggest cities in Alberta, which is regarded as the main gateway to the Arctic region whose isolated

inhabitants are mainly Inuit, one of three First Nations groups.

It is not polite any more, I should note, to call the Inuit Eskimos. Equally, the word 'Indian', used to describe most of North America's indigenous people, is incorrect, a misnomer that supposedly derives from explorers' thinking, like Columbus, they had arrived in India. The Canadian city of Edmonton, however, has a widely supported professional football team called Edmonton Eskimos, founded in 1949. Apparently, in discussions on the team's name, some Inuit approached on the matter did not find it disrespectful. Others felt it was time to move on.

The Inuit now have their own self-governing region in the Arctic, Nunavut, the first to have a majority indigenous population – and strikingly beautiful it is, too, as I discovered myself. Here too is the renowned

Below: In Edmonton's estimable Royal Alberta Museum wide-ranging displays include this diorama of an eagle with its chick.

Northwest Passage, linking the Atlantic and Pacific oceans, and now accessible to shipping. Which it was not in 1845 when Sir John Franklin, a British explorer seeking the route, not only became icebound near King William Island but lost his life, his two ships, HMS Terror and HMS Erebus and his 129-member crew. (There is a gripping saga in the recent discovery of the sunken ships.)

Above: Linking the Ottawa River in Ottawa to Lake Ontario in Kingston, the 202-km (125 miles) canal, completed in 1832, was originally conceived as protection for Canada in case of war.

Below: A prosperous city on Canada's North Saskatchewan River in eastern Alberta province, Edmonton has an elegant city centre.

Retreating sea ice, however, does not favour the region's spectacular wildlife. There is already considerable concern for threatened polar bears and, as the Arctic becomes more navigable, for vulnerable walruses, narwhals and bowhead and beluga whales.

The capital of Canada, Ottawa, is not the most visited city, yet it has an intriguing Unesco World Heritage Site in the 202 km (125.5 mi) Rideau canal, cleverly engineered for military purposes in 1832 to connect the city to Lake Ontario and the Saint-Lawrence River. It also has several excellent museums and neo-Gothic architecture in the legislature complex on Parliament Hill. And all Canada has almost more lakes than anyone can count.

Above: A warming Arctic and melting ice are already making life difficult for polar bears. It was a thrill to see this healthy mother and her two almost grown cubs.

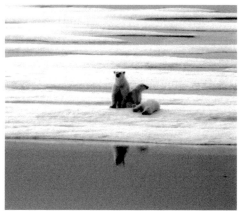

Right: A view of a pack ice-covered Arctic from an expedition ship includes a distant polar bear with her cubs.

Below left: A mighty cliff is gateway to the Arctic's magnificent Gibbs Fjord, off Baffin Bay, the rock walls dating to a pre-Cambrian era.

Below right: Icebergs in Arctic waters come in all shapes and sizes. This one, gloriously blue, seemed to resemble a cat.

Its huge wilderness started Canada on the path to government. A fur trade built on trapping was the basis of rivalries between the early settlers – French, English and Dutch. The Hudson's Bay Company, as I remember from school history books, was founded by London traders in 1670. Brits benefited from the various wars and rivalries in following years to form a Dominion of Canada in 1867. A new railway, a gold rush, immigration, led to a more cohesive nation. By 1931 British dominions were completely autonomous. And though, in 1965, the Canadian flag no longer included a British flag, a warm alliance, already demonstrated in both World Wars, continued.

From 1968 until 1984 the leading political figure was the Liberal Party's Pierre Trudeau. Progressive Conservatives followed, interchanging with Liberals in subsequent elections. In 2015, succeeding Conservative Stephen Harper, the Liberals' Justin Trudeau (son of Pierre Trudeau) won power by a landslide. Popularity, however, hangs by a slender straw. Publication of long ago photos of Trudeau attending a party in blackface was likely to have a negative impact. He was, however, re-elected in 2019, though with a much narrower victory.

Islamic extremism has not left Canada untouched. Across the years there have been plots and incidents and violent responses which seem sadly inappropriate in the context of Canada's pursuit of a peaceable role in a complex world. Their immigration policy alone, which included a programme of offering citizens the opportunity to sponsor refugees privately, has been a good deal more

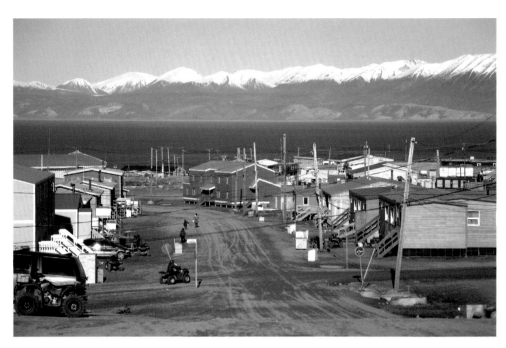

Top: The main street of the town of Pond Inlet.

Above left: In Pond Inlet, Nunavut, three generations in an Inuit family: mother, child and grandmother.

Above right: In Pangnirtung, in the Canadian Arctic, young Inuit women, their costume a mix of trad and mod, prepare to entertain visitors.

open than almost any other country. Total population even now is just under 38 million. Nationalities and ethnicities listed by immigrants would seem to cover the entire planet.

Canada is exceptional in a variety of ways. Its size, its huge wilderness, its atypical mix of population, its tolerant national outlook embracing open borders and open markets. Even its

conservatives are less conservative than most others including, say, American Republicans. Xenophobia is practically non-existent. True, violence against indigenous girls and women has been shockingly frequent but Canadians rarely hate other Canadians or almost anyone else. And nobody hates Canadians.

Costa Rica

■ **COSTA RICA** – Biodiversity – a rich wildlife and birdlife in a natural setting – is what brings most visitors (including me) to this small Central American nation, its western coastline facing the Pacific ocean, its eastern coast overlooking the Caribbean sea. The fine capital, San José, is beaten as attraction by its rugged landscapes and largely protected jungle and beaches. I won't be the first to have noticed that tourism overtook bananas decades ago in national economic terms.

In Costa Rica it's ecotourism that matters, so happily there's little that's gaudy or loud – excepting the more vivid birds such as scarlet macaws and

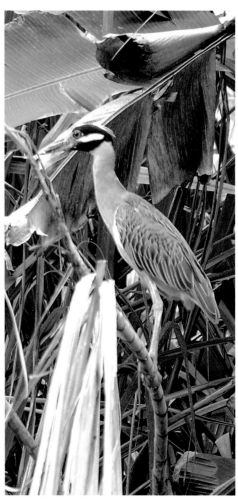

Top left: An unattractive design, I thought, for a boat carrying people to see wildlife but, in a short outing, we didn't see much anyway.

Top right: A howler monkey actually howling? Or maybe just having a yawn.

Above: Happy to see what was said to be a sloth, I have only this poor picture to prove it. (But is it?)

Right: A beautiful bird, great, but with an unfortunate background.

quetzals. The national bird is a modest clay-coloured thrush, just one of 850 species of birds sighted there in a variety extending from hummingbirds to eagles. (I saw birds, too, but none of the above.) Mammals include coatis and, the national animal, white-tailed deer. Perhaps I should mention, if only for balance, that wildlife also includes some quite unpleasant spiders and snakes, millipedes and mosquitoes.

All the prime features and attractions, quality museums in San José apart, are rooted in nature. The live Arenal volcano and its hot springs are conspicuous. National parks include Manuel António, Tortuguero, Corcovado and the Monteverde Cloud Forest reserve as well as the Santa Elena Cloud Forest reserve. (Equally, none of these exists in isolation and all the usual tourist facilities are at hand.) Alongside protected areas, too, quite a few citizens engage in agriculture – tropical fruits including bananas and pineapples are still a useful export. (I saw a lot of bananas.) And increasingly all the stuff of high tech life is evident in corporate services for foreign companies and in free trade areas.

Looking online to see what else I might find, an interesting fact emerged. In Costa Rica the sun rises and sets at the same time 365 days a year.

Top right: *Attempting to show Costa Rican lifestyle, I picked on this bungalow. How representative is it? I don't know.*

Right: *I saw only a little of Costa Rica (the Rich Coast) during a poorly arranged visit but I did see a lot of bagged bananas.*

Cuba

■ CUBA – For many of us the one word, or name, associated with Cuba is Fidel, so strong was the charismatic image of the cigar-smoking, bearded soldier, Fidel Castro, who, with his brother, Raul, their Marxist colleagues and supporters, ran the Caribbean island of Cuba from 1959 to 2006. But he wasn't there always, he's not there now, and there are other perspectives. Still, what the Cuba regime chooses to call a 'people's democracy' is no democracy at all, according to nearly all foreign governments and human rights organisations.

From 1492 until the 19th century Spain was the predominant power. Hernán Cortés, who would go on to wreak destruction in Mexico and South America, was a member of an expedition to Cuba, got himself a job there and even became mayor of the town of Santiago. Later, at a time when slavery and sugar plantations were a central theme and much was happening in the American mainland, there was an interesting exchange that ended a 'seven years war' involving Spain, France and Britain. A treaty gave Britain Florida in

Top right: An inland view that includes distant mountains and sugar cane. Sugar was always Cuba's prime export, and still is.

Right: A 'classic' American car on a Havana street. Cubans loved big American cars and imported them until Fidel Castro, after 1959, stopped them coming. Cars from the 1940s and 1950s are sill cherished but few survive.

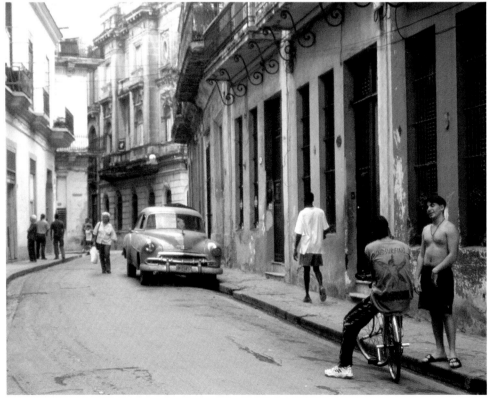

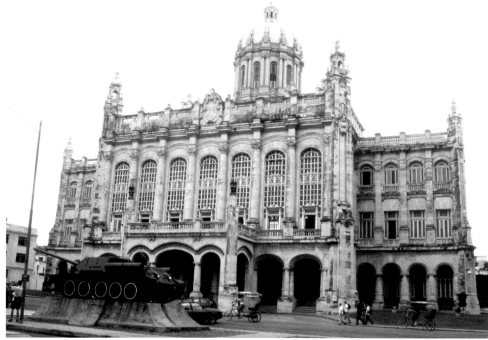

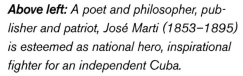

Above left: A poet and philosopher, publisher and patriot, José Marti (1853–1895) is esteemed as national hero, inspirational fighter for an independent Cuba.

Above right: What was once a presidential palace became the Museum of the Revolution, in front a tank said to be used by Fidel Castro in the 1961 Bay of Pigs battle.

exchange for Cuba, which most British thought a poor deal.

Everything changed as the British colonies in North America declared their independence, a revolution exploded in France in 1789, and slaves rebelled in Haiti in 1791. Movements towards independence arose in Cuba, but were not successful. They did however give modern Cuba its first national hero, José Marti, who fought fiercely for Cuban independence. With the eventual departure of Spain from the scene, it was inevitably Americans who moved in. By 1902 American companies owned most of the sugar

estates. In that year, too, Cuba gained its independence, with the exception of a lease to the US of the then not particularly significant Guantánamo Bay. Business was good. Tourism had made a successful start.

The arrival of socialism in 1925 was a key moment in political change. The next was a coup organised in 1933 by a sergeant named Fulgencio Batista, who pushed out the disliked governing Gerardo Machado, and succeeded, with help from the US, in making himself rich, and president, and in charge (more or less) until

Above left: Lest anyone forget, a large sign reminds passersby of national political beliefs.

Above right: An elderly Dodge is someone's treasure.

1959 when he was forced to flee by Fidel Castro and his guerilla army.

Fidel had made one attempt at revolt in 1953. It had failed and he had been briefly imprisoned. The successful attempt went into history: Fidel's journey to Mexico, where he met and was joined by Argentina-born

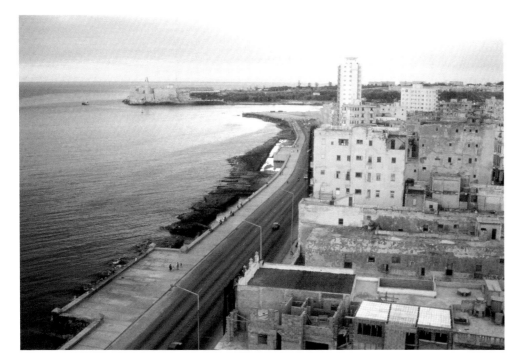

Above left: The northern foreshore and sea wall of Havana, known as the Malecón, is a popular esplanade and promenade.

Above right: Efforts have been made in recent years to restore Havana's stylish architecture, much of which had become degraded by time and poverty.

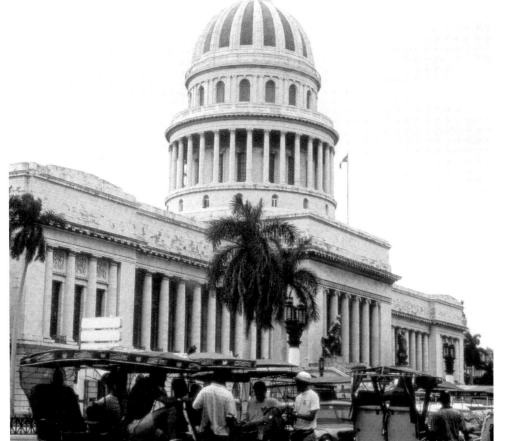

Left: Once Havana's American-style Capitol, it later housed the Cuban Academy of Sciences.

Ernesto 'Che' Guevara; their sojourn in Cuba's Sierra Maestra mountains; their advance into Havana, Fidel Castro becoming prime minister.

From here on Cuba ran its own highly individualistic path as a communist state. All US businesses were nationalised without compensation. The US promptly broke off diplomatic relations, which would not be normalised until 2015, in Barack Obama's presidency. Those fifty years were marked by numerous crises: the 1961 'Bay of

Pigs' aborted invasion by Cuban exiles; the 1962 missile crisis, when Cuba had allowed the USSR to place nuclear missiles on the island; the 1970s use of Cuban troops in Africa; the 1990s US economic embargo and its consequences; the efforts of Miami-based exiles to aid fleeing families; Cuba's own censorship and crackdown on its

Benedict in 2012), former US president Jimmy Carter in 2002, and tourism discreetly opened up. That Ernest Hemingway had delighted in Cuba, had a home there and regularly drank in a couple of favourite Havana bars, undoubtedly helped.

In the first years of the 21st century the familiar image of Fidel Castro slowly

excellent dinner at a reasonably smart restaurant, listened to music everywhere. Legendary American cars with their big fins were parked in the main square and handsome city buildings were being restored and painted. Fine cigars were being touted in the streets. This was well before tourism had reached five million visitors a year, and

dissidents. A point in Fidel's favour: his regime brought education and universal health care to all islanders.

From the chaos there also emerged a small and crucial group of people: musicians. When Cuba's traditional music and Wim Wenders' film 'Buena Vista Social Club' reached the outside world in 1999, guitarist Compay Segundo, singer Omara Portuendo, the equally entertaining Ibrahim Ferrer and their mostly elderly fellow musicians achieved instant worldwide fame. With that warmhearted music the tide turned. Cuba, still devoted to communism, began to welcome visitors. Pope John Paul II came by in 1998 (and Pope

faded. Illness led to retirement and in 2008 his brother Raul Castro took over as president. A range of restrictions was lifted, detainees freed, ties with old enemies and friends renewed. In 2011 a law was passed allowing individuals to buy and sell private property for the first time in fifty years. More reforms were on the way when Fidel Castro died in 2016. In 2018 a Communist Party politician, Miguel Diaz-Canel, became president, marking the end of six decades of rule by the Castro family.

I remember celebrating a birthday in Havana several years ago with a good friend. We drank a mojito at one of the Hemingway-favoured bars, ate an

Above left: *A fine Havana house still (in 2001) awaiting rehabilitation..*

Above top: *Cuba tourism still depends on blue seas and sunny skies.*

Above: *A single guitarist or a group of musicians performs in most restaurants though the music is not always appreciated by diners.*

few people had any money. An old woman, whose entreaties I had not understood, was asking us for soap. But the mood was relaxed and congenial. Cuba, its hard times very nearly over, was on the mend.

Mexico

■ **MEXICO** – Because of the heavily reported 2019 anti-immigrant policies of its pugnacious northern neighbour, it might seem as if Mexicans do little else but try to enter the US. In fact, while the American population includes many Mexicans, there legally and illegally, Mexico itself is home to some 126 million people whose concerns are entirely local. According to the statistics, in 1900 there were only 13 million or so Mexicans, so the increase is extraordinary. Is it, I wondered, due to a high fertility rate, high immigration (what an irony that would be), or to some other source. I failed to find a clear answer. Things are what they are.

In part my interest was due to a moment when, in a Mexican street, I noticed a short Mexican man heading into a money exchange agency, and saw he was sending money to someone in the US. So much for the general

Above: Monte Albán is a large and spectacular pre-Columbian archaeological site near the city of Oaxaca. An early Meso-american city, it was inhabited by the Zapotec people for many hundreds of years

belief that US dollars were keeping Mexican families in tortillas. Moreover, statistics show, too, that it is not mainly Mexicans who are among the many people US immigration authorities face daily, but distressed families from South American countries, their wretched state due to conditions close to home.

Like so many other territories in the Americas, Mexico's modern origins are due to the aggression of Spain's conquistadores. In they came in 1521 and, in effect, stayed for 300 years. Gold was what they were after. Hernán Cortés, an avaricious man who despised the indigenous civilisations, encountered the Aztecs, was

Above right: It's shoeshine time. Oaxaca, a vibrant Mexican city with a comfortable climate, appealing ambience and many good restaurants, is popular with North Americans and Mexicans.

welcomed in their capital, Tenochtitlán (later Mexico City), tricked their leader Montezuma, and kidnapped him. Unfolding events, including the arrival of smallpox, were disastrous, most of all for the Aztecs.

Mexico, Spanish-style, grew in fits and starts, gains and losses. In 1824 it became a federal republic, in 1836 it 'lost' the province of Texas, which soon joined the US.

Ten years later, war with Americans brought further loss. California, Nevada, New Mexico, Arizona and Utah all went to the northern power. In Mexico, the society was largely divided between Spanish-descended

landowners and indigenous peasants. Also in the picture: large numbers of 'mestizos', the mixed race product of rapid social growth.

Instability and revolution dominated the Mexican scene for years. Heroes arose – guerilla leader Pancho Villa in events leading to a constitutional government; and Emiliano Zapata, the leader of a revolt in the far south and inspiration for a larger rebellion in Chiapas in 1994. An uncertain stability had begun in 1929 with the formation of the Institutional Revolutionary Party (PRI). They would dominate government until 1997 when, to the surprise of most Mexicans, the party lost its majority, making way for Vicente Fox, the first opposition candidate in 71 years to become president, after the 2000 elections. Nothing lasts. In the nature of the game, a PRI candidate won in 2012 – but in the 2018 presidential

elections it was the former mayor of Mexico City, left-wing Andres Manuel López Obrador, who got the top job.

Politics was one thing, daily life another, and drugs the pretext for horrific violence dispensed by brutal

Top Left: *Olmec colossal head no.1 is in the Xalapa anthropological museum in Xalapa, Veracruz. Dating to at least 900 BC this and other basalt heads come from Mexico's earliest civilisation.*

Left: *Mexicans, as passionate about football as any other nation, have carved out a fine field in rough wilderness*

Below left: *In the governor's palace in Oaxaca a mural by Arturo Garcia Bustos portrays native son Benito Juárez who became President of Mexico.*

Below right: *A photo showing Oaxaca's mixed cultures..*

Above: Oaxaca's splendid St. Domingo church has a baroque façade, cloisters, a remarkable Tree of Jesse and much golden decoration.

Above: Its ornamental façade displays worshippers' love for their church in the small town of Ocotlán.

Above: The significance of the church in the Chiapas town of San Juan de las Casas is not its plain exterior nor even its plainer interior, but its congregation of entirely indigenous Tzotzil people who gather in family groups on the rush-covered floor to pray among smoky candles. Visitors may enter the church but photos are forbidden.

Left: A handsome cathedral that dates to colonial times and is an impressive sight in San Cristóbal de las Casas in Chiapas.

gangs. More than 50,000 deaths were listed in one five-year period. Intimidation included gruesome beheadings, shootings, mutilations, one atrocity after another aimed to terrorise rival gangs – and government. All because of the rich rewards provided by American consumers.

I read the appalling stories but was never involved in reporting them. I saw a Mexico of beauty, culture, tradition, people who were skilled at crafts,

Above: *Mexican markets are commerce and lifestyle, colour and crowds. At **right**,*

impressive churches, still-standing ruins of extraordinary architecture dating from Mexico's sophisticated past. I enjoyed Mexico's spicy cooking, drank its tequila, watched

Below left: *Women's dresses on sale at the market in Ocotlán, a town in the Oaxaca region popular for its variety.*

in a corner of Oaxaca's Zócalo, central square, gaudy souvenirs are on offer.

a little of its football, became a fan of Frieda Kahlo, stood back from Day of the Dead celebrations, saw some of its quieter places. I was just a traveller and loved it all.

Below right: *Art and culture are represented in a simple bench.*

Panama

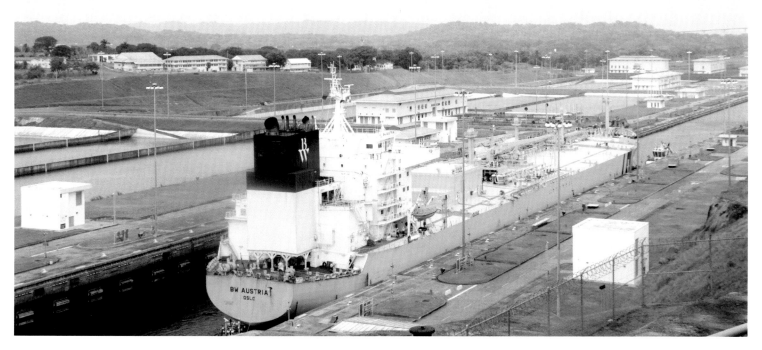

PANAMA – All the world knows of the Panama canal, a remarkable feat of engineering that provides a shipping route between the Atlantic and Pacific oceans. I wonder how many are aware that Panama's national territory includes 1600 islands, rainforest, hundreds of rivers, thriving parks, exhilarating wildlife and cities, most of all the capital, Panama City, distinguished by handsome colonial as well as elegant highrise buildings. Few nations, moreover, can claim as odd a geographical shape as that of an isthmus, especially one between two mighty American continents. And a land facing two

Above: Everything, it seems, benefits from an upgrade. In 2016 an expansion of the original canal doubled its capacity.

oceans? The first European mariners found it hard to believe.

The American context, after the initial Spanish explorations and colonisations, has understandably dominated Panamanian life and history and much of its economic development. Involved for a time in the mesh of central American plans of the ambitious Simón Bolívar and his project for a 'Gran Colombia' (1819–1830), Panama – described in a letter by Bolívar as 'the center of the Universe' – declared independence from

Spain in 1821 and 'separation' from *de facto* controlling Colombia in 1903.

The canal, with a riveting history all its own, was started in 1882 by a French diplomat, Ferdinand de Lesseps, known for his work on the Suez canal. When the project failed for a variety of reasons, construction after much politicking involving US president Theodore Roosevelt, was taken on between 1904 and 1914 by the US Army Corps of Engineers. The section cut through by then was under US sovereignty. All of it was returned to Panama on 31 December 1999.

New investment brought new locks. From an illuminating visitor

centre I was able to see both old and new locks as well as the huge Lake Gatun where ships wait to enter the locks. It appears to be a well-administered process and shipping companies pay large sums to use it.

In the 'American' decades, Panama's government veered between civilian and military. In 1983 General Manuel Noriega assumed power despite a civilian winning the presidential election. In 1988 Noriega was indicted in a US court for drug trafficking. Presidential elections in Panama in May 1989, won by a civilian, Guillermo Endara, were swiftly annulled by Noriega. On 20 December American forces invaded and, 'objectives achieved', began to withdraw on 27 December. Endara was sworn in as president in an American base, Noriega removed to a US prison to serve a 40-year sentence for drug trafficking.

Of course, it wasn't as simple as that. But life and politics did continue, peace return and prosperity increase. In May 2019, presidential elections, the sixth since the US ousted Noriega,

Above: *Lake Gatun, artifically created by a dam, forms a large part, 33 km (20.5 miles) of the Panama canal.*

Below left: *A howler monkey is a denizen of the lush forests on the Gatun shore.*

Below right: *Wildlife inhabits the Lake Gatun. A caiman lolls on a log near a shoreline.*

Above: From a hillside viewpoint beside the new locks the old locks are visible across a green plain.

Below left: The slow, steady progress of ships passing through the canal is matched by a sloth up a canal-side tree.

Below right: The old canal lock is visible from a roadway beside the container ship looming above.

were won by the centre-left Laurentino Cortizo. A former agriculture minister, he promised, like all the candidates, to fight corruption, deal with unemployment and rid Panama of an unfortunate money-laundering image. More positively, Panama is said to be a popular place for companies to invest due to its favorable tax laws.

For myself, I was enchanted to see in a brief visit the extent of wild places

Above: Panama's capital is 50 miles (80 km) to the south; these are the port buildings of Colón, the city on the Caribbean coast close to the canal entrance.

and some of the wildlife that inhabits it. Giant ships proceed through the canal in a slow and regular pace. Three-toed sloths, close by, seem to progress no faster.

United States

■ **UNITED STATES** – Outside a museum in Bozeman, Montana, stands a splendid skeletal Tyrannosaurus rex. I found it most reassuring as it reminded me that the United States today is not all internet based, all high tech, apps, Wi-Fi and social media, but has a thrillingly earthen, bony past. Inside this Museum of the Rockies were more dinosaurs, more fabulous creatures, more wonders from our planet's life story. No doubt it is the latest technology that helps create the displays but I can ignore that. Like the moon landings and images of Neil Armstrong and Buzz Aldrin walking on the moon's surface, the breathtaking is more mind-blowing than any scientific explanation. And Americans, brilliantly inventive and with a gloriously rich culture, are clever at providing thrills in all the arts as well as in science.

As to American history, it is quite a shock to recall that until 4 July 1776, what was in that largely unexplored continent were a mere thirteen British colonies. How quickly things changed. The freshly united states were fortunate in the quality, imagination and determination of their founding fathers. What a fine Constitution they drew up. What a magnificent Bill of Rights. What a shame that it took a civil war and the goodwill of a few upright and worthy men (and women) to craft a nation where good intentions prevailed. All the same, while the legacy of early presidents George Washington and Abraham Lincoln is rightly honoured, it seems to have been difficult for some of their successors to keep on a principled path.

Above: This sweeping view towards Manhattan is from the Jersey City side of the Hudson river.

Right: Street signs in New York tell their own story

As the United States of America grew, gathering new states and lands through war or negotiation to reach a total of fifty – the last two, Alaska and Hawaii, admitted only in 1959 – so grew its influence, wealth and impact on the rest of the world. The young country had learned it could buy its way anywhere. It had acquired from France in 1803, in the so-called Louisiana Purchase, a whole state, or around 828,000 square miles (2,123,790 squ.km), for $15 million. Massive immigration in the 19th

century of hardworking Europeans overcame indigenous rights to the land, mainly in the West (generating gaudy Western literature and blood-and-thunder movies), and raised to fever heat and civil war in the south the issue of slavery and its abolition.

To this day Americans are deeply connected with their past. Whether it's in their obstinate attitude to guns, absurd to many other nations, or in the white supremacist views of a large segment of the population, or the reactionary stance on abortion, or resistance to Darwin and to climate change, a conservative and narrow-minded outlook is common in a society still clinging to religious and fundamentalist notions. Fortunately, there is also a high level of open-minded and egalitarian opinion, a remarkable culture, excellent – if diminishing – newspapers and magazines.

None of us in a connected world can ignore the US. Its wealth and power mean that its role in matters military, diplomatic, financial,

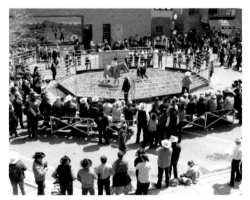

Top left: *The Chicago Mercantile Exchange Eurodollar pit in 2004, one of the world's busiest 'futures' exchanges.*

Centre left: *In Cody, Wyoming, an auction is in progress – of horses. From all the stetsons you know you are out west.*

Centre right: *They start them young in cowboy country.*

Left: *Yellowstone National Park, the first park to be established in the United States, offers thrills galore, from wolves to high-spouting geysers, not forgetting brawny bison, coping here with deep snow.*

Top left: *Driving from California into Nevada crosses landscapes where sun, sky and grasslands dominate.*

Top right: *A glorious freshwater lake in the Sierra Nevada, Lake Tahoe is a favourite weekend retreat for many Americans.*

Centre left: *In terrain of dry Sierra grasses this lovely sundappled cottonwood tree is like a striking piece of art.*

Above: *Out west, this signpost marking entry from California into Nevada seems to be out of a movie.*

Left: *A visiting family looks at a Yosemite view dubbed the Tunnel for its apparently endless space through rocky mountains.*

Top left: *The most famous rock wall in Yosemite National Park, El Capitan enthrals all climbers.*

Top right: *I saw far finer views of San Francisco but this was the first.*

Left: *In San Francisco Bay, Alcatraz is an island with a long, rich and dramatic history – as fort, prison and setting for many movies.*

environmental or technical is always in the headlines. Many of us are engaged in its sports, note the doings of its celebrities, enjoy its entertainment, have views on its politics, even keep an eye on Wall Street. The historic crash of 1929 sparked a Great Depression that extended beyond American shores.

With the outbreak of World War II, the 1941 Japanese attack on Pearl Harbour, which brought the US into the war, was a critical event not only for the United States. President Franklin Roosevelt was more than the close ally he became.

D-Day and the Normandy landings that led to the end of the war in Europe were an intensely shared experience. The nuclear bombs dropped on

Hiroshima and Nagasaki by order of America's President Truman transformed the civilised world. The postwar Marshall Plan helped restore Europe's shattered economies.

There were also incidents and events and wars which seemingly had an entirely American character. Senator Joseph McCarthy's obsession with communism in the 1950s was cruel and damaging. The Korean War at much the same time – what was that about? And then there was the disastrous Vietnam War in which 58,000 Americans died, and thousands more Vietnamese – but they, at least, were the victors.

In America, business rolled on, the military expanded, scandals made

Above: To see beautiful and historic Charleston at a good slow pace take a tour with a horse and carriage.

headlines, presidents came and went – John F. Kennedy assassinated in 1963 in a drama that gave conspiracy a new meaning – the roughhewn Lyndon Johnson, whose presidency brought into law the Civil Rights Act which aimed to end discrimination on grounds of race, colour and religion; Richard Nixon, forced to resign; Gerald Ford, briefly; Jimmy Carter's time cut to one term by a hostage crisis in Iran; handsome film actor Ronald Reagan, who nobody could dislike; then George H.W. Bush, for a term, followed by the Arkansas Democrat Bill Clinton, caught

Above: *Every city has intriguing architectural features: in Charleston many fine houses have their porches in an odd place.*

out in a lie and sex scandal and (unsuccessfully) impeached. Oh, what times these were.

The 21st century brought another George Bush, son of H. W, whose presidency was struck by the worst terrorist attack the US had ever known. Exceeding even the most tragic of mass school shootings, the '9/11' act of terrorism – it happened on 11 September 2001 – brought down Manhattan's World Trade Center towers in clouds of fire, smoke and dust, and killed close on 3,000 people. Thousands were injured. More deaths would follow. The attack, by the Islamist Al Qaeda group, involved four hijacked aircraft and aimed at other targets including the Pentagon.

Americans did not easily overcome the shock and grief. An all-inclusive Homeland Security Department was created, among concerns over civil liberties, and a 'war on terror' launched against Afghanistan and Iraq. In 2011, in the presidency of Barack Obama, the first black American to hold that office, US forces killed Al Qaeda leader Osama bin Laden, found hiding in the Pakistani city of Abbottabad.

In 1968 black civil rights leader Martin Luther King had been assassinated. In 2015 a white supremacist shot dead nine African-American worshippers in a church in Charleston. Race, evidently, remained an enduring issue. The Charleston attack was in the second term of

President Obama, who had won high praise, from Democrats at least, not just for his eloquence but for his political achievements. Among them were a bill on health care reform, an arms reduction treaty with Russia, measures for improving environmental quality and, along with world powers that included China and Russia, France and Germany, a nuclear deal with Iran that would prevent Iran from advancing its nuclear facilities.

In a surprising result, the 2016 presidential elections were won, not by

Democrat Hillary Clinton as predicted, but by Republican Donald Trump. She won the popular vote. He won the decisive electoral college votes by 304 to Clinton's 277. Trump at once began to tear down every Obama achievement, starting with withdrawing the US from the internationally accepted Paris Agreement on climate change. He tried, but failed, to destroy Obama's health care reforms, but attacked every measure Obama had signed into law including the Iranian nuclear deal. He also piled on sanctions wreaking havoc on Iran's economy.

No-one following events can have forgotten Trump's earlier attempts to claim, falsely, that Obama, then only a candidate for the presidency, was not born in the US.(Obama was obliged to prove that he was.) Few now saw

Top: Of Chicago's remarkable buildings I loved this one in East Wacker Drive with more of the city artfully reflected in its gleaming walls.

Above: For Chicago, city centre in the distance, Lake Michigan, at right, is an enduring and charismatic presence.

anything but malice in Trump's actions. During his presidency Trump has been frequently described as liar and racist, as a person unfit for the high role to which he had been elected. It was noted that he liked to promote friendships with dictators rather than allies, that he aggressively slashed environmental regulations, employed inhumane measures against migrants and demonised opponents as dangerous extremists attempting to destroy America. And while Trump was successful in maintaining a considerable 'base' of core supporters, his detractors were not all Democrats or even politicians. Among elected Democrats were some who urged that he be subjected to impeachment.

With divided opinion and in a context where most Republicans, the Senate majority, would not support any impeachment, it seemed unwise to pursue an investigation. Yet the provocation was strong and, in September 2019, proceedings cautiously began. And in a telephone call Trump made to the Ukraine president, a former comedian, came evidence of abuse of power. There had rarely been a day without a new lie, a vicious insult, a failure of judgement, a childish tweet – capped in October by Trump's cruelly wilful betrayal of the Kurds, America's ally in Syria. By pulling out the small US force and allowing an immediate Turkish assault he unleashed chaos. Even loyal Republicans were critical.

The impeachment of President Trump, inevitably, was unsuccessful. With his acquittal, he promptly fired two distinguished witnesses whose testimony he did not like. As *Guardian* journalist Jonathan Freedland noted, there was 'Trump bragging and

Above: *At the time, Barack Obama, speaking in a Chicago suburb, was campaigning to be a Senator. All the history-making rest followed.*

swaggering in vengeful celebration as he escapes punishment for a high crime he clearly committed'. And many thoughtful people wondered how much more damage this perfidious president might do to his country and the world.

America, as far as I was concerned, could never be dull. My first taste of it was in 1968 in Las Vegas. A friend in Kansas had won a prize for a week's free stay for two – she said it was from letting someone show her how a vacuum cleaner worked – and she invited me. At that time a keen young photojournalist, I lived in Nairobi, Kenya. Las

Vegas was everything I imagined the US to be (and it wasn't nearly as glossy and glittering as it is now). We ate the extraordinary meals that were available at all hours, drank free cocktails, looked into ridiculous wedding chapels, explored casinos and, just once, cautiously played the slots. (I put in a nickel, got back a dime and left Las Vegas 100 per cent up. Or that's how I remember it.)

As the years passed I was frequently in New York, mainly to talk stories and photos with photo editors at *Time* and other magazines. I adored catching up with eminent photographers. *Life* photographers were in the same building. Some for me were heroes. Ken Regan and his colleagues at Camera 5 became good friends. And for a few years I was quite often in Washington DC, the photo director at *National Geographic* Bob Gilka and his colleagues always welcoming. I had family in the US, too, who generously hosted 'cousinly gatherings'. I loved the America I saw on many visits, a few of them for work. Living now in France, I am absurdly pleased that the Statue of Liberty, so much a symbol of what was an openhearted United States, was created by a Frenchman, Frédéric Auguste Bartholdi. And I would unhappily agree that, as Roger Cohen put it in *The New York Times*, 'The triumph of indecency is rampant...The only blow Trump knows is the low one. As the gutter is to the stars, so is this president to dignity...' But I am an optimist, and I hope that's not a fatal flaw. I believe the United States will again have a decent president that all the world can admire.

Part 6

South America

SOUTH AMERICA A continent in the Western Hemisphere, yes, but surely not a sub-continent, as some definitions have it. There seems to be a patronising edge to that 'sub', a hint of superiority. But maybe I am just imagining it. I've managed to get to a few of the South American countries and, while I've seen poverty and a rundown society, I couldn't say any place, or person, has been 'sub'. Rather, what I have seen has often been marvellous and the people I met distinguished at best and tolerable at worst. Like anywhere else.

And as Britain became obsessed with Brexit, the EU and the South American economic bloc Mercosur, already linked, concluded a huge trade deal aimed to create a market for nearly 800 million consumers. The agreement, cutting or removing tariffs, was the world's largest in terms of population.

Crime and cruelty fester in dark corners and corruption is a curse in many societies. That's what I have read. Murder across South America accounts for too many deaths. There is hunger and disease and misery. Women get the worst of it in both the richest and the

Above: *Capital of Argentina's Tierra del Fuego archipelago, Ushuaia, surounded by the Martial mountains, is also known as the 'End of the World' for its setting at the tip of South America.*

least civilised communities. There is a tragic lack of common sense – or perhaps an excess of greed – in matters where care of the environment is vital. As in, say, the heedless approach of the far-right Jair Bolsonaro government to

Brazil's great Amazon rainforest, where deforestation has been rampant.

'The Amazon is ours, not yours,' President Bolsonaro reportedly snapped to a European journalist. In a meeting around that time it was a German government minister – Germany being a contributor to a forest conservation programme – who politely reminded those present that protecting the Amazon was a global imperative, given its role in absorbing and storing carbon dioxide. Mr. Bolsonaro's view was that the protected lands should be opened up to commercial exploitation. He is no fan either of indigenous tribes living peaceably within the forests. He described them as being like animals in zoos.

In Peru, it is the new international Chinchero airport being built near the Inca citadel at Machu Picchu that has alarmed many conservationists, as well as the residents of the Sacred Valley area. Under discussion for many years, construction began amid huge protest. Visitor numbers to Peru's most popular attraction – it is indeed a magical sight – have reached more than 1.5 million a year. The new airport is designed to handle up to six million

people a year. More positive news: visits to the Machu Picchu citadel itself are being controlled and a plan for a cable car has been turned down.

South America has many riches in its stupendous landscapes – and seascapes, if Easter Island and the Falkland Islands are included (though I am listing the Falklands under 'Islands'). Recently, in the southern fjords of Chile, I saw a number of astonishing glaciers and could hardly believe what I saw. The region is not newly discovered but it is not the target of mass tourism. Clearly, a little isolation helps. But there are troubling issues, too, among populations elsewhere.

The effects of climate change, the risks of environmental catastrophe, as well as increasing inequality and extreme and ever-present violence, seem to have affected South America more than anywhere else. It is a disturbing sight when presidents call in the military to help put down protests, as in Chile and Ecuador and elsewhere. As I write, the generals have been upholding democracies, not returning to the time of military dictatorship. Yet when expectations are not met, worries increase. In Bolivia, the first indigenous president, Evo Morales, resigned and took off for Mexico when angry disputes arose over election results and the military chose not to support him.

Since 2008, the UN refugee agency, UNHCR, has recorded a nearly fivefold increase in asylum seekers arriving at the United States frontier from El Salvador, Guatemala and Honduras. These refugees have fled from a surging tide of violence. The question is not so much where can they go but how to stop the violence. It is not one anyone seems able to answer.

Argentina

Above: *Almost an abstract, the photo shows tall buildings and windows in fast-growing Buenos Aires as I was whizzed through the city.*

■ **ARGENTINA** – Great spaces, a great emptiness, the magic and myths in the southern plateau of Patagonia, are what immediately come to mind. Buenos Aires, the capital, is vivacious and cosmopolitan. In Ushuaia, too, at the tip of the continent, Argentina has a pleasant city and vital harbour 'at the end of the world'. Even more astonishing, at Iguazú, its northern frontier, with Brazil beyond, are a series of spectacular waterfalls. No walkways, fences and tourist viewpoints can spoil them. They are dazzling natural wonders.

The Spanish were the first colonisers, and the people who were there before them in what's called the pre-Columbian era had to be hardy to survive. Most died out. The indigenous Guarani are still present in small communities mainly in the north. And this being a football mad nation, there is a Club Deportivo Guarani Antonio Franco – not, though, at the top level. But if it is the landscapes of this huge nation that predominate (about 4,000 km, 2485 miles, from top to toe), it is also the unhappy history of so much of the relatively recent past.

Argentinians have experienced good government. For decades after 1880 there was progressive

Top left: *From Ushuaia harbour ships set sail for the Falkland Islands and the Antarctic. Patagonia and its legends are not far north.*

Top right: *Prosperous from the regular inflow of cruise passengers, Ushuaia also suffers from the many issues of a fast–growing population.*

Above left: *Viewed from a hotel where I first stayed, only the snow-patched mountain slope was impressive.*

Above right: *A stopover in the great city of Buenos Aires led to a gorgeous evening's display of tango (photographs forbidden, alas) and a delay at the city's secondary airport, Jorge Newbery, on the shore of the Rio de la Plata. An airport window provided a watery view.*

leadership and steady growth in population and income. In 1946 Juan Perón, an army colonel, won presidential elections, his wife Eva – 'Evita' – in his cabinet with responsibility for labour. In 1951 Perón was re-elected but when Evita, only 33 years old, died in 1952 of

cervical cancer, his popularity soon declined. In 1955 military uprisings forced him into exile. Yet he made it back in 1973, his wife now Isabel Martinez de Perón. When he died suddenly in 1974, she became president, her old colleague, José Lopez Rega, a government minister

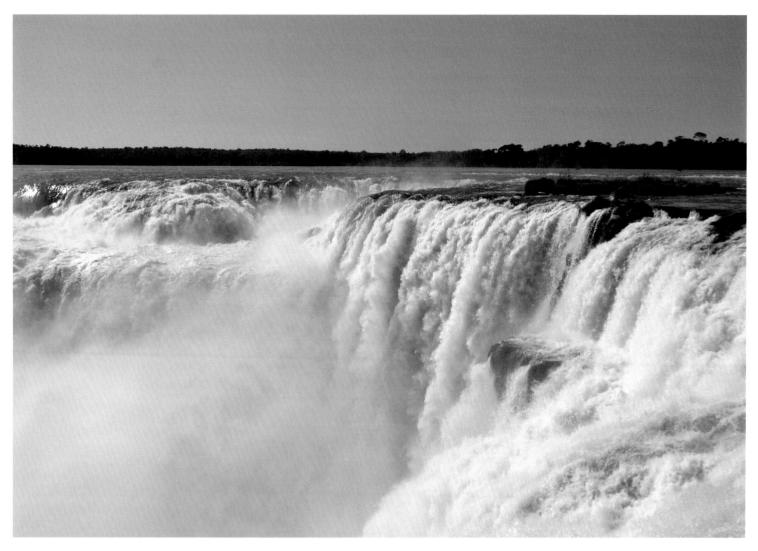

Above: *Iguazú falls are the fabulous waterfalls on the Iguazú River where Argentina meets Brazil. Every view is astonishing.*

Left: *The large number of visitors to the glorious Iguazú falls, and their food, attracts the close attention of the local population of coatis, a member of the raccoon family.*

at her side. Vega was cunning and unpleasant. Kidnappings, murders and 'disappearances' began to mount.

Military dictatorships have governed Argentina over several periods. In one of them, under General Jorge Videla, between 1976 and 1983, up to 30,000 people were killed or disappeared. The word 'disappeared' signified the unknown fate of a dictator's alleged enemies, citizens who literally vanished. It is not forgotten, either, that Argentina provided sanctuary for Nazi war criminals, including the horrifying Josef Mengele who conducted pseudo medical experiments, largely involving nearly 1,500 pairs of twins and mainly on Jews and Roma (gypsies) in the

Auschwitz death camp. Escaping Israeli searches, he died in 1979, swimming off a São Paulo beach.

In April 1982 Argentina, claiming sovereignty over islands they called the Malvinas, invaded the British-ruled Falkland Islands. An outraged Margaret Thatcher, British prime minister at the time, promptly dispatched forces to repulse the Argentinians. By June the 'war' was over, the islands back in British hands. Despite grief and fury over the deaths

suffered on both sides, including a British submarine's destruction of the Argentine cruiser 'General Beltrano' with a loss of 323 lives, full diplomatic relations were restored in 1990. Argentina, with a Peronist government from 1989 to 1999, led by Carlos Menem, maintained its claim to the 'Malvinas' and, as I write, still does.

A recession-hit Argentina continued to have a hard time, even defaulting on a $800 million debt repayment to the World Bank in 2002. In May 2003 Nestor Kirchner was elected president. Debt refinancing meant that the nation could repay an even larger debt to the International Monetary Fund (IMF) in 2006. Kirchner, unwell for some time, died in

2007 and was succeeded by his wife Cristina Fernández de Kirchner. As the economy grew back to health she was re-elected in 2011.

In 2015 elections the conservative mayor of Buenos Aires, Mauricio Macri, beat the Peronista opposition to become president. Macri's policies of slashing subsidies did not bring economic benefits, as he promised, and the population suffered. In the 2019 elections Macri was out, the Peronist Alberto Fernández in – with Cristina Fernández de Kirchner back as his deputy.

In 2013 a singular event had occurred: Cardinal Jorge Mario Bergoglio of Buenos Aires was elected Pope. The first Latin American, and the first Jesuit, to lead the Roman Catholic Church, he took the name of Francis. The popularity that he had experienced at home for his liberal views was not shared by the Rome hierarchy. A papacy, always as much political as spiritual, became dogged by bitterness and heated argument. Pope Francis also had to cope with revelations of priestly sexual abuse and priestly attempts to hide it.

Argentinians, meanwhile, for whom Diego Maradona had once been the world's shining football star, could focus on the brilliance of Lionel Messi. Or, if they were so inclined, on tango, the national dance art form. Born in poor neighbourhoods of Buenos Aires, tango brought life and style and intricate coupling to any dancefloor.

Its music and rhythms are unique. In cities around the world, Argentine tango is performed and enjoyed. Ballroom dancing was transformed. But it is in the dancehalls of Buenos Aires that it is most at home

Brazil

■ **BRAZIL** – The prime dates in the history of Brazil are: 1500 when Portuguese ships under the command of Pedro Álvares Cabral arrived on its shores and laid claim to all the land beyond; 1822 when Brazil declared its independence; and 1958 when Brazil won the World Cup in football for the first time. Brazil were world champions again in 1962, 1970, 1994 and 2002, runners up twice, and have taken part in every tournament since 1930. Some might say forget everything else. In fact, as Brazil is the largest country in the South American continent, and the most heavily populated, there's much to think about.

Power in Brazil has been divided over many decades between civilians and military. In the 1930s Getúlio Vargas ruled as dictator with military backing. In 1954, given the choice of resigning or being overthrown, he killed himself. Next came President Juscelino Kubitschek, successful economically and so imaginative he dreamed up the new capital, Brasilia. Civilians then interchanged with military until 1989 when Fernando Collor de Mello was elected. He had little luck and was forced to resign. With the election of Fernando Henrique Cardoso as president in 1994, things began to improve. He was even re-elected. Then came the workers' hero, President Luiz Inácio Lula da Silva, better known as Lula.

Exceptionally popular as union and labour leader, Lula was elected president in 2002 and ran for two terms. He achieved not only economic growth but introduced social

Above: *The iconic emblem of Rio de Janeiro, a statue of Christ the Redeemer stands atop the granite peak of Corcovado mountain.*

programmes – increasing the minimum wage, family grants for the poor – that brought benefits to millions of Brazilians. Legally unable to run for a third time, he was succeeded by an ally, Dilma Rousseff. Predictably, both had enemies.

Rousseff was impeached and removed from office for 'manipulating the budget', in fact a standard practice, and Lula found guilty of corruption and imprisoned. Both denied the charges. The judge in Lula's case was found to have shared information with the

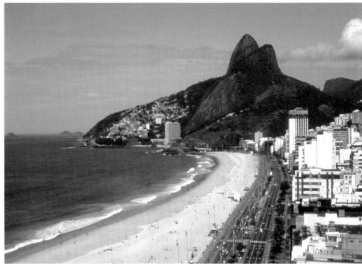

prosecutor, messages that raised serious questions about the judge's impartiality. Lula insisted all the accusations levelled against him were politically motivated. When he was suddenly released late in 2019, after the Supreme Court ruled 'that defendants should only be imprisoned if they had exhausted all appeal options', there was much rejoicing.

Michael Temer, briefly succeeding Dilma Rousseff, had also been caught up in the corruption scandals. Capitalising on Brazil's recession and other troubles with a populist campaign, the next president, installed in January

2019, was the far-right Jair Bolsonaro. There were many, however, who lamented his bigoted policies. They were alarmed at his admiration of the military eras, disapproved of his intention to appoint his son ambassador for Brazil in the US, worried about deforestation and the increased licensing of hazardous pesticides, the obliteration of vast tracts of jungle, and feared for the future of the Amazon rainforests and the tribes who lived with decreasing protection within them.

When João Gilberto, a much loved musician, died in July, 2019, there were protests at the meanspirited

Above left: Rio de Janeiro is noted for its extraordinary setting. This view looks towards Guanabara Bay.

Above right: In Rio, the fabled song about the Girl from Ipanema lends an extra dimension to the Ipanema beach.

Below left: Rio's famous Copacabana beach is a lively hub for city sunlovers.

Below right: Out in Guanabara Bay Fiscal Island, once used for Customs purposes, is still the setting of a fine neo-Gothic palace.

Above left: Brasilia came to life as Brazilian capital in 1960, its chief architect the renowned Oscar Niemeyor. Its cathedral was just one distinctive design.

Above right: Rio de Janeiro, sprawling across more than 1,200 square km (464 square miles), has a colonial history and interesting architecture.

Below left: Curitiba, in the south, may be best known for its theatre. Civic authorities worldwide hail its bus design and city transport services.

Below right: Tattoos have been around for thousands of years. The decision to wear one, and to show it off, is now nearly always personal.

response from Bolsonaro, adding to the fury his anti-environmental policies were garnering – a crime, some said, calling it ecocide.

Brazil's mighty rivers are also changing. They encompass not only the Amazon but the Araguaia and the 2,450-km long Tocantins, the name too of the newest of 26 states. Where there's a river there are often rainforests, dams, industry and national parks as well as a breathtaking variety and quantity of wildlife and birdlife. The Tocantins, however, has been so dammed it has lost its flow.

Rather better known is Brazil's urban life. The two biggest cities, Rio de Janeiro, the gorgeous, mountain-framed beach-focussed capital, and São Paulo, all business, finance and skyscrapers, account for a considerable proportion of Brazil's population. Brasilia, the inland capital, has intriguing architecture, much of it by the renowned Oscar Niemeyer, and qualities all its own. Even in gardens a special quality is to be found. On the

outskirts of Rio de Janeiro is the home and garden of Roberto Burle Marx (1909-1994), a designer of landscapes, streets, parks and gardens widely admired across the country.

Brazilians are a sociable and buoyant people who work hard and play hard. There is music everywhere and it's not just bossa nova, jazz and 'The Girl from Ipanema'. Their culture is an ethnic mix that derives from early Portuguese colonialism (also the source of the national language), from slaves imported from Africa, said

Top left: The Boa Viagem beach in Recife, Pernambuco, in northern Brazil is almost as famous as Copacabana in the capital.

Top right: Basilica, convent, square, the church of Nossa Senhora do Carmo has been part of the life of Recife since 1663.

Centre right: It is dusk on Recife's long beach but families will stay, and play, until dark.

Right: Francisco Brennand is a famous name in Brazil. He died aged 92 in 2019. I was fortunate to visit his gallery and workshop in Recife during his lifetime.

Left: Brazil was exporting coffee in the early 19th century and even today coffee remains a vital export. This hillside plantation is in the state of Minas Gerais.

Below left: Two friends in a small town in the state of Tocantins relax outside their startlingly pink-painted house.

Below right: On the São Francisco river in northeast Brazil a dam is backdrop for some fishing.

to be as many as four million, and from 19th century immigrants from Italy and Germany, Japan, Poland and Spain. Considering the white supremacist tactics of President Trump in the US, it seemed surprising that President Bolsonaro apparently liked to be called the Trump of the Tropics.

For many of us Brazil is best known for its ravishing carnivals and samba schools, for its coffee – it has been the world's chief producer for more than a century – for its pumas and jaguars and colourful birds, and of course for football. I also remember an expression from schooldays intended to teach us geography: 'Brazil is where the nuts come from'. Lately, it could have described a few unpleasant politicians.

Left: In the vastness of Brazil roaming vaqueiros, cattle men, herding their flocks and herds are a common sight.

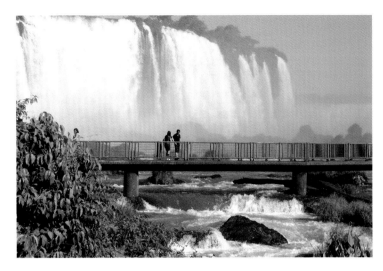

Top left: *On the Brazil side of the mighty waterfalls at the frontier with Argentina a visiting couple stands on a lower level bridge.*

Top right: *A group of Brazilian schoolchildren are on an outing to see the waterfalls that are one of the country's grandest sights.*

Right: *From one view of the great Iguaçu falls (Iguazú on the other side in Argentina) there is always a rainbow.*

Below right: *Of all the many-splendoured views of the great waterfall on the River called Iguazú in Argentina and Iguaçu in Brazil, this one on the Brazilian side is probably the grandest.*

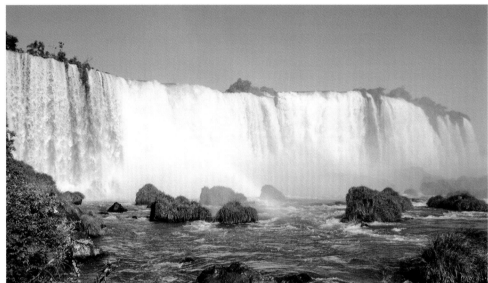

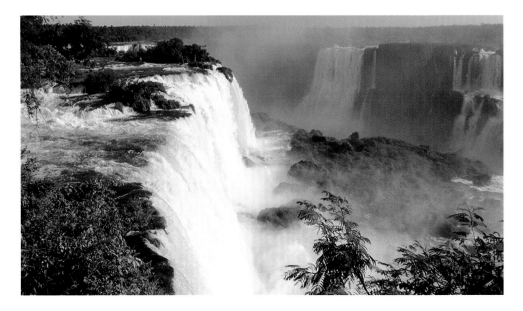

Chile

■ CHILE – Among Chile's remarkable features, its shape is the most prominent. Long and thin, with the Andes mountains and Argentina on one side and the Pacific Ocean on the other, Chile on the map seems almost squeezed by geographic circumstance. When you are there, perhaps standing in the lee of a huge glacier, it all looks entirely different.

The glaciers are mostly in the south, tucked into visually thrilling fjords, channels, sounds and straits of which there are an astonishing 868, according to official sources. Water-

ways to this day remain Chile's prime transportation routes. Some of their names are famous, like the Beagle Channel or the Agostini Fjord. A few lead to important ports like Punta Arenas. Most are uninhabited, but each has a name. A Dutch navigator, Willem Schouten, was apparently the first outsider to round the tip of South America, in 1616, hence Cape Horn (from Hoorn). The Strait of Magellan (actually Magalhães, he was Portuguese) was named for the commander of the fleet who discovered the strait in 1520 during the first

Above: A monumental arch in downtown Valparaiso was a gift from British colonists in 1910 to the city of Valparaiso to mark the centenary of Chile's independence.

successful attempt at circumnavigating the earth.

By striking contrast, the Atacama Desert in northern Chile is so dry scientists use it for Mars experiments and film directors for their movies. Its clear skies have led astronomers to build observatories, as well as a powerful radio telescope shared and

Above: The Garibaldi glacier is not named for the Italian statesman but a Silesian priest who travelled the region in the 1920s.

Right: The Serrano glacier is close to the Torres del Paine national park; above it sprawls the Darwin ice field.

Below left: This glacier seems to have two names, El Brujo, the witch, and/or Asia. Either way, it is magnificent.

Below right: Not quite big enough to be called icebergs but solid ice all the same.

operated by several countries. Sports enthusiasts use its huge empty spaces for rallies. The active Lascar volcano is dramatic setting for an annual marathon. Most profitably for Chile, the desert contains the world's largest copper mines. (Gold and silver are also mined.) Chile, with its huge open-cast pits is the world's leading producer of copper, and holds the world's largest reserves.

As in most South American countries, Spaniards were the main colonisers. Of the original indigenous inhabitants, Mapuche are the only significant survivors and struggle constantly for recognition and rights. Chilean independence came in 1818, after the defeat of a Spanish army. Bernardo O'Higgins, a Chilean landowner of Spanish and Irish ancestry, was hailed as supreme leader.

Dictatorship became something of a pattern in Chile's progress, countermanded by efforts to build freer systems of government. Ending one dictator's rule, a Popular Front coalition of Communists, Socialists and Radicals governed from 1938 to 1946. But when in 1970 Salvador Allende became the world's first democratically elected Marxist president and tried to launch a programme of nationalisation and radical social reform, it was too much for conservatives.

In 1973 General Augusto Pinochet ousted Allende in a coup, in which Allende died of self-inflicted wounds. (Bizarre photos show 'the last stand' of this bespectacled and helmeted physician in a plain jacket, rifle over his shoulder.) Pinochet soon established a brutal dictatorship. It was widely believed that US President Richard

Above: Cape Froward is said to be the southernmost point of the American mainland. Lands to the south (from where we sailed) are presumably islands.

Nixon, together with his national security advisor Henry Kissinger, had encouraged Allende's fall through the CIA, and 'extensive evidence' was found of United States' complicity in the coup. It proved harder to get rid of Pinochet, responsible for the death and torture of thousands of Chileans. He eventually retired in 1998, yet this was not quite the end.

Pinochet was in England for medical treatment when he was indicted on human rights violations and arrested in 1998 at the request of Spain. Held for eighteen months, he was then free to return home. Although he was implicated in some

three hundred criminal charges, he died of a heart attack in Santiago in December 2006 without having been convicted in any case.

Good news arrived in January of that year. Michelle Bachelet, a socialist in the centre-left Concertación coalition, won the second round of presidential elections to become Chile's first woman president. Most interruptions to her presidency came from natural causes – an erupting volcano, tempests and downpours. She decreed morning-after pills for girls as young as fourteen and she visited Cuba, a first for a Chilean leader in forty years. But Chile's conservatives were easing ahead, and in the 2010 presidential election wealthy right-wing candidate Sebastian Pinera won the top job. He had hardly been installed when a massive earthquake, the largest in years, struck central Chile, causing heavy damage and hundreds of deaths.

In October that year all the world watched an amazing televised rescue: thirty-three miners winched to safety after being trapped underground for sixty-nine days. Nationwide jubilation was not enough to keep Pinera in office and, in 2014, Michelle Bachelet was back as president. While courts continued to pay reparations to families affected by the barbarous Pinochet era, she announced plans to end Chile's total ban on abortions and, catching the attention of conservationists everywhere, the creation of two new marine reserves in the Pacific Ocean, one of them surrounding Chile's renowned Easter Island.

Yet in the seesaw world of politics, nothing lasts. In the next presidential election billionaire Sebastian Pinera was back, though would soon be

Above: *Castro is a lively city on the Chilean island of Chiloé. It's noted for its distinguished San Francisco church and for art.*

Below: *Palafitos is the word used to describe the colourful houses built on stilts above tidal waters; these are on Chiloé island.*

Above: I had come by sea, via spectacular glaciers. In the old city of Valparaiso was the vivid graffiti of a city of students.

facing angry protesters demanding their rights. As for Bachelet, she promptly took on, in September 2018, the role of United Nations High Commissioner for Human Rights.

Glaciers and fjords got me to Chile and I travelled by ship, amazed by wilderness, birds, forests and the ice sheets above them. The very word Patagonia to me is exciting. Strong winds, all too common, prevented a visit ashore to the Torres del Paine National Park. I was sorry to miss its guanacos. I did, though, get to Chiloé Island with its impressive wooden churches and modest homes on stilts. Surrounding waters are home to blue whales. Regrettably, all I saw were a few hazy spouts.

Journey's end was in Valparaiso, a city whose brightly painted houses seem to tumble down a steep hillside. Among them are pleasant restaurants with good food and Chile's own excellent wines. In plazas, baroque buildings, markets and palm-lined avenues – vividly adorned with graffiti – all Chile's history is encapsulated. High on a hillside sits La Sebastiana, one of the homes, now a museum, of beloved national poet Pablo Neruda, a Nobel prizewinner. Much of his poetry is too emotional for my more pragmatic taste, yet I can't argue with these lines from 'Die Slowly': 'He who does not travel,/who does not read,/who does not listen to music,/who does not find grace in himself, dies slowly.'

Left: Pablo Neruda (1904–1973) was a Chilean poet who won the Nobel prize for Literature. A house he lived in, now a museum, is on a hilltop above the city of Valparaiso.

Colombia

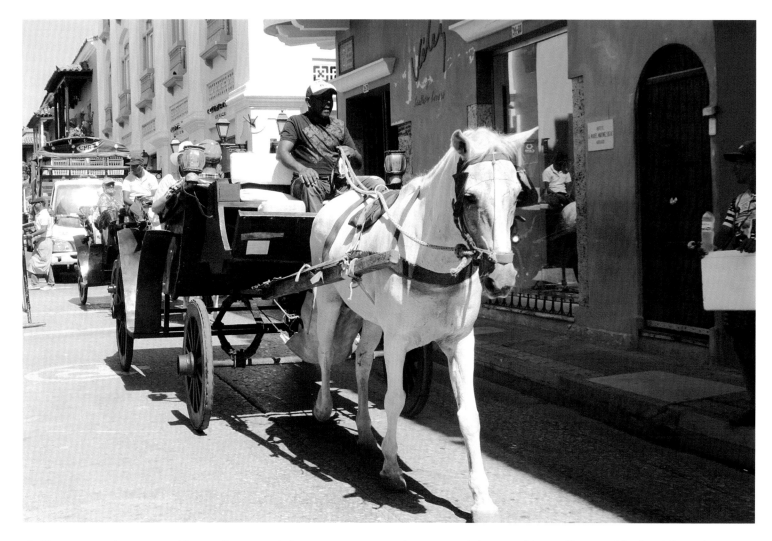

COLOMBIA – In personal terms I've managed to visit, for various periods of time, all Colombia's neighbours. Now, for a mere token stay, I can include this sorely ravaged South American nation to my list of yups. (Explanation: ever been to Colombia? Answer: yup.) Colombia has all the requisite assets to be a shining light in a vast continent. It has abundant oil, gold, a range of desirable minerals, a fine landscape, hardworking people, an unchallenging climate. What Colombia has also had is continuous violence among armed groups, vicious drug cartels, deep social inequality, a weak government and an intimidated press. Yet the word is, cautiously, things are getting better.

Things had been bad since the end of the 19th century when, arising from politics, a bitter civil war was fought between Liberals and Conservatives. Thousands died before the solution came, decades later, with a coalition. Then, in the mid-20th century, a series of leftist guerilla groups with at least four different ideologies created

Above: Transport for tourists and a pleasing sight on the streets of Cartagena.

Top: Brightly dressed women called palenqueras patrol the streets of Cartagena to sell fruit and, for tourists, to pose for photos (to be paid for too).

Above: Cartagena, from a view of its harbour, manages to keep its charm as well as do business.

havoc. The most prominent: the Revolutionary Armed Forces of Colombia (FARC). Peace talks with the government began in 1998, ending only in 2016. Yet a referendum supposed to gain national approval revealed that most people hated the deal. New negotiations followed until agreement was reached.

More in the public eye across the years were the monstrous drug barons. Most notable among numerous traffickers was Pablo Escobar, for years able to taunt authorities from his private properties and his own fleet of aircraft. Desperate government leaders were helpless against the might and wealth of the barons, their operations fuelled and funded by high demand for cocaine in the US and elsewhere.

The drug cartels became renowned too for their violence. Even Colombian president Trujillo (1990–1994) couldn't decide which was the worst – the Cali cartel or the Medellin? Between them, in the 1990s, they were said to be earning $6 billion to $8 billion a year. Assassinations of judges, policemen, anyone in the way or refusing bribes, was commonplace.

Coca is still grown, drugs are still trafficked, but the heyday of the barons is past. Coca farmers, after the deal with FARC, were paid to grow other crops. Coca plantations are still being eradicated, 'factories' burned. Escobar himself is not forgotten. He actually entered politics but gave himself up to the law. Briefly imprisoned, he escaped, was trapped on a rooftop and, in 1993, died from a shot in the head.

Other traffickers were caught by US authorities and imprisoned. For all

the wrecked lives, the real tragedy, their stories went into lighthearted movies and books. A few years ago much was made of hippos discovered in a river near Escobar's former ranch, Hacienda Napoles, now a 'family-friendly' theme park. Among the pleasures he had treated himself to was a private zoo. The lions and elephants were dispersed by authorities in the 1990s. Hippos, it seems, got away.

Drugs make headlines but Colombia, its population nearly 50 million, is much more than a cocaine producer. The government, now headed by president Iván Duque Márquez and aided by what's called a 'democratic security strategy', has inherited a solid economy that includes shipbuilding and a growing information technology (IT) industry.

Tourism is in there, too, in Cartagena's 'old town' and nearby beaches, in Santa Marta, along the coast and the lovely Quinta de San Pedro Alejandrino where the renowned Liberator, Simón Bolívar passed his last days, in national parks, quiet bays, other cities, nor forgetting the capital, Bogotá. Even Medellin, a name once only associated with drugs, is now a pleasant city more noted for an annual flower festival. Or so I'm told. Unfortunately, I didn't make it there.

Top right: *Inside Cartagena's impressive cathedral.*

Right: *Santa Marta's cathedral square on a sunny weekday.*

Above: *In the cool green gardens of the Quinta de San Pedro Alejandrino in Santa Marta is a statue of Simón Bolívar who spent his last days here.*

Below left: *Traders who don't have a shop make do with the street.*

Below right: *In the Quinta de San Pedro Alejandrino, Santa Marta, a guide stands beside an effigy of Simón Bolívar to tell the story of the last days of the great Liberator.*

Ecuador

■ **ECUADOR** – In Quito, Ecuador's capital and a Unesco World Heritage Site, the façade of the imposing Basilica del Voto Nacional includes sculpted iguanas. Iguanas do not appear on France's Bruges cathedral, the inspiration for Quito architect Emilio Tarlier. They are, though, relatively common in South America and are celebrated denizens of the volcanic Galápagos islands. The twenty-one islands, unique in their diversity of wildlife and inspiration for Charles Darwin's theories of evolution and natural selection, are an Ecuadorian territory 500 miles (926 km) to the west in the Pacific Ocean.

In past centuries Spain was the dominant coloniser in most of South America. A newly independent Ecuador

Above: The gargoyles conspicuous on the façade of Quito's basilica are a common local lizard – iguanas.

simply appropriated the islands in 1832. An English buccaneer, Ambrose Cowley, had however passed by in 1684 and given the islands English names as he saw fit. Navigation charts drawn by Captain Robert FitzRoy of the Beagle, the ship on which Darwin sailed in 1835, incorporated some of those names. The name Galápagos, however, comes from the Spanish word for tortoises, and Ecuador from equator.

Given Ecuador's intriguing persona, it seems right that its principal exports are oil and bananas. Its political history is as varied, with forty-eight presidents in 130 years of independence. Being

overthrown was mild. At least one president was kidnapped and beaten up by his army. Another, José Maria Velasco, was elected five times. In 2006 Raphael Correa became president and in 2009 and again in 2013 won elections. In 2018, when Correa's vice-president Lenín Moreno had succeeded him, Ecuadoreans voted in a referendum to prevent presidents from holding more than two terms in office. Moreno, shot in a robbery in 1998, was subsequently obliged to use a wheelchair.

Ecuador has faced issues arising from its neighbours Colombia and Peru, from volcanoes and earthquakes and, when there is a cause to fight for, from its own fiercely determined indigenous people. Then there is the peculiar

affair of WikiLeaks and its Australian-born founder Julian Assange, charged by the US and Sweden on alleged offences and given refuge in 2012 in Ecuador's London embassy. Relations between Assange and Ecuador's government worsened after President Lenín Moreno took office in 2017. In April 2019, Ecuadorian officials allowed British police to arrest him and he was taken to Belmarsh Prison. Controversy continued regarding his asylum, his possessions, his cat.

The Galápagos Islands, with their volcanic beauty and their abundant wildlife, are Ecuador's greatest prize. Here are giant tortoises, land and marine iguanas, sea lions and a fantastic array of land birds and sea birds

– among them finches and hawks and the astonishing blue-footed booby. Seeing them up close and unafraid is a rare experience, though perhaps, as visitor numbers increase, not quite as rare as it was.

Land-based tourism is causing alarm. Hotels (as I write) number more than 300, requiring infrastructure and staff. Only five of the islands are inhabited. Puerto Ayora, a fast expanding town on Santa Cruz Island, had a resident population of 12,000 in 2019. Small-ship cruising is more easily managed. On my own visit, by small ship, a few passengers accounted for the entire visible human presence as we moved from island to island.

We walked on set routes. Stumbling

Top left: A solitary blue-footed booby, standing tall.

Top right: A seabird, the red-footed booby, is at home in the Galápagos.

Above: If they have blue feet, you know you are looking at blue-footed boobies.

over rock hard lava on Fernandina Island, I tripped and fell close to a cluster of scaly-headed marine iguanas. They didn't even quiver. What fabulous creatures they are, lizards that can loll in the sun or swim like fish in the sea. In theory I could have picked one up, tucked him under my arm and smuggled him home. I hope it goes without saying that I didn't.

Above: A pair of Nasca, or masked, boobies are wholly concentrated on their chick.

Right: Several species are endemic to the Galápagos; this giant tortoise lives freely in a reserve on Santa Cruz Island.

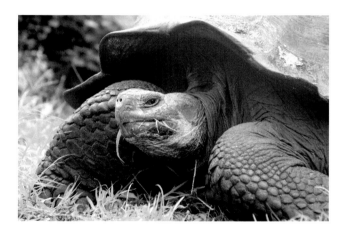

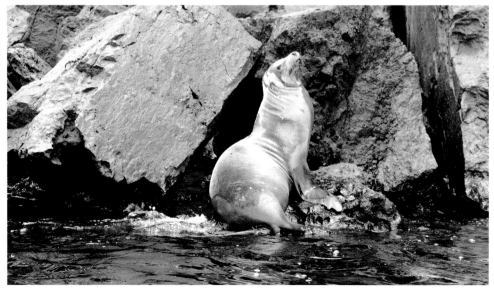

Top left: A Great Frigate bird, almost fledged, in its nest.

Above: Two penguins are clearly communicating with each other – but what might they be saying?

Right: A sea lion, another in the water just below, relaxes against large lava rocks in the spectacular Galápagos islands.

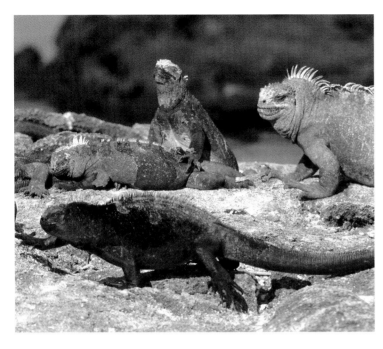

Above: Marine iguanas, adept on land and in the sea, couldn't care less about close hovering humans.

Below: A small, green-edged brackish lake on Santa Cruz Island is the peaceful habitat of this solitary flamingo.

Above: An iguana, a protected species, in the Galápagos islands.

Below: One of the most photographed views in the Galápagos, it shows sea, beach, landscapes and the tall pinnacle rock on Bartolomé Island.

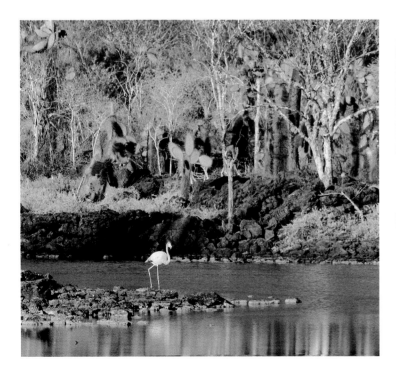

Peru

■ **PERU** – The Inca citadel of Machu Picchu, set amid steep mountains, is the most famous panorama in Peru, and the flourishing Inca culture, its capital in Cusco, dominated the entire region. Yet the Incas were not the only ancient civilisation that left a mark. Museum collections display the heritage of Nazca, Chimu, Moche and others. Outside Trujillo, in the north, Chan Chan's adobe walls show the scale of a Chimu city. It is a dazzling cornucopia of riches for one country.

The Inca empire had reached a peak of range and power precisely

Above: *Surely the most famous view in all Peru, it shows the 15th-century Inca citadel in the high Andes mountains above Peru's Urubamba River.*

when Spanish conquistadores arrived in 1532. Soon, lands and wealth were lost in military conflict to the invaders. Disease, to which they had no resistance, was a massive killer among indigenous people. Spanish colonisers usurped power, took gold and silver, built churches, a capital in Lima and an administration, all under the rule of the Viceroyalty of Peru.

As time went by, Spanish arrogance only aggravated local resentment. There were frequent uprisings. The rebellion of a local leader, Túpac Amaru, in 1780 brought hope and yearnings to a suppressed population. Not all by now were indigenous. A mixed-race creole society had developed, a criollo oligarchy which had privileges and rank. Spain began to lose authority over its colonies. The name Simón Bolívar rang loudly across South America as leader and torchbearer of a vigorous independence movement.

At his side was General José de San Martin, whose army occupied Lima and declared Peruvian independence on 28 July 1821.

Regional fighting and inter-community rivalries continued. There was little peace, not much sustained growth. Military became assertive, coups cut into periods of stability. Through the 20th century, presidents came and went. Economic turbulence around 1980 led to the growth of insurgent movements, among them the communist Sendero Luminoso (Shining Path). Thousands died in the social tumult that followed.

Alberto Fujimori, Peru's 62nd president, crushed the insurgency and restored stability but was himself caught up in scandals. To avoid charges of human rights violations and corruption, he resigned and went into exile in Japan where he had roots. Returning to South America, he was arrested, tried, convicted of corruption, bribery, crimes against humanities, murder, and other charges and sentenced to 25 years in prison.

Being president of Peru does not appear to offer a comfortable living. In July 2006, Alan Garcia, who had been president from 1985 to 1990, was elected once again and would remain president until 2011. He died in April 2019, from a self-inflicted gunshot wound while being arrested for involvement in a corruption scandal. A predecessor, Francisco Morales-Bermúdez, was sentenced to life in prison by an Italian court in January 2017. Another president,

Left: The Cusco cathedral dominates the region's most important city, once the capital of the Inca empire.

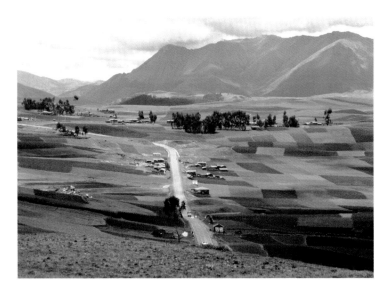

Above left: *Flat lands close to Cusco are easily cultivated and have been the 'breadbasket' for centuries of Peruvians.*

Above right: *The people of the Cusco plains are mainly Quechua; in a tourist-trodden area kids show up in curious droves.*

Below: *Drawing huge numbers of tourists, the Machu Picchu name also attracts serious hikers.*

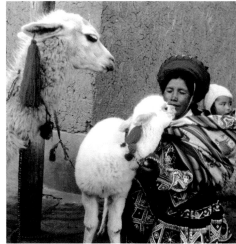

Above left: *The handsome main square in Lima, Peru's capital.*

Above right: *On the outskirts of Cusco a Quechua mother, her baby, her llama, her llama's baby.*

Alejandro Toledo, his term 2001–2006, withdrew from politics and moved to California to avoid prosecution.

Ollanta Humala, president from 2011 to 2016, was arrested with his wife at the end of his term. Detained for six months while being investigated on matters related to corruption, they were released. He was succeeded by Pedro Pablo Kuczynski, who granted a humanitarian pardon to ex-president Alberto Fujimori, hospitalised while serving his 25-year sentence. Kuczynski resigned in March 2018. A year later he was charged with corruption, convicted and sentenced to three years in prison.

Following Kuczynski's resignation, Fujimori's pardon was rescinded and he was re-arrested. The current president (as I write) is Martin Vizcarro

Left: *On a street corner in Lima, the Cordano bar is a good place to pause.*

Cornejo, an independent politician and former engineer. He was vice-president when the top job became available. (I know next to nothing about him. I wish him luck.)

The only hint of bad behaviour I saw in my travels in Peru were stones where children may have been sacrificed in pre-Columbian times in gruesome religious rituals. (I read too, in *National Geographic*, that archaeologists discovered two child sacrifice sites, a desperate act by the Chimu, north of the Chan Chan complex.) In Lima, the capital, I observed quite a few women police officers – less likely to take bribes, I was told. For the rest, all was peaceful.

On Lake Titicaca (elevation 3,812 m; 12,506 ft), I found Aymara people living on matted reed islands and reed boats being constructed – one with a striking puma stemhead. On Taquile island young men were busily knitting garments to be sold in their tourist shops. And somehow a 19th century British-built gunboat, the *M.S. Yavari*, had made it to the lake. In a land rich in sensational South American culture Brits had made their mark.

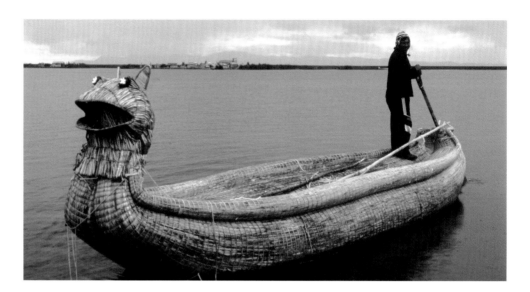

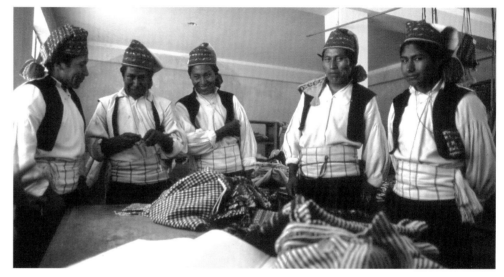

Top right: *The puma stemhead on this reed boat on Lake Titicaca is a surviving symbol of ancient mythology.*

Centre right: *Almost every man I saw near Lake Titicaca was knitting, the resulting garment for sale in a smart crafts shop they ran.*

Right: *A friendly welcome from a reed home; Lake Titicaca sustained small populations of people living on islands made entirely of reeds.*

Top and left: Birdlovers come to Peru just to see its amazing birdlife which includes the hoatzin and condors.

Above: fearsome Moche art (50–800AD) revealed at the pyramid of the moon near Trujillo.

Venezuela

■ **VENEZUELA** – In myth and legend El Dorado signifies a magical city abounding in gold, a dream realised, a shining moment. The El Dorado I saw in Venezuela was a small dusty roadside town of no distinction. Signs suggested willing buyers for gold. Poky shops and shanties conveyed a message of poverty. Yet gold is there, alluring, hard to extract, a murderous metal. The story of Walter Raleigh, who went himself in search of it, is one of the grandest, saddest tales in literature. Now, the gold story is one without end.

Above: *From a hilltop, reached by cablecar, Caracas appears below, almost without character.*

Spanish colonisation after 1521 is a story with an ending – Venezuela declared its independence in 1810 – but in many aspects appears to echo events in other South American countries. Moving in, taking over, plundering and pillaging, relentlessly shattering indigenous lives and generating populations of *mestizos*, people of mixed blood who came to be the rule, not the exception. An

equally familiar story as centuries rolled by was the pattern of constructive leadership struck down by coup and countercoup.

The first years of the 20th century were marked by the discovery and production of oil, reaching a point when Venezuela was the world's leading exporter. There was even, in the 1940s, a period of civilian government – and another after the late 1950s. By the 1990s it was Colonel Hugo Chavez who was making waves. He spent a couple of years in prison, though, before being

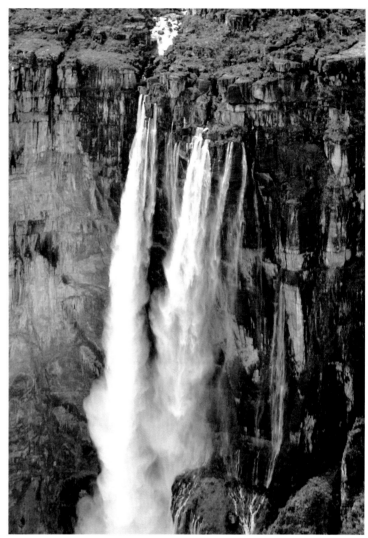

Above left: *More than 150 national heroes, including a few women, are buried in Venezuela's National Pantheon.*

Above right: *Said to be the world's highest uninterrupted waterfall Angel Falls, at a height of 979 metres (3,212 ft), has a plunge of 807 m (2,648 ft) and is located in Venezuela's Canaima National Park. The waterfall is named after an American aviator who first recorded it.*

Right: *El Dorado signifies a noble dream, an unattained utopia. In Venezuela it is the name of a tawdry village on the southbound road.*

elected president in 1998. And even afterwards, as he launched his socialist 'Bolívarian revolution' with a new constitution and popular social policies, not quite everything went his way.

High oil prices funded his reforms aimed to benefit poor sections of society. Landowners saw property nationalised. Oil became state oil. When two American-owned companies refused to hand over majority control, the Venezuelan government promptly expropriated them. The US became even more alarmed in 2006, when Chavez signed a multi-billion arms deal with Russia that included the purchase of fighter aircraft and helicopters, followed by an agreement over oil and gas. In December of that year he won a third term in presidential elections by a landslide. In 2009 a referendum success abolished term limits allowing him to stand again, and in October 2012 he won a fourth term.

Below: A Pemón girl from the Indian community in Venezuela's Gran Sabana.

A fight he could not win, however, was against a pitiless killer. Hugo Chavez, 58 years old, died of cancer in March 2013. In April the successor he chose, Nicolas Maduro, was elected president, the margin so low the result

Above: Miners, legal and illegal, pan for gold in many sites across southern Venezuela. Few make fortunes.

Below: In a small town near El Dorado women gather at a small roadside shop.

Above: Los llanos, *broad low-level plains in Venezuela, is cattle country where rivers host caimans.*

Below left: Venezuela's great territory includes the cool highlands of the Andes.

Below right: Jaji, an attractive small town in Merida province.

was contested. Oil prices were sinking when, in December 2015, the opposition Democratic Unity coalition won a majority in parliamentary elections, the first loss for socialists in sixteen years. In May 2018, Maduro's victory in presidential elections was widely contested.

On 23 January 2019, when more than two million Venezuelans had fled

Above: Tempted by a fishy offering, a caiman leaps high above its natural abode.

the country, Juan Gaidó, President of the National Assembly, pronounced himself interim president and asked the military to depose Maduro on the grounds that the 2018 election was rigged. His claim was supported by the

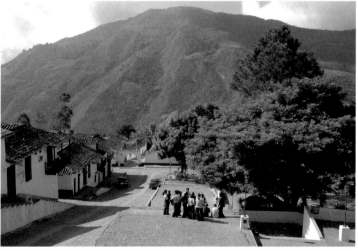

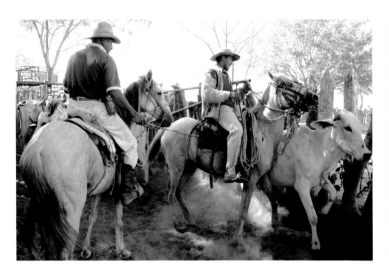

US, the EU and other countries – but not by Russia or China. Hopes that the situation could be quickly resolved faded. A UN report accused Maduro's security forces of committing 'gross violations' against Venezuelan dissenters. Venezuela government assets were frozen in the US. Were these sanctions likely to be effective? It seemed that only ordinary working people were suffering and they, alas, were powerless..

I had seen another Venezuela. In *los llanos*, great plains where ranch hands, *llaneros*, rode their horses and herded the landowner's cattle –

Top left and right: The 'cowboys' who work with the region's cattle are vaqueros in this Spanish-speaking land, and the huge ranches are haciendas.

Above: The mighty Orinoco River, 2140 km long (1330 miles), its vast delta in the Atlantic, flows mainly through Venezuela.

and where caimans and piranhas seemed to inhabit every river. I had photographed the broad Orinoco, where Warao Indians lived an almost unchanging life. And I had got to the remote south where, in the

Above: This cool couple are street traders In the bustling city of Ciudad Bolívar.

southeastern corner of the Canaima National Park, table-topped sandstone mountains called *tepuis*, dominate the landscape.

They have an aura of mystery, an intriguing plant and animal life, and are

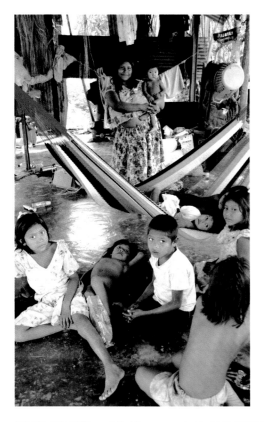

Above: *The south in Venezuela is adorned by mysterious, flat-topped mountains called* tepuis, *the inspiration for Conan Doyle's thrilling adventure story,* The Lost World. *I saw this one through an aircraft window as I was leaving.*

Left: *A Warao family living on the banks of the Orinoco.*

famous for having inspired Sir Arthur Conan Doyle's novel *The Lost World*, in which weird things happen, prehistoric predators among them, to an expedition aiming to explore these strange mountains. Mount Roraima (2810 m; 9220 ft high, with a 31 sq. km.,12 sq. mi plateau), edged on all sides by tall cliffs, is the predominant *tepui* of about a score in the region – and known for centuries by the indigenous people who inhabit that isolated terrain.

Another *tepui* is the staggering backdrop for Angel Falls, the world's highest waterfall at 979 m (3,212 ft), with a plunge of 807 m (2,648 ft). The falls are named after a young American pilot, Jimmie Angel, who flew over them by chance in November 1933. He returned four years later to explore the area. He crash-landed his plane with its three passengers, one of them his wife. They survived unharmed and trekked for eleven days with very little food before reaching a settlement. What a feat! And I had thought I had overcome a major obstacle when, on arriving at the international airport for Caracas, I was informed there was no access to the capital because of structural problems with a bridge on the main highway. Nonsense, of course. There are always, or nearly always, side roads, secondary roads, serviceable tracks to wherever you want to go.

Left: *Macaws, more or less tame, living in hotel gardens.*

Part 7

Oceania

Oceania – Definitions differ (not a continent, just a region; includes New Zealand, excludes New Zealand, etc). I am choosing the definition that Oceania is a continent and that it includes New Zealand – and a whole batch of islands and nations that I haven't yet visited or even heard of. Australia, however, with a population of more than 25,000, is the fascinating biggie, a land usually said to have been discovered by England's Captain Cook in 1770.

Discovery has changed meanings in recent years. It implies being the first to do something, the first to be anywhere, the first to achieve anything. Nowadays, even when it relates to historic voyages, the word is now often framed in quotes, or qualified with subheadings like 'first documented'. Captain James Cook, for instance, was indubitably a brilliant navigator and cartographer, recognised for his skills, dedication and courage. Possibly he did not know that more than a century earlier European navigators had landed in Australia and sailed nearby waters. And all 'discoverers' either totally ignored the existing human populations, or dismissed them as inferior, and never

accepted aboriginal ownership of lands they had just come across.

The actual ocean Oceania relates to is the Pacific, the largest and deepest of the oceans that cover half of our planet. It was given its name by the Portuguese mariner known as Ferdinand Magellan who, in his circumnavigation of the globe, found it peaceful, or pacific. Its reach is enormous---California to China, and from the Arctic in the north to Antarctica, or the Southern Ocean, in the south. It encompasses long lists of nations and dependent territories, some 25,000 islands and several volcanoes.

One of its features is the so-called 'Ring of Fire', an area of high volcanic and seismic activity. Across the Pacific's great range hurricanes and typhoons, monsoons and cyclones, have come and gone. El Niño has caused terror, regular trade winds have brought profit and amicable exchange. In its waters are creatures as large as whales, smaller than shellfish – and volumes of plastic. Wars have been fought there, and atomic bombs dropped. Satellites have crashed, minerals have been exploited, pearls harvested. Its largest inhabited land is Australia, which includes Tasmania and several smaller islands. As I have seen only the mainland, and ridiculously briefly, my account is patently limited.

Left: The Western Australia coast, scrub and white sand beach, faces the vast Pacific Ocean with no land in sight for hundreds of miles.

Australia

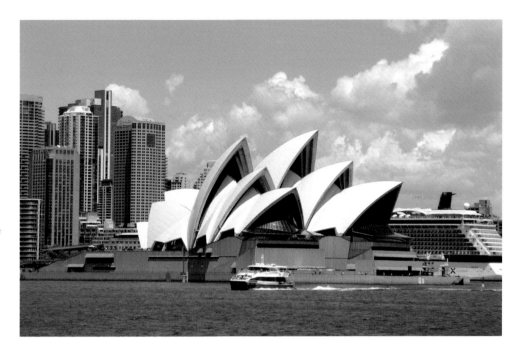

■ **AUSTRALIA** – On the Aboriginal story, I have been largely educated by the unequivocal photos of the courageous and humane photo-journalist Penny Tweedie, who sadly took her own life in 2011. I learned more from two Australian journalists, John Pilger and Jill Jolliffe, a good friend. Both were concerned with Aboriginal Australians who were there centuries before Europeans arrived.

As John wrote: 'Australia's hidden history is Aboriginal' adding, with regard to the federal government's hostile 1998 legislation, 'Nothing as openly racist has been enacted in a modern, democratic parliament.' Jill has despaired at Australia's handling of East Timor whose sufferings she has courageously reported. Many more protest vociferously at Australia's rigid and inhumane immigration policy of offshore detention.

In my own journey across Australia, I didn't meet a single indigenous Aus-

Above: In Sydney harbour the iconic Opera House is the city's most famous image.

Below: Opera House crowds are there for the building's unique personality, only occasionally for the music.

tralian in the cities and environs I visited, although it was encouraging to find a gallery close to Sydney's iconic opera house that sold superb Aboriginal art.

In an often shocking saga is the Aboriginal Protection Act of 1869,

which prompted the removal of many Aboriginal children from their families and communities. Referred to as the 'Stolen Generations', it was just one of a range of policies that caused the steep decline of the indigenous population. Better known is another policy, entirely British, that saw more than 160,000 convicts transported to Australia between the 1780s and 1860s to become settlers and colonisers. The divisive debates of more modern times over immigration possibly began here.

Queen Elizabeth II is still the head of a federal parliamentary constitutional monarchy, as I write. There have been several attempts by republicans to change the system. More heated politics is devoted to which party is up and who is prime minister. Broadly, the main parties are either centre-right or centre-left, with others to one or other side of them. None is seriously extreme. And if beach life seems to outsiders to preoccupy laidback Australians, there is no ignoring that theirs is a highly developed society much involved in mining, banking and manufacturing.

For all its fine cities and urban lifestyle, its gorgeous coast and numberless beaches, excellent museums and impressive homegrown wines, modern as well as Aboriginal culture and respected literature, Australia's essence remains in its great spaces, its 'outback'. Aussies as well as tourists love to explore the wilder places and to see remarkable wildlife, from saltwater crocodiles to furry koalas. But it is not all an idyll.

The Great Barrier Reef has suffered severe coral bleaching and pollution. The Kakadu National Park in the Northern Territory is listed as of 'significant concern'. The magnificent Blue Moun-

Above: At the end of the street, Flinders Street Station is rather more than a railway hub.

Right: Any building dating to the 19th century is history in tradition-minded Melbourne.

tains near Sydney have been affected by urban development, land clearing and appalling bush fires that burned, in the last weeks of 2019, huge areas of Australia, many homes, a few people and a tragically large number of wild animals. The Australian dingo is currently endangered and threatened with extinction. Tourists, learning that the renowned Uluru, formerly Ayers Rock, would soon be formally closed off, rushed in litter-strewing masses to climb the great red rock, outraging the local Anangu custodians of what was to them a sacred place.

As for me, a temporary observer, I am now enthralled by Australia and worry about a future likely to be

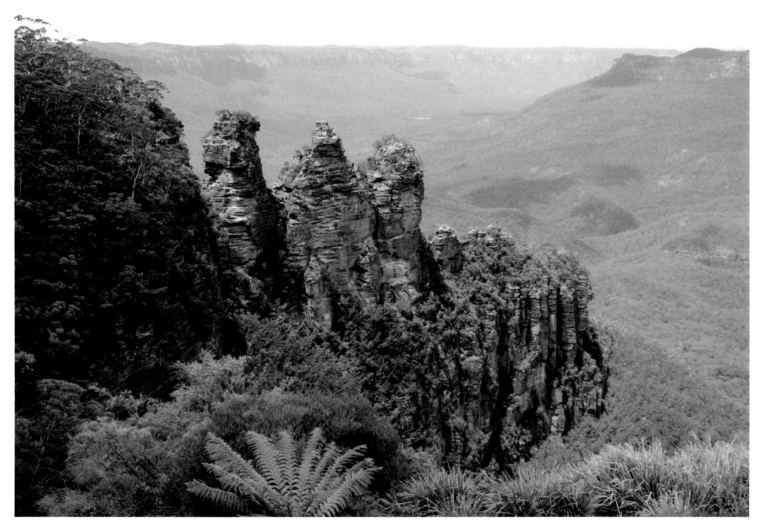

Above: The Three Sisters is the name understandably given to a jutting rock formation in the forests and valleys of the Blue Mountains near Sydney.

Right: Australia is framed by georgeous beaches. Two visitors to Queensland pause to admire the view of a beach near Cairns.

plagued by drought and fire. How absurd, therefore, that I enlisted resident friends more used to 'roos as roadkill to find for me, before I left this great land where up to 50 million kangaroos are said to be out there, a free roaming closeup kangaroo.

Top left: *Swan valley in Western Australia is known for quality wines but here's where I saw, at some distance, my first kangaroos.*

Above right: *Evidently a commonplace for some, the almost tame kangaroos in Perth's Heirisson Island were thrilling to me.*

Left: *The kookaburra, I learned, is a type of kingfisher. This one was in a wildlife park near Sydney.*

Below left and right, right: *Aboriginal art is admired and respected around the world. These three artworks were among fabulous designs I came across.*

© Alison Buchanan – Junuy Maruwan

© Paddy Tjamitji + Warmun Art Centre

© Warlukurlangu Artists Aboriginal Corporation

New Zealand

■ NEW ZEALAND – It might seem odd that New Zealanders, generally an easy-going and friendly people, are happy with their widely used nickname, kiwi. One meaning of kiwi is a hen's egg-sized green fruit, sometimes known as a Chinese gooseberry in the genus *Actinidia*. Another is a small endemic flightless bird, genus *Apteryx*. These are the only birds with nostrils at the end of their beaks. They are nocturnal and normally monogamous, their relationship lasting as long as twenty years. The national rugby league team, dauntless and muscular All Blacks, are also kiwis – and thrill crowds with the challenging *haka,* a vigorous stamping dance they perform before every major match. The women's team also perform a *haka* before the start of play.

The *haka*, a Maori word that once meant a war dance, has a long history, as have the Maoris. Now about 15 per cent of a total population numbering less than five million (Europeans are 75 per cent, Asians and others the rest), Maoris are acutely sensitive

Above: Snowy mountains adorn the road south of Christchurch on South Island.

about their history, culture and current role. In the national 120-member parliament seven seats are reserved for Maoris, with representation dating back to 1867 when four seats were allocated. For one reason or another, reserved seats are controversial.

Politics in this small nation is lively. As I write, the government since 2017 elections is a coalition of three parties led by Prime Minister Jacinta Ardern

of the Labour Party, at 37 the world's youngest female leader, with veteran politician Winston Peters of NZ First as deputy prime minister and James Shaw of the Greens providing support. The most notable event in the course of this government was the depraved Christchurch mosque shootings by a white supremacist on 15 March 2019, in which 51 people were shot to death and 49 injured. In an obscene side act, copies of the live-streamed video were reposted on many platforms and file-sharing websites. More positively, gun laws were promptly amended.

A much happier event had taken place earlier when, on 21 June 2018, a daughter, Neve, was born to Prime Minister Ardern, her first child, the father Clarke Gayford, a television presenter. Events, good and bad, brought New Zealand worldwide attention. How the economy and tourism were affected it was hard to say. Christchurch had experienced a devastating earthquake on 22 February 2011, causing 185 deaths and widespread damage.

New Zealand is a popular travel destination whose mixed economy still includes a large number of sheep. It was said once that there were twenty sheep to one person. More recently the ratio became seven to one. The first sheep in New Zealand was a flock brought there by navigator Captain James Cook in 1773. In my own brief stay I met a young woman with a small flock of her own parented by the hand-fed Marjorie and Sean.

Birds as strange as kiwis inhabit the wilds of New Zealand – yellow-eyed penguins, tuis, an endemic honeyeater, a type of owl called a

morepork, wekas, keas and kakapos. It needs time and patience to see them. The landscapes need only strong legs and, luckily, splendid vistas are accessible by car and bike. Because of its gleaming snow-capped alpine mountains, I chose South Island over

Top: Aoraki, or Mount Cook, is the highest mountain in New Zealand rising to 12,218 ft (3,724 m). For climbers, it is a serious challenge.

Above: More astonishing beauty in the Southern Alps.

North Island as my personal favourite. Others will prefer North Island's pools, waterfalls, pinnacles and peaks. Almost best of all, except for moments when a bus disgorges chattering tourists, the spaces are largely empty. Another feature of this graceful land: most of the people whose job it is to engage with travellers are not kiwis at all but a smiling community of immigrants who have, they are pretty sure, found their own paradise.

Above: Dawn light on glorious mountains near Fox Glacier in South Island.

Below: Stacking stones is a ritual from ancient times. These were on a fallen tree in a riverbed.

Below: A pastoral scene with a few sheep. New Zealand is said to have 28 million sheep, considerably fewer than in years past.

Part 8

Islands

ISLANDS Our extraordinary planet has a great deal of water, fresh, frozen and salty. It is a miracle of nature, or geology, or whichever science it is, that the arrangement of land, earth, sea and sky is so organised that as well as the great continents we also have literally millions of islands. Yes, the quantity of water is changing by the minute and yes, the areas of land with its ancient rock, forest, soil and lake is changing, too. While it can all be defined, measured and named, it remains infinitely challenging to explain and understand. And no god has anything whatever to do with it.

Everywhere that humanity has touched has left a mark. Quite often that mark reflects a faith, a belief, in an otherworldly being. So we are frequently attached to, or neighbour to, a church, mosque, chapel or other emanation, including quantities of art, that suggest we do not control our own destiny. 'To each his own' might be the appropriate view on this. Philosophically, conversationally, practically, even photographically, the human connection has contributed massively to our daily lives.

Islands constitute a different idea from anywhere or anything else. Bounded on all sides by sea, they are – or in instances of gross development – initially were dream worlds, treasure islands where the treasure was not gold but bliss, pure, simple and private. Defending an island seems more worthy and vital than defending a nation or a principle. The British never forget that their small kingdom is an island. Australia, nestled in a great ocean, is also an island.

The islands briefly profiled in the following text happen to be those that I have visited. Not many, really, consid-

Above: *In South Georgia, with no permanent human population, penguins are curious but unafraid. Elsewhere, human impact has changed everything.*

ering the profusion out there. Some are self-contained nations with a flag, a registered identity, a constitution. Others are dependent on a mother country. Each has its own essential character. I don't despair that I have missed out on the abundance of other islands in our marvel of a planet. I am grateful that I have been able to make the journey, so far.

Azores

■ **AZORES** – Scholars have found hints of previous settlement but Portuguese explorers were the first to land and thrive on these beautiful islands, and the flag of Portugal still flies over them. They are nine dots in the Atlantic, an archipelago formed by volcanic thrust and heave. Volcanic origin is still evident in the twin blue and green Sete Cidades lakes in the great caldera of São Miguel, the island's geothermal

Above and left: *The nine Azores islands were created by volcanic activity. Tallest peak is Pico, 2,352 m (7,713 ft)) viewed from Faial Island.*

hot springs at Furnas, in the shape of Mount Pico on Pico Island, and elsewhere.

The oldest city is Angra do Heroismo on Terceira Island which has a complicated Iberian history. The island's Lajes air base was significant in World War II and a few years ago saved from a watery grave an Airbus that had sprung a leak on its way from Canada to Lisbon. Then again, Faial and the harbour of its main town Horta is the target of almost every yacht crossing the Atlantic. Many of them have left a record of their passing on the harbour walls. On the wilder, hillier São Jorge Island the local cheese is the source of pleasure and wide fame.

Graciosa, with its gracious name, was almost without modern tourism until a hotel and resort was recently opened there. There is even an airport. It is still largely rural – as are all the islands. Flores Island, in the most western of three groups, is as rural as the other islands but has the distinction of being the westernmost point of all Europe. Just 15 miles, or 24 km, across the water Corvo Island, once a refuge for pirates, now with its one village, is the smallest island in the Azores. These tranquil islands have a bloody past. Whaling was practised, largely on Pico Island, until it ended in 1984. Azorean men had not only gone to work with the big American whalers, who valued their skills as lookouts, boatmen and harpooners, they did it too at home

Top right: *Fishing boats on a São Miguel beach.*

Right: *Islanders take advantage of volcanic steam at Furnas on São Miguel Island to cook lunch.*

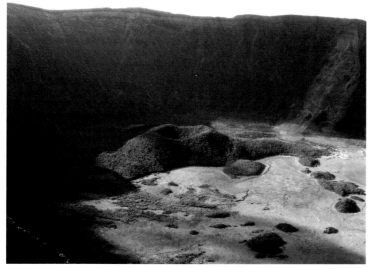

Top left: *This is the main square of Ponta Delgada, the islands' capital on São Miguel Island in 1984.*

Above: *A large and dramatic crater is part of the scenery on Faial Island.*

Above right: *The best known bloom in the Azores is the blue hortensia, or hydragea, often seen in hedgerows. These however are lilies, adorning Faial Island.*

Above: *On Faial Island, Ponto do Capelinhos, its lighthouse and lava field are a stark reminder of volcanic eruption in 1957.*

in small open boats off Pico Island in whose waters seasonally congregate great sperm whales. Appalled by what I saw, as photojournalist I photographed the flensing of whales in the shoreline yard of the factory. Now, happily, the same skills have been transformed into whale-watching tourism.

The islands, despite the volcanic power that brought them to life, have simplicity and grace. The Portuguese architecture, amended with a volcanic touch of stark black and white, sits well among the green fields. Stark walls here and there frame miniature vineyards. And framing well-maintained roads are glorious hedges of blue hydrangeas. Perhaps this peaceable outpost of Portugal's culture needs a qualification: it rains a lot.

Above: In the pretty little island of Graciosa, a rustic cart with wooden wheels does sterling work.

Below: Youngsters with the bones of slaughtered whales in 1984, their uses including ornamental scrimshaw.

Below: Open boat whaling was still practised in 1984. An official ban, enforced by 1986, opened the way for whalewatching tours and for the Atlantic Ocean's sperm whales to live out their natural lives.

Above: São Jorge cheeses are delicious and known in countries far distant from these islands.

Below: Islanders, with their bundles, await the ferry in Madalena, Pico Island, that will take them home.

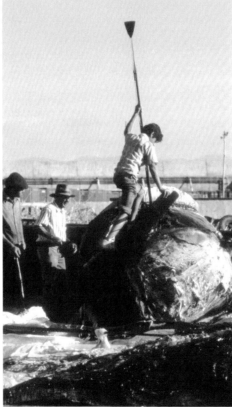

Cape Verde

■ **CAPE VERDE** — It's a grim thought that the trade between the 16th and 19th centuries that brought these Atlantic islands prosperity was in slaves – and that when slavery ended the islands sank into economic decline. Portuguese explorers had discovered and settled the islands in the 15th century. Then, noting their ideal

Above: A busy shop in the main street of Praia, capital of Santiago, main island in the Cape Verde group.

Left: Of the ten islands in the Cape Verde archipelago Santo Antão has the most dramatic scenery.

location, merchants and privateers went into business. Fortunately, post-slavery, mid-Atlantic possibilities brought a different commerce and new role as stopover on shipping routes.

In the years that I lived in Portugal, after the 1974 revolution that deposed the odious Salazar regime, I knew of the islands only as source of cheap labour for building contractors. I knew too that Salazar's cruel agents had used the islands as a dumping ground for political exiles. I did not expect that, when I finally travelled around the islands in the 21st century, I would encounter exciting landscapes, thriving communities and a stable democratic society, formally independent since 1975. An odd fact: through emigration over many years (actual resources are limited), the population of Cape Verdians is larger outside the islands than within them.

An archipelago of ten volcanic islands, geographically and politically linked to Africa, Cape Verde presents a different aspect at every shore. Santiago Island has the capital, Praia (a word meaning 'beach'), the main

Left: This is Fogo. A bleak landscape, dark lava, an arid crater – and there, somehow, poinsettias bloom.

Top: The heartland of Santo Antão is an astonishing vista of high mountains and deep valleys.

Above: The island of Fogo (meaning fire) still has a live volcano, the last eruption in 2014.

administrative and commercial facilities, and a large proportion of the islands' half-million population. Mindelo, the main town on São Vicente Island, harbours mercantile as well as pleasure boats and is a centre for music and the arts. Its airport is named for the wonderful Mindelo-born singer Cesária Évora, whose warm and lustrous tones with traditional music brought her worldwide fame.

The islands have the requisite sandy beaches for tourist sunbathers, busy fishing ports and, on Antão especially, unexpectedly stark, stunning mountains and green valleys where agriculture thrives. Fogo, where an active volcano dominates a dark lava-strewn landscape, capitalises on its dramatic scenery. Sal (which I didn't see) is dedicated to tourism. Other islands are vibrant with small businesses, fishing or agriculture. Party politics is mainly a matter of two competing parties. Churches, in the Portuguese Catholic style, are architecturally handsome and well attended.

Above: *A trick of nature has given a beach in the island of São Nicolau a curious blend of contrasting colours.*

Below left: *Fishing sustains the lively port of Ponto de Sol in Santo Antão Island.*

Below right: *The liveliest of the Cape Verde islands is São Vicente, its main city, Mindelo, a cultural hub for music and entertainment. The singer, Cesária Évora, known for her 'morna', or blues, style, was born here. The harbour is graced by its own Table Mountain.*

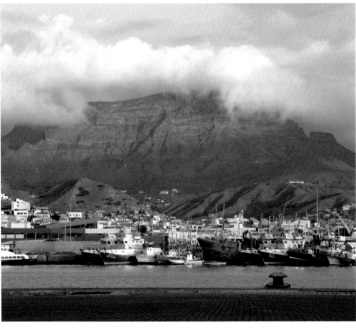

It is, though, the people who have made their islands places of wonder, stable and progressive, and the people are what is often called a melting pot. So many nationalities have come and gone and stayed that Cape Verdians are a rich blend of mixed Portuguese and mixed everywhere else. Mulatto, mestiços, creole, pale or dark, the islanders are a story that certainly includes slavery but, with the alchemy of history, has become a pot of gold.

Above: Mindelo, São Vicente's main city, still has a Rua de Lisboa and other features from a Portuguese past.

Above: In Maio, poorest of the islands, salt is a useful product. For early explorers, Maio was a haven.

Above: Cape Verde's mid-Atlantic location was always of interest to traders, initially for slaves. Trade has fortunately moved on and to container ships.

Comoros

■ COMOROS – In the Indian Ocean, off the east coast of Africa, Mozambique and Madagascar nearest neighbours, the four Comoros islands, have not made much of a success of even the few resources that they have, mainly spices. Visited by a succession of traders after the 16th century, the small population was a mix of French, British and Arabic. After World War II the islands became a French overseas territory. By 1961 they were autonomous, and finally independent in 1975. Three islands, Grande Comore, Anjouan and Mohéli, are Muslim-oriented. The fourth, Mayotte, chose to remain French and to this day is administered as a *département* by France. It is also an 'outermost region' of the European Union.

Quarrelling leaders provoked frequent coups. A notorious mercenary, Bob Denard, who had been involved in covert operations in several African countries and had come to live in the Comoros, acted as spy for southern Africa's white-led regimes. He led three takeovers until the French, tiring of his depredations, forced him out in 1989. An attempt to return in September 1995, failed. The mercenary group was gone by October. The islands are so poor, what coup leaders expected to gain was hard to fathom.

As it happens, in the fathomless depths of the ocean near the islands is the one thing that has given the islands a peculiar renown: coelacanths. A coelacanth is a very big fish with scales like armour, more than 2 metres, or 6-ft-plus long, and weighing up to 200 lb, just over 90 kilos. It was

thought by ichthyologists to have been extinct for 66 million years, until one was hauled on to a fishing trawler in 1938 – 'the biological find of the century' – and identified by Dr. J. L. B. Smith, a South African museum curator who knew he had come upon a rare beast, as a 'living fossil'. Later, more

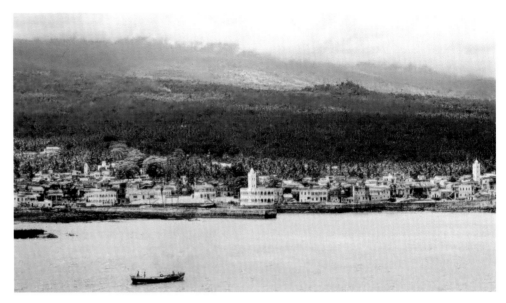

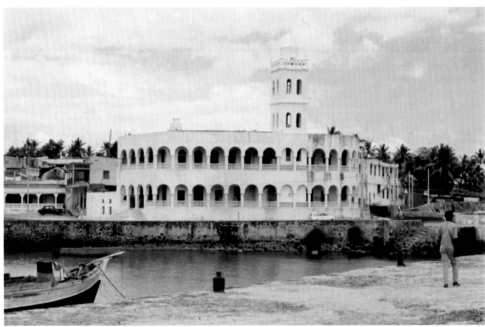

Top: *Of three islands formerly under French rule, Grande Comore, Moroni its capital, as viewed from the sea.*

Above: *The most visible building on Moroni's waterfront is its Grand Mosque. Little of the rest is as imposing.*

were found near the Comoros (and a separate population in Indonesia).

Some scientists believe that the coelacanth, *Latimeria chalumnae,* is a step in the evolution of fish to terrestrial four-legged amphibians. That view is mainly due to the coelacanth's double pair of lobed fins (eight altogether) that stand out from its body like legs, along with other factors. Science has moved on since the 1938 catch – to mitochondrial DNA sequencing of coelacanths. More coelacanths have been found. Another discovery: they taste horrible. Their status is critically endangered.

The Cormorian government, modest as it is, controls Grande Comore,

Above: In a downtrodden capital this drapery shop was a cheerful sight.

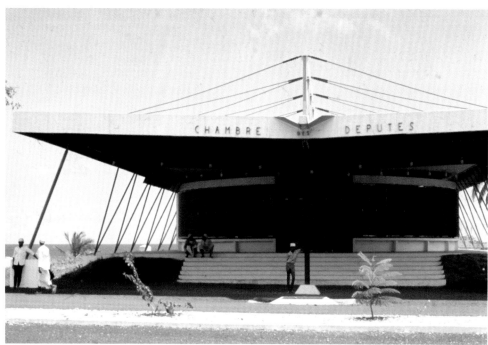

Top: Government was still French when I passed by. A French flag flew over a handsome residence.

Above: The system of government included representatives and a modern-styled Chambre des Députés.

Anjouan, and Mohéli islands. The economy is based on subsistence agriculture and fishing. Even rice, the staple food, is imported. The Comoros, though, is the world's principal producer of ylang-ylang, an essence derived from the flowers of a tree used in manufacturing perfumes and soaps. Ylang-ylang essence is a major component of Chanel N°5.

The islands are also the world's second largest producer of vanilla, after Madagascar. Because of poor infrastructure, tourists are few. Those who make it will value the lack of crowds and enjoy spectacularly beautiful beaches. I made it there, long ago, by ship. Its name was *Pierre Loti*, after a French writer, and it (she?) belonged to a merchant shipping line called Messageries Maritimes. Its golden age long past, the line is now sadly extinct.

Top left: *In islands that became renowned for a rare fish called a coelacanth the most conspicuous boat was this one.*

Top right: *A tatty alley near the waterfront was not encouraging.*

Left: *Perhaps I was there on a bad day but this was the dreary marketplace I saw.*

Corsica

Corsica – A favourite Mediterranean holiday island for the French, for whom this is their *île de beauté,* Corsica easily justifies the designation. Snow-capped mountains – Mount Cinto the highest at 2705 m, 8875 ft – frame green valleys where quality wine is made, blue seas lap a coast of cliffs, rocks, sandy beaches and pleasant towns. Ports dotted with prettily painted boats offer fishing and touring. Ample restaurants, bars and graceful hotels cater to travellers' every need. The food is good. This is, after all, France.

Its location at the heart of a much-travelled, and fought over, sea also gave Corsica a long and incident-filled history. Older, in fact, than anyone

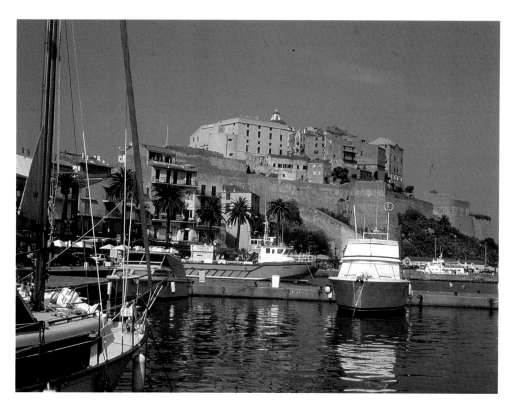

Top right: *Corsica, France's own 'île de beauté' in the Mediterranean.*

Right: *High on craggy hills Corsica's former capital, Corte.*

Below: *Birthplace of Napoleon in Ajaccio.*

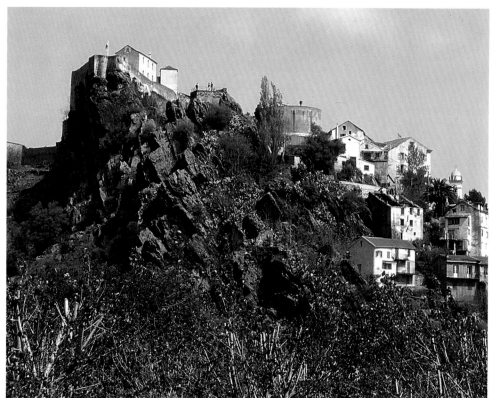

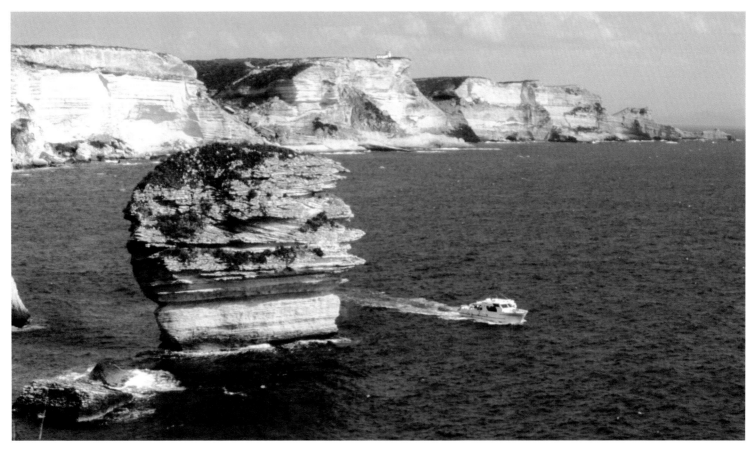

realised until a megalithic site was discovered in 1946. There now, at a place called Filitosa, are statue-menhirs dating to around 1500 BC and archaeological finds from even earlier. Statues and museums around the island recall more recent times. Ruled by the Republic of Genoa after 1284, Corsica developed an Italian character which it hasn't completely lost. The 18th century saw conflict in which the French ultimately dominated, but in the various battles a British role was marked. There was even an Anglo-Corsican kingdom for a couple of years.

Barely noticed at the time, on 15 August 1769, Napoleon Bonaparte was born to a modest family of Italian descent in Ajaccio, Corsica's capital. He trained for the military in a Paris

Above: Cliffs and Mediterranean waters are part of Corsica's appeal.

Right: A megalith at Filitosa, prehistory revealed in Corsica.

academy and joined the army. The French Revolution exploded in 1789 and revolutionaries had soon overthrown the monarchy and declared a republic. By 1796 Napoleon, who had spent the revolution's earlier years in Corsica, had reached high command. Three years later he was 'first consul', the leading political figure. In 1804, in a sumptuous ceremony at the Notre Dame Cathedral in Paris, he crowned himself emperor of France. His remarkable life, his marriages, his battles, his victories and, finally, his

defeats and death, are amply recorded. Including, inevitably, in the cafés and street names of his hometown, Ajaccio.

The lives of other Corsican notables, local and cultural heroes, are also zealously recorded, and the former capital, Corte, high in the mountains, is well worth visiting. On a misty day those mountain towns have an eerie quality. Yet another factor in the Corsica story is its high murder rate. One notorious killing, in 1998, was of the leading French administrator. 'There are many murders,' a hotelier admitted when I cautiously raised the subject, 'but never, never of tourists.' Local politics, family feuds and a persistent and lively mafia have helped maintain an old tradition.

Nationalism is strong and has on occasion led to violence. The French government is open to a democratic Assembly with considerable powers but is keen to avoid total autonomy in case other regions of France get similar ideas. Politically, a coalition called *Pè a Corsica* (For Corsica) is prominent. Corsicans themselves appear to be split, some demanding total independence, others eager for reforms that promote Corsican identity. For apolitical residents and the many visitors to the *île de beauté,* Corsica, its multiplicity of coastal and mountain joys and the diverse pleasures offered everywhere across the island, are evidence enough of a dynamic Corsican character.

Right: *Mountain towns and villages add to island mystique.*

Falkland Islands (Islas Malvinas)

■ FALKLAND ISLANDS (ISLAS MALVINAS)

The existence of these Atlantic islands off the southeast coast of South America only became widely known after the short-lived (74 days) war launched in 1982 by Britain's prime minister Margaret Thatcher against an Argentinian invasion force. The British won but Argentina has not dropped its claim. Determined to keep these remote islands under its flag – the Falklands version displays not only the Union Jack but a sheep – Britain's parliament in 1983 added law to the rights of possession with a British Nationality (Falkland Islands) Act.

A British sea captain first saw the islands in 1765 and Britain has only held them since 1833. In between were almost standard coloniser's conflicts involving the French and Spaniards. In truth, where sheep are farmed and a

Top: Carcass island in the western Falklands has landscapes that seem to echo the Scottish highlands.

Above: The islands show off a little of their history

few hardworking farmers live, great colonies of albatross, rockhopper, king and magellanic penguins and other seabirds have an older claim. The small human population of about 3,500 lives mainly on East Falkland where the capital, Stanley, is situated – and also, since the war, an RAF station and garrison called Mount Pleasant. West Falkland is the other main island. Maps indicate some 770 smaller islands, nearly all uninhabited.

Stanley at first glance looks British to the core. Many houses are in a suburban style. In tidy gardens daffodils and tulips bloom. Christ Church Cathedral and the post office could be in any British town. There are several pubs and a golf course, a police station, sports centre and school. A well-maintained 'Historic Dockyard' museum is jampacked with British trivia,

as well as objects from its history, including the war. But it is windy there and in front of the cathedral is a whalebone arch. The town map also includes a bomb disposal unit. And along with war graves, the islands still have many minefields.

The Falklands have their own peculiar quality. Hospitable British housewives offer homemade cakes to visitors, good beer is available in the pubs, sheep are pastured in fields that look like Berkshire. Yet seals of several species gather on island shores, whales are frequently seen in island waters – and many of the ships that pause in Stanley's harbour are sailing on to the Antarctic.

Top right: Houses in the capital, Stanley, with the suburban air of many an English town.

Right: Apparently finding peace amid the chaos a pair of rockhopper penguins.

Below left: An albatross couple stands out in the crowded West Point colony.

Below right: At West Point in the Falklands an impressive colony of albatrosses and rockhopper penguins.

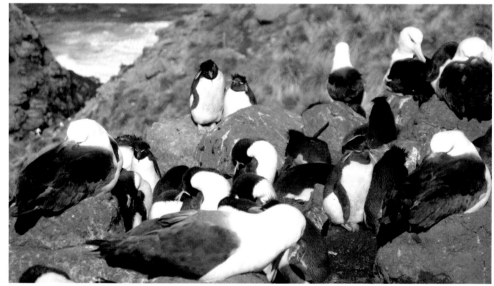

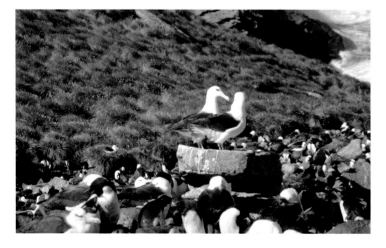

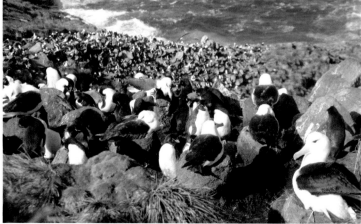

Hong Kong + Macau

■ **HONG KONG + MACAU** — Hong Kong Island is an island but, with Kowloon and the New Territories, it encompasses more than sixty. And Hong Kong and Macau, two dissimilar territories in the Pearl River delta, are joined since 2018 by the 55 km, 34 mile, Hong Kong-Zhuhai-Macau bridge, so that where each was for centuries its own distinctive entity, they are now yoked together by smart engineering.

Since 1997, Hong Kong has been a 'special administrative region' in China. Its name means 'fragrant harbour'. Population density is 6,300 people per square km. Hong Kong island fascinated the British, who had gained possession of it in 1842 after the so-called Opium Wars. Then, in 1898 the British acquired the 'New Territories', with a commitment to return the land to China in 1997.

World War II had a powerful impact on Hong Kong. Even before the outbreak of war in 1939, mainland Chinese were rushing to escape the oncoming Japanese. In 1941 the Japanese occupied the island, provoking terror, loss of property and acute food shortages. In 1946, after the Japanese defeat, Hong Kong was quickly repopulated, beginning its economic revival. Overcoming social issues, the island experienced a boom in population, business activity, highrise building and high technology. Under British rule, Hong Kong became a prosperous centre of finance but, years before the handover to China was due, began to worry.

By 1984 a 'one country, two systems' agreement was in place by which,

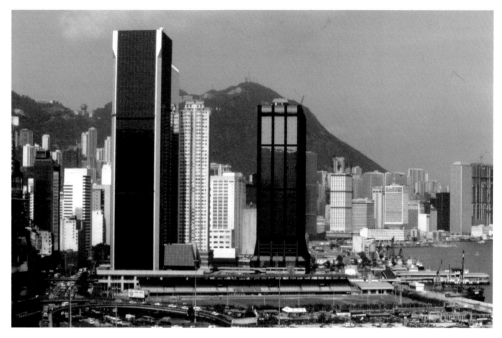

under China's government, capitalism and a partial democracy would continue for fifty years. Beijing promised that Hong Kong citizens would be free to elect their local government. In 1992 Hong Kong's last British governor, Chris Patten, attempted to improve the future voting system and was howled down by China. The actual handover in 1997 was properly ceremonial, but every word and act afterwards, including by the Legislative Council (Legco), Hong Kong's governing body, was closely watched by Chinese authorities and the Hong Kong populace, each side with a different interpretation of the agreement.

China ensured that full democracy was not in the cards. Recent policies suggest an urge to integrate the area into a single Pearl River megacity. The Hong Kong populace gathered in their multitudes to demonstrate that 'two systems' could not be broken. As years passed pro-democracy hunger

Top: *A view of Hong Kong in 1984 flashes high style and modernity.*

Above: *Hong Kong, always crowded, lives on many levels.*

Top left: *A junk under sail at sunset with Hong Kong as backdrop.*

Top right: *A woman who knows how to live on water.*

Right: *Small boats, mainly sampans, are home to a large population.*

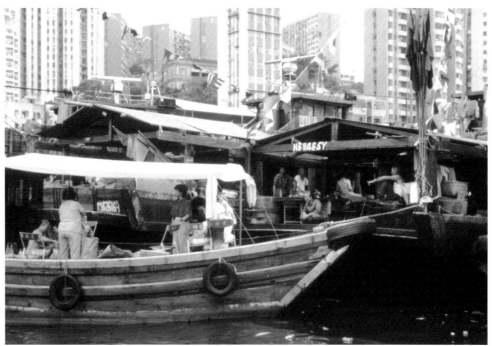

became ever stronger – countered, in 2014, by China's insistence that only approved candidates to Legco leadership would be permitted – in effect, breaking a promise.

In 2017 Chinese President Xi Jinping came to Hong Kong himself to swear in the new chief executive, Carrie Lam, and to warn against activity hostile to China's role as supreme power. From July 2019, Hong Kong experienced huge and determined anti-government and pro-democracy protests with an increasingly brutal armed response. Clashes with police, initially against a proposal to allow extradition to mainland China, developed into mass demonstrations demanding full democracy. District Council elections in November 2019, normally a dull administrative exercise, gave pro-democracy activists a striking

victory. In a vivid detail, massed umbrellas, first seen in 2014 crackdowns against radicals, appeared again. But along with batons, so did bullets.

It was a continuing crisis affecting boardrooms as well as youthful demonstrators. Cathay Pacific, Hong Kong's flag-carrying airline founded in 1946, announced the resignation of its chief executive. With 2047, the fifty-year deadline, looming ever closer, the world was watching.

Portugal's last relic of a once great empire, Macau was Portuguese-ruled from 1557 to the end of the 20th century – until, by agreement, handover to China in 1999. Like Hong Kong, a 'Basic Law' ensured Macau would retain its capitalist legal system and own currency, the *pataca*, based on Portuguese civil law. Macau would also keep its legislative system, people's rights and freedom for fifty years. Like Hong Kong, it is a special admin-

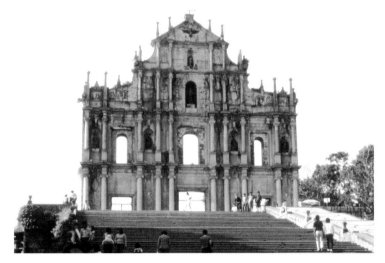

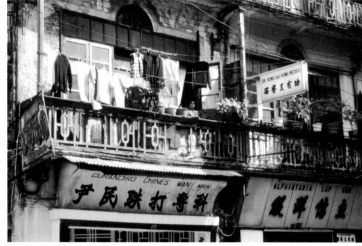

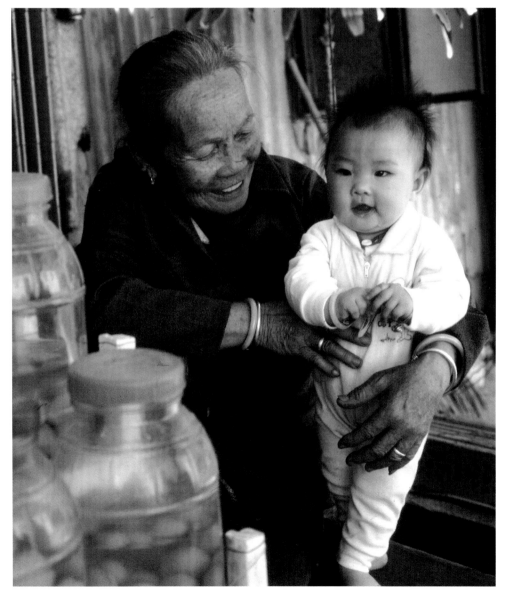

Top left: A Macau landmark, the St.Paul façade is all that remains of a 17th century religious complex.

Top right: A Portuguese colony for hundreds of years, Macau's heritage shows in shops and buildings.

Left: A grandmother lovingly tends baby and shop.

istrative region of China, a status that will expire in 2049. What is strikingly different between the two onetime colonies is their character, their economy and their relationship with China.

The agreement has allowed Macau to function normally and without the tensions so visible in Hong Kong. 'Normally', in this context, means continuity of a society long dependent on gambling. Casinos, vast, gaudy and glamorous or modest and relatively lowkey, are almost everywhere. The Portuguese touches are in detail – cobblestone calçadas just as in Lisbon and a few buildings, including churches, in the Portuguese architectural style.

But where casino gaming is illegal in mainland China and Hong Kong, Macau has a fully legal monopoly,

Above: The bridge to Taipa was a proud Macau achievement in 1984; a much longer one linking Macau to Hong Kong opened in 2018.

Right: The round tower, the Lisboa Hotel and casino in this 1984 photo, bears little resemblance to the glitz and glamour there today.

enhanced by a 'Closer Economic Partnership Arrangement' agreed with China in 2003. Macau is wealthy, its GDP (income) in the world's topmost countries. If there are any issues over democracy they haven't been aired in public. And if social protest did arise, it would perhaps focus not on money but housing. I had found Hong Kong's population density alarming. In Macau it is three times as high, 21,340 people per square km. Where I live in southwest France it is 30 to the square km.

Iceland

■ ICELAND — In southwest Iceland a grassy area below a cliff of tumbled black volcanic rock was this northern country's national parliament, or Althing, from 930 to 1798. The Iceland flag still flies there but everything else has changed. As predictably, though more troubling, are the changes happening to Iceland itself. As prime minister Katrin Jakobsdottir wrote in *The New York Times* in August 2019, 'An ice-free Iceland is no joke'. That month she was commemorating the first disappearance of an Icelandic glacier, Ok, in the knowledge that more would soon follow. 'Ok's disappearance,' she wrote, 'is yet another testimony of global irreversible climate change.'

Politically, too, Iceland's status has changed across the centuries. Erik the Red, who colonised Greenland around 986, is a great national hero. Early in the 13th century Icelanders accepted the king of Norway as their ruler. In 1380 Norway and Iceland formed a union with Denmark. Not until 1918 did Iceland gain full self-government. World War II introduced new factors: German troops in Denmark, British troops in Iceland, then Americans. Finally, on 17 June 1944, Icelanders completed a total break with Denmark and were fully independent.

Fishing rights and limits were an issue in the following years. Whaling, from the 1990s onwards, was also controversial. In 2006 Iceland broke its own 21-year moratorium for a catch of minke and fin whales. Banks were at the centre of a greater crisis when the system crashed in 2008. Banks collapsed, governments fell. In 2009 a

Above: Of the many waterfalls in Iceland, Gullfoss in the southwest, is the grandest and most powerful.

Right: It's Independence Day in Iceland, June 17, and a young girl smilingly poses in national dress beside a memorial in Reykjavik.

centre-left coalition won a majority. The International Monetary Fund (IMF) provided loans to help resolve debts. Arguments and confrontations continued. Yet, by 2019, Iceland was rated on its GDP in the world's top ten.

Volcanic eruptions were commonplace, but crashing banks and bitter rows over suffering savers were as nothing when the volcano Eyjafjallajokull exploded with a massive eruption in 2010, creating a huge ash cloud that disrupted flights throughout Europe for weeks. It took time, but Iceland began

to recover from hard times, and was able to ease austerity and to be able to pay compensation to angry savers.

By contrast with edgy finances, tourism took off as eager visitors – more than two million a year since 2017 – arrived to explore Iceland's extraordinary landscapes, its mighty waterfalls, the volcanoes and showy geysers, its hot springs and glaciers. I had got myself to Jökulsárlón, a large glacial lake in southeast Iceland, a place where great ice boulders tumble through the waters. Now, like many others, I wonder what a warming climate will do. But vacationers take pleasure, too, in Iceland's mosses and summertime vegetation, in appealing parks and good-tempered ponies.

The more sophisticated pleasures of the capital Reykjavik and nearby Blue Lagoon all help to create, even as the ice is quietly melting, a thrilling new image of Iceland. Image, of course, is a word well understood by Iceland's most famous star, the singer Bjork. In a total population of less than 370,000 that there are few famous names is not surprising. But get into another, earthier topic like, say, geothermal power and Iceland is the tops.

Left: The popular Blue Lagoon is a shallow lake and geothermal spa situated in a lava field near Reykjavik.

Above, top: A flag, a green space: this is Thingvellir, where Iceland held its first Parliament in 930 AD. Now it is a national park.

Above: In Reykjavik the tallest building at 74.5 m (244 ft) is a Lutheran church, Hallgrimskirkja; built of concrete, its design was inspired by natural basalt formations.

Top: *The striking design of Reykjavik's concert hall and conference centre, Harpa, features coloured glass panes.*

Above left: *Jökulsárlón, in the southeast, is a glacial lagoon dotted with multi-coloured icebergs that move and flow. It is a compelling sight.*

Above right: *A couple of visitors walk beside the Jökulsárlón glacial lagoon.*

Left: *Puffins nest around Reykjavik's harbour; tours are available to see their rocky habitat.*

Jamaica

■ JAMAICA — The charismatic athlete Usain Bolt brought lustre to his island nation yet Jamaica was famous even before his impressive track achievements. Famous for Bob Marley and reggae music most of all. For a remarkable bobsled team that, coming from a land with a tropical climate totally lacking ice and snow, bravely faced the world in an Olympian context. For Rastafarianism, its heritage in a religion that venerated Ethiopia's emperor Haile Selassie.

For historians and proud Jamaicans there's fame in the name of the pan-Africanist orator and hero Marcus Garvey. Fame, too, for Jamaica's rum (though beer is just as popular). Some will say Jamaica is famous for its crime, and others will remember only its handsome beach resorts in the alluring setting of the West Indies and Caribbean waters.

Inland are mountains — Blue Mountain peak at 2256 metres (7402 feet) the highest. There are numerous rivers, caves and rich greenery, amply visited but not exactly famous. Latterday explorers will find much to discover.

A colonial history left the island under British rule and with a largely black population descended from slaves colonists brought to the island.

Top right: Radiant smile from a gardener who has worked for more than 20 years at a Jamaican plantation house.

Right: In a tourist store a saleswoman with colourful nails offers a small-size bottle of the famous local rum.

Independent since 1962, Jamaicans still have a serious issue with Britain based on the unjust treatment given to several members of the present generation, all now British, descended from a generation of invited immigrant workers. In a simplistic definition they are known as the 'Windrush generation' (or sometimes the 'Windrush scandal') for the ship that brought them to England.

As to music, my own favourite is a brilliant jazz pianist, Monty Alexander. Over many years he has dazzled audiences around the world. I've enjoyed his skill, style and wit in France's Marciac jazz festival – but also caught his appearance in the 2019 Proms season in London's Albert Hall. I too have much to discover. In a brief passage through Jamaica I cannot even lay claim to spending time in the capital, Kingston. But I feel able to state that Jamaica deserves a lot more attention than I have given it.

Top: *In tourist territory a Hip Hop shop has the goods.*

Right: *Happy and high and it's not even lunchtime.*

Above: *A busy street market in Montego Bay.*

Above: *Rose Hall, a former plantation house, still has a fine garden and lily pond.*

Right: *Jamaica society expresses its joyful reggae music in its street art too.*

Madagascar

Above left: *A bustling market in Antananarivo, capital of a quirky Indian Ocean island nation.*

Above right: *Hillside houses in Madagascar's capital.*

■ **MADAGASCAR** — An island in the Indian Ocean with fantastic wildlife, none of which I have seen except elsewhere, but I am including it because of its significance and because, who knows, I may yet get back there. All I have seen, and that was long ago, was a city and a market. I was passing by. Now I regret that I failed to go and see for myself its enthralling lemurs — over one hundred species — or any of its other mammals and birds. I was also interested, as photojournalist, in the curious funerary tradition, reburying the dead, a custom called *famadihana*. But I didn't see that either.

Looking to see what has been happening there, I found only grim news, the latest about thieves getting at the economically vital vanilla crop. Since gaining independence from France in 1960, I read, 'Madagascar has experienced repeated bouts of political instability, including coups,

HELLVILLE

MARCHÉ

violent unrest and disputed elections.' There has been 'international condemnation and economic sanctions… The political situation remains fragile.'

Moreover, for those who like to follow the news (count me in) Madagascar is a particular challenge if only because of family names, nearly always long and, for any outsider, difficult. For example, 'Hery Rajaonarimampianina's election as president in 2013 brought fresh hope following years of political instability.' If it were not for the computer's copy-

Above left: A town with an intriguing name in the offshore island of Nosy Be (Nossi Bé in 1966).

Above right: Reading, a good way to pass the time.

and-paste facility I would most likely not have managed even that small item.

Past events and personalities remain in Malagasy concerns. In 1975 Didier Ratsiraka seized power in a coup and ruled for some thirty years. And then? In 2001, after a disputed presidential

election, Didier Ratsiraka fled to France. In a more recent report, in 2018, former leaders Marc Ravalomanana and Andry Rajoelina stood against President Hery Rajaonarimampianina in November elections.

Well, I can spell vanilla and I have been to Madagascar's capital, Antananarivo, and elsewhere, and I can recall the entirely competent national airline's name for a year or two in the 1960s was an unfortunate Madair. On the daily life of the country's 25 million people and for the lemurs, I hope there is better news to come.

Top left: *A salesman with attitude.*

Top right: *Women whose clothes brighten the street.*

Left: *Architecturally odd, function clearly official.*

Mauritius

■ **MAURITIUS** — Who was there first it is hard to say, as mariners from Portugal, the Arabian coast and elsewhere are known to have stopped by during and after the 15th century. Early visitors – hungry Dutch seamen, allegedly – would also have been largely responsible for causing the extinction of a plump flightless bird, the dodo. Almost as odd is that the dodo lives on in memory and language. Whatever, Mauritius, a singular island east of southern Africa in the Indian Ocean, was colonised by the Dutch, the French and the British before it became independent in 1968.

The population, as it happened, was largely Indian. Thousands of 'indentured' labourers had arrived across decades to work on sugar plantations and in other agricultural areas. The first prominent politician was Seewoosagur Ramgoolam, Indo-Mauritian leader of the Labour Party. Mahatma Gandhi his inspiration, he was prime minister at independence and held the post until 1982. He was so much admired that the leader of the party that succeeded him appointed him governor-general. He died in 1985. Several streets, gardens, the airport and other public places bear his name. His son, Navin Ramgoolam, became leader of the Labour Party.

It's earlier events that I photographed, among them a 1960s rally of the opposition Parti Mauricien, addressed by a young and dashing Gaëtan Duval, who was lobbying for integration with Britain, adamantly opposed in London. Duval, of a creole family, would become Sir Charles Gaëtan Duval, QC Kt, distinguished

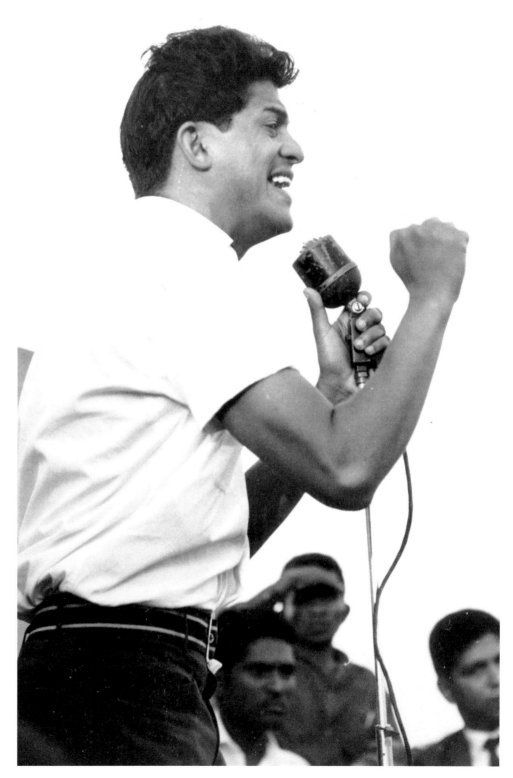

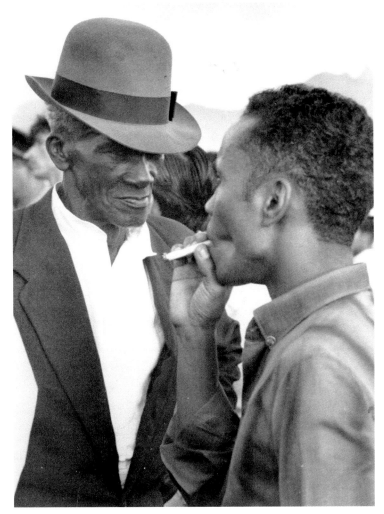

barrister and statesman who held government posts until his death, aged 65, in 1996. A son and grandson also entered politics. Successful politicians, indeed any professional, need to be articulate in both English and French.

A factor in Mauritian politics at the time, too, was the Chagos archipelago, British islands in the Indian Ocean, deviously destined to be an American military base. All Chagos islanders were forcibly removed before the end of April 1973, some to Mauritius, others to the UK. Their protests taken to court, their case partly won, continue to this day. An oddity in Commonwealth and colonial government are islands in

Opposite left: Gaëtan Duval, a dashing politician (later knighted, he became deputy Prime Minister), campaigning in the pre-independence 1960s.

Above left and right: Faces in a crowd listening to Gaëtan Duval. Apparently, I was there only to cover a 1960s election.

what's called BIOT, British Indian Ocean Territory. They hide a great deal of injustice.

Over the years the lagoons and beaches, gorges and a rainforest, surfing and snorkelling and a coral reef, the attractions of the capital, Port Louis, with French architecture and a 19th century horse-racing track, have become the basis of a steady tourism industry. Cultural diversity adds to the island's natural appeal. Tourism numbers of around 1.3 million a year double the island population. Sugar cane farming is not quite as substantial as it once was, but island rum – so I'm told – is superlative.

Réunion

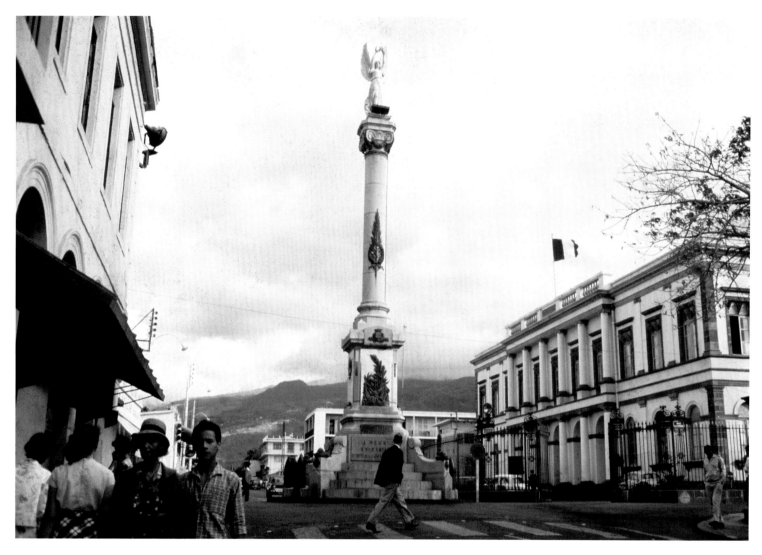

■ **RÉUNION** — Just another small Indian Ocean island, perhaps. Just another region of France. But this one has a remarkably lively volcano. Recent pictures show fiery red lava streams pouring from the Piton de la Fournaise, the 'summit of the furnace'. It looks terrifying but, as eruptions are quite frequent, is a fixture in island life rather like a snarling pet dog kept on a chain and closely watched. Unlike pet dogs, though, this wild beast is a Unesco World Heritage Site.

Above: St. Denis, capital of La Réunion, Indian Ocean island and department of France.

Less charming is a fairly recent wildlife development. For whatever reason, shark attacks became so common that the French government banned all surfing and swimming on the island's coast.

The island's past, the volcano apart, follows in several ways the pattern of its ocean neighbours, Mauritius and Mada-gascar. Discovered by Portuguese, colonised by French who initially called it Bourbon, briefly grabbed by the British between 1810 to 1815, not coinciden-tally a period dominated by Napoleonic wars. Sugar cane plantations, the impor-tation, post-slavery, of labour from India, Asia and East Africa, to work them – leading to the growth of a mixed society. Not only culturally but in terms of wealth. Colonial architecture in the capital, St. Denis, once signifying social position, is now a travel experience.

The Réunion Island National Park is the leading tourist attraction. Its one highly dramatic volcano, another dormant volcano, fissures and lava fountains, calderas and roiled landscapes are a grand show, all described as totally harmless and as 'climbing destinations' with hiking trails. The island has the aura of a movie set – and inevitably has been the location of quite a few. One was directed by François Truffaut. Titled *La Sirène du Mississippi*, or 'Mississippi Mermaid', it starred Catherine Deneuve and Jean-Paul Belmondo.

Based then in Kenya, I was assigned in the late 1960s to go to La Réunion and do photos of this renowned trio for *People* magazine. As almost overwhelmed starstruck movie fan, I did the photos – black-and-white then – and dispatched them to New York. No simple computer transfer existed then. I never saw the results. The movie itself, which I've seen described as 'a romantic drama' and 'an unusual *noir*', was not one of Truffaut's best. La Réunion, however, has a natural drama all its own.

Above: *A glimpse into a roadside home.*

Left: *La Réunion's volcanic origins are evident.*

Below: *France overseas and island beach.*

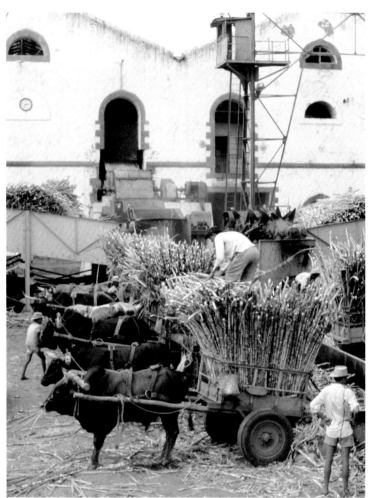

Top left: *Striking scenery in an Indian Ocean island.*

Top right: *Sugar cane is ferried to a processing plant by oxcart.*

Right: *Island traffic.*

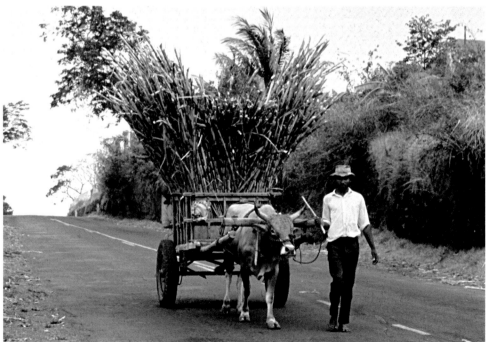

Seychelles

Left: *A gorgeous palm-fringed beach, island essential for a booming tourist industry.*

■ SEYCHELLES — Island fantasies come true in this beautiful chain of 115 granitic and coral islands. That's the boast of hoteliers and it is hard to dispute. The big guns of world tourism have moved in, creating resorts on islands fringed by palm trees and white sand beaches. Yet the Seychelles has managed to maintain almost everywhere a delicious 'desert island' quality, which began years ago with a law that made it illegal to build a hotel higher than a palm tree. How to preserve the idyll is of paramount concern in an age beginning to experience overtourism.

The mood and language in the few inhabited islands, with Victoria on Mahé the capital, reflect a small population (under 100,000) whose first language is a Seychellois creole. The French were there in the 18th century, followed by the British who took possession and began colonisation in the early 19th century. The islands became an independent republic in 1976.

It was the building of an airport in 1971 that turned a traditional agricultural community into a country whose main business was tourism. In parallel, fortunately, with keen conservation instincts. Even as the number of tourists annually tripled the resident population, a high percentage of the Seychelles territory, above 47 per cent, is protected by national park status.

When I lived and worked in Kenya, I visited the Seychelles frequently. These

Above: Endemic to the Seychelles, a rare black paradise flycatcher, La Digue its only habitat.

Above: In a broadly matriarchal society, a grandmother tends two small children.

Above: A serious little girl faces the camera.

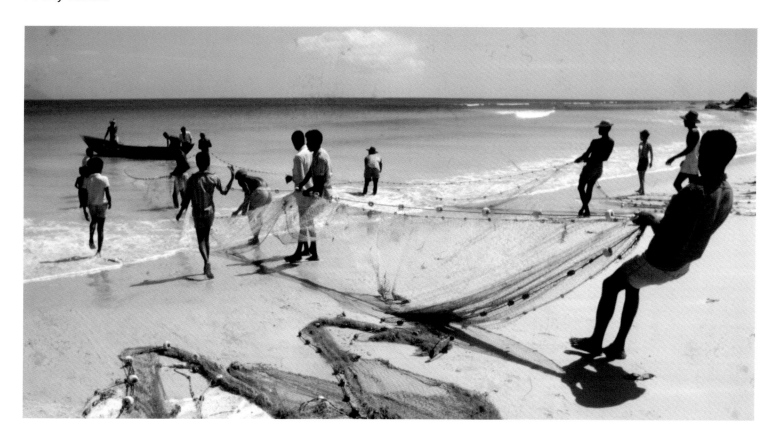

were its early years as independent nation. Even before there was an airport, I was there and recall the courteous welcome I was accorded by the family of the British governor, an administrator with a distinguished career in the colonial office who possessed the wonderful title of Earl of Oxford and Asquith. His elegant home, on a hill above Victoria on Mahé, later became State House and the residence of Seychellois presidents.

The first president, James Mancham, was an energetic businessman, lawyer, founder and leader of the Democratic Party and promoter of Seychelles tourism. He had hardly become president when he was ousted by his socialist prime minister, France-Albert René, backed by a force of Marxist-trained revolutionaries from Tanzania.

Opposite left: Seine net fishing is a small part of the islands' fishing industry.

Top left: A Mahé feature, a water fountain honours Britain's Queen Victoria who ruled a long-gone empire.

Top right: How Victoria, the capital on Mahé island looked in 2003.

Above: Houses on the steep slopes of Mahé, a granitic island in an archipelago of 115 islands.

Above left: A long-legged girl working in a small coconut factory extracts the fibrous nut's white meat.

Above right: In a more modern occupation a saleswoman with some of her stock of dresses.

Right: Once hunted by passing sailors, the giant tortoise inhabits Aldabra and other Seychelles islands.

Mancham lived in exile in London as successful entrepreneur until 1992, when he was able to return to the Seychelles and even, in full reconciliation mode, re-enter politics. René, for his part, leader of the Seychelles People's United Party (later the People's Party), was an active president from 1977 until 2004.

A colourful intrusion in 1981 came from a South African group of 43 mercenaries aiming to restore Mancham to power. Led by veteran Mike Hoare, the coup attempt failed miserably, getting no further than the airport where they had just arrived. The men only got away by hijacking an Air India passenger aircraft. The one Seychellois soldier from the national defence force who was killed was declared a hero.

What began as one-party rule eased to a democratic multi-party state which abandoned its socialist economy, began market-based policies and encouraged foreign investment. René, re-elected three times, resigned in April 2004, when his vice-president James Michel succeeded him as president. In 2016 Michel stepped down as president, citing the need for new leadership. Vice-President Danny Faure was sworn in as president to complete the rest of Michel's term.

Michel's presidency had included having to deal with Indian Ocean piracy. In 2015 the Seychelles became the first regional nation to chair the Contact Group on Piracy off the Coast of Somalia, serving for two years. The small nation was conspicuous in its cooperation with other countries combatting piracy through counterinsurgency and anti-piracy operations and is recognised as a leader in maritime security.

In June 2019, both James Michel and the current president, Danny Faure, received 'Planetary and Leadership' awards from the National Geographic Society for their work 'shielding national parks, wilderness areas and marine

reserves' from exploitation. During Albert René's presidency it had been my own good fortune to photograph, on expenses, aspects of the islands for the magazine.

I had friends there, too. Brendon Grimshaw, a former journalist, had purchased Moyenne Island for £8000 on a whim years before he could retire. Finally, he landed there to find an island little more than sand and rock. With the help of René Lafortune, initially a Seychellois hired hand who became a good friend, he planted thousands of endemic trees, brought in a quantity (the plural allegedly is 'creep') of the islands' giant tortoise, and turned his little island into a one-man 'Robinson Crusoe' haven – willing it, as national park when he died, to the Seychelles government.

Other good friends included an American golf enthusiast, no longer there, who was so passionate about the sport he hit countless golf balls into the sea. Friends, too, are the exceptional artist Michael Adams and his wife Heather. Michael's portrayal of the islands, where he has lived and worked since 1972, his evocation of their people and culture in a vivid style all his own, is a feast of colour, skill and imagination.

These ravishing Indian Ocean islands possess an individuality, a richness, that to my mind bears no

Above left: Ground-nesting sooty terns are abundant in the Seychelles and their eggs (harvested mainly from Desnoeufs and Bird islands) became a delicacy.

Above: Of more than 250 species of birds counted in the Seychelles the white-tailed tropic bird – here a. fledgeling in its nest – is one of the loveliest.

Top right and right: Fairy terns, found on most islands, are an exotic sight – as is their young, born from eggs laid on tree branches, not nests.

comparison with any other esteemed island group. What beauty there is in the juxtaposition of mighty boulders, palm trees, blue seas and beach. What extraordinary birdlife there is, ranging from the black paradise flycatcher to the white fairy tern. In lovely gardens, plants from pitcher plants to the frangipani dazzle the senses. Clearly, I am prejudiced. But even the briefest look at tiny La Digue, a wander in Praslin with its famous coco-de-mer, the bird islands, Cousin and Bird, the lively markets and hilly landscapes of Mahé, or a spell on any other accessible island, national park or otherwise, is a treat, a joy, that will stay in the mind and memory.

São Tomé and Principe

■ **SÃO TOMÉ AND PRINCIPE** – Two islands off Africa's west coast, they were part of Portugal's empire. Initially they were seen as ideal for sugar plantations which, needing labour, led to an active slave trade. Later, the islanders would turn to cocoa. Slowly the islands developed and, since 1975, have been theoretically independent. The qualification is because without support they would lack the means to function. The economy is described as fragile, two-thirds of the 200,000 population live in poverty, and even in accounting language things don't look good – the islands face 'serious fiscal problems having recorded budget deficits in nine out of the last ten years'.

Government since independence has more or less been in the hands of a small elite. Fradique de Menezes was president for ten years. Father and son in the Trovoada family have been prominent in politics. As to stability, coups are not unknown. On 15 August 1995, Manuel Quintas de Almeida ousted Miguel Trovoada for six days, and on 16 July 2003, Major Fernando Pereira deposed Fradique de Menezes for seven days. The current president, as I write, is Evaristo Carvalho. One of his first acts following his election was to re-establish ties with China. For a period the islands had diplomatic relations with Taiwan.

Top right: A rocky coast in São Tomé; formerly Portuguese, the island, together with Principe, attained independence in 1975. Economic hopes are pinned on oil.

Right: A distinctive rocky outcrop rises above a plantation on São Tomé island.

Perhaps it is judged to be good that 60 per cent of the population have electricity. On the dry measure of the human development index, all children get primary schooling (which is compulsory). The islands export a modest amount of cocoa, they survive on modest agriculture and, when I was there, they had modest hopes of finding oil.

A recent report tells of considerable amounts spent on prospecting possibilities with little actual income. Comments under a heading of 'Development Challenges' are not encouraging. Elsewhere, a text regarding wealth lists São Tomé as having the '55th-highest Gross Domestic Product among African countries…' As the African continent is made up of 54 countries, this isn't an encouraging rating.

Top left: *São Tomé city is also capital of the two-island nation; a notable building is the Casa da Cultura.*

Left: *A busy market is a highlight of São Tomé.*

Above: *A fort and statues reflect a past in which Portuguese explorers and navigators were prominent.*

Then again, on the plus side, for any travellers who trouble to get themselves to the islands, there are intriguing sights to see, among them Pico Cão Grande, Big Dog Peak, a 'volcanic plug' rising above the surrounding terrain on São Tomé. The legacy of extinct volcanoes also includes other volcanic peaks, gleaming beaches, a waterfall or two, equatorial forests. There's deep-sea fishing and whale-watching, snorkelling in clear waters and birdwatching – 35 species are listed.

In my own visit I found welcoming people, descendants of an ethnic mix from across the centuries – slaves from Africa, Portuguese colonists and other Europeans, Chinese and other Asians, labourers from many countries. All spoke Portuguese (as well as a local language, *forro)*, allowing me to brush up my own low-level skills from the time I lived in Portugal. The food, tropical fruits, seafood and spices in a 'creole' cuisine, was great. In economic terms, oil is still the shining mirage. Perhaps, with better infrastructure and more

Top left: *Rural houses are mostly built from wood.*

Above left: *In Pantufo, the church is also a community centre.*

Above right: *Women, as so often, are active money earners*

tourists, the islands' prospects would not be too bad. Privately, what a pleasure it was to be where mass tourism was no more than a distant dream.

South Georgia

■ **SOUTH GEORGIA** – Shattering reality is to watch the sun rise on this remote South Atlantic island and to see penguins, more than two hundred thousands of penguins, come into view as if they were performers in an extravagant wildlife movie. It is an amazing sight, it is real, and it happens on an island that is extraordinary in its physical attributes and its history, some of it appalling.

In a rich marine world, whaling and sealing expeditions – sealing mainly in the 19th century, whaling in the first

Above: In a cold, wild, mountainous island the largest population is of king penguins; there is no permanent human residence.

half of the 20th century – became a hideously bloody and murderous slaughter, ending barely in time for remaining populations to begin to recover. More than 175,000 whales were butchered. One of the whaling stations, Grytviken, is still there, a rusting, haunting boneyard.

To this island, too, in 1916 came explorer Ernest Shackleton and five men in a lifeboat after an 800-mile (1300-km) journey from Elephant island where the crew of his sunken ship, *Endurance*, were barely surviving. He then climbed the alpine peaks of South Georgia's mountains to reach the whaling station where a rescue mission could be organised. In one of the most enthralling sagas of the sea, the crew was rescued with not a single man lost. Undaunted by these harrowing events Shackleton

Above: *Steep mountains form a central spine in South Georgia; Shackleton, to get help for his men, climbed over them.*

had hopes of further Antarctic exploration. He died in South Georgia of a heart attack in 1922. His grave and that of Frank Wild, his closest companion, is in the small graveyard near the island's church.

The island, 165 km (103 miles) long and 35 km (22 miles) wide, is grouped with the Sandwich islands to form a singular British Overseas Territory. (Argentina, based on earlier claims, occupied it briefly in 1982 during the Falklands War.) The human population of the island is around 35 in summer, 16 in winter. The capital is a small research station, a collection of huts, at King Edward Point. Almost the

only buildings are the South Georgia Museum and a Norwegian Lutheran Church. There is no airport. Visitors arrive by ship in numbers rarely exceeding a hundred at a time, or up to around 5,000 in a year. Most, as I was, are on their way to the Antarctic.

With its snow-capped mountains and long tussock-edged beaches which, in season, are carpeted with bellowing elephant seals and their cuddlesome young, as well as by families of fur seals, the island is

strikingly beautiful. Shackleton's highly talented expedition photographer, Frank Hurley – photographer on other expeditions as well – took marvellous photographs. Many can be seen online. Now we are all photographers, but none of us can match his courage and experiences and very few of us his artistry. Yet in every direction there is much to see. Climbers in organised expeditions attack Shackleton's route over the mountains.

The brash seals and eight species of penguins, the king penguin most numerous, emperors and Adélies rare here, are the most prevalent wildlife on the island. But with 78 species of

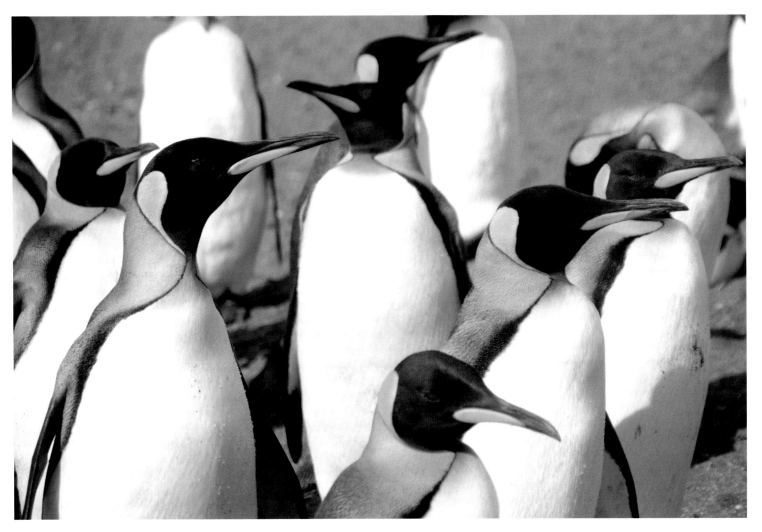

Above: King penguin colours seem almost tailored.

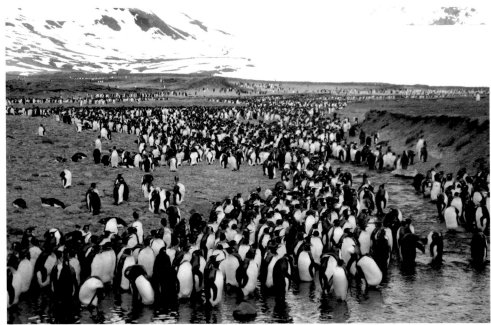

Left: Penguins colonise the island in huge numbers.

birdlife listed, the range is formidable. Here are wandering and black-browed albatross, petrels, shearwaters, cormorants, kelp gulls and terns. The bossy and aggressive brown skua even I, not a brilliant birdspotter, could recognise.

But it was the penguins that touched me most of all. Fearless adults or fluffy young, they lead such a hard life. Their world is icy ocean,

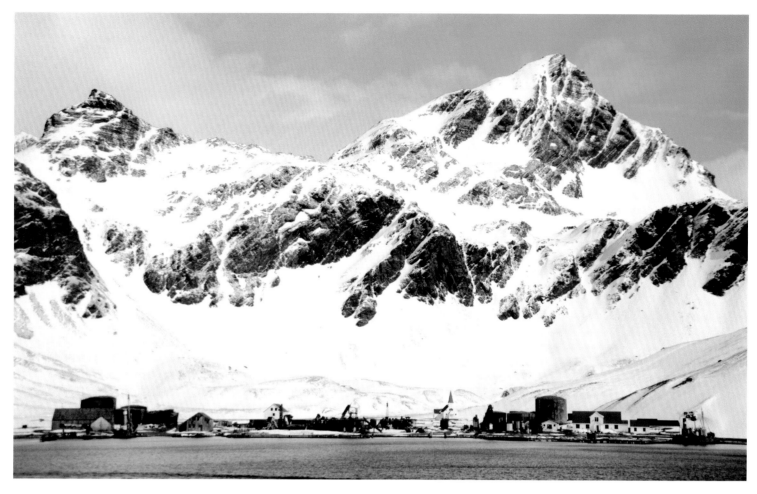

bleak rock and stony beach, daunting cliff, a cruel, demanding nature. They seem to parade contentedly in huge numbers, to have all the food they need in the ocean's fisheries and abundant krill – but the smallest shift in the natural order could confound them. What will happen when waters are warmer, when krill diminishes, when nature's balance is altered? Science is good at providing answers. All the same, we should all worry

Above: Once a place of monstrous whale slaughter, Grytviken is now a haunting row of ruins.

Right: Elephant seals slumber peacefully in the rusting ruins of Grytviken.

Above: *Very early morning and a rising sun reveals vast populations of penguins.*

Above: *For throngs of penguins and elephant seals South Georgia is a place to rest and to raise their young.*

Above: *Parents need to find their infants, the young to be recognised. A still fluffy chick seems to be saying 'Hey mum, it's me'.*

Above: *The bond established, a young penguin gets fed by a parent.*

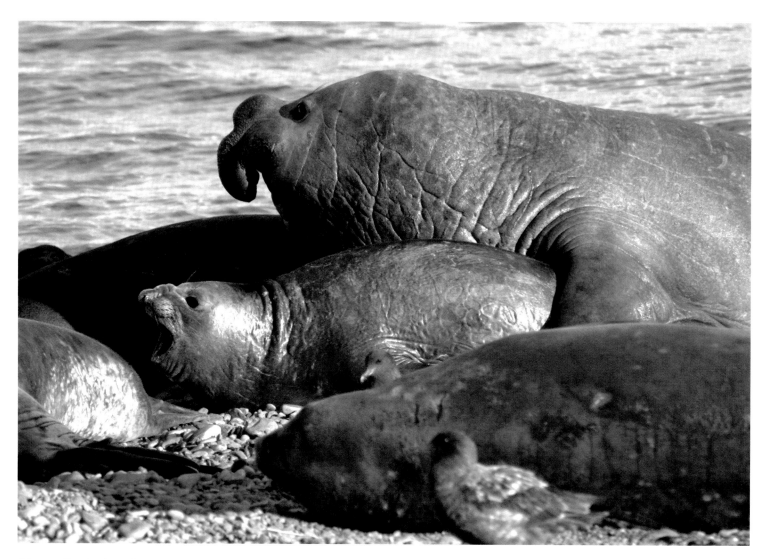

Above: *On the beach an orgasmic moment occurs as a male elephant seal clasps the much smaller female to him with his flipper.*

Right: *A dramatic sunset over an amazing South Georgia.*

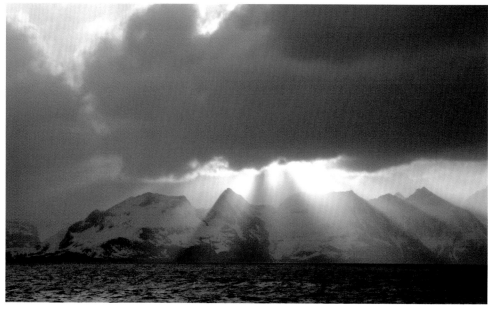

Vancouver

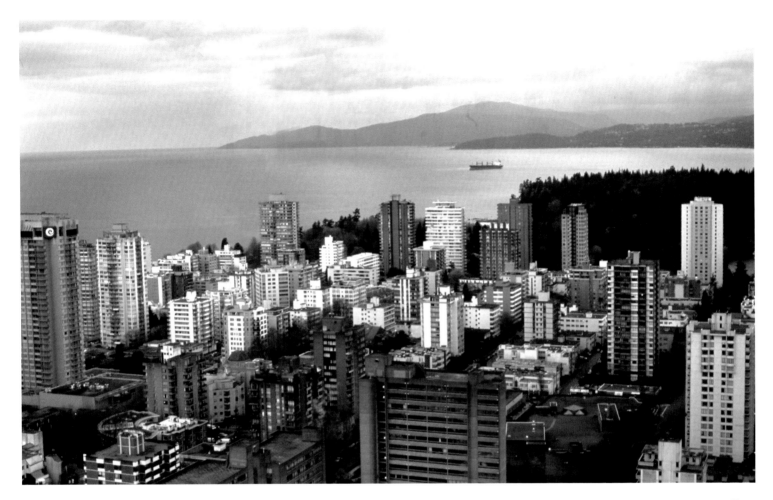

■ **VANCOUVER** – Canada is so big that Vancouver, way over to the left on a map of the country to which it belongs, is not much more than a speck. On the island, the outlook is very different. The Pacific Ocean, lapping its shores, is one reason for that. Another is that it has such a strong identity within the British Columbia province it sometimes feels like a country in itself. (Few Canadians would agree.) As island, it's a fair size, 460 km (290 miles) from top to toe, 100 km (62 miles) at its widest, making it the largest island on the west coast of the Americas, although it's not by any means Canada's largest island.

Above: With the vast Pacific Ocean beyond, Vancouver Island lies between Burrard Inlet and Fraser River.

The climate is pleasant, the landscape varied. On the island are dense forests, high mountains and cool lakes, and Mediterranean areas where lemon trees grow. Wildlife includes black bears and elk, cougars and wolves, and in the rivers and lakes are trout and salmon galore. The main city, Victoria, or Greater Victoria, if the full metropolitan area is included, is as technologically advanced as anyone might expect. There are several airports,

water aerodromes for floatplane traffic and busy ferry services.

Above all, there are the people, around 800,000, of whom about half live in Greater Victoria. They include descendants of the indigenous 'First Nations' tribes, some still speaking their tribal language, descendants of European fur traders and of British settlers, initially linked to the Hudson's Bay Company. The island was also a launching pad for gold-rush miners and at times was bustling with gold-hungry mobs. Outside Victoria the economy is still largely based on logging, an industry that in an

environmentally-conscious era is controversial. New residents include immigrants from many countries.

As it happens, I didn't see much of Victoria or any of the mountains. I was in Vancouver Island to attend a memorial gathering commemorating a good friend who had unexpectedly died. Her home had been in Sooke, a small town in the south of the island. The name Sooke, I learned later, derives from the T'sou-ke First Nation.

There were no First Nations people at our gathering, but as my friend was a journalist of Welsh extraction and we had together walked the Gower peninsula and I had worked with her in London, I felt international tribute had been made. (I also managed to bring French cheeses to what turned out to be a joyful celebration of my friend's life, not at all a sad farewell.)

Sooke stood in for a lost life and valued friendship. It was as good a reason to travel to a Pacific coastal island as any other. I saw ocean, and ferries, and a quiet world new to me. The Canada that I glimpsed here was totally different from the spectacular Arctic or graceful Ottawa, but added a new perception to memories, and sometimes photographs, reaped and cherished across the years.

Right: *Vancouver Island protects the Strait of Georgia from Ocean weather.*

Right: *Vancouver Island is almost a world unto itself.*

Top: *Vancouver Island is a renowned part of the British Columbia coast.*

Above, left and right: *There is much pleasure to be had in Vancouver Island waters.*

Zanzibar

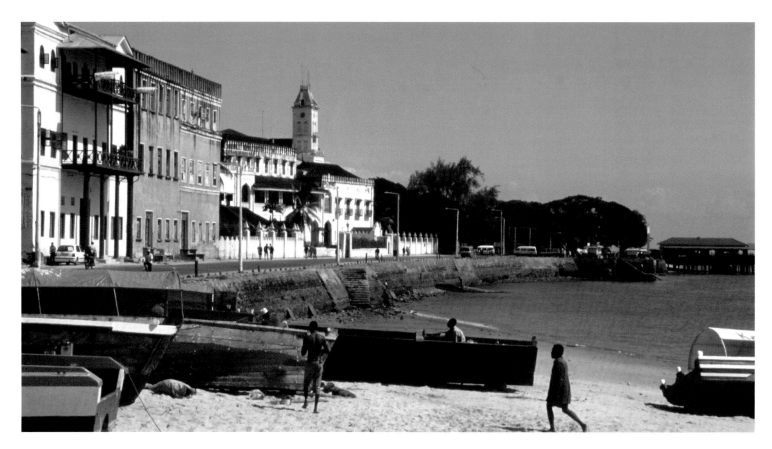

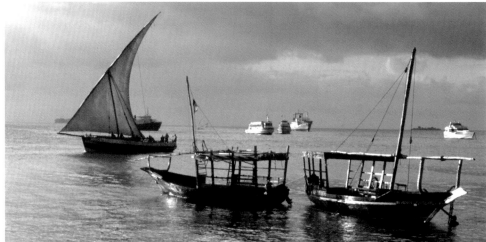

■ **ZANZIBAR** – An island that has been a part of Tanzania since the 1960s, and today heaves with tourist hotels and resorts, Zanzibar has also been a conspicuous player in history across centuries. Portuguese explorer Vasco da Gama was there in 1498 on his way to finding a sea route to India. Persian, Indian and Arab traders were there as early as the 10th century. A British ship dropped anchor in 1591 when a few Portuguese had taken root. Disliking these European invaders, local Swahili leaders invited Omani merchants from the Sultanate of Oman to take over.

In 1840 or thereabouts the Sultan of Muscat and Oman moved his capital to Stone Town in Zanzibar. In a brilliant step,

Top: Zanzibar, looking towards Stone Town, the informal name of its old city. Tall on the left is the House of Wonders, built in 1883. Among its wonders – the island's first electricity.

Above: Zanzibar's history is closely tied to trading – slaves, notably – and the sea.

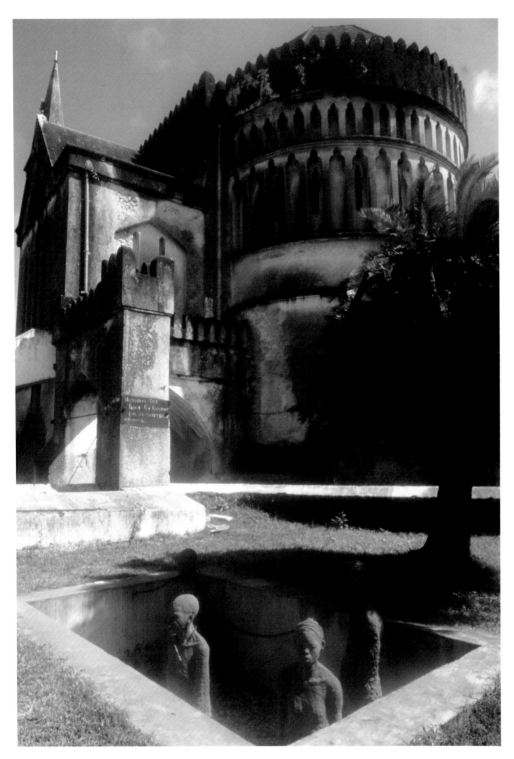

Above: *The British brought the Anglican cathedral; so-called slave pits in its gardens were created to honour the many victims of the years of trade.*

Top: *For David Livingstone, 19th century missionary, doctor and explorer who hoped to find the source of the Nile, this house was his Zanzibar home. Since his time it has had many uses.*

Above: *In the 16th century spices were vital to Portuguese traders. Later, Omani rulers introduced cloves, which became a national resource and treasure.*

he introduced cloves, a true treasure, to the island. Cloves and other spices, as well as ivory, were tempting cash crops, not even diminishing in value as the expanding slave trade proved more rewarding. Zanzibar, the place from which Livingstone and Stanley set off on their African explorations, became East Africa's entrepôt for the slave trade.

The best-known slave trader had the memorable name of Tippu Tip. He was notorious for the large expeditions he organised into the depths of Africa. The slaves he bought cheaply from local chiefs he sold at a considerable profit in the Zanzibar slave market, establishing himself as one of the island's wealthiest residents.

Omani rulers at the same time were increasing contacts with the British, whose prime objectives were the abolition of slavery and expansion of their empire. As the ships of other nations were also busily engaged in the slave trade, Britain's policy was not immediately successful. By 1873, with the Royal Navy at hand, the British consul was able to threaten Zanzibar's ruler, Sultan Barghash, with a blockade of the island. Treaties were signed and the worst horrors of the slave trade and its markets came to an end, at least in Zanzibar.

In 1890 Zanzibar's relations with Britain were formalised by its new status as protectorate. The arrangement lasted until December 1963, and was terminated by the British whose plan was to ease the island, once again under an Omani sultan's rule, towards independence within the Commonwealth. Zanzibari revolutionaries thought otherwise. On 12 January 1964, the sultan was forcibly deposed, banished into exile,

and replaced by a People's Republic led by the socialist Afro-Shirazi Party. In a violent transition, thousands of the wealthier islanders were killed.

Within a year there was another development. The new republic merged with mainland Tanganyika, independent since 1961 and led by the mild-mannered socialist Julius Nyerere, the two states becoming the United Republic of Tanzania.

Zanzibar, along with its neighbouring island Pemba and a few smaller islands in the group, retained a nominal semi-autonomous status, interpreted by Zanzibari leaders as full autonomy.

Politics in Zanzibar remained turbulent. The 1964 coup had been launched by John Okello, an aggressive Ugandan who called himself Field Marshal. He was soon pushed aside. The first president, Abeid Karume, a keen socialist, imaginative but hot-tempered, frequently embarrassed Julius Nyerere. In 1970 he announced there would be no more elections in Zanzibar for at

Top left: Stone Town, with its long history, has many byways and narrow streets – now recognised by Unesco.

Top right: Handsomely carved doors to important buildings became a splendid feature of Zanzibari culture.

Above: Fine carving, though maintained, at times meets with disrespect; graffiti knows no boundaries.

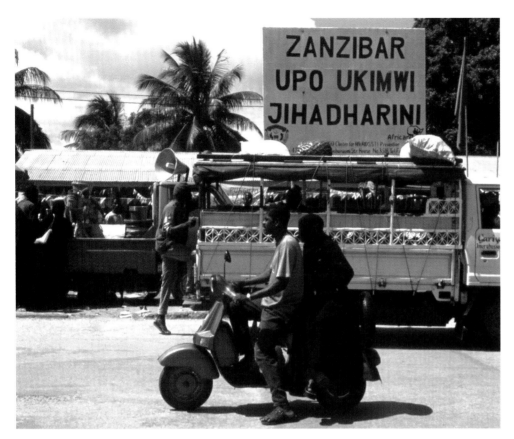

least sixty years, and that developing the country was more important than a constitution. But in April 1972, as he sat with colleagues in the cool of the evening in the Afro-Shirazi headquarters, he was assassinated, gunned down by a young soldier whose father

Top left: *Some Muslim women wear the enveloping* bui bui; *many others don't. In this transport centre the Swahili sign is a warning about AIDS.*

Top right: *On an island popular with tourists, a young woman has had henna artistically applied to her hands and feet in the style of local women.*

Left: *A setting sun shines brightly on Zanzibari women attending a meeting.*

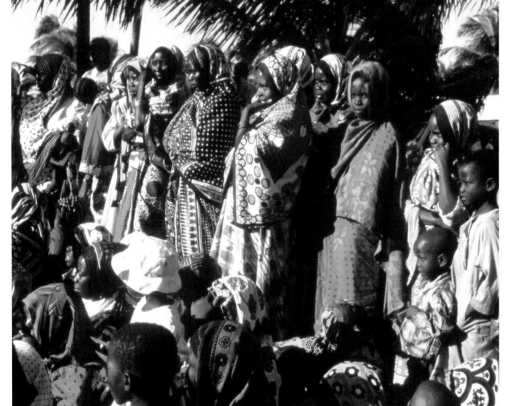

had been executed. His successor was the more moderate and pragmatic Aboud Jumbe, a former schoolmaster.

The president, Zanzibar's seventh, as I write years later, is Ali Mohamed Shein, who hails from Pemba. The nation still calls itself a socialist republic. Spices are still valued, although clove production, once guarded like diamonds, is now well below Indonesia's. Tourism has become a large and profitable industry in Zanzibar. I counted nearly 600 hotels and spas, their promotion including such phrases as 'with seaview massage parlours', 'guided walks… sensitively conceived', 'many eateries along the beach', 'fusion dishes with a European slant'. Fine, in a mass-tourism context, but far from my own experience.

I had first seen Zanzibar in 1963, having got myself there from Dar es Salaam, on the mainland, aboard a rickety schooner named *Sea Luck*. It needed all the luck it could get. We experienced a storm and breakdowns and it took thirty hours to make the 45-mile, 72-km, journey. But I was still in time to see the last of the sultans in his red Rolls Royce as it made its way through a narrow alley. I was back, as photo-journalist based in Kenya, when the island turned socialist and, after Abeid Karume had been assassinated, for his funeral.

Above: *Literally, People's Bank of Zanzibar, and it's a fine building.*

As a Muslim, this meant Koranic incantations and the lowering of his wrapped body into a grave. I was the only woman among graveside mourners and the press. Recording the moment, I wrote how a soldier, 'restraining the throng, put his hands on my chest. A thoughtful expression crossed his face and, tentatively, he squeezed. Surging crowds, heaving cameras, broke the moment.'

For the hardworking press, humour often eases the pressure. In August 2019, a small news item appeared about a company called Zanzibar Gold Inc. mobilising field crews to explore two properties in Tanzania, Mkuvia and Fukawi. How my old mates in the press would have howled with glee. We thought we had invented a joke about explorers lost in Africa moaning 'where the fukawi?' and here it was, a fabled titbit in print.

Zanzibar, when I lived in Africa, was on my beat. I was there too for moments more pleasant than coups and funerals. For a total eclipse of the sun, for a new seashore hotel when tourism was just beginning. And for the first Zanzibar international film festival, ZIFF, in which a photo of mine of an Arab dhow under full lateen sail was used for the poster. I was invited, the fortunate guest of one of the sponsors, an enthusiastic hotelier by the name of Emerson Skeens who adored Zanzibar and its Afro-Arab culture. Three of his delightful hotels have outlived him. ZIFF, too, has lived on, grown to one of Africa's most successful cultural festivals.

All islands cast a magic spell. The name, the very word, Zanzibar, is intoxicating. Subject to the laws of nature, and of governments, the island has been both paradise and paradox. I am grateful that, once, I knew it well.

Postscript

Sir Michael Palin writes:

It's not just what you see that makes travel such an addictive experience. It's how you see it, and how much you understand of what you're seeing whilst you're seeing it.

Compared to Marion Kaplan's eighty years my journey round the world in eighty days might as well have been in a rocket. Marion Kaplan makes you feel as if you're seeing the world from an open-topped bus, frequently re-fuelling, lingering in markets for provisions and picking up passengers along the way.

This is the way to see the world. And I mean the world. There's hardly a corner of the planet untrod by Kaplan's boots. I can't remember a travel book which brought together, under the same roof, Burundi and the Galapagos, Panama and South Georgia, Yemen and Lithuania, Madagascar, Andorra and Mexico. And yet this is not a tick-off book, a 'been there, seen it' country-spotter's list. All these disparate locations are part of a lifetime narrative of exploration, enquiry and experience which is deliberately and unashamedly personal. Marion Kaplan is, as all good travellers should be, insatiably curious. Curious rather than judgemental. Places like Gabon and the Central African Republic rarely get much attention, yet they are both significant countries which we should know more about, and quite rightly she gives them space.

I've often felt frustrated by photos without context. I'm one of those nerds who like to know where exactly a photograph was taken and why. I want to hear the background history or just a piece of gossip or whatever it is that enriches the picture. Luckily, Kaplan is not just a photographer, she's a photo-journalist and she trains a reporter's ear on the world – at times baleful, at times ecstatic, but always wry, unsentimental and informed.

Not only has Marion Kaplan been everywhere but she's also met everybody and like a good journalist she's always looking for the back-story, and over the decades of the 1950's to the 1970's, as decolonisation loosens shackles across the world, there's plenty of material to go round.

She has a good sense of fun. Hugh Hefner and two bunnies squatting on top of an embarrassed cheetah clearly dying to tear them all apart. A giraffe sticking its long neck into a very smart dining room.

I like the fact that the book is not over-curated. It's divided along simple geographical lines, by continents (plus a rewarding chapter on Islands) and countries. We're not drawn into "industry" or "post-colonialism" or any other editorial interferences. Kaplan knows what's important to her and she wants to get as much of the world in as possible, leaving the reader to make up their minds what they take from it.

The scale and scope of her eighty year journey is breath-taking. There are photos that bring back powerful memories for me – the eye-catching decoration on the buildings of Bhutan, the boatyards of Iran and Kuwait where sturdy dhows are still constructed as they have been for hundreds of years, the massive, thrashing waters of the Iguazu Falls. And there are

© John Swannell

tantalising glimpses of places I haven't seen but still hope to. The Galapagos islands, the mini-Manhattan mud towers of Sana'a in the Yemen, the remote beauty of South Georgia with its ice-covered mountains and long beaches on which colossal numbers of penguin gather shoulder to shoulder, staring out to sea as if waiting for the end of the world.

Binding all these images together, and making them all relevant, is Kaplan's sense of history, her view of the world as an ever-changing place of marvels and mysteries, of human mess and natural beauty side by side.

There is a sense that she is comfortable anywhere in the world, and that eighty years of travel has not been too much for her, but too little.

Michael Palin, London, March 2020

Acknowledgements

First, I wish to honour my late parents who provided the genes, the tolerance and the liberal outlook that enabled me to embark on a lifetime of challenging projects. Then, huge credit to Eric Robins, a 'veray parfit gentil knight', a Chaucer description that, as the hardworking Fleet Street journalist he once was, he would balk at – for the constancy, concern, imagination, moral support and dry humour that sustained me for 35 years.

More immediately, I am fortunate in benefiting from the skills of the book's designer, Mark Tennent, and text editor Jan Dodd, whose piercing eye caught my errors. (Any that remain are entirely my fault.) I am grateful, too, to my widespread family and to protective neighbours, and to the many writers and photographers whose creativity has given me decades of joy and inspiration. I must also acknowledge the invisible faces within the cyberworld of the internet and all other sources of facts and figures.

One fact that cannot be ignored: ours is a world with a high level of nastiness, cruelty and deceit. Somehow, I have encountered very little of it. Looking back over more than 80 years, I can only offer heartfelt thanks to the countless people in the many countries where I worked, travelled and took photographs for their hospitality, kindness and generosity of spirit.

About the Author

Marion Kaplan is a London-born photo-journalist and writer. She lived in Africa for twenty years and, as freelance, worked for a wide range of newspapers and magazines including *National Geographic*, *Time* and *People* in the United States, *The Observer* and *The Times* in London.

She is author of *Focus Africa*, a book on Africa's post-independence period; *The Portuguese: the Land and Its People*, recently listed in the *Telegraph* as the best non-fiction book on Portugal; *So Old a Ship*, a vivid account of the last great trading dhows; and *France: Reflections and Realities*. Her photographs have also appeared in numerous other books and international media. She now lives in southwest France.

Above: *At the end of her five-month dhow voyage, Marion Kaplan in Mombasa, Kenya, with the nakhoda (captain), two of his sons and a friend from home.*

Index

Photographs are indicated in bold.